FRENCH STYLE

© 2012 Assouline Publishing
601 West 26th Street, 18th floor
New York, NY 10001, USA
Tel.: 212-989-6769 Fax: 212-647-0005
www.assouline.com

ISBN: 9781614280996

Introduction translated from the French by Denise Raab Jacobs.
Texts translated from the French by Christopher Caines.
Color separation by William Charles Printing.
Printed in China.
Design by Camille Dubois.

BÉRÉNICE VILA BAUDRY

FRENCH STYLE

ASSOULINE

INTRODUCTION

Martine Assouline, my editor, challenged me to "define French style in one hundred and twenty-five words." I immediately jotted down the first words that came to mind, then others, and within one hour I had assembled a jumbled, slightly inane and harebrained list of more than three hundred words. Looking it over, I was both surprised by its diversity and dismayed by the choices that would eventually have to be made. In my view, French style is not just about savoir faire and *savoir vivre* but also and especially about how to think and behave. It applies to clothing design, home decor, and cooking just as it does to building bridges, having a conversation, protesting, and writing. Therefore my list would include writers and poets as well as scientists, explorers, artists, and those who represent the nation's expertise; political figures preceded fictional characters, singers followed comedians. Tabletop designers were featured alongside landscape artists; national treasures were listed with the castles of the Loire; Godard's name brought up Belmondo; Voltaire elicited Zola, then Sartre; Edith Piaf brought to mind Chanel's famous little black dress. Certain concepts and ideas had to be included in this book: universalism, the Revolution, Cartesianism and critical thinking, but also strikes, activism, and indeed the French language itself.

I showed this Prévert-style lineup[1] to my closest friends. Their reaction caused me to feel immensely isolated in my thinking: One friend pointed out that I had left out Courrèges—"After all, Courrèges is very French..." Another felt that I had to mention Boulle: "Boulle marquetry is very French." Still another spoke of "ménage à trois"—"Libertinage is very French, *non?*" And still another insisted that I include "spelling": "What other country besides France is as obsessed with spelling and *dictées?*" Then came the reprimands: You would include Voltaire but not Rousseau? Escargots but not foie gras? Sartre but not Simone de Beauvoir? Goscinny[2]

but not Moebius[3]? Cognac but not Calvados? Louis XIV but not Francis I? The final blow came from none other than one of my compatriots, another French-Argentine, who whispered, half seriously, half kidding: "And what about Borges? You wouldn't include Borges? Isn't he considered to be a French invention?" Just as there are more than one thousand and one French regional *spécialités*, there are more than one thousand and one different ideas (and specific ones, I must add) that define French style. The task was not going to be easy.

Having spent several years living away from France, whether in Argentina, Spain, or the U.S., I've had the opportunity not only to understand how the French are perceived throughout the world, but also to take stock of my own distinctive French characteristics. Indeed, there really is a French style, which is very specific, unique, renowned, and universally celebrated. This very small country, situated between land and sea, is world famous, if only because of its diplomatic representation and the preponderance of French lycées. It is both proud and self-conscious but also open-minded. French style exists only by comparison and through the eyes of foreigners. France is striking in its diversity and creativity. While its image is typically associated with exceptional savoir faire, gastronomy, and couture—which establish France as a model of luxury and sophistication—it actually represents more than that. The French are known and recognized for their creativity and craftsmanship, but also for their inventors, artists, builders, and intellectuals. This has been made very clear to me by people all over the world: A Japanese architect will mention Jean Nouvel; a Chinese mathematician will ask me about the French school of mathematics; engineers will speak of bridges and canals built by Frenchmen throughout the world; young people will quote David Guetta or the musical group Justice, while others will bring up Jean Dujardin, etc. Just recently, people have randomly talked to me about Ubisoft, the French video game developer; Patrick Blanc, the creator of the Vertical Garden; Frenchwomen in general and the actress Marion Cotillard in particular; Royal de Luxe, the street theater company whose giant marionettes have performed in the streets of Liverpool, Santiago, and Berlin; Roger Vivier shoes, the Curie Institute, the astonishing number

of roundabouts on French roads, the Tour de France, and of course, the strikes, the thirty-five-hour work weeks, and the arrogance of the French. There are one thousand and one different ways for foreigners to speak about France.

The paradoxes and contradictions within France and its people can be disconcerting. Consider the sobriety of the little black dress within the gilded setting of a Louis XVI reception room. Consider the poets and mathematicians: France boasts the highest number of Nobel prizes for literature as well as the most Fields medals per capita. Consider the fact that huge groups of strikers gather in a country that is one of the global economic powers. Or that Coluche, a French comedian, ran for the presidency with the support of famous philosophers. Or the endless discussions taking place in cafés, living rooms, and restaurants that focus inevitably on food and politics. And consider the fictional heroes, so human and imperfect and therefore so unique, that the French have created: valiant and rebellious musketeers; Cyrano de Bergerac, brimming with panache and faith in everlasting love; the indomitable Gauls Astérix and Obélix, who celebrate the dénouement of their comic-strip adventures with a huge feast. French style encompasses all of these in a glorious mix of frivolity, sophistication, rigor, and analytic spirit. In France, cars may be small but ideas are conceived on a universal scale. We love traditions but dare to go against them: A glass pyramid was installed in the courtyard of the Louvre; the works of Senegalese artist Ousmane Sow were exhibited on the Pont des Arts; and the sculptures of American artist Jeff Koons were shown in Versailles. Jean-Paul Goude organized the traditional Bastille Day parade for the bicentennial of the French Revolution, and Yves Saint Laurent's designs were presented at the World Cup soccer finals in Paris to the astonished audience of sports fans from all over the world. We French like to display a certain attitude of nonchalance. We enjoy provocation as much as satire, be it political or social, with a definite penchant for debate, for criticism as well as self-criticism. To this day, France still resembles that village of rowdy yet congenial Gauls who are proud, who may resist politically and culturally, but never hesitate to visit their neighbors.

Finally, because I am who I am and because I love literature, French style is also about the French language, whose rules and idiosyncrasies shape French thought. The French language has always been seductive and inspiring; many world authors have chosen to write in French, from the Irishman Samuel Beckett to the Albanian Ismaïl Kadaré, as well the Czech Milan Kundera, the American Julian Green, the Romanian Eugene Ionesco, the Egyptian Edmond Jabès, the Spaniard Jorge Semprún, or the Chinese Gao Xingjian. France honors its poets and thinkers as the true fathers of the nation—schools are often named for writers and philosophers.

Among the entries chosen for this book, some explore stereotypes and clichés. Others reveal aspects that are less familiar but just as representative of French style. All are linked by connections that are sometimes evident and sometimes more elusive. I shied away from a static reflection, choosing instead to reveal, through the echoes of words and images, a living kaleidoscope of French style in all its glory.

BÉRÉNICE VILA BAUDRY

[1] The writer Jacques Prévert [1900–77] penned the surrealist poem *Inventaire*,
a miscellaneous list of random items.
[2] co-creator of the *Astérix* comics series.
[3] aka Jean Giraud, comic book artist.

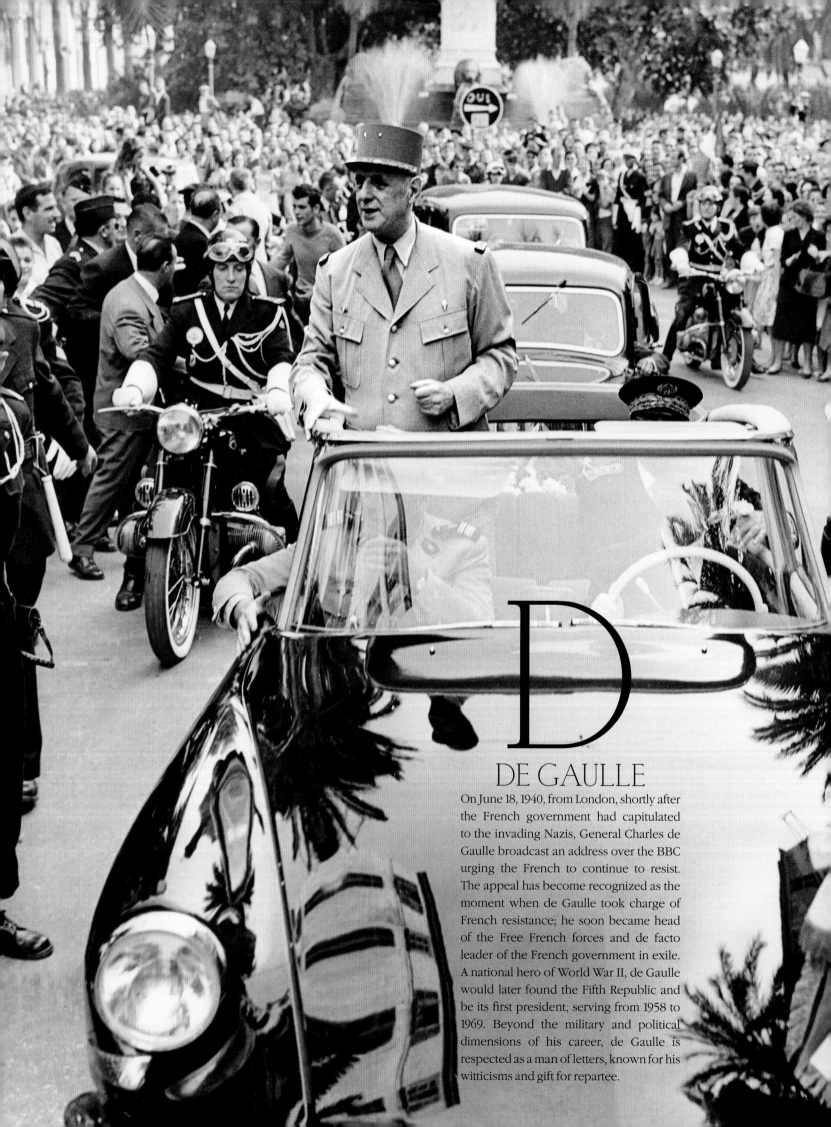

D

DE GAULLE

On June 18, 1940, from London, shortly after the French government had capitulated to the invading Nazis, General Charles de Gaulle broadcast an address over the BBC urging the French to continue to resist. The appeal has become recognized as the moment when de Gaulle took charge of French resistance; he soon became head of the Free French forces and de facto leader of the French government in exile. A national hero of World War II, de Gaulle would later found the Fifth Republic and be its first president, serving from 1958 to 1969. Beyond the military and political dimensions of his career, de Gaulle is respected as a man of letters, known for his witticisms and gift for repartee.

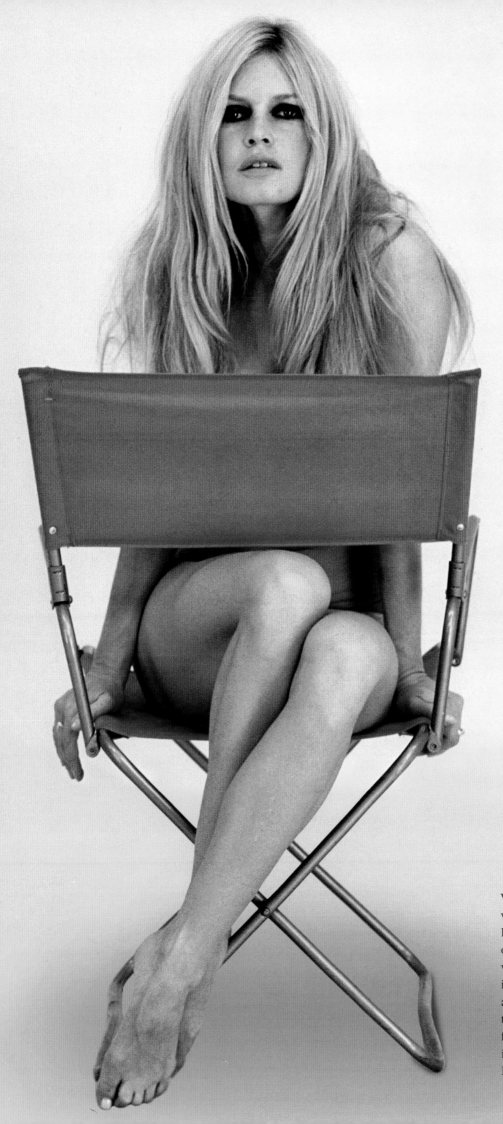

B

BARDOT

When a journalist once asked her, "What was the most beautiful day of your life?" Brigitte Bardot replied, "A night." Muse of the 1950s and '60s, and a French star without precedent, "BB" became an international icon of women's liberation and sexual freedom. She inspired the greatest filmmakers of her day, from Jean-Luc Godard to Louis Malle, including, along the way, René Clair and Roger Vadim.

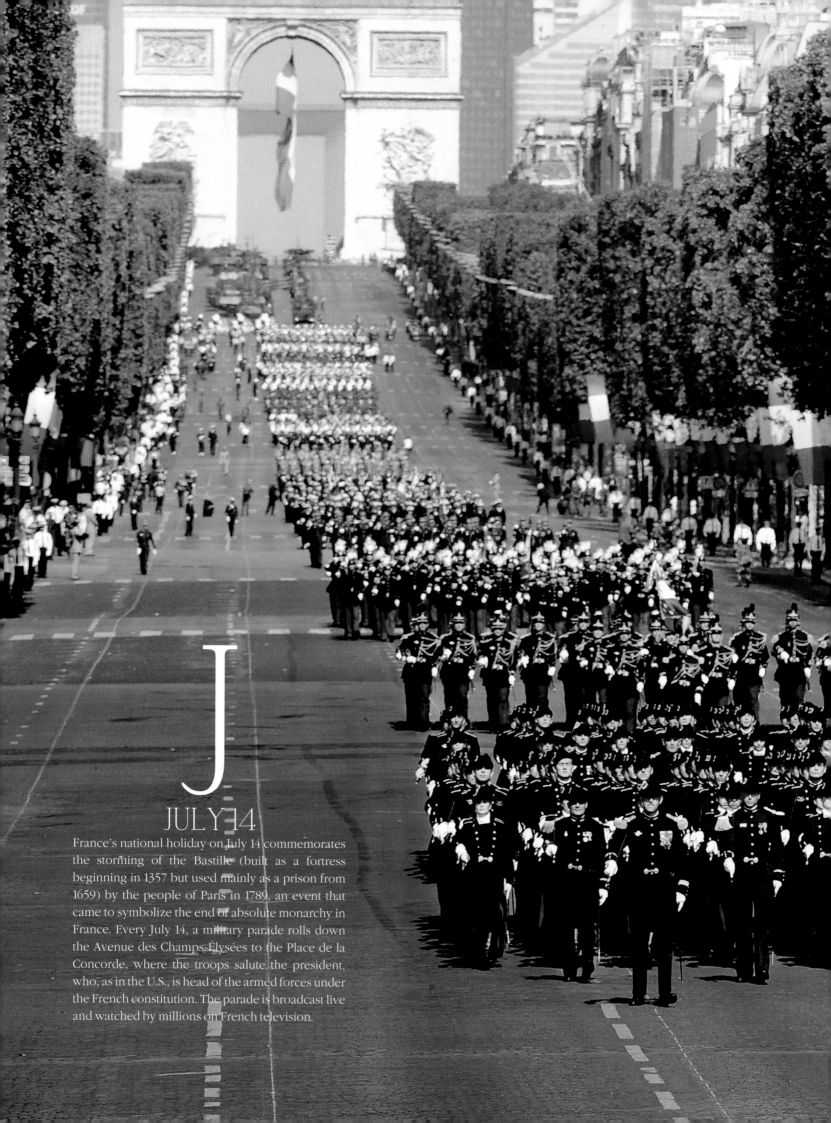

J
JULY 14

France's national holiday on July 14 commemorates the storming of the Bastille (built as a fortress beginning in 1357 but used mainly as a prison from 1659) by the people of Paris in 1789, an event that came to symbolize the end of absolute monarchy in France. Every July 14, a military parade rolls down the Avenue des Champs-Élysées to the Place de la Concorde, where the troops salute the president, who, as in the U.S., is head of the armed forces under the French constitution. The parade is broadcast live and watched by millions on French television.

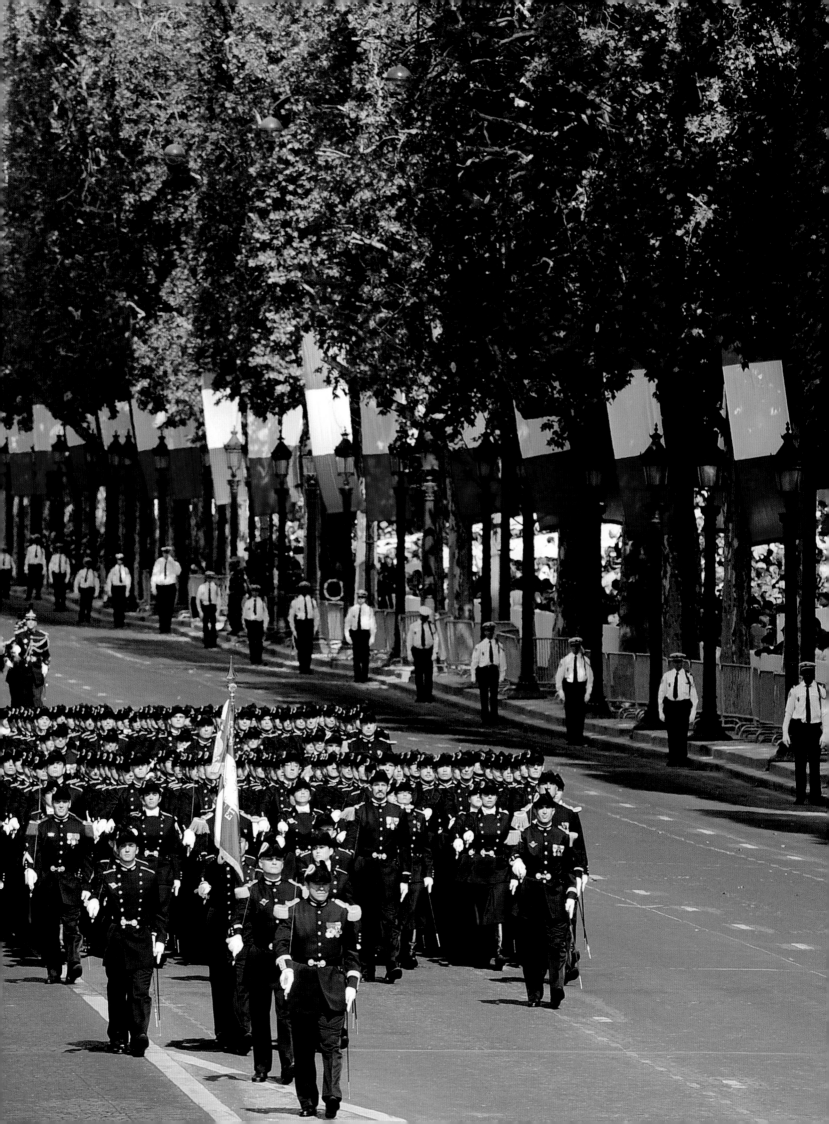

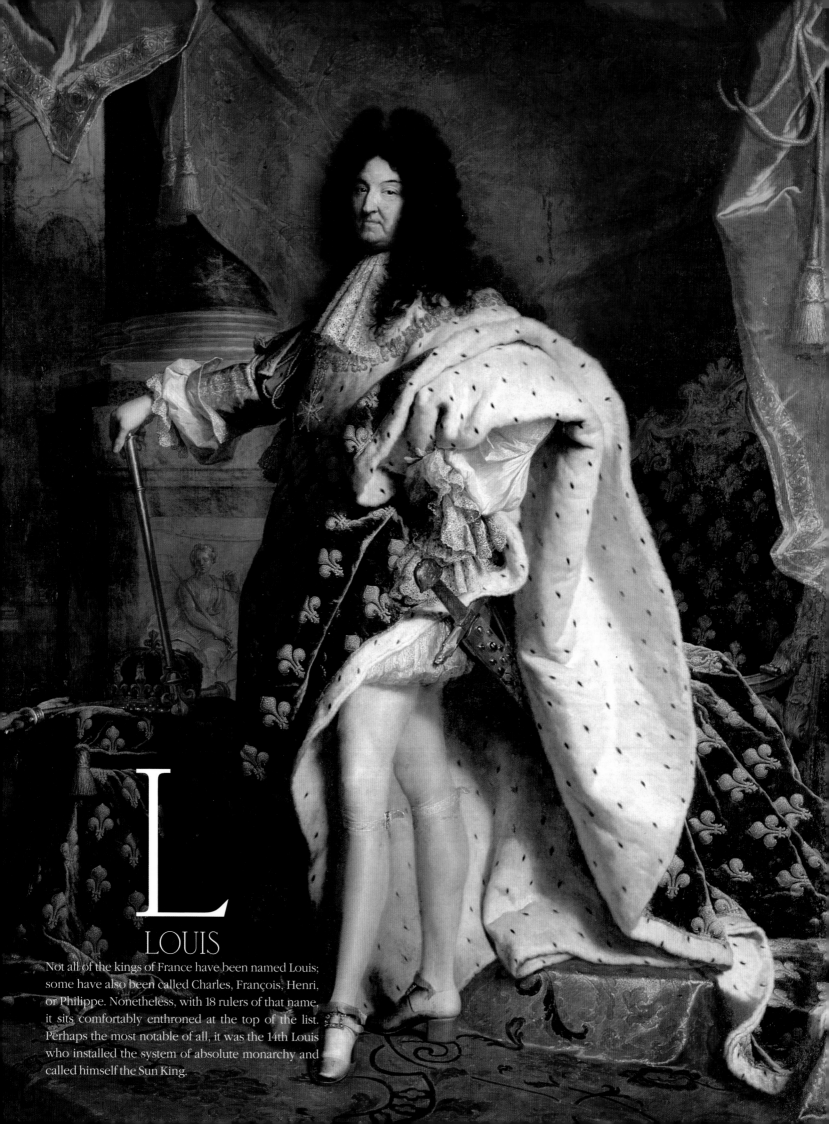

L
LOUIS

Not all of the kings of France have been named Louis; some have also been called Charles, François, Henri, or Philippe. Nonetheless, with 18 rulers of that name, it sits comfortably enthroned at the top of the list. Perhaps the most notable of all, it was the 14th Louis who installed the system of absolute monarchy and called himself the Sun King.

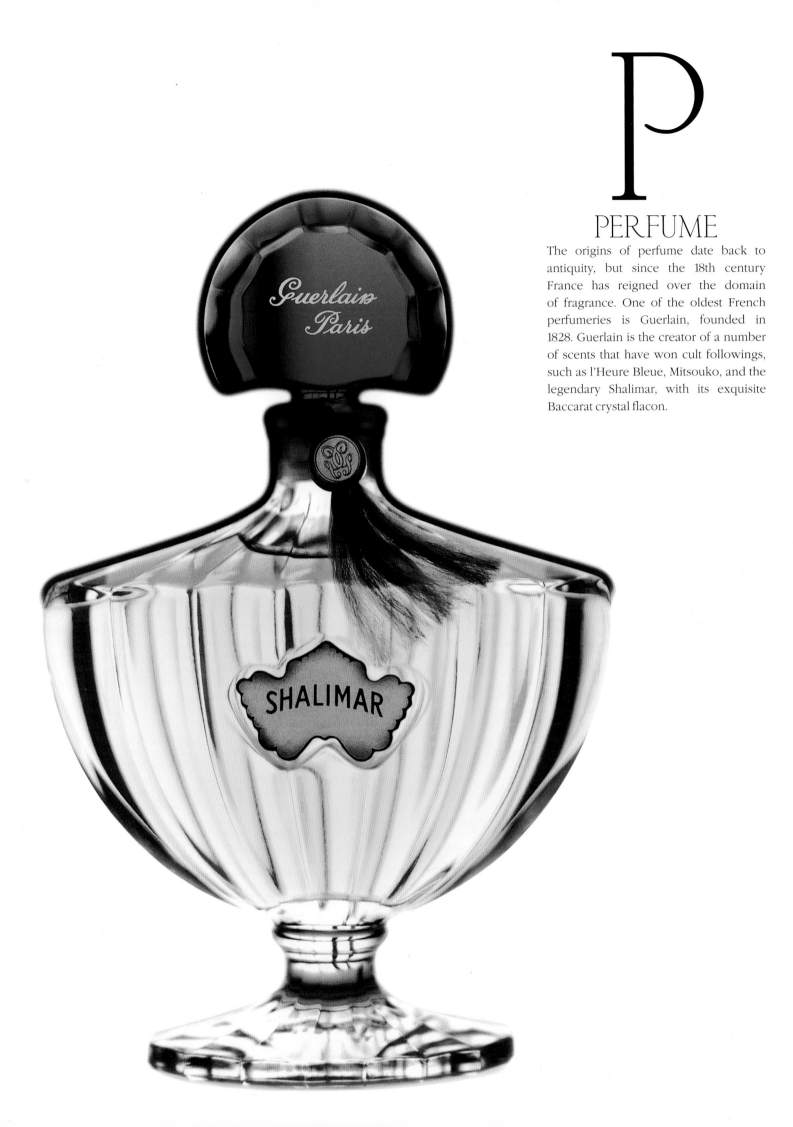

P

PERFUME

The origins of perfume date back to antiquity, but since the 18th century France has reigned over the domain of fragrance. One of the oldest French perfumeries is Guerlain, founded in 1828. Guerlain is the creator of a number of scents that have won cult followings, such as l'Heure Bleue, Mitsouko, and the legendary Shalimar, with its exquisite Baccarat crystal flacon.

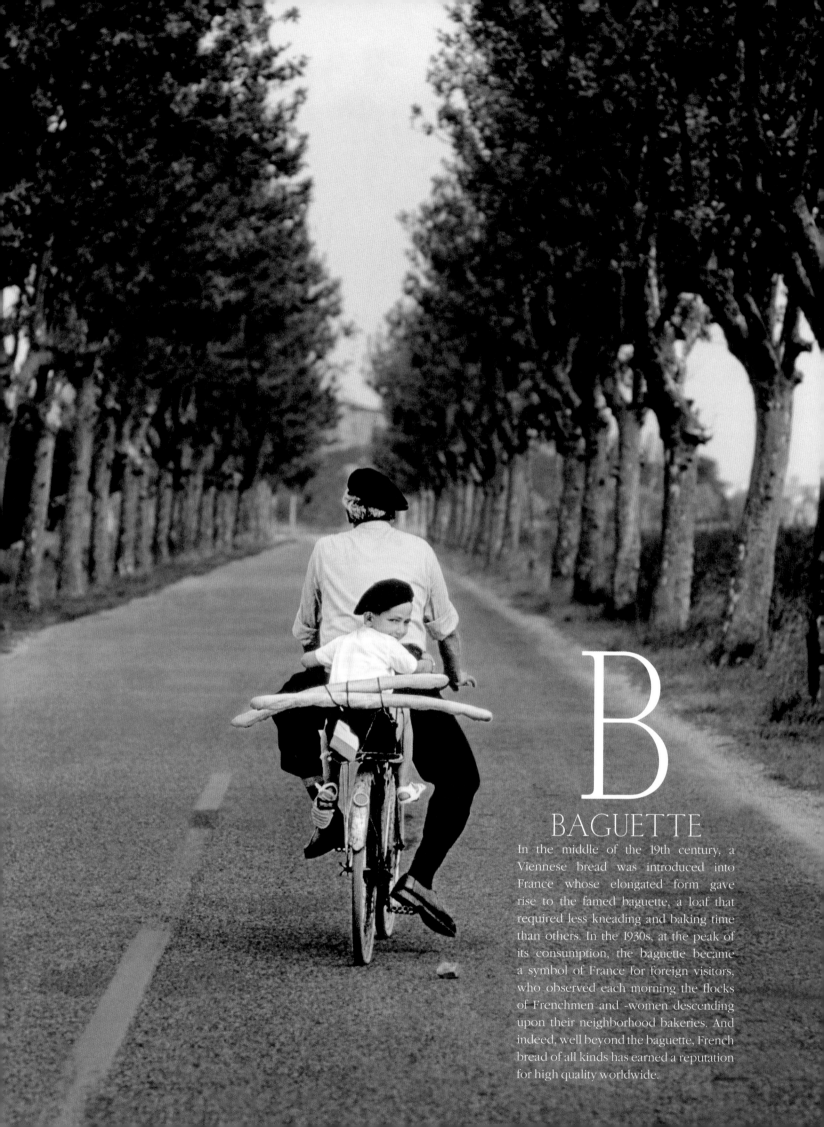

B
BAGUETTE

In the middle of the 19th century, a Viennese bread was introduced into France whose elongated form gave rise to the famed baguette, a loaf that required less kneading and baking time than others. In the 1930s, at the peak of its consumption, the baguette became a symbol of France for foreign visitors, who observed each morning the flocks of Frenchmen and -women descending upon their neighborhood bakeries. And indeed, well beyond the baguette, French bread of all kinds has earned a reputation for high quality worldwide.

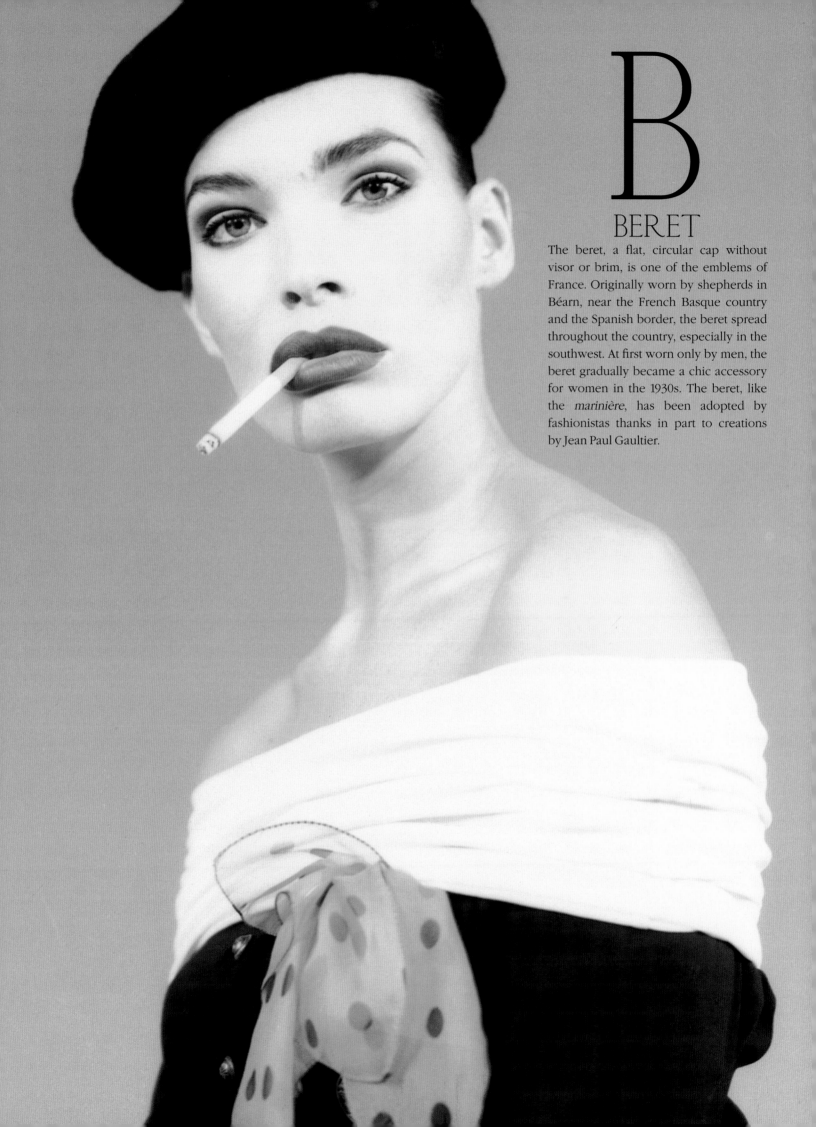

B
BERET

The beret, a flat, circular cap without visor or brim, is one of the emblems of France. Originally worn by shepherds in Béarn, near the French Basque country and the Spanish border, the beret spread throughout the country, especially in the southwest. At first worn only by men, the beret gradually became a chic accessory for women in the 1930s. The beret, like the *marinière*, has been adopted by fashionistas thanks in part to creations by Jean Paul Gaultier.

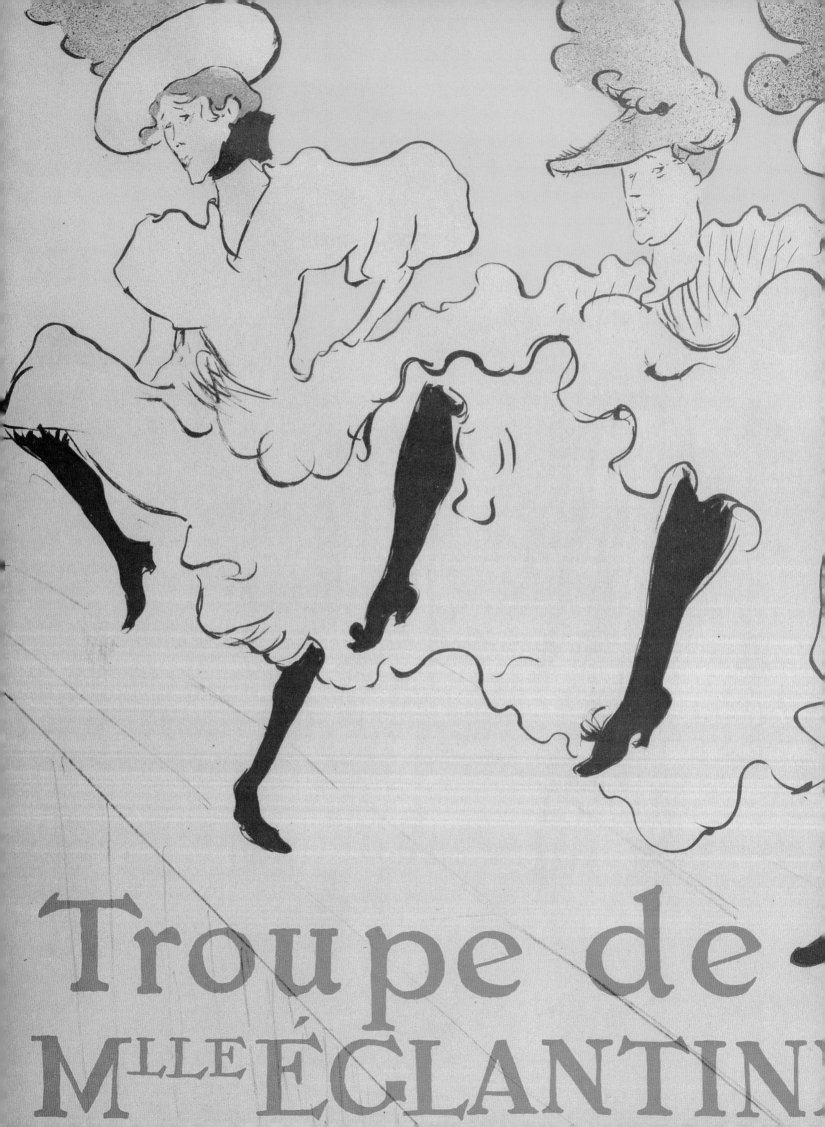

Troupe de
M^{LLE} ÉGLANTIN

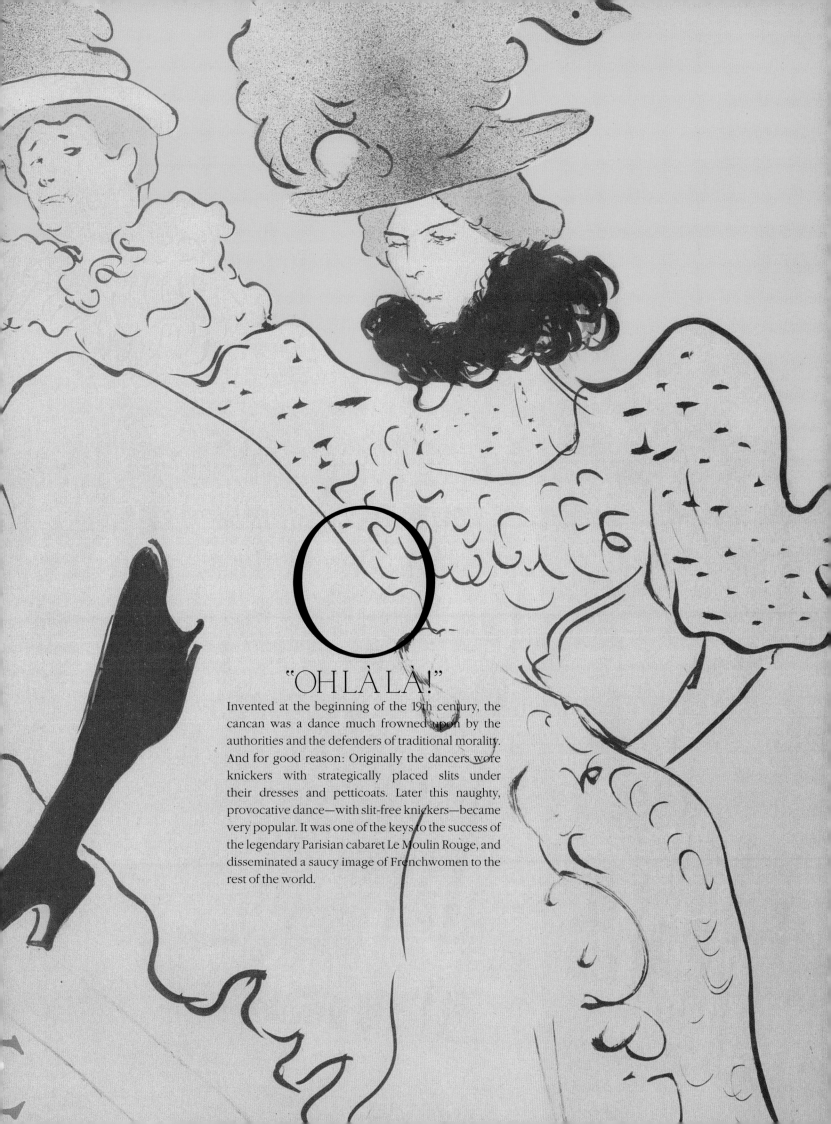

"OH LÀ LÀ!"

Invented at the beginning of the 19th century, the
cancan was a dance much frowned upon by the
authorities and the defenders of traditional morality.
And for good reason: Originally the dancers wore
knickers with strategically placed slits under
their dresses and petticoats. Later this naughty,
provocative dance—with slit-free knickers—became
very popular. It was one of the keys to the success of
the legendary Parisian cabaret Le Moulin Rouge, and
disseminated a saucy image of Frenchwomen to the
rest of the world.

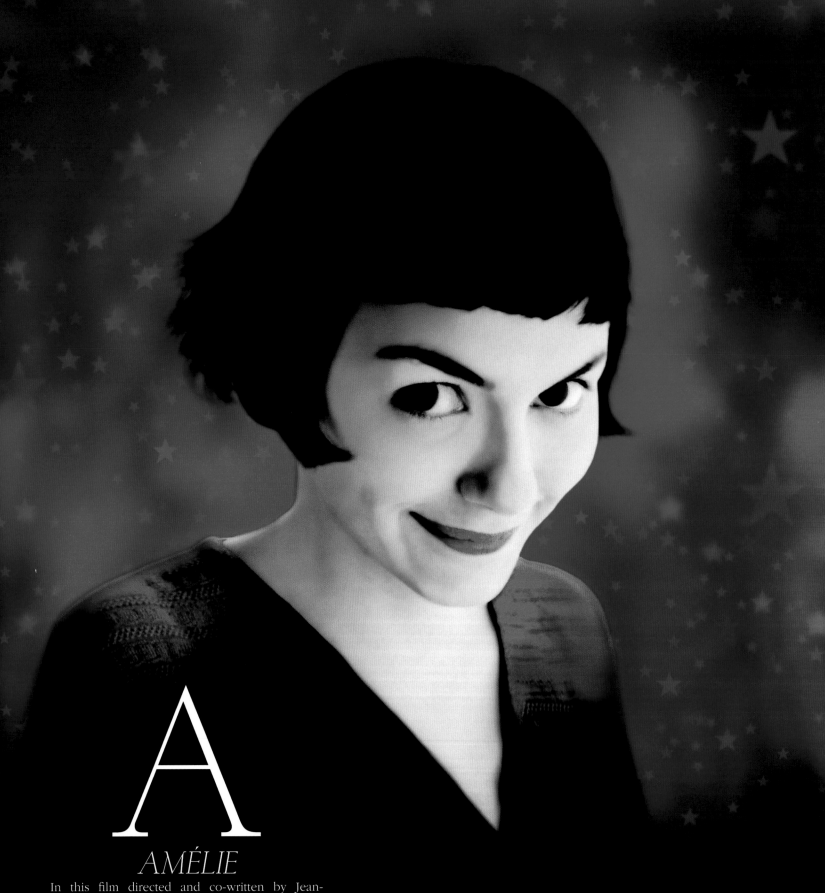

A
AMÉLIE

In this film directed and co-written by Jean-Pierre Jeunet and introducing actress Audrey Tautou, Amélie, a daydreaming young waitress in a Montmartre café, decides to devote her life to helping others find happiness. But how will she find her own? The title character's strange and poetic world, the appealing cast of characters, and the film's idealized view of Paris, shot in intensely saturated colors, made *Amélie* (originally released in 2001 in French as *Le Fabuleux Destin d'Amélie Poulain*) a perfectly French little gem.

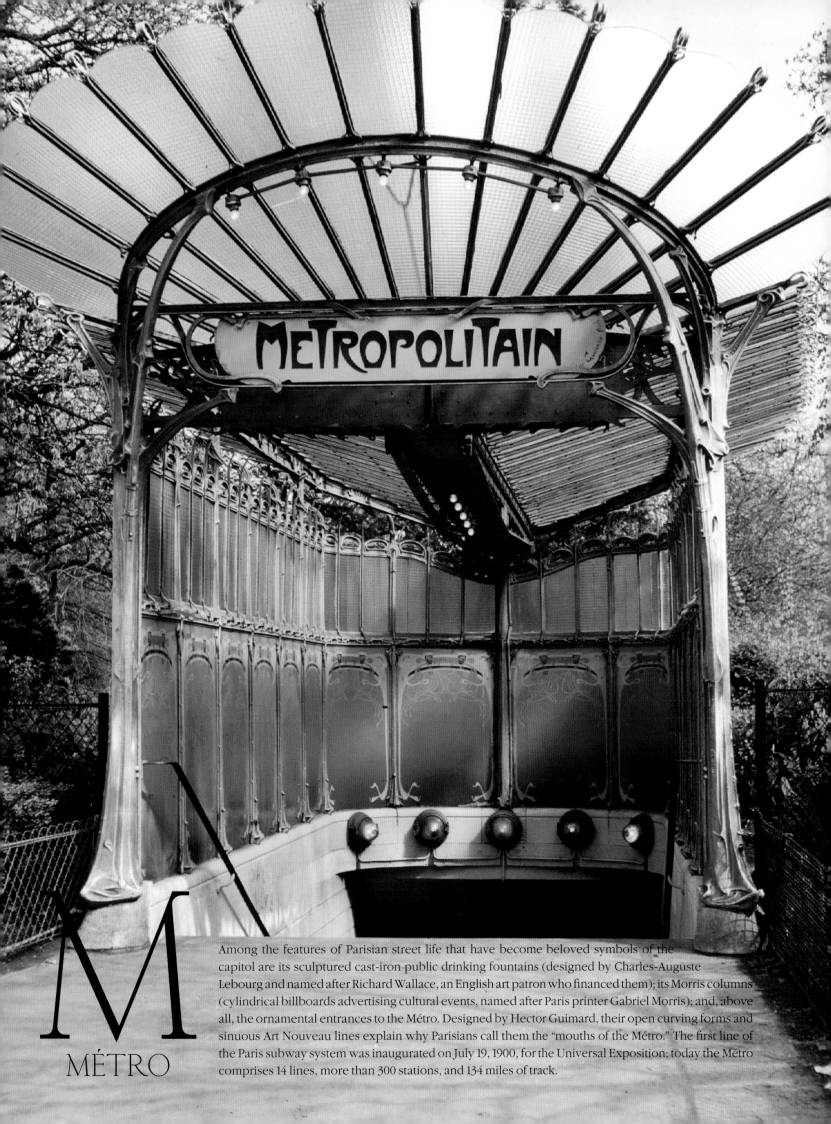

M
MÉTRO

Among the features of Parisian street life that have become beloved symbols of the capitol are its sculptured cast-iron public drinking fountains (designed by Charles-Auguste Lebourg and named after Richard Wallace, an English art patron who financed them); its Morris columns (cylindrical billboards advertising cultural events, named after Paris printer Gabriel Morris); and, above all, the ornamental entrances to the Métro. Designed by Hector Guimard, their open curving forms and sinuous Art Nouveau lines explain why Parisians call them the "mouths of the Métro." The first line of the Paris subway system was inaugurated on July 19, 1900, for the Universal Exposition; today the Métro comprises 14 lines, more than 300 stations, and 134 miles of track.

C
COCTEAU

There are few artistic domains into which Jean Cocteau did not venture, and with equal talent in all. Primarily a writer, poet, playwright, and draftsman, he was also a painter, illustrator, director, graphic designer, ceramist, and an actor as well, one of a handful of artists who profoundly marked the cultural and artistic life of the 20th century. This true aesthete, with his insatiably curious mind, launched any number of new fashions and discovered many other talented artists. A poet above all, as he said himself, Cocteau is best known as the author of the 1929 novel *Les enfants terribles*, and the director and scenarist of the films *Beauty and the Beast* (1946), *The Eagle With Two Heads* (1948), and his Orphic Trilogy. Cocteau died on October 11, 1963, a few hours after learning of the death of his friend, singer Édith Piaf.

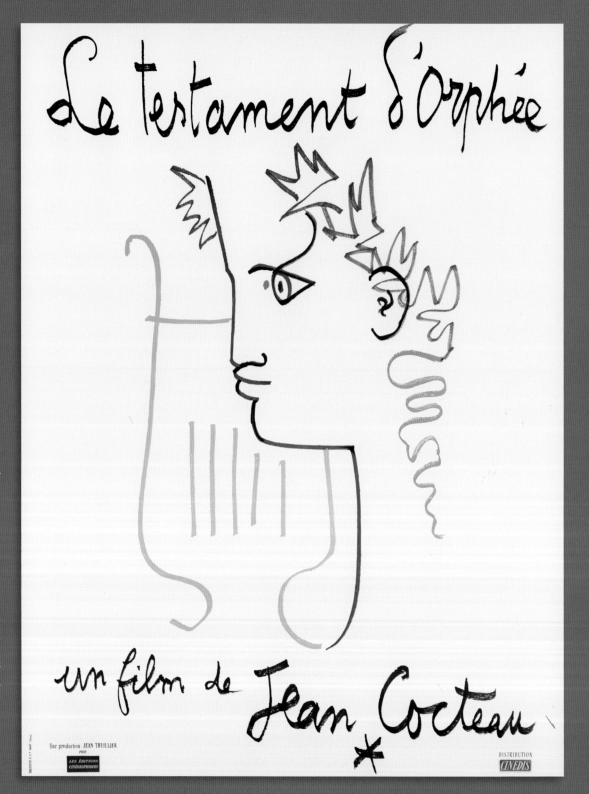

20

N

NAPOLEON

Born in Corsica in 1769, Napoleon Bonaparte was a general who led the armies of the French Revolution, became the first consul of France in 1799, and then emperor beginning in 1804. This historic figure is wreathed in both a golden legend and a dark one. Viewed by some as an exceptional leader and a strategic genius who awed the world, Napoleon is seen by others as an authoritarian warrior whose thirst for power and conquest cost millions of lives. Yet no one could deny the importance of the Napoleonic heritage: France (as well as Quebec, Louisiana, and other former French colonies) owes to him the Napoleonic Code (the French civil code), the French penal code, and the Senate, not to mention such monuments as the Arc de Triomphe and the Vendôme Column in Paris. Finally defeated at the Battle of Waterloo by a pan-European coalition, Napoleon died in captivity in 1821 on the English-controlled island of Saint Helena.

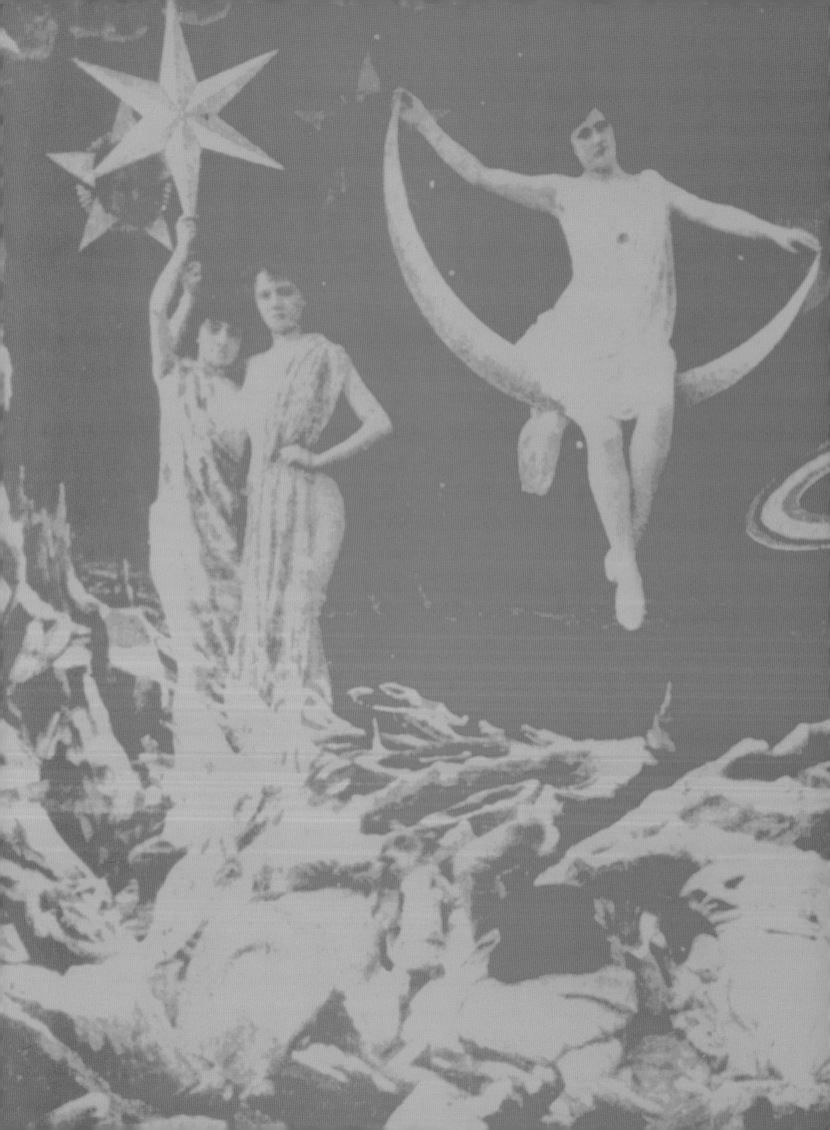

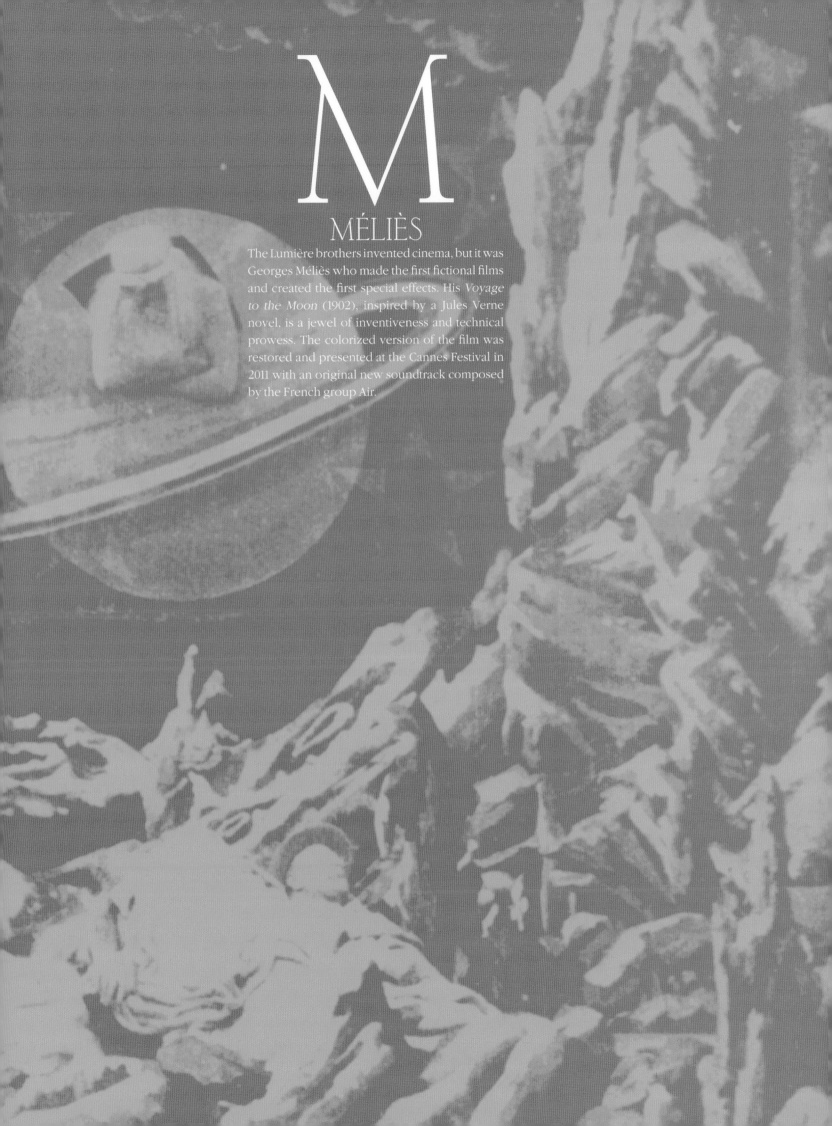

M
MÉLIÈS

The Lumière brothers invented cinema, but it was Georges Méliès who made the first fictional films and created the first special effects. His *Voyage to the Moon* (1902), inspired by a Jules Verne novel, is a jewel of inventiveness and technical prowess. The colorized version of the film was restored and presented at the Cannes Festival in 2011 with an original new soundtrack composed by the French group Air.

P
PROUST

Born in 1871, Marcel Proust is beyond question the greatest of all French writers. Proust's masterpiece, the seven-volume novel *À la Recherche du Temps Perdu*—originally translated into English under the title *Remembrance of Things Past*, and more recently (and accurately) as *In Search of Lost Time*—tells of a young man who plunges into Parisian high society, including aristocratic circles, at the beginning of the 20th century. In the end, he discovers (in C. K. Scott Moncrieff's classic translation) that "Real life, life at last laid bare and illuminated . . . is literature." The story begins with the famous episode in which the narrator, by dipping a madeleine cake in a cup of herbal tea, opens the door of time that will allow him to make his way through the labyrinth of his own consciousness. In no other literary work has psychological analysis been pushed so far and allied to a style so majestic, with its long sentences both abundant and precise. A lifelong asthmatic, Proust died of exhaustion in 1922, having devoted 13 years to the editing and publication of *À la Recherche*.

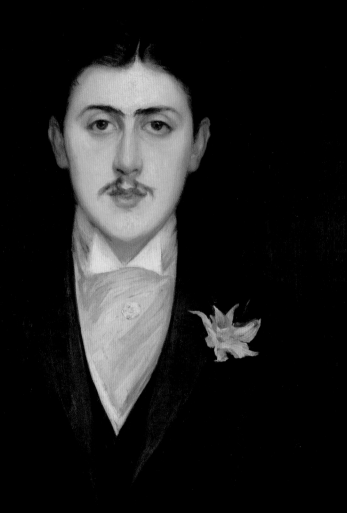

B
BUREN

Painter and sculptor Daniel Buren is an important French conceptual artist whose work is known worldwide. Since 1965, Buren has been developing his own idea of site-specific installation art, in which a work both emerges from and reveals the space in which it is created. Buren's name remains linked in the public mind above all with the truncated columns he created in 1986, titled *Les Deux Plateaux*, for the courtyard of the Palais-Royal in Paris. Commissioned by the Ministry of Culture, it caused a scandal when unveiled, but today it seems impossible to imagine the Palais-Royal without its black and white striped columns.

E

ESCARGOTS

French cuisine is known both for its refinement and for a few specialties that have earned the French such nicknames among foreigners as "frogs" and "snail eaters." Other unusual dishes that never fail to intrigue—when they don't inspire grimaces—include *tête de veau sauce gribiche* (calf's head in a mayonnaise-style sauce with chopped hard-boiled eggs, capers, and herbs), *haricot de mouton* (mutton and white bean stew), and pigs' feet.

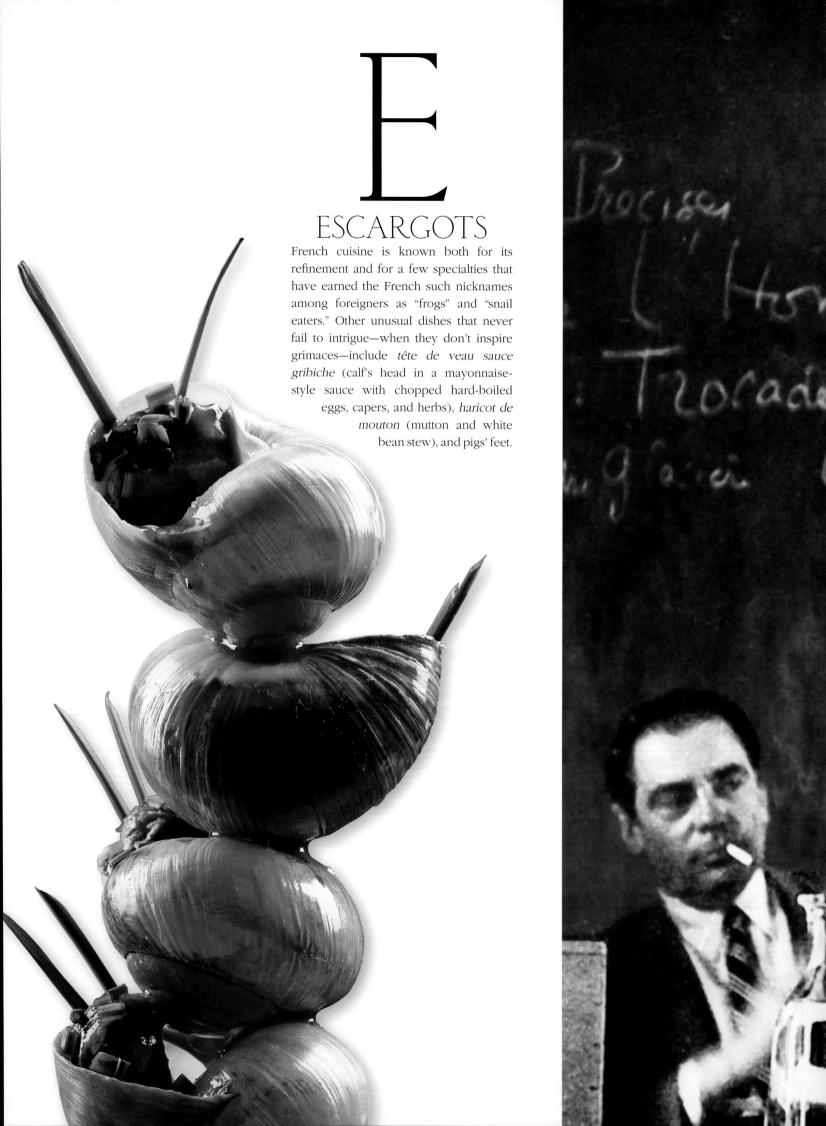

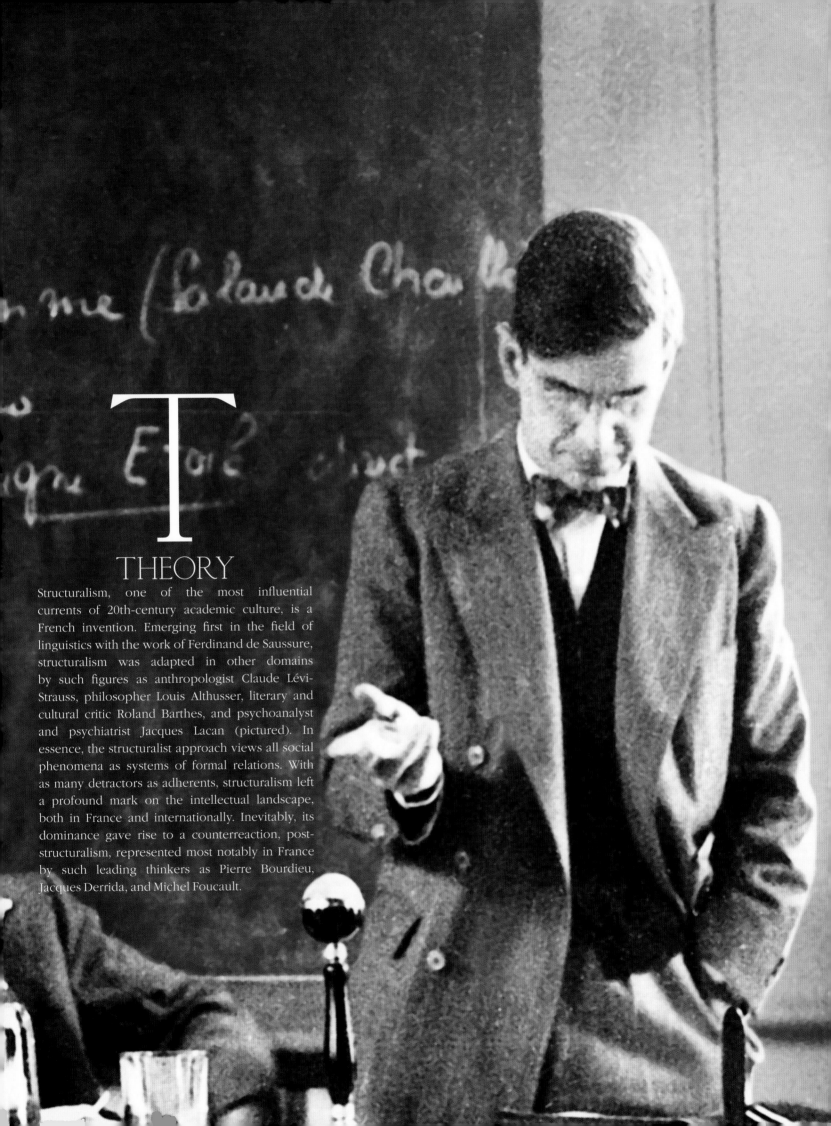

T
THEORY

Structuralism, one of the most influential currents of 20th-century academic culture, is a French invention. Emerging first in the field of linguistics with the work of Ferdinand de Saussure, structuralism was adapted in other domains by such figures as anthropologist Claude Lévi-Strauss, philosopher Louis Althusser, literary and cultural critic Roland Barthes, and psychoanalyst and psychiatrist Jacques Lacan (pictured). In essence, the structuralist approach views all social phenomena as systems of formal relations. With as many detractors as adherents, structuralism left a profound mark on the intellectual landscape, both in France and internationally. Inevitably, its dominance gave rise to a counterreaction, post-structuralism, represented most notably in France by such leading thinkers as Pierre Bourdieu, Jacques Derrida, and Michel Foucault.

F

LE FIGARO

Named after the hero in playwright Pierre-Augustin de Beaumarchais' famous trilogy, the newspaper *Le Figaro* was founded in 1826 as a witty arts and literature weekly, and in 1866 began publishing daily with a more serious political and journalistic focus. During the Nazi occupation, the paper briefly suspended publication rather than submit to government censorship. Today *Le Figaro* is the oldest surviving French newspaper; it remains one of the most widely read papers in the nation, and has expanded to include daily economic and lifestyle editions; popular weekly literary, health and science, and entertainment supplements; plus the Saturday *Madame Figaro* and *Figaro* magazines.

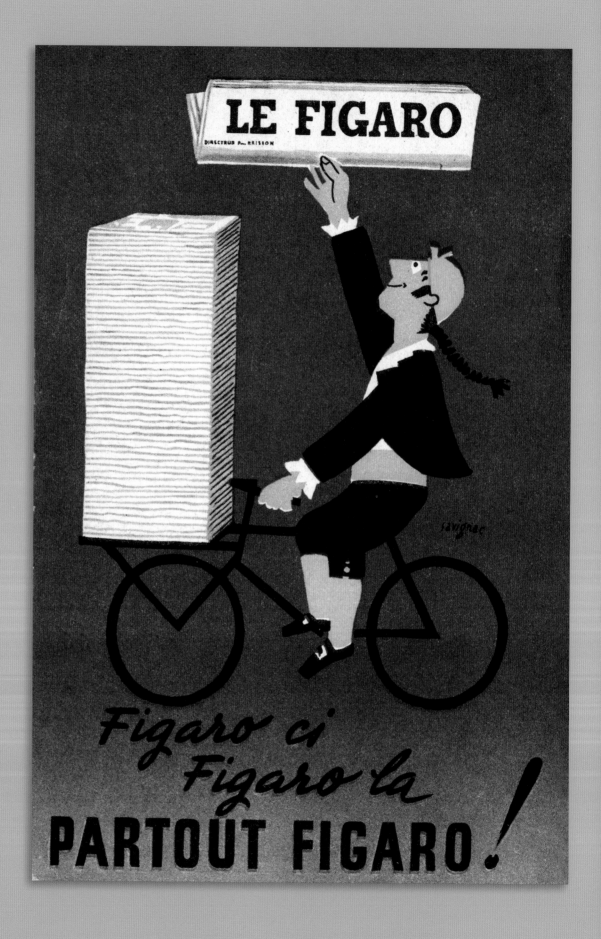

L
LITTLE BLACK DRESS

When she created the little black dress in 1926, Coco Chanel revolutionized the style of French women. A genuine fashion phenomenon, a distillation of simplicity and elegance, austere or sexy, the little black dress is the alpha and omega of every woman's closet. The muse of French cinema and the embodiment of French feminine charm, Catherine Deneuve wore the creations of Chanel (pictured, from *Paris Match*, January 1963) and Yves Saint Laurent with perfection.

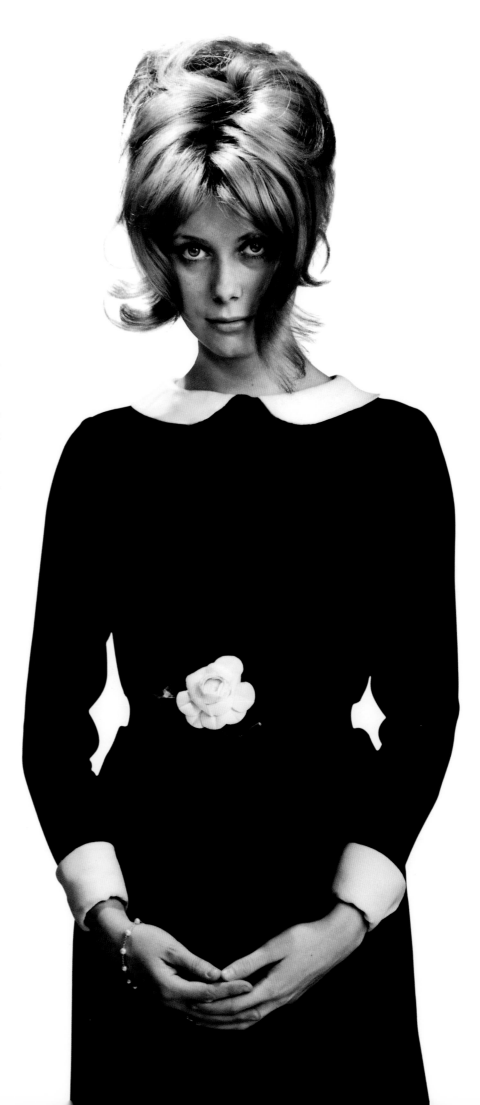

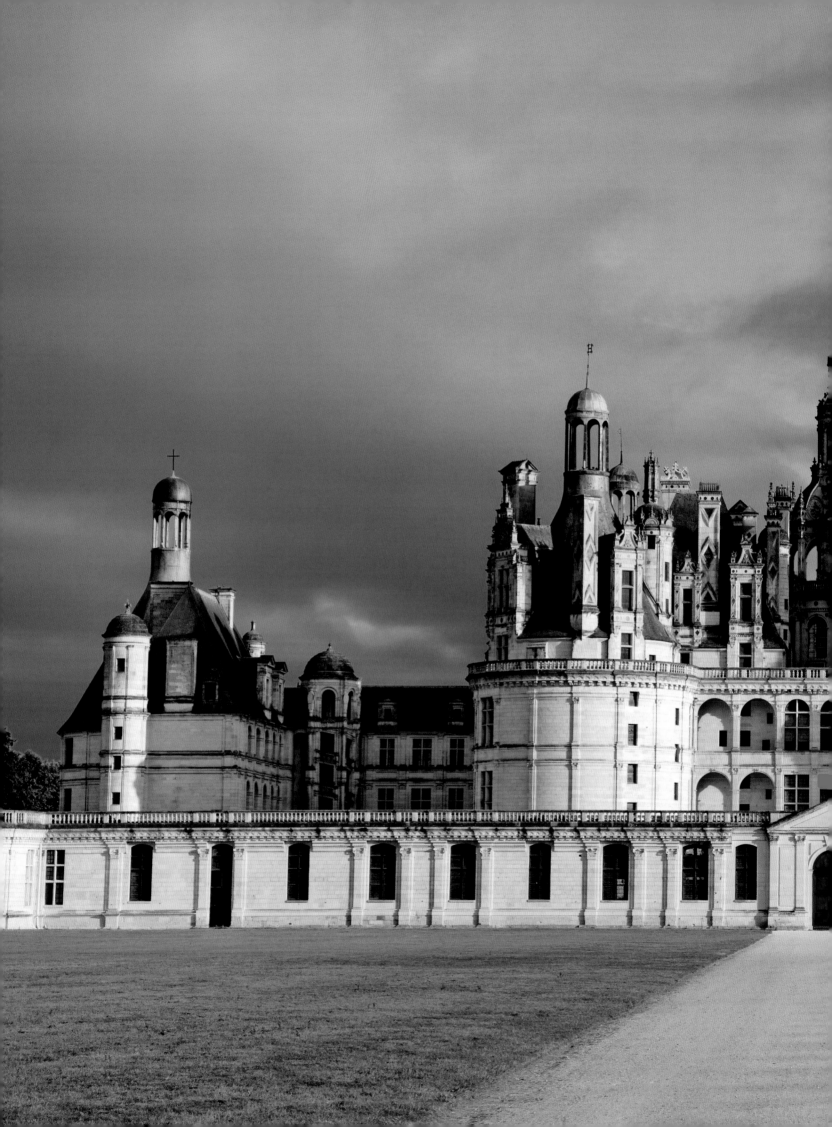

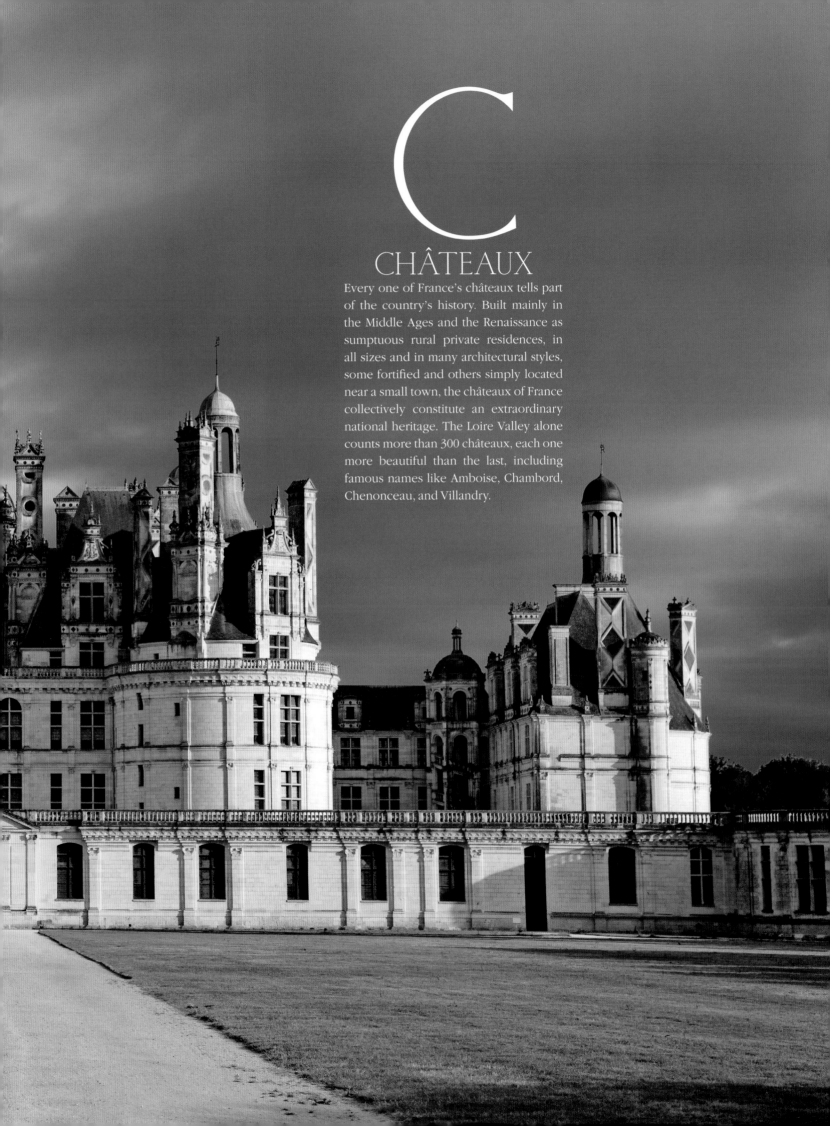

C
CHÂTEAUX

Every one of France's châteaux tells part of the country's history. Built mainly in the Middle Ages and the Renaissance as sumptuous rural private residences, in all sizes and in many architectural styles, some fortified and others simply located near a small town, the châteaux of France collectively constitute an extraordinary national heritage. The Loire Valley alone counts more than 300 châteaux, each one more beautiful than the last, including famous names like Amboise, Chambord, Chenonceau, and Villandry.

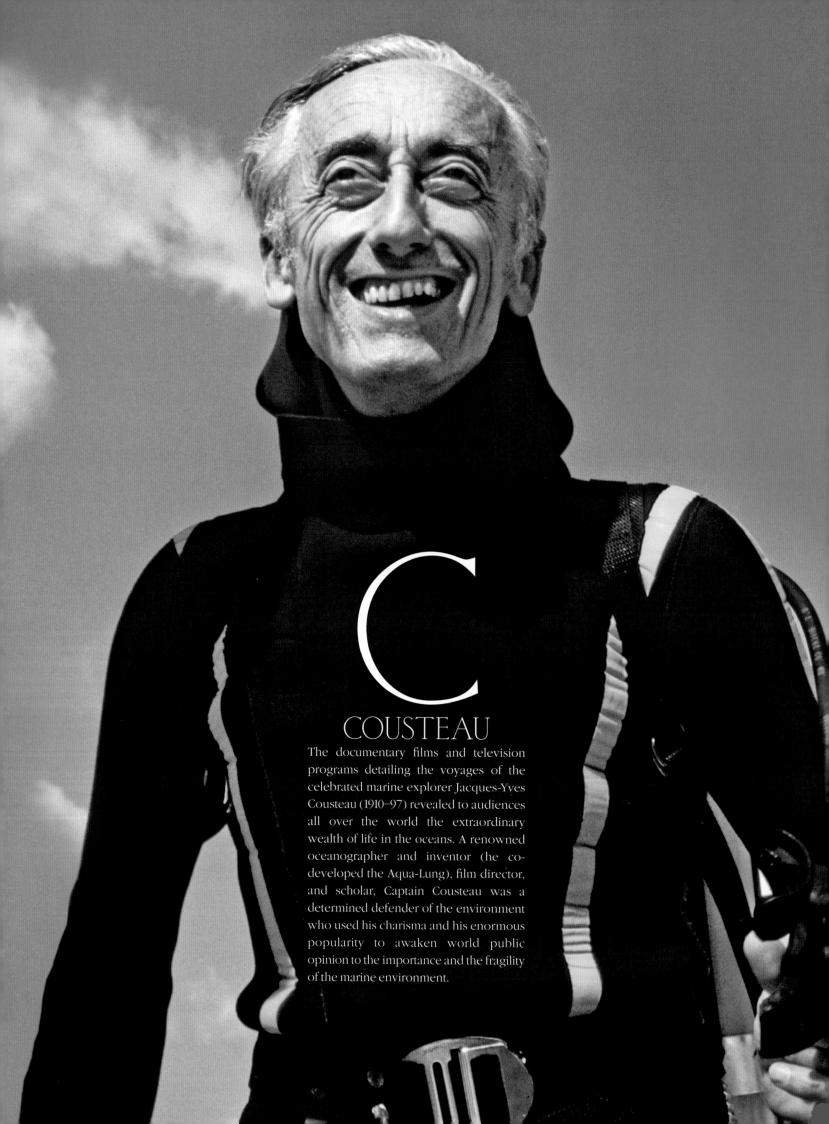

C
COUSTEAU

The documentary films and television programs detailing the voyages of the celebrated marine explorer Jacques-Yves Cousteau (1910–97) revealed to audiences all over the world the extraordinary wealth of life in the oceans. A renowned oceanographer and inventor (he co-developed the Aqua-Lung), film director, and scholar, Captain Cousteau was a determined defender of the environment who used his charisma and his enormous popularity to awaken world public opinion to the importance and the fragility of the marine environment.

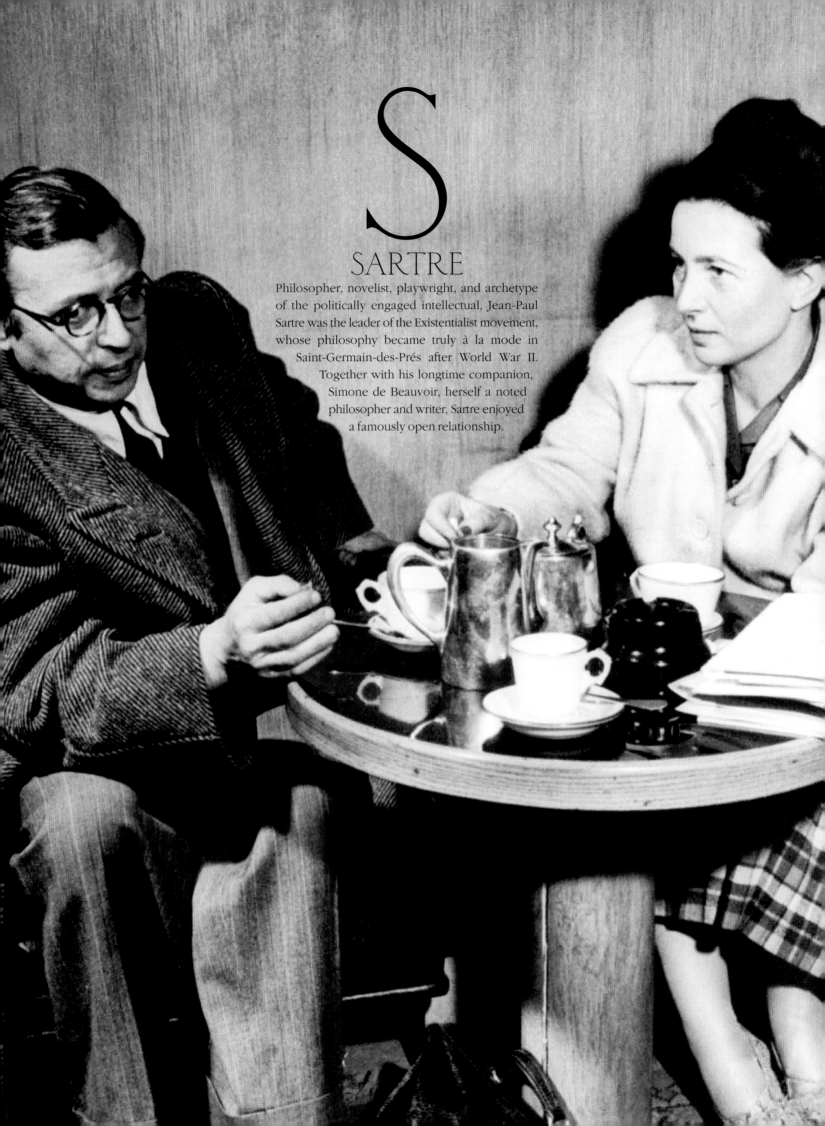

S

SARTRE

Philosopher, novelist, playwright, and archetype of the politically engaged intellectual, Jean-Paul Sartre was the leader of the Existentialist movement, whose philosophy became truly à la mode in Saint-Germain-des-Prés after World War II. Together with his longtime companion, Simone de Beauvoir, herself a noted philosopher and writer, Sartre enjoyed a famously open relationship.

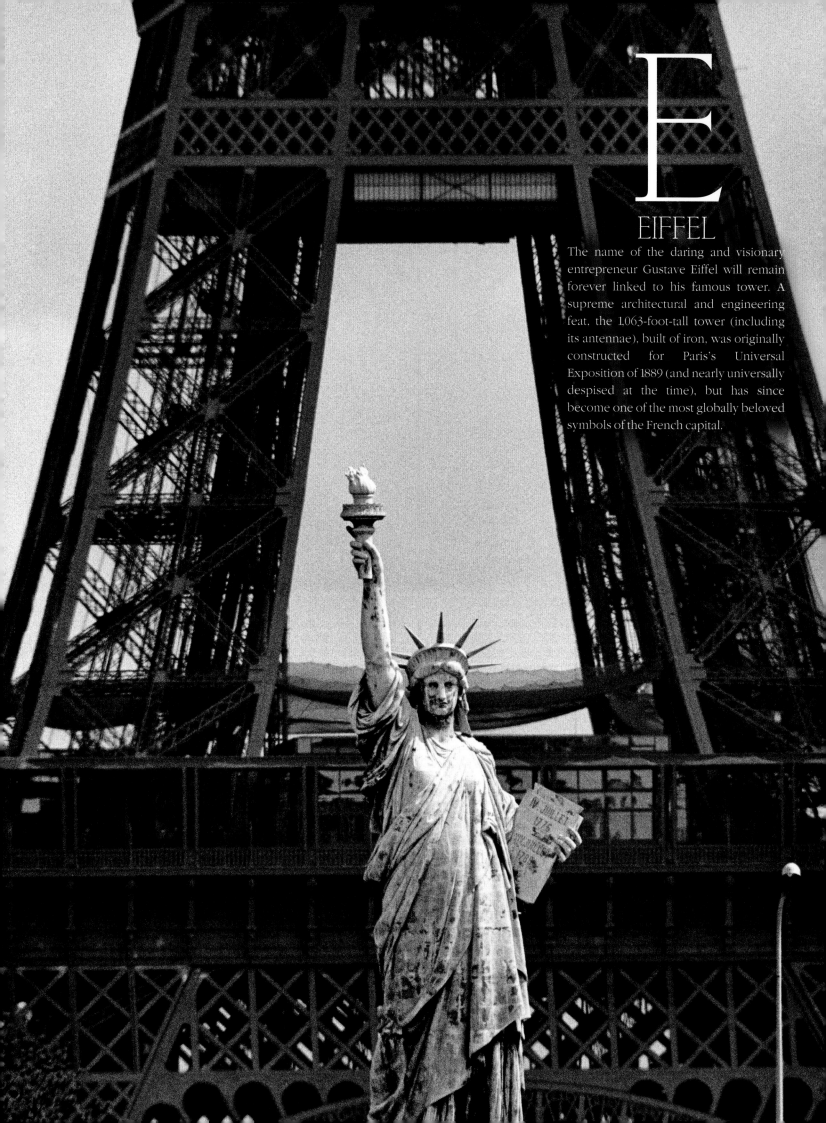

E

EIFFEL

The name of the daring and visionary entrepreneur Gustave Eiffel will remain forever linked to his famous tower. A supreme architectural and engineering feat, the 1,063-foot-tall tower (including its antennae), built of iron, was originally constructed for Paris's Universal Exposition of 1889 (and nearly universally despised at the time), but has since become one of the most globally beloved symbols of the French capital.

M
MARIANNE

Marianne, sporting her famous Phrygian cap, a symbol of the Republic, was born during the French Revolution. She soon became the incarnation of the Republic and its values: liberty, equality, fraternity. Actresses Brigitte Bardot, Laetitia Casta, Catherine Deneuve, and Sophie Marceau, as well as fashion diva Inès de la Fressange, have all lent their faces to Marianne, whose glorious bust adorns every city hall in France.

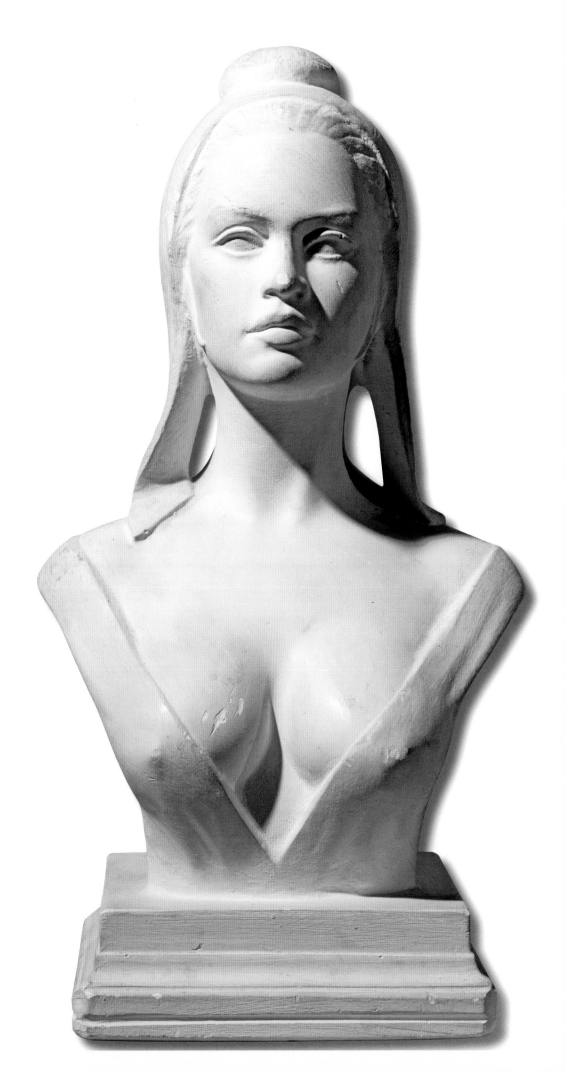

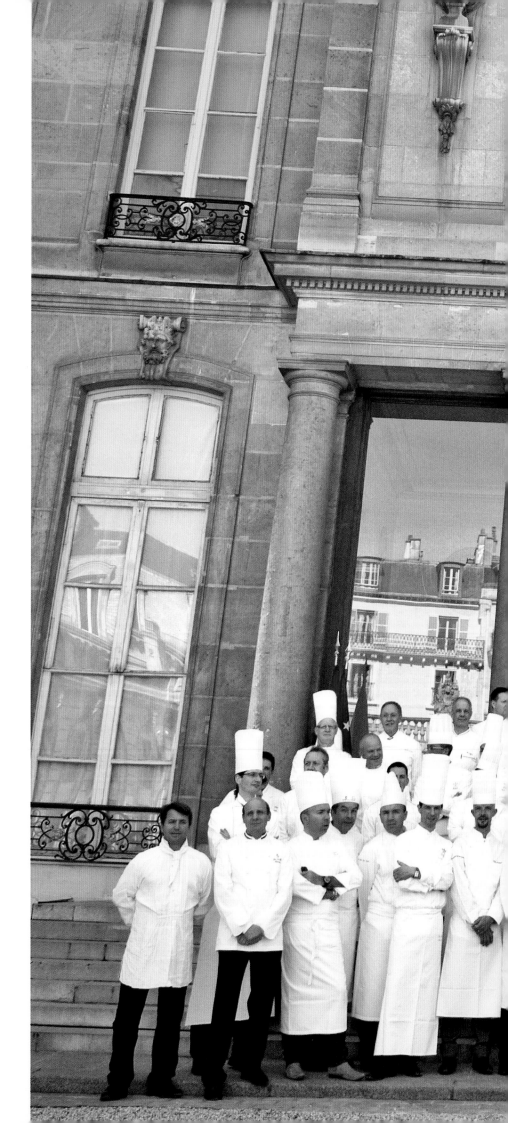

C
CUISINE

In France, every celebratory occasion includes a good meal. Dining in France unfolds in a precise ceremony, from the aperitif and the wines to the cheeses presented under a glass dome and finally the miniature sweets that accompany coffee, all served on a prettily decorated table. In 2010, the traditional French gastronomic meal was added to the UNESCO list of intangible world heritage. All around the globe, France's great chefs are ambassadors of the French *art de vivre*.

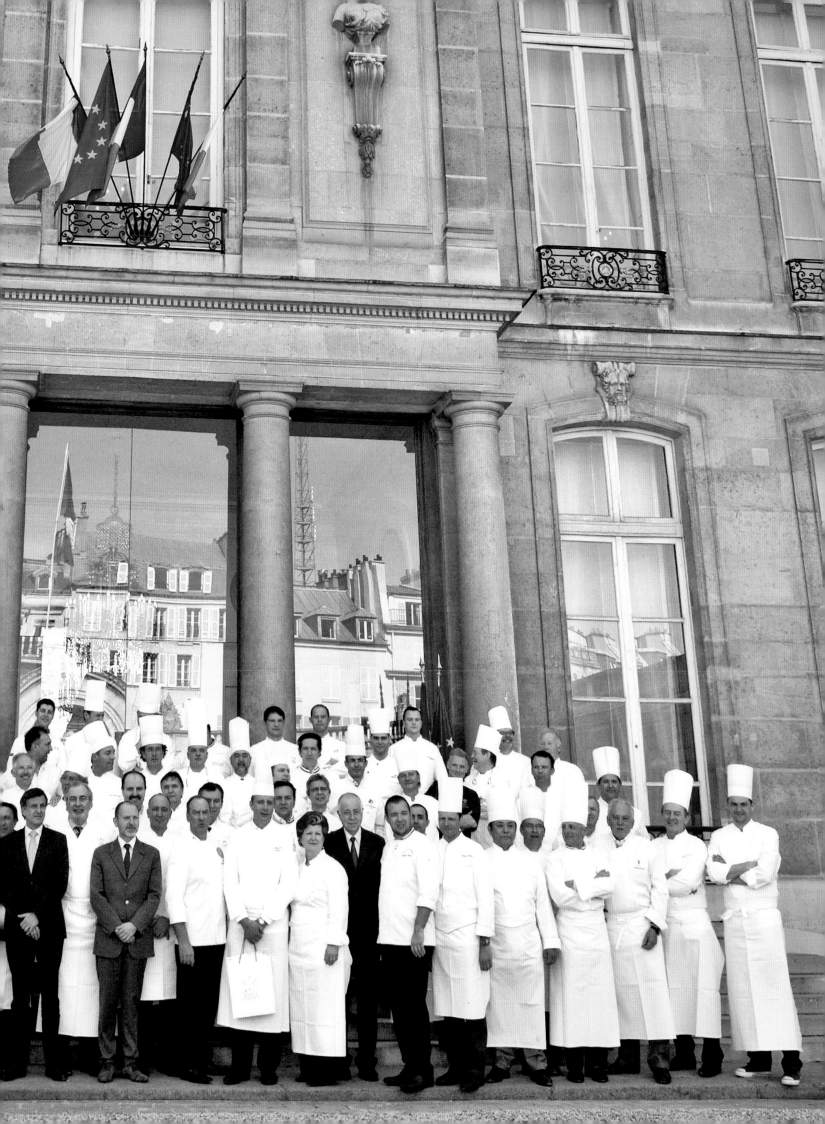

P

PASCAL

"There was a genius who, at the age of 12 years, had with bars and rings created... mathematics; who, at 16, had composed the ablest treatise on conic sections... who, at 19, reduced to a machine a science existing entirely in the understanding; who, at 23, demonstrated the phenomena of the gravity of the air... who, at an age when the intellectual faculties scarcely begin to expand in others, having gone through the whole circle of human sciences... turned all his thoughts toward religion; who, from that moment till his death, (which happened in his 39th year)... scattered at random upon paper thoughts not less indicative of a superhuman than of a human mind. The name of this stupendous genius was Blaise Pascal."
—François-René de Chateaubriand, *The Genius of Christianity*, 1802 (translated by Charles I. White, 1871)

H

HUGO

Victor Hugo is a monument of French literature, the author of numerous poems, novels, and plays that have become classics. Perhaps his best-known collection of poetry is *The Legend of the Ages* (1859); to English-language readers, he is most famous for the novels *The Hunchback of Notre-Dame* (1831) and *Les Misérables* (1862). Hugo was also a major 19th-century statesman whose political views and public opposition to Napoleon III drove him into exile for many years. At his death in 1885, more than a million mourners gathered around his coffin before his remains were transferred to the Pantheon.

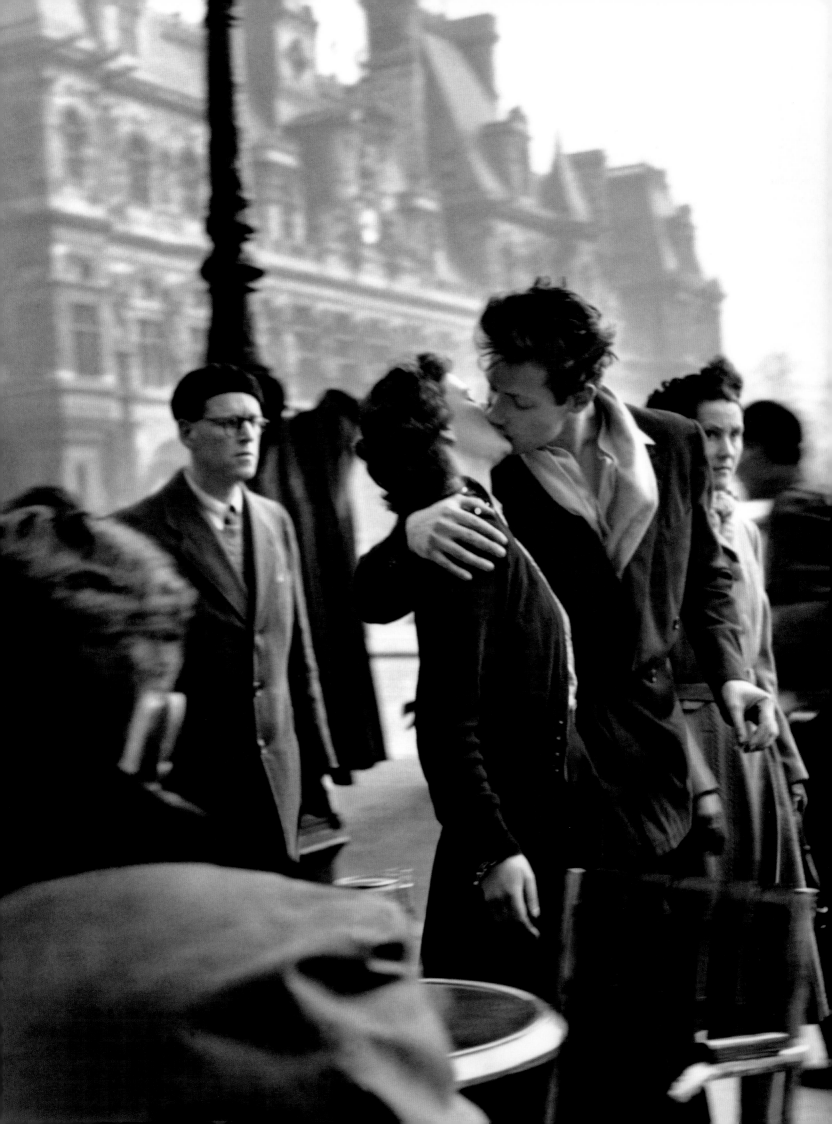

K
KISS

This famous photograph of two lovers kissing in front of the Hôtel de Ville (City Hall) in Paris, immortalized by Robert Doisneau in 1950, has become a worldwide cliché of French romance. In English, romantic kissing is of course called *French kissing*; partly for this reason, perhaps, Paris is known as a city for lovers, a place where love is at once lighthearted and passionate.

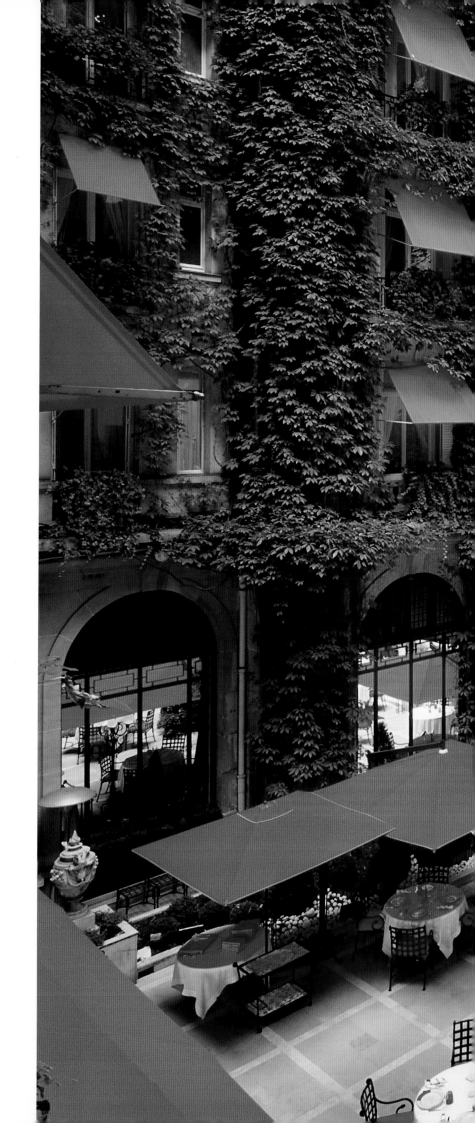

P
PALACES

Among the 150 five-star hotels in France today, a mere 12 have officially received recognition as a "palace." In Paris there are the Plaza Athénée, the George V, and the Bristol; *en province*, as the French say (meaning, anywhere in France outside Paris), the Hôtel du Palais in Biarritz, in the Basque country, and the Grand-Hôtel du Cap-Ferrat, near Nice, are also members of this select circle. These extraordinary establishments, showcases of *luxe à la française*, are distinguished by the exceptional beauty of their locations, architecture, and rooms, together with their outstanding level of service and, of course, their gourmet restaurants.

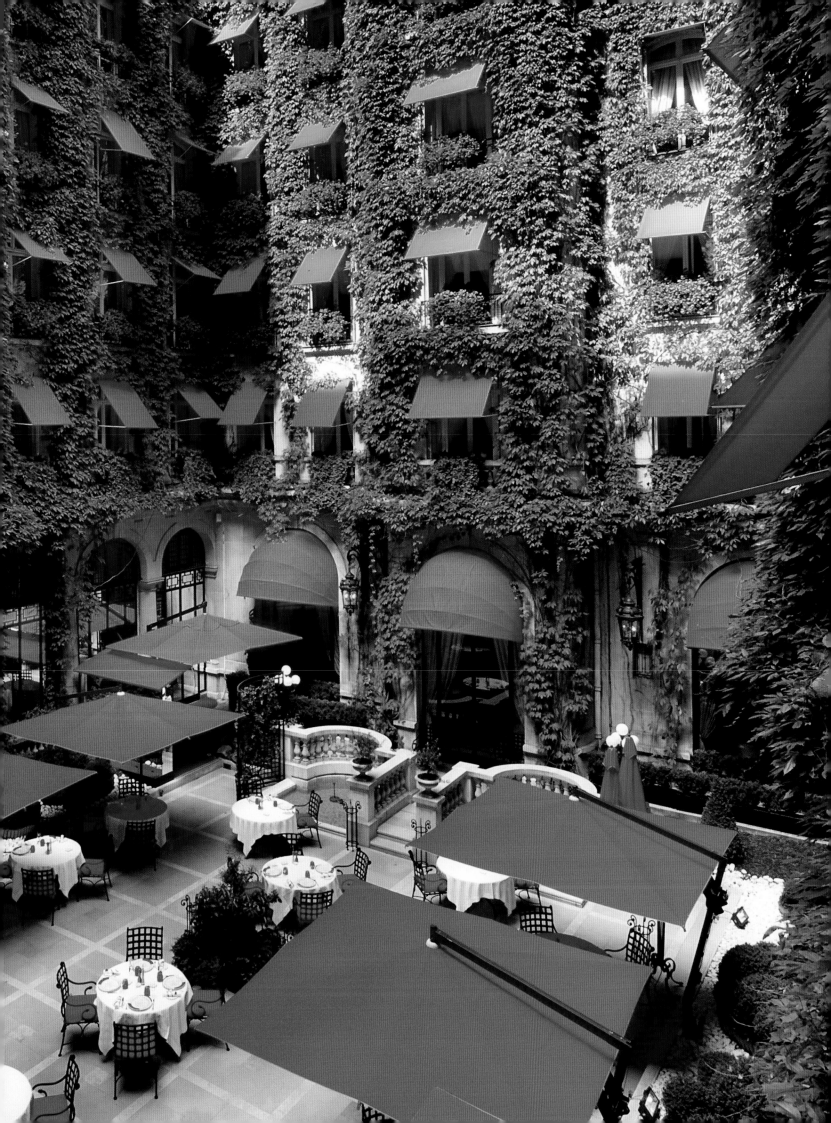

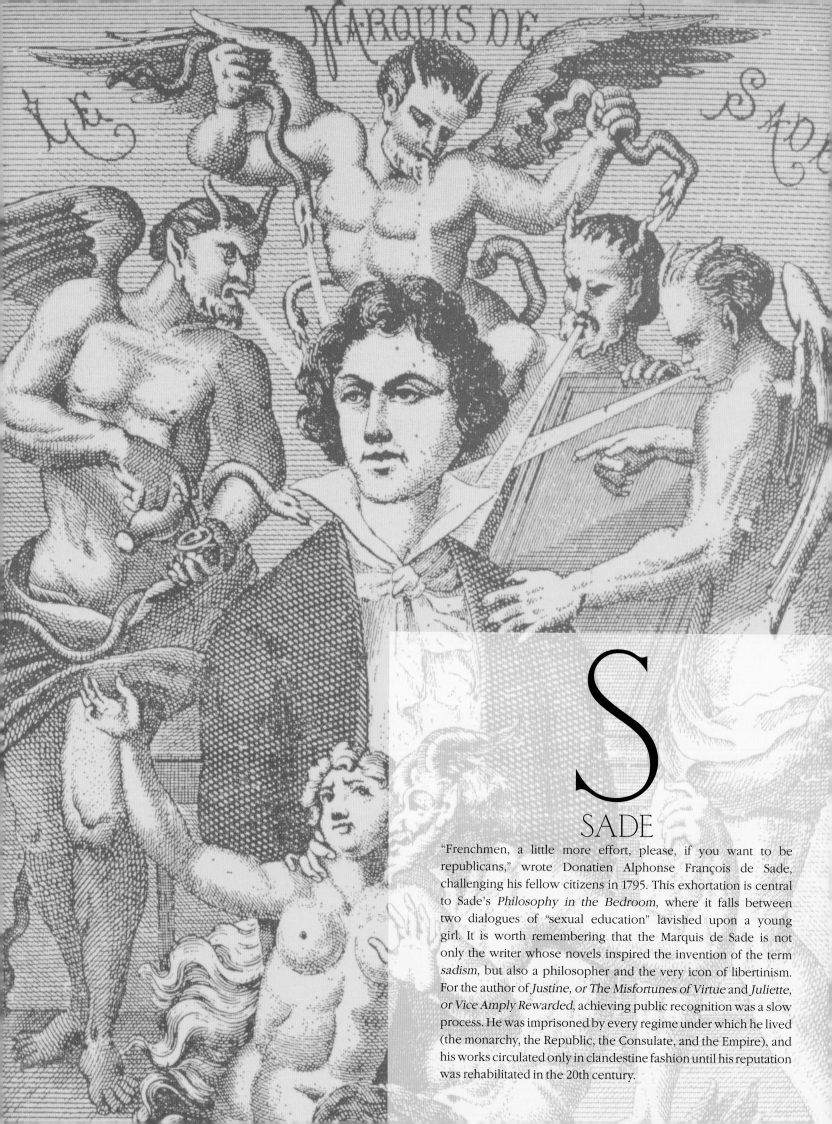

S

SADE

"Frenchmen, a little more effort, please, if you want to be republicans," wrote Donatien Alphonse François de Sade, challenging his fellow citizens in 1795. This exhortation is central to Sade's *Philosophy in the Bedroom*, where it falls between two dialogues of "sexual education" lavished upon a young girl. It is worth remembering that the Marquis de Sade is not only the writer whose novels inspired the invention of the term *sadism*, but also a philosopher and the very icon of libertinism. For the author of *Justine, or The Misfortunes of Virtue* and *Juliette, or Vice Amply Rewarded*, achieving public recognition was a slow process. He was imprisoned by every regime under which he lived (the monarchy, the Republic, the Consulate, and the Empire), and his works circulated only in clandestine fashion until his reputation was rehabilitated in the 20th century.

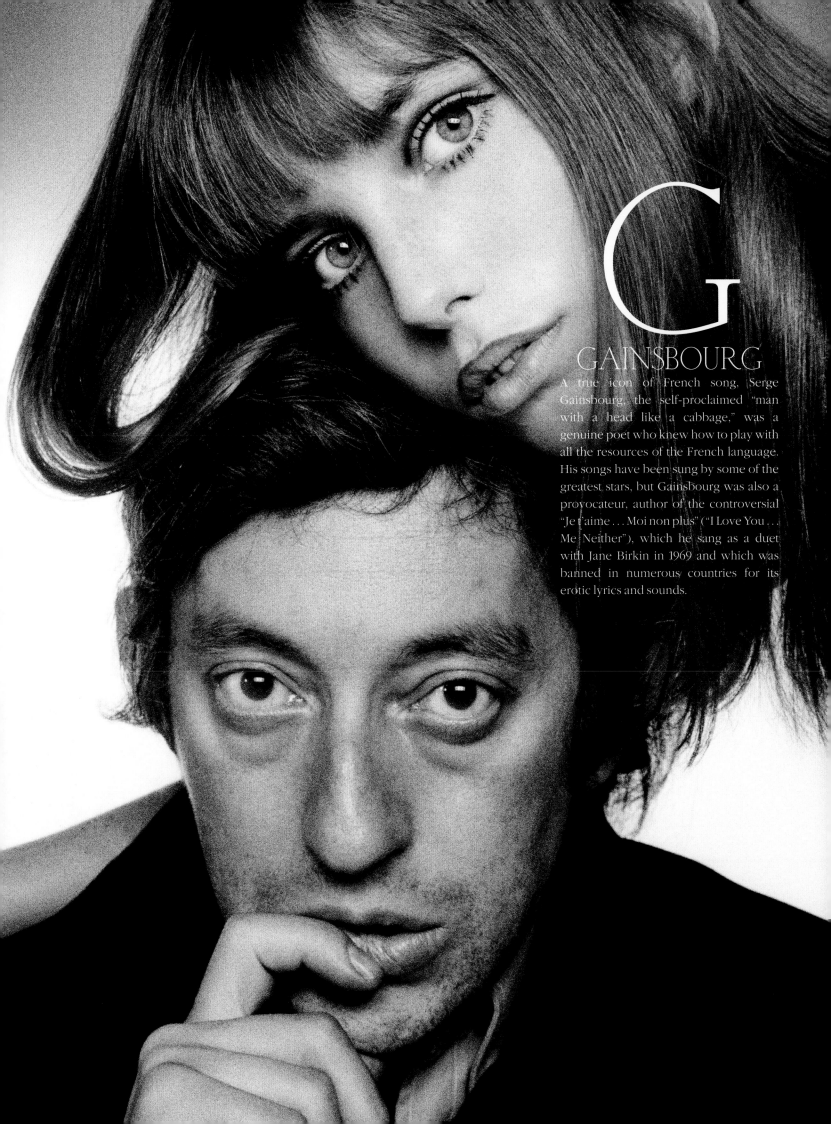

G

GAINSBOURG

A true icon of French song, Serge Gainsbourg, the self-proclaimed "man with a head like a cabbage," was a genuine poet who knew how to play with all the resources of the French language. His songs have been sung by some of the greatest stars, but Gainsbourg was also a provocateur, author of the controversial "Je t'aime...Moi non plus" ("I Love You... Me Neither"), which he sang as a duet with Jane Birkin in 1969 and which was banned in numerous countries for its erotic lyrics and sounds.

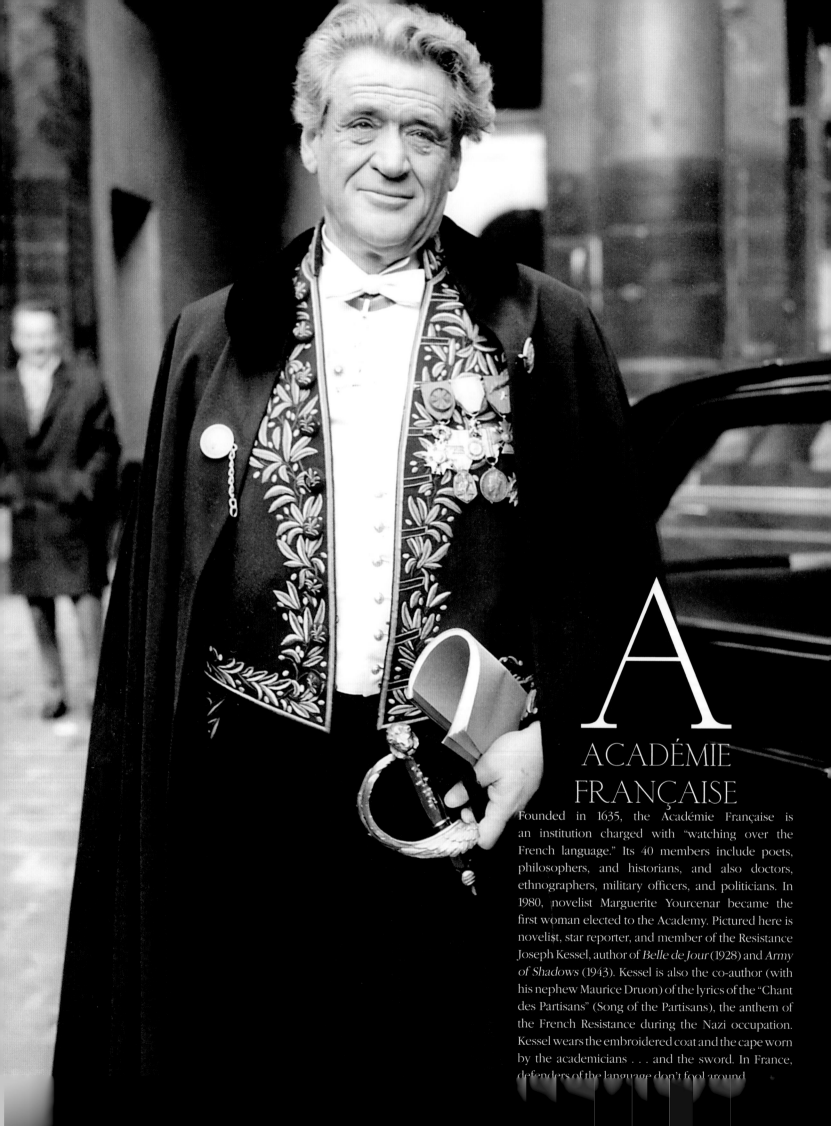

A
ACADÉMIE FRANÇAISE

Founded in 1635, the Académie Française is an institution charged with "watching over the French language." Its 40 members include poets, philosophers, and historians, and also doctors, ethnographers, military officers, and politicians. In 1980, novelist Marguerite Yourcenar became the first woman elected to the Academy. Pictured here is novelist, star reporter, and member of the Resistance Joseph Kessel, author of *Belle de Jour* (1928) and *Army of Shadows* (1943). Kessel is also the co-author (with his nephew Maurice Druon) of the lyrics of the "Chant des Partisans" (Song of the Partisans), the anthem of the French Resistance during the Nazi occupation. Kessel wears the embroidered coat and the cape worn by the academicians . . . and the sword. In France, defenders of the language don't fool around.

Cinq Centimes — JEUDI 13 JANVIER 1898

Deuxième Année. — Numéro 87

Directeur
ERNEST VAUGHAN

Directeur
ERNEST VAUGHAN

LES ANNONCES SONT REÇUES :
142 — Rue Montmartre — 143
AUX BUREAUX DU JOURNAL

L'AURORE

Littéraire, Artistique, Sociale

J'Accuse…!

LETTRE AU PRÉSIDENT DE LA RÉPUBLIQUE
Par ÉMILE ZOLA

J'ACCUSE…!

On January 13, 1898, novelist Émile Zola published an open letter addressed to the French president in the newspaper L'Aurore under the now famous headline "J'Accuse…!" Zola wrote in defense of Alfred Dreyfus, a Jewish officer in the French army falsely accused of espionage. In so doing, Zola launched a new era characterized by the power of the press and politically engaged intellectuals and became the worthy successor to Voltaire in the fight against injustice.

B

BIKINI

In 1946, the United States tested the world's first nuclear weapons on the South Pacific atoll of Bikini. A few days later, Louis Réard launched his famous miniature two-piece swimsuit, sold in a matchbox, under the slogan "The bikini, the first anatomic bomb." In 2003, artist Jean-Paul Goude famously dressed—or rather, undressed—Lisa Pomares's perfect body in a "little bikini" for the upmarket Parisian department store Galeries Lafayette.

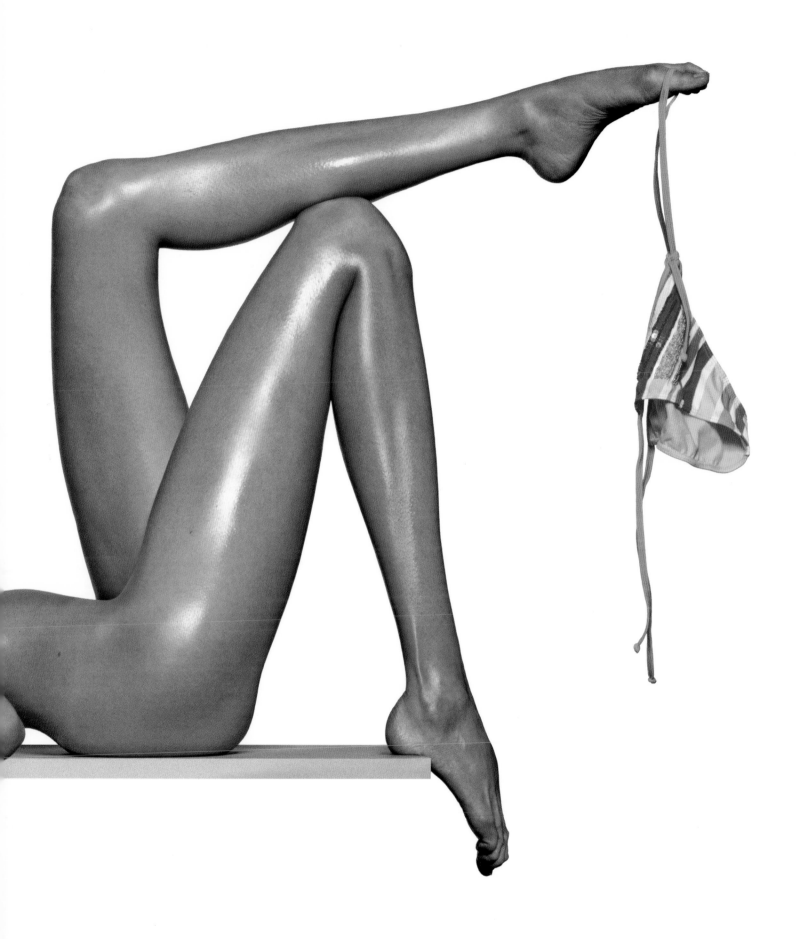

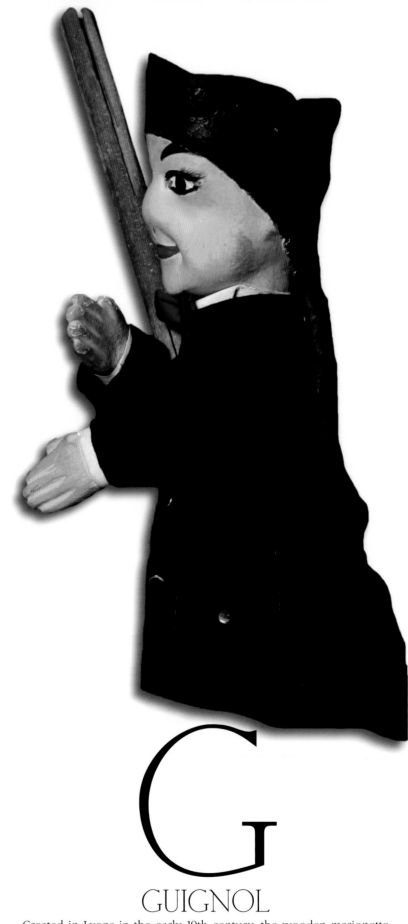

G

GUIGNOL

Created in Lyons in the early 19th century, the wooden marionette named Guignol is an enduring part of the French culture of childhood. The word *guignol* in fact designates not only the puppet character of that name, but also by extension the French form of comic marionette theater. You find a *théâtre de guignol* in most of the public gardens in large French cities. One of the guignol's modern avatars is the very popular satirical televised marionette show *Les Guignols de l'info*, which, in the form of a news program, caricatures the worlds of politics, media, and contemporary life in and beyond France.

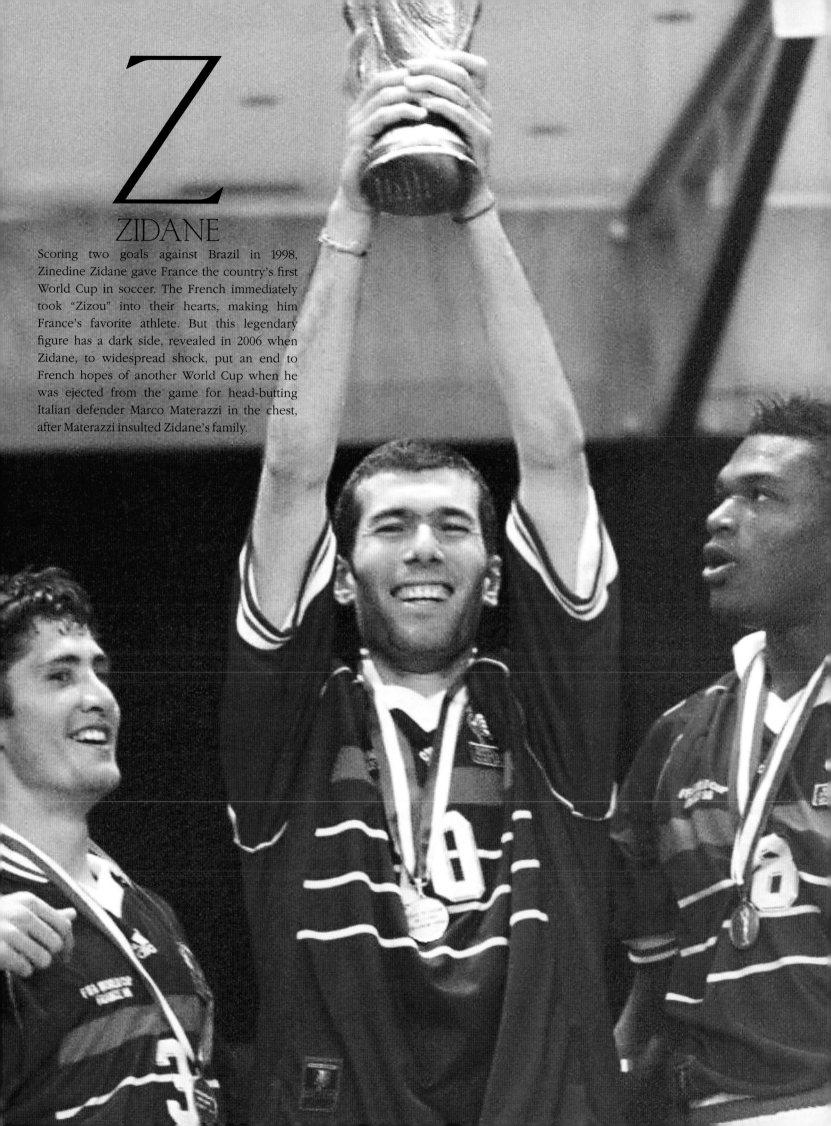

Z
ZIDANE

Scoring two goals against Brazil in 1998, Zinedine Zidane gave France the country's first World Cup in soccer. The French immediately took "Zizou" into their hearts, making him France's favorite athlete. But this legendary figure has a dark side, revealed in 2006 when Zidane, to widespread shock, put an end to French hopes of another World Cup when he was ejected from the game for head-butting Italian defender Marco Materazzi in the chest, after Materazzi insulted Zidane's family.

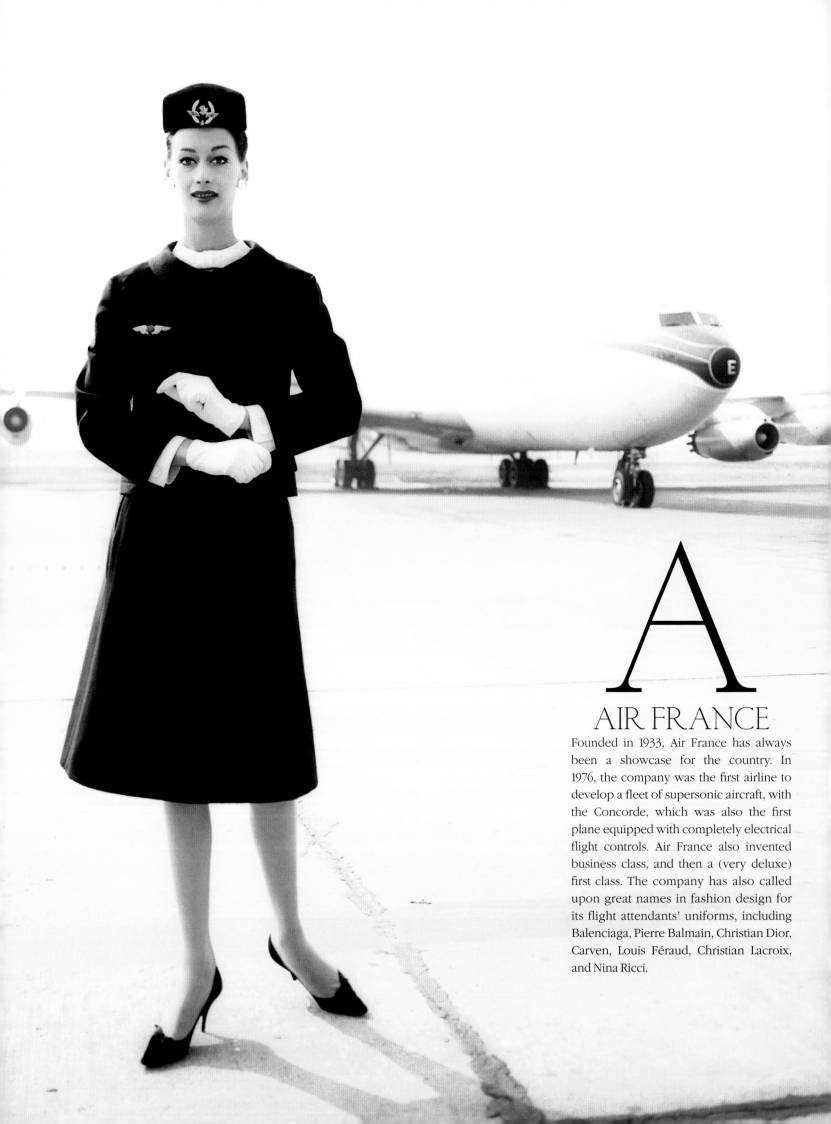

A

AIR FRANCE

Founded in 1933, Air France has always been a showcase for the country. In 1976, the company was the first airline to develop a fleet of supersonic aircraft, with the Concorde, which was also the first plane equipped with completely electrical flight controls. Air France also invented business class, and then a (very deluxe) first class. The company has also called upon great names in fashion design for its flight attendants' uniforms, including Balenciaga, Pierre Balmain, Christian Dior, Carven, Louis Féraud, Christian Lacroix, and Nina Ricci.

B

BIC

In 1950, the Bic company, founded by Marcel Bich and Édouard Bouffard, launched its famous Bic Cristal pen, with its disposable ballpoint ink cartridge. The tiny rolling ball in the nib was a giant revolution, and the ballpoint very soon displaced the fountain pen. Today, the ballpoint is the most widely used kind of pen in the world, with more than 100 billion sold. To crown its success, the Bic ballpoint has been displayed in both the Centre Pompidou in Paris and in New York's Museum of Modern Art. Simple—but irresistible.

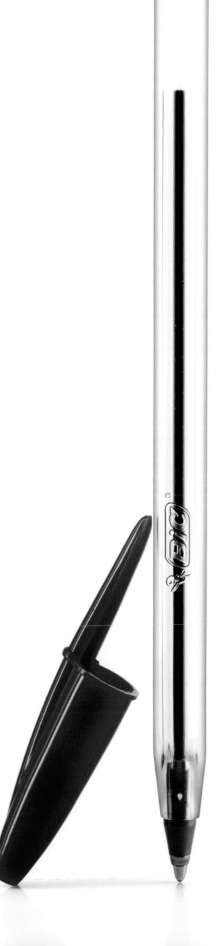

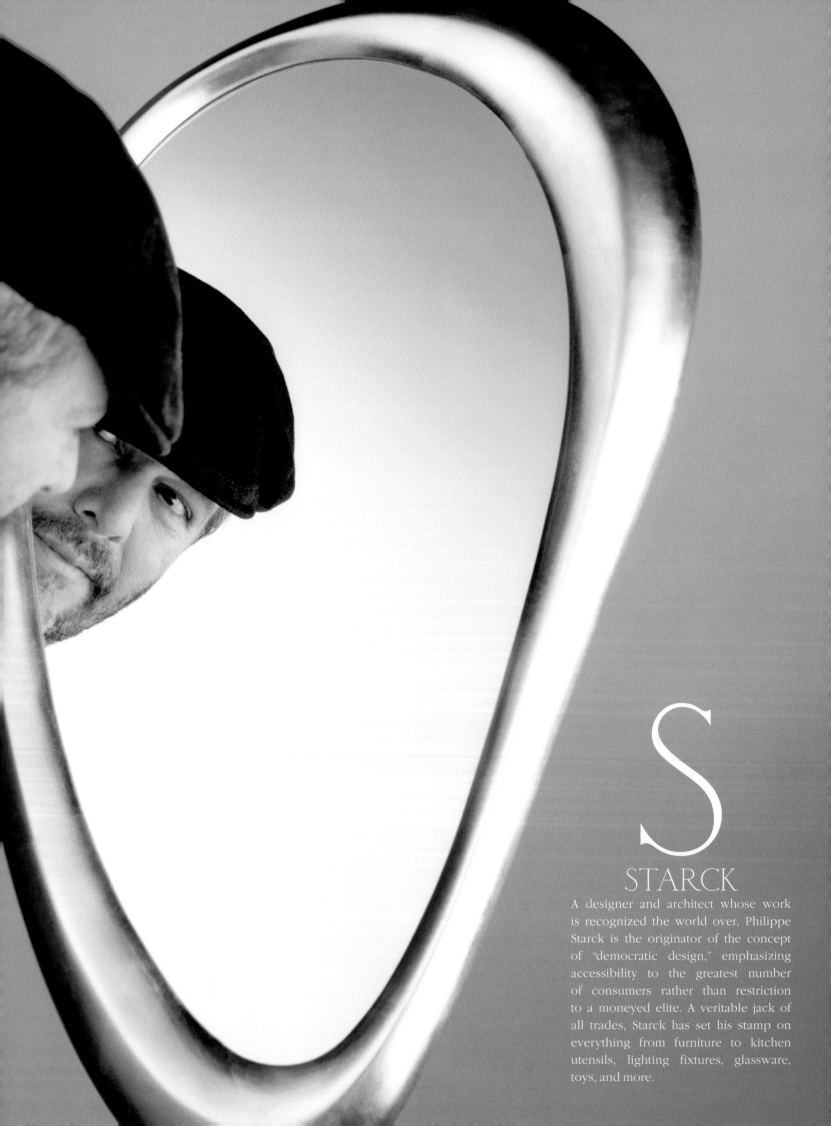

S

STARCK

A designer and architect whose work is recognized the world over, Philippe Starck is the originator of the concept of "democratic design," emphasizing accessibility to the greatest number of consumers rather than restriction to a moneyed elite. A veritable jack of all trades, Starck has set his stamp on everything from furniture to kitchen utensils, lighting fixtures, glassware, toys, and more.

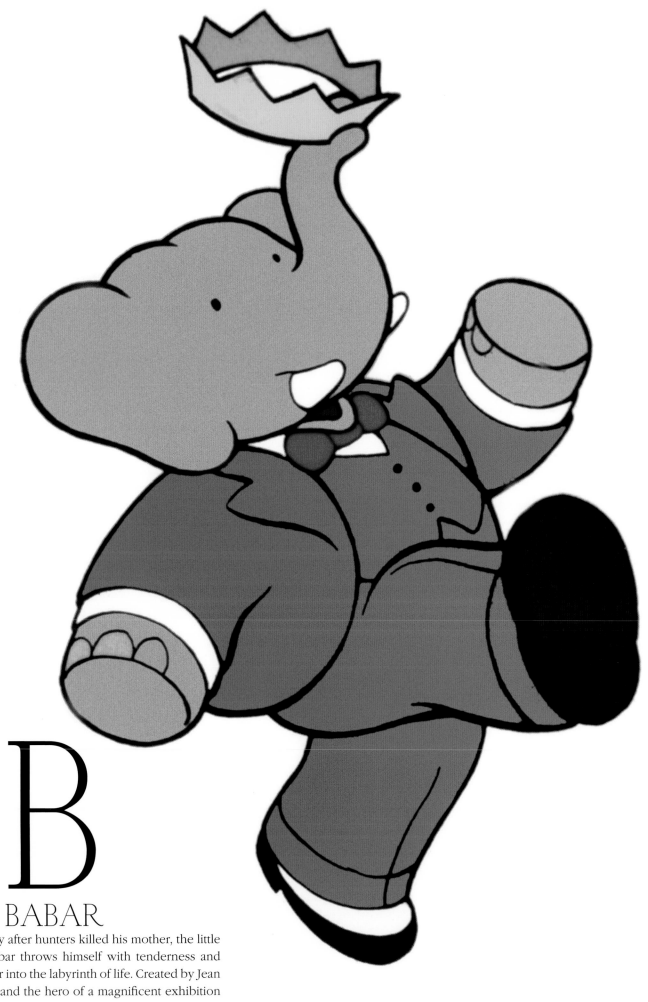

B
BABAR

Raised by an old lady after hunters killed his mother, the little elephant named Babar throws himself with tenderness and cheerful good humor into the labyrinth of life. Created by Jean de Brunhoff in 1931, and the hero of a magnificent exhibition at the Morgan Library in New York in 2008, Babar continues to enchant generations of readers worldwide.

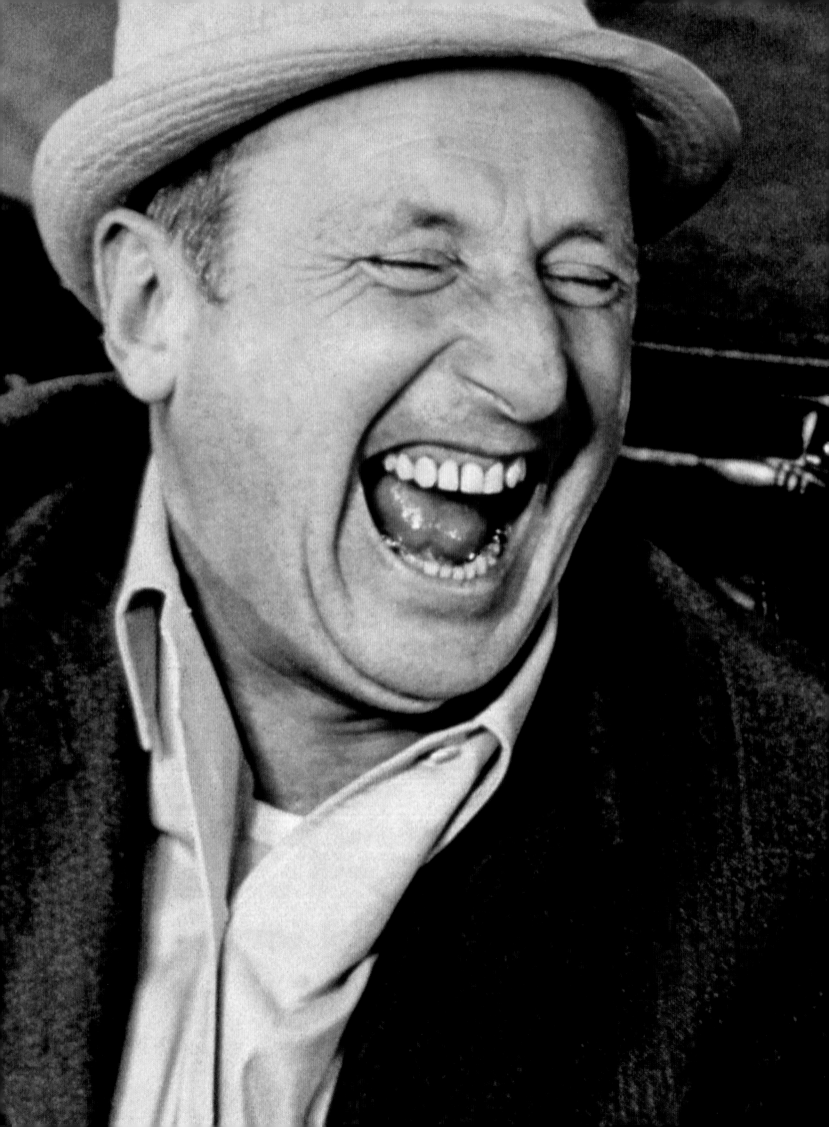

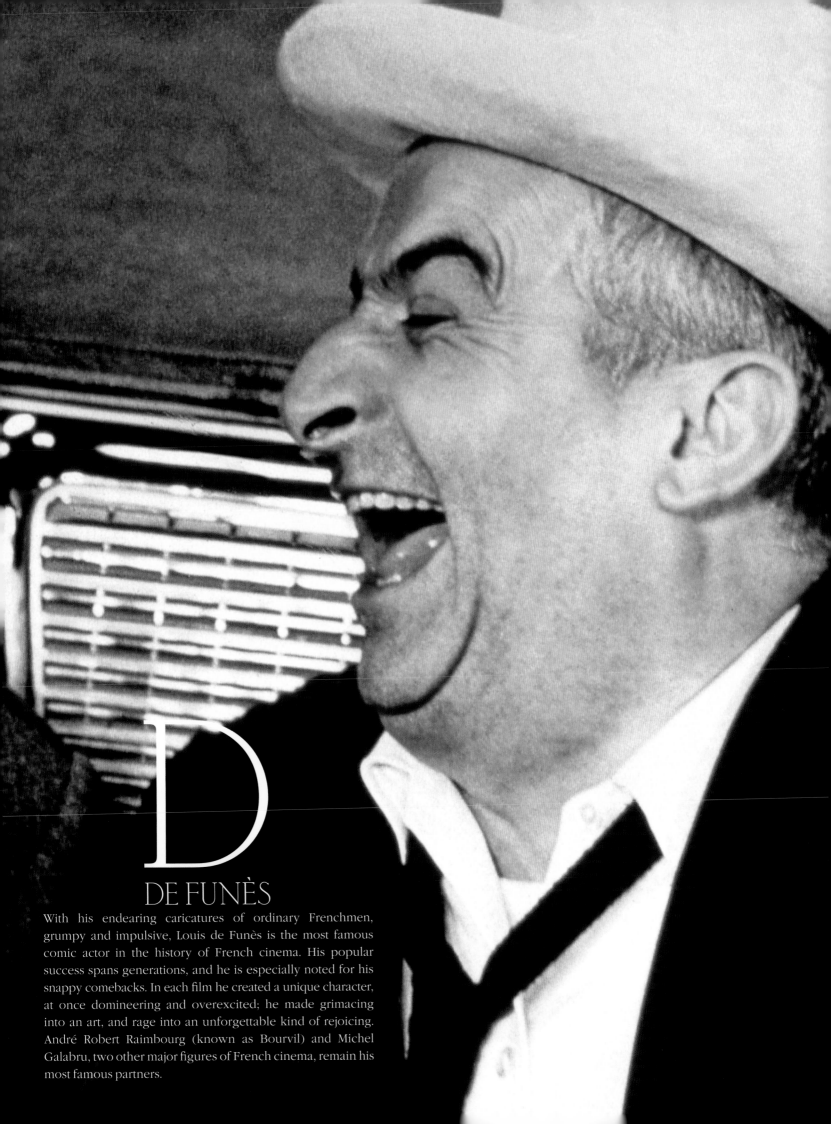

D
DE FUNÈS

With his endearing caricatures of ordinary Frenchmen, grumpy and impulsive, Louis de Funès is the most famous comic actor in the history of French cinema. His popular success spans generations, and he is especially noted for his snappy comebacks. In each film he created a unique character, at once domineering and overexcited; he made grimacing into an art, and rage into an unforgettable kind of rejoicing. André Robert Raimbourg (known as Bourvil) and Michel Galabru, two other major figures of French cinema, remain his most famous partners.

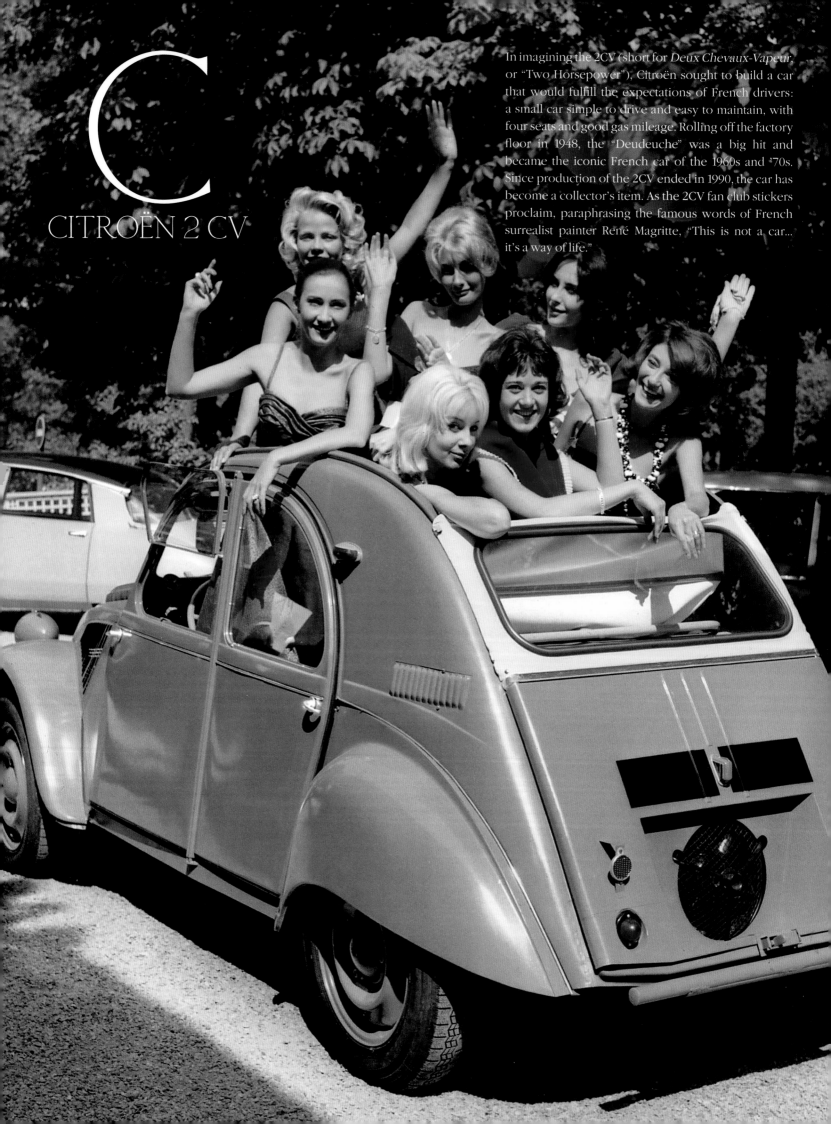

C

CITROËN 2 CV

In imagining the 2CV (short for *Deux Chevaux-Vapeur*, or "Two Horsepower"), Citroën sought to build a car that would fulfill the expectations of French drivers: a small car simple to drive and easy to maintain, with four seats and good gas mileage. Rolling off the factory floor in 1948, the "Deudeuche" was a big hit and became the iconic French car of the 1960s and '70s. Since production of the 2CV ended in 1990, the car has become a collector's item. As the 2CV fan club stickers proclaim, paraphrasing the famous words of French surrealist painter René Magritte, "This is not a car... it's a way of life."

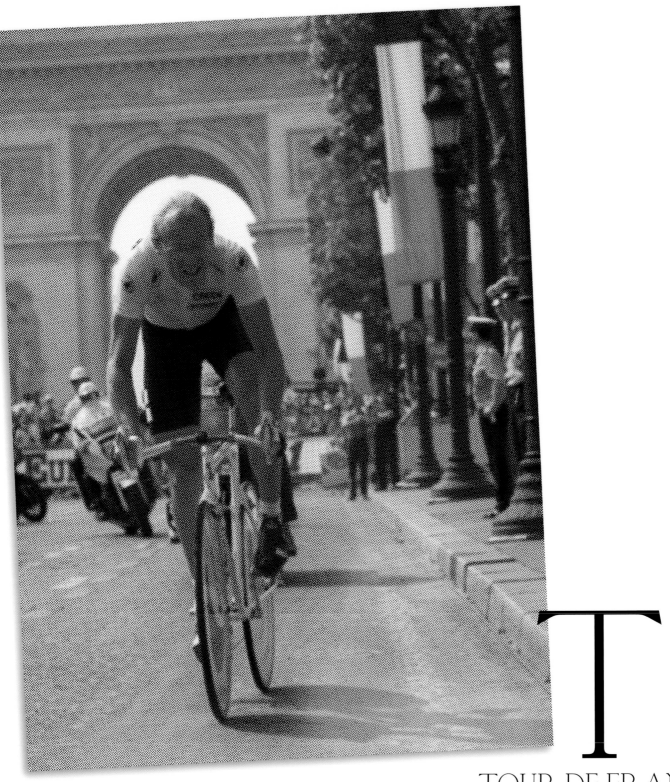

T
TOUR DE FRANCE

France plays host every year to internationally renowned sports competitions, including the 24 Hours of Le Mans sports-car race, the French Open tennis tournament, and above all the Tour de France long-distance cycling race. First held in 1903, the competition takes place primarily in July: The racers must cover 2,000 to 3,000 kilometers (1,243–1,864 miles) in a series of stages (the exact route changes year to year), and the cyclist with the fastest aggregate time at any point is the leader of the race and wears the famous yellow jersey. Among the champions in the sport, Jacques Anquetil and Laurent Fignon are feted French heroes.

C
CHEESE

"How can you govern a country that has 246 kinds of cheese?" General de Gaulle once exclaimed. (Today, France in fact produces nearly 400 varieties.) Iconically paired with a slice of bread and a glass of red wine, cheese is at the heart of the French *art de vivre*, the art of living well. So much so that at the end of a meal the traditional question is, "Cheese or desert?" People rarely have both. Could this be the key to solving "the French paradox"?

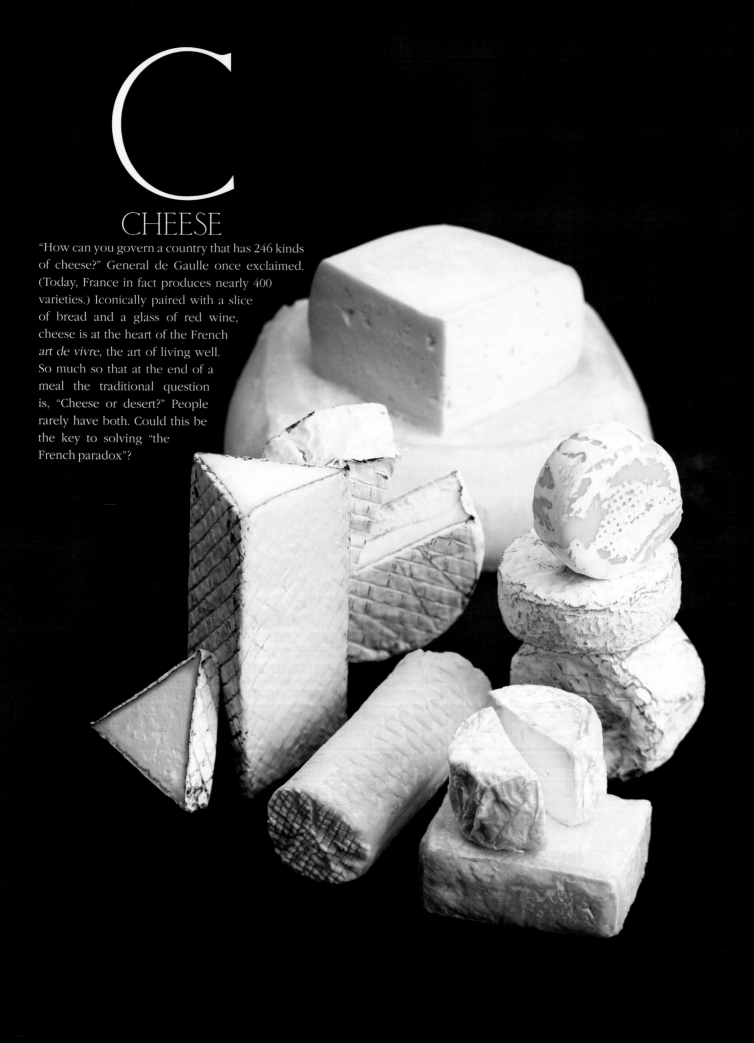

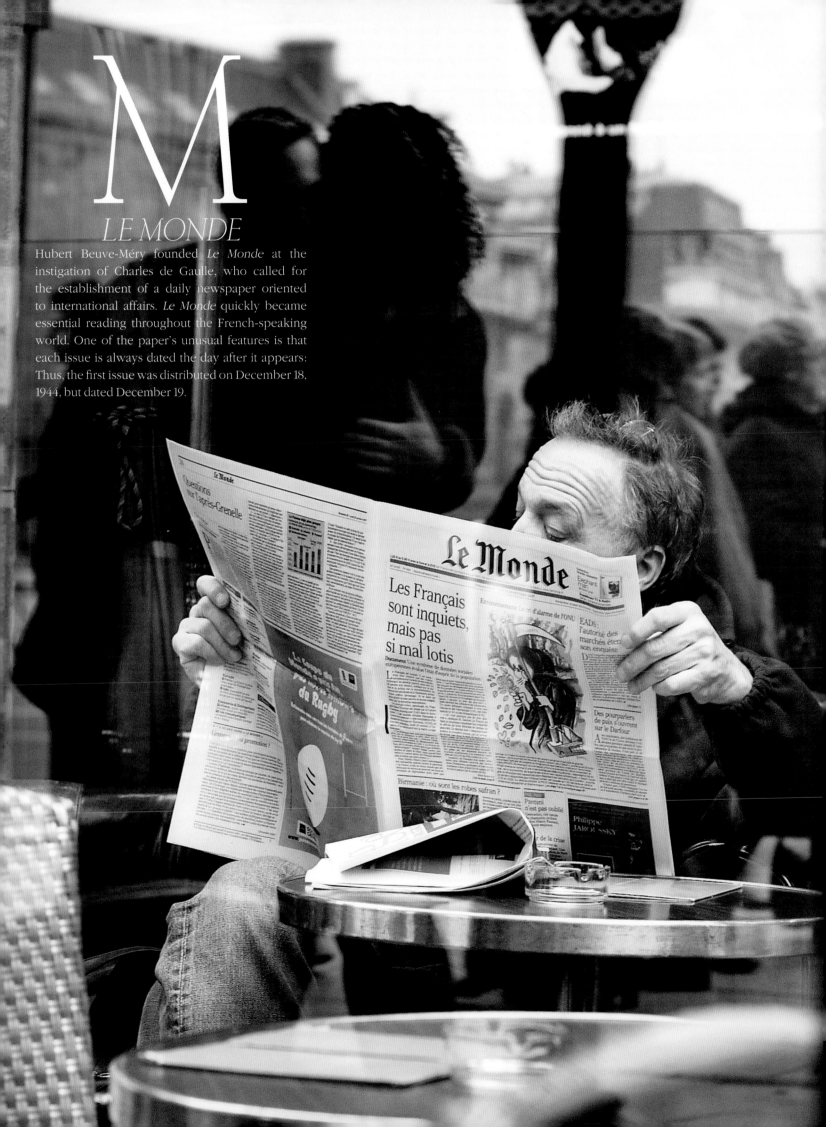

M
LE MONDE

Hubert Beuve-Méry founded *Le Monde* at the instigation of Charles de Gaulle, who called for the establishment of a daily newspaper oriented to international affairs. *Le Monde* quickly became essential reading throughout the French-speaking world. One of the paper's unusual features is that each issue is always dated the day after it appears: Thus, the first issue was distributed on December 18, 1944, but dated December 19.

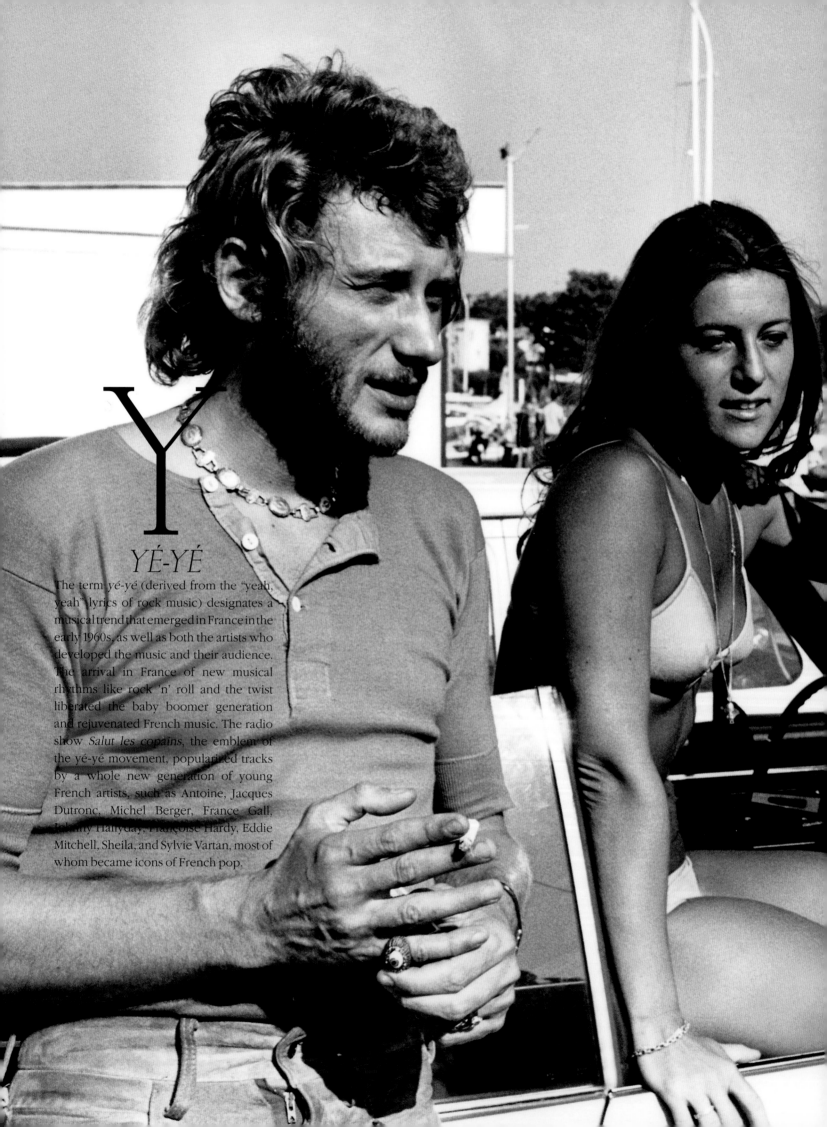

Y

YÉ-YÉ

The term *yé-yé* (derived from the "yeah, yeah" lyrics of rock music) designates a musical trend that emerged in France in the early 1960s, as well as both the artists who developed the music and their audience. The arrival in France of new musical rhythms like rock 'n' roll and the twist liberated the baby boomer generation and rejuvenated French music. The radio show *Salut les copains*, the emblem of the yé-yé movement, popularized tracks by a whole new generation of young French artists, such as Antoine, Jacques Dutronc, Michel Berger, France Gall, Johnny Hallyday, Françoise Hardy, Eddie Mitchell, Sheila, and Sylvie Vartan, most of whom became icons of French pop.

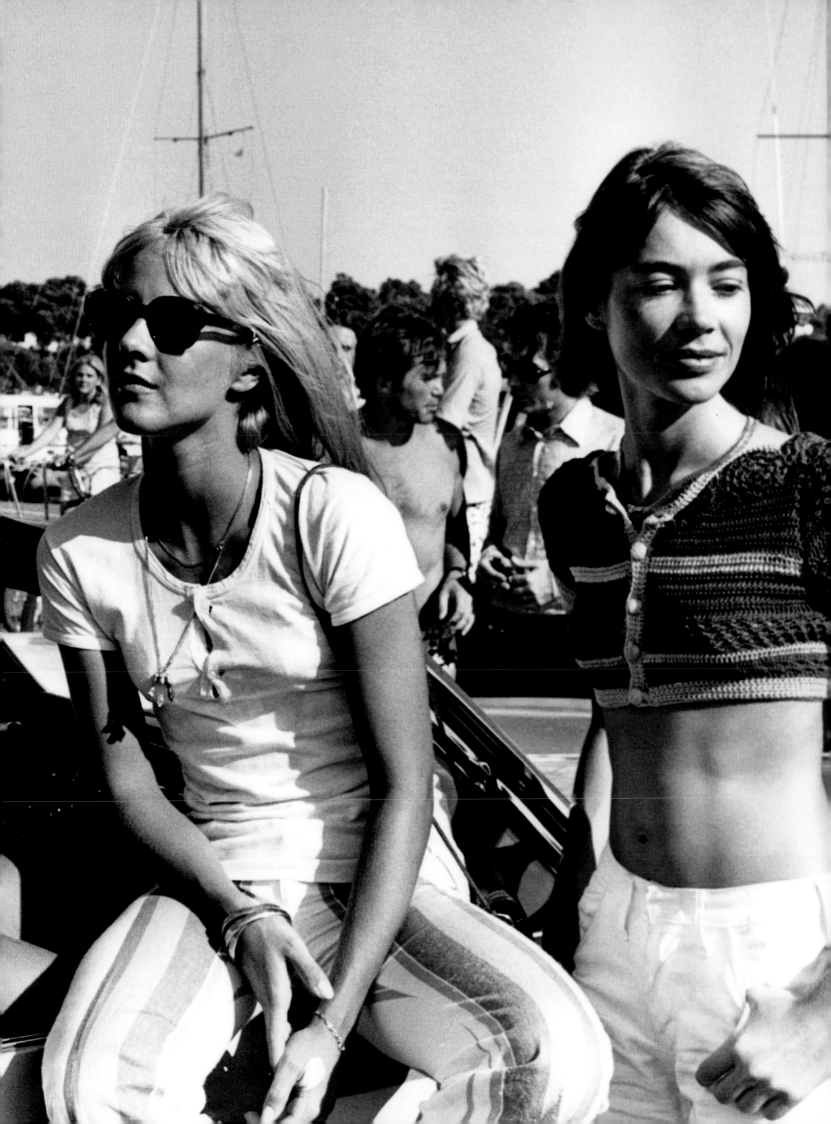

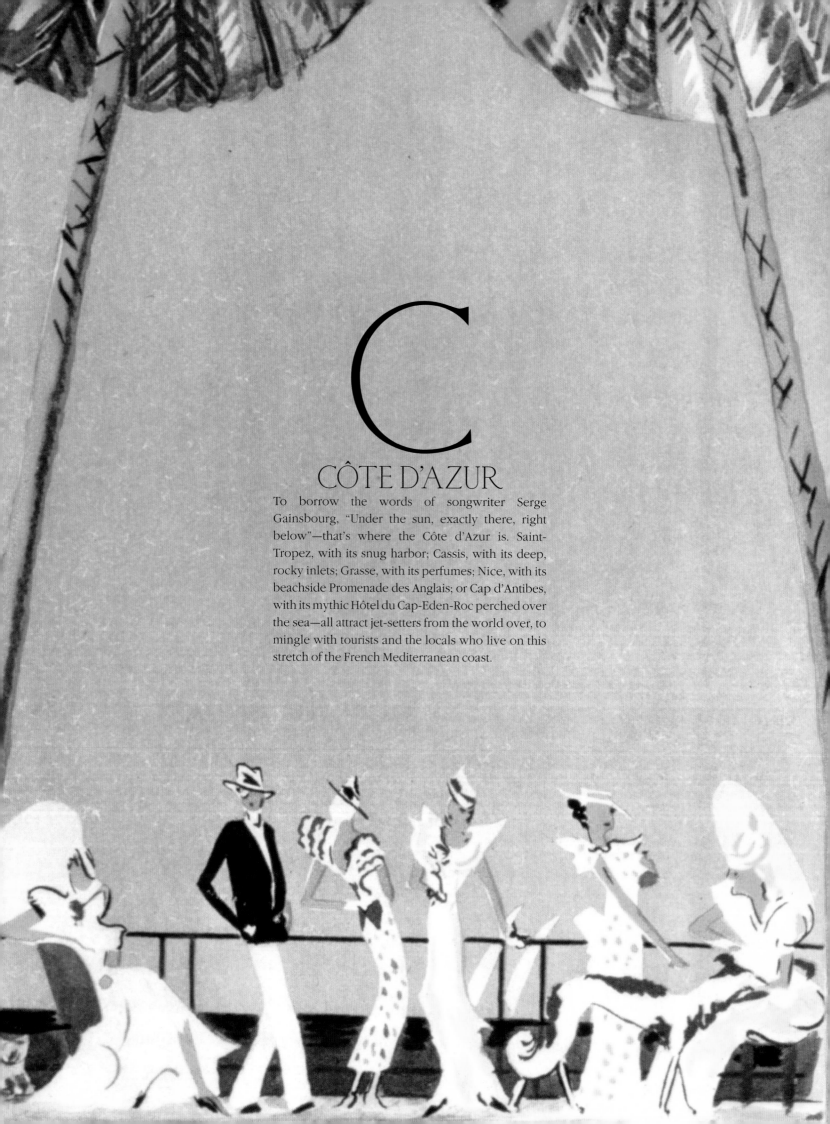

C
CÔTE D'AZUR

To borrow the words of songwriter Serge Gainsbourg, "Under the sun, exactly there, right below"—that's where the Côte d'Azur is. Saint-Tropez, with its snug harbor; Cassis, with its deep, rocky inlets; Grasse, with its perfumes; Nice, with its beachside Promenade des Anglais; or Cap d'Antibes, with its mythic Hôtel du Cap-Eden-Roc perched over the sea—all attract jet-setters from the world over, to mingle with tourists and the locals who live on this stretch of the French Mediterranean coast.

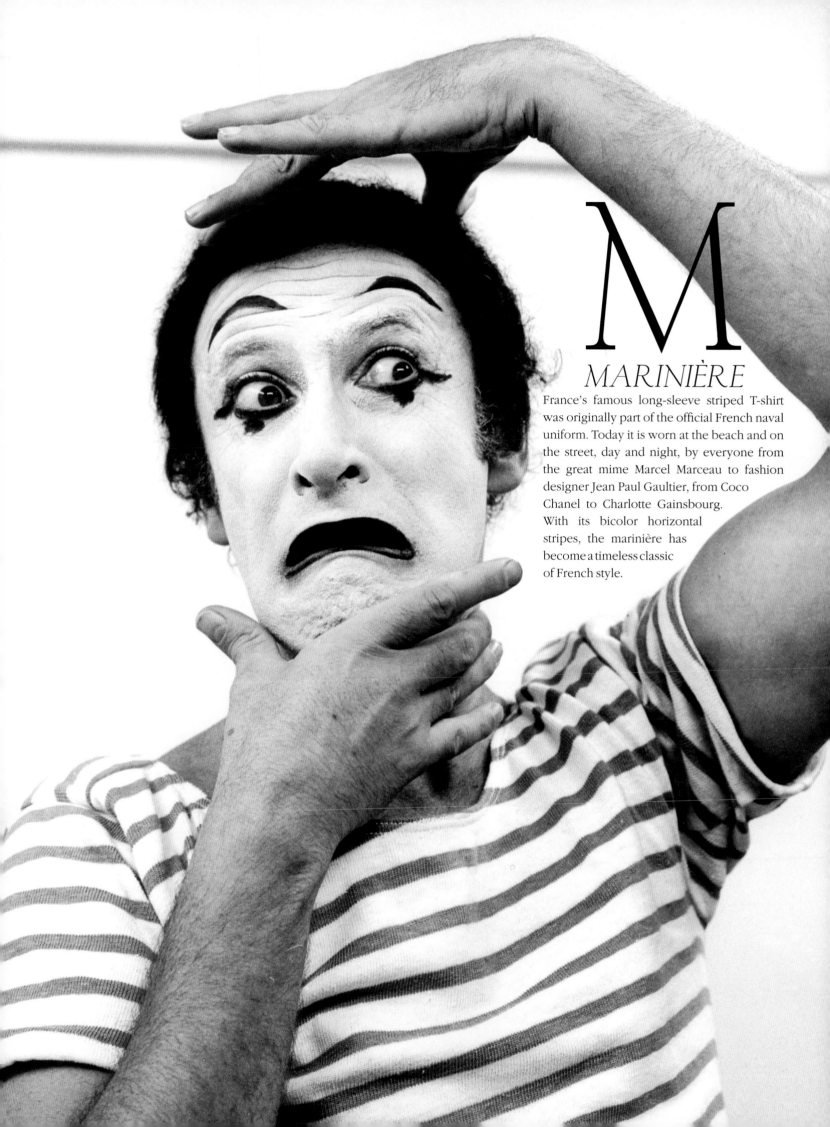

M

MARINIÈRE

France's famous long-sleeve striped T-shirt was originally part of the official French naval uniform. Today it is worn at the beach and on the street, day and night, by everyone from the great mime Marcel Marceau to fashion designer Jean Paul Gaultier, from Coco Chanel to Charlotte Gainsbourg. With its bicolor horizontal stripes, the marinière has become a timeless classic of French style.

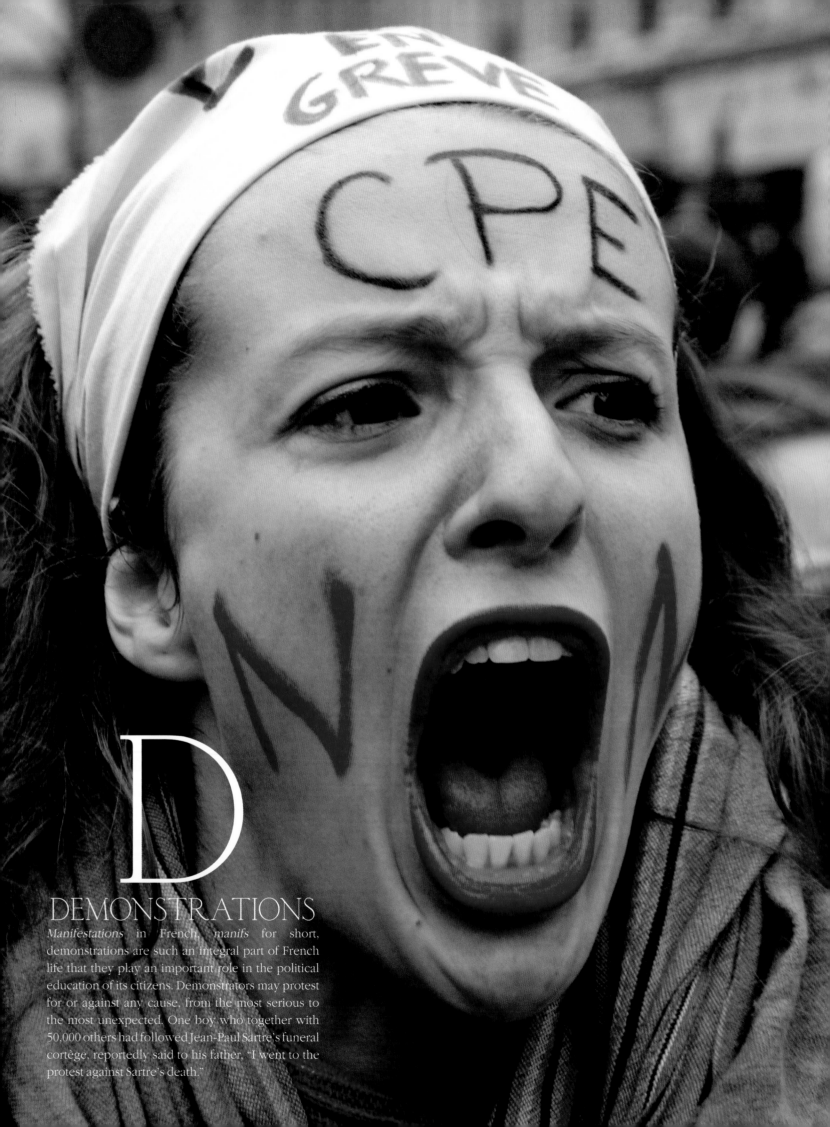

D
DEMONSTRATIONS

Manifestations in French, *manifs* for short, demonstrations are such an integral part of French life that they play an important role in the political education of its citizens. Demonstrators may protest for or against any cause, from the most serious to the most unexpected. One boy who together with 50,000 others had followed Jean-Paul Sartre's funeral cortège, reportedly said to his father, "I went to the protest against Sartre's death."

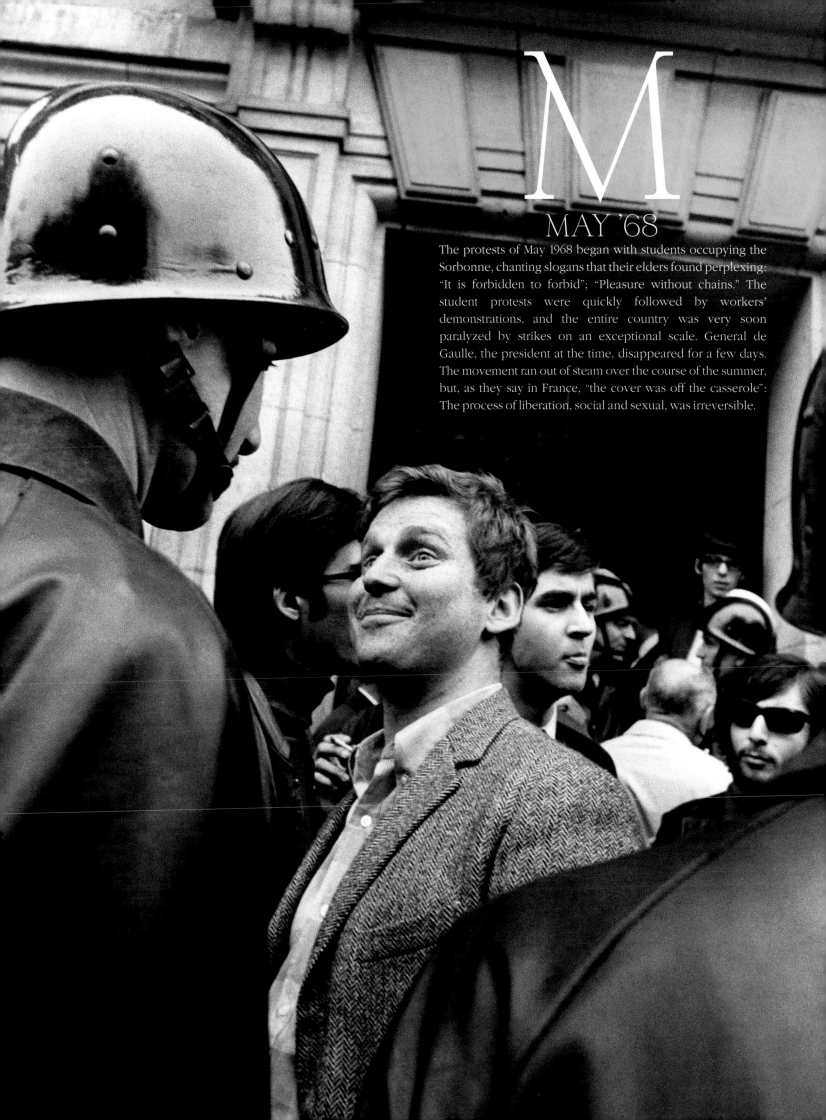

M
MAY '68

The protests of May 1968 began with students occupying the Sorbonne, chanting slogans that their elders found perplexing: "It is forbidden to forbid"; "Pleasure without chains." The student protests were quickly followed by workers' demonstrations, and the entire country was very soon paralyzed by strikes on an exceptional scale. General de Gaulle, the president at the time, disappeared for a few days. The movement ran out of steam over the course of the summer, but, as they say in France, "the cover was off the casserole": The process of liberation, social and sexual, was irreversible.

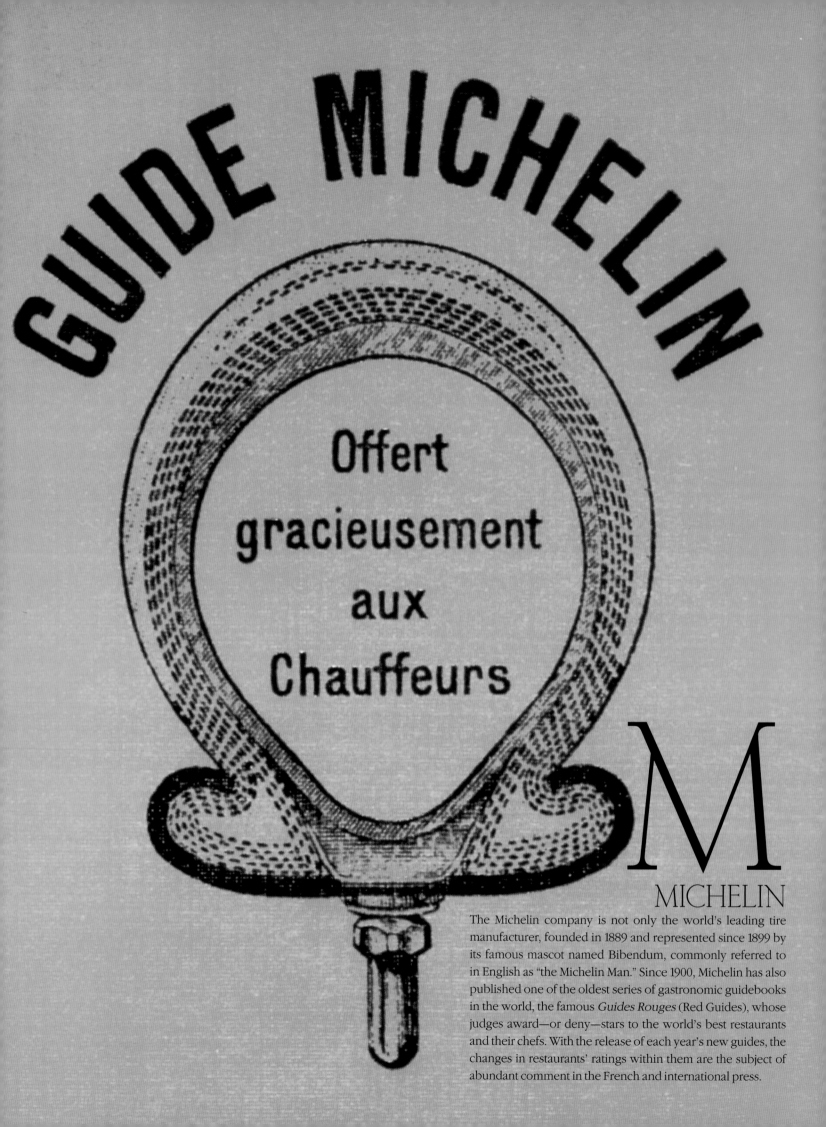

GUIDE MICHELIN

Offert gracieusement aux Chauffeurs

M
MICHELIN

The Michelin company is not only the world's leading tire manufacturer, founded in 1889 and represented since 1899 by its famous mascot named Bibendum, commonly referred to in English as "the Michelin Man." Since 1900, Michelin has also published one of the oldest series of gastronomic guidebooks in the world, the famous *Guides Rouges* (Red Guides), whose judges award—or deny—stars to the world's best restaurants and their chefs. With the release of each year's new guides, the changes in restaurants' ratings within them are the subject of abundant comment in the French and international press.

I

IMPRESSIONISM

Emerging in France in the latter half of the 19th century, the Impressionist movement proved to be a genuine artistic revolution, and was as much rejected and decried in the era of its birth as it is admired and valued today. Indeed, it is with Impressionism that modern art was born. For the leading figures of the movement, such as Cézanne, Degas, Manet, Monet, Pissarro, and Renoir, it was most important for the artist to privilege his subjectivity and to depict his own impressions of the world. Together these painters created new pictorial techniques: the use of pure, bright hues and heavy impasto, bold juxtapositions of colors, application of paint in tiny strokes or dots, and so on. Impressionism in painting found an analogue in certain atmospheric effects of late Romantic French music composed around the turn of the 20th century: Some works of Claude Debussy and Maurice Ravel especially have been labeled "impressionist," although Debussy himself rejected the term.

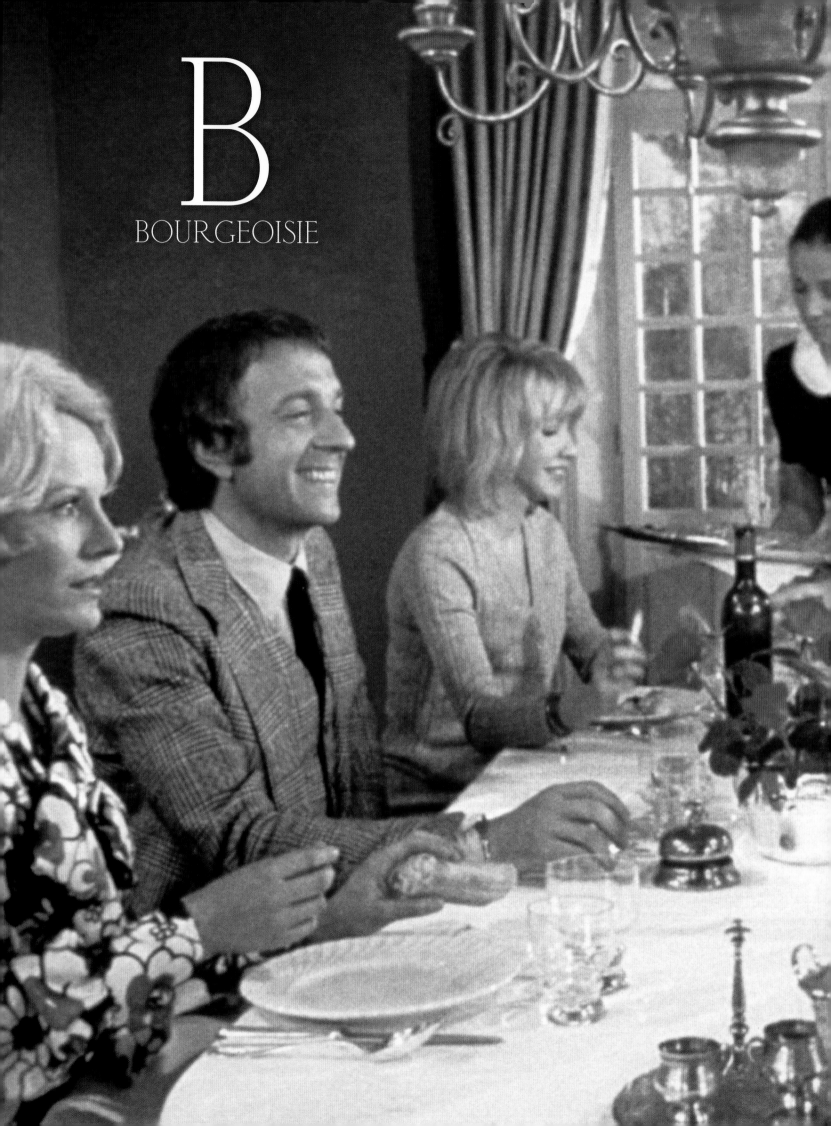

B
BOURGEOISIE

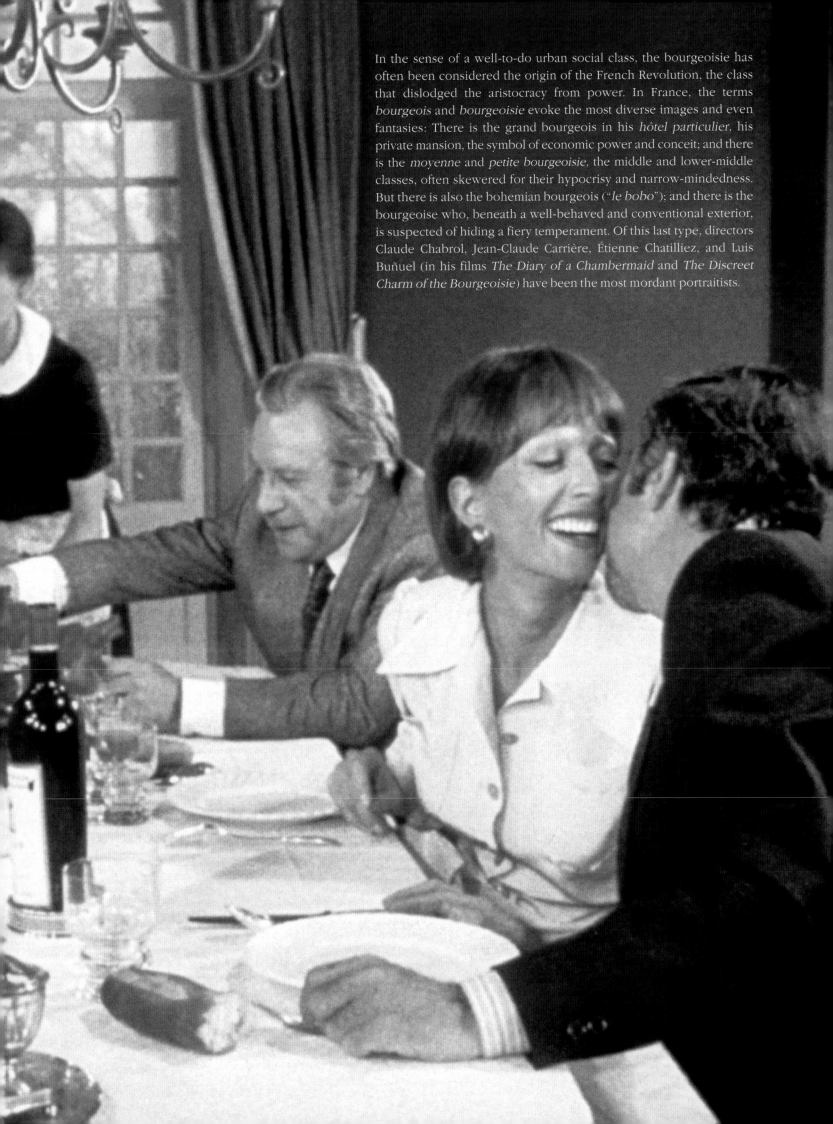

In the sense of a well-to-do urban social class, the bourgeoisie has often been considered the origin of the French Revolution, the class that dislodged the aristocracy from power. In France, the terms *bourgeois* and *bourgeoisie* evoke the most diverse images and even fantasies: There is the grand bourgeois in his *hôtel particulier*, his private mansion, the symbol of economic power and conceit; and there is the *moyenne* and *petite bourgeoisie*, the middle and lower-middle classes, often skewered for their hypocrisy and narrow-mindedness. But there is also the bohemian bourgeois ("*le bobo*"); and there is the bourgeoise who, beneath a well-behaved and conventional exterior, is suspected of hiding a fiery temperament. Of this last type, directors Claude Chabrol, Jean-Claude Carrière, Étienne Chatilliez, and Luis Buñuel (in his films *The Diary of a Chambermaid* and *The Discreet Charm of the Bourgeoisie*) have been the most mordant portraitists.

R
RAP

Emerging at the end of the 1980s, and obviously inspired in its early years by the American genre, French rap quickly developed its own identity, characterized by a great diversity of styles. Since the '90s, French rap has moved beyond the limits of the suburbs where it grew up and has established itself on the airwaves with such groups and performers as IAM, MC Solaar, and Suprême NTM.

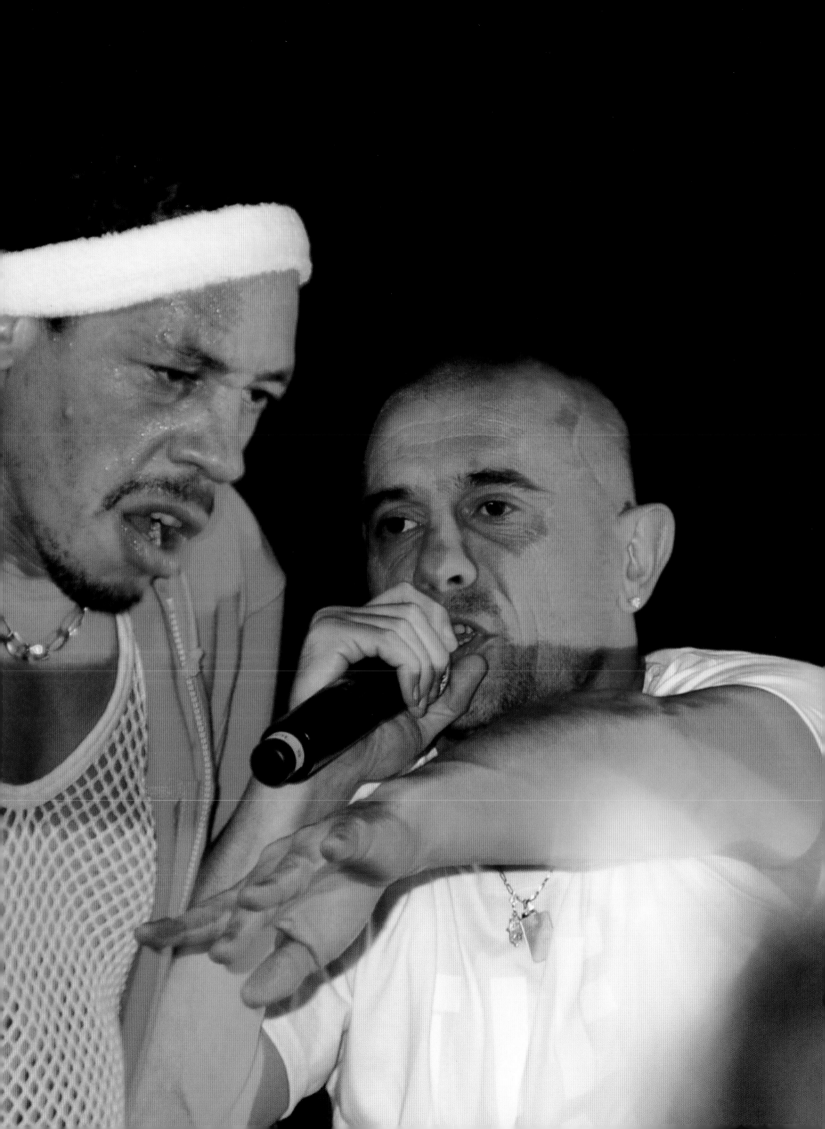

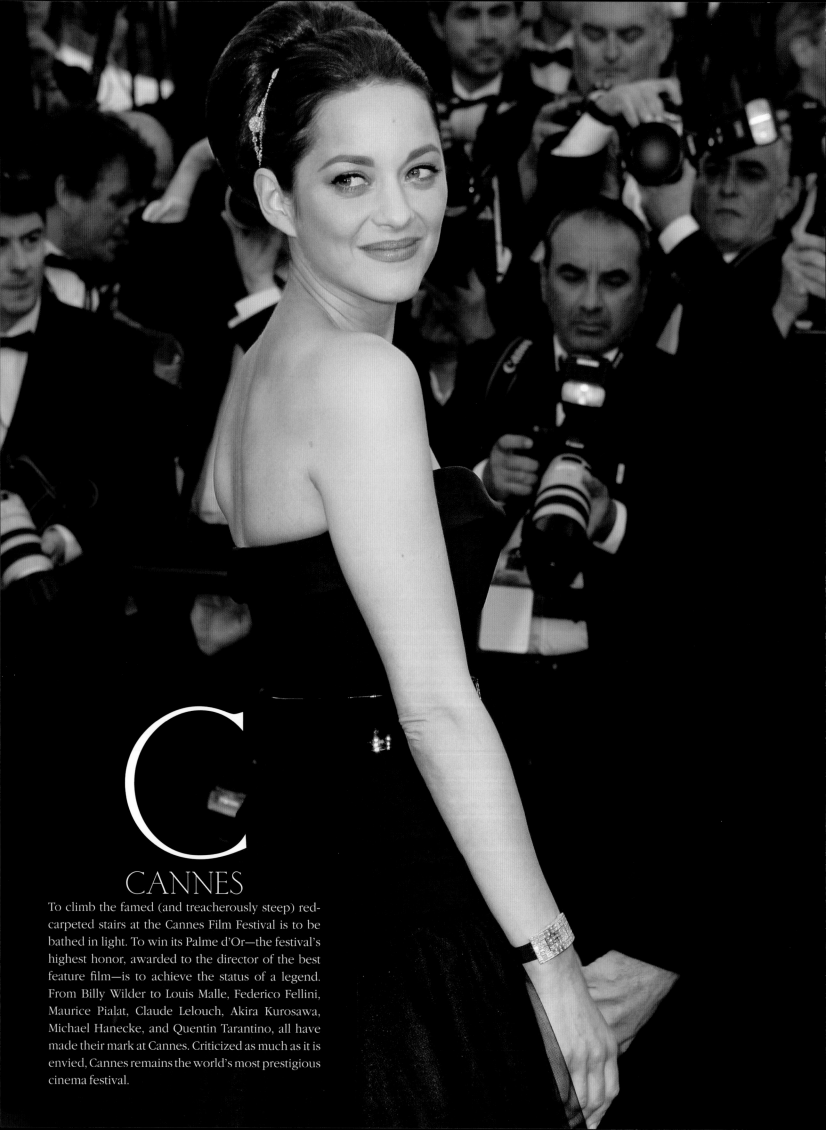

C
CANNES

To climb the famed (and treacherously steep) red-carpeted stairs at the Cannes Film Festival is to be bathed in light. To win its Palme d'Or—the festival's highest honor, awarded to the director of the best feature film—is to achieve the status of a legend. From Billy Wilder to Louis Malle, Federico Fellini, Maurice Pialat, Claude Lelouch, Akira Kurosawa, Michael Hanecke, and Quentin Tarantino, all have made their mark at Cannes. Criticized as much as it is envied, Cannes remains the world's most prestigious cinema festival.

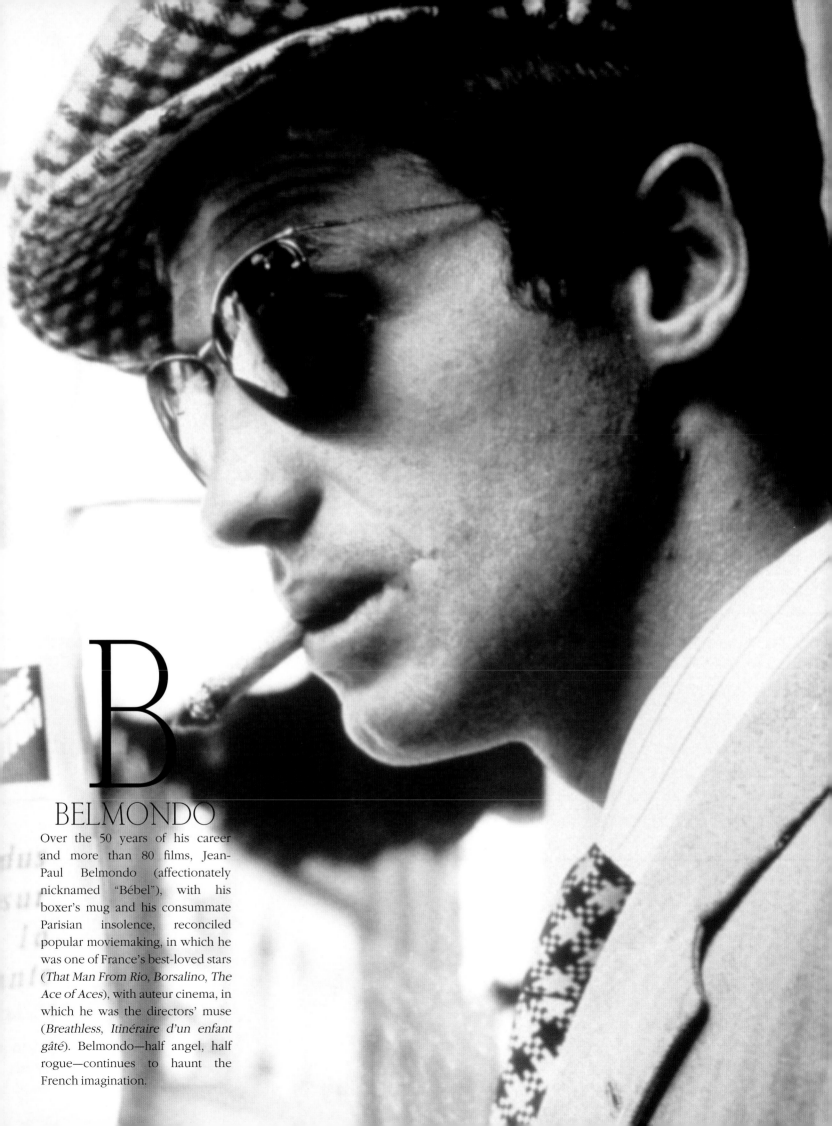

B

BELMONDO

Over the 50 years of his career and more than 80 films, Jean-Paul Belmondo (affectionately nicknamed "Bébel"), with his boxer's mug and his consummate Parisian insolence, reconciled popular moviemaking, in which he was one of France's best-loved stars (*That Man From Rio, Borsalino, The Ace of Aces*), with auteur cinema, in which he was the directors' muse (*Breathless, Itinéraire d'un enfant gâté*). Belmondo—half angel, half rogue—continues to haunt the French imagination.

D

DELON

With his spectacular physique and exceptional acting talent, Alain Delon is one of the brightest superstars of French cinema. Unforgettable in *Rocco and His Brothers* (1959), *Purple Noon* (1960), *The Leopard* (1963), and *The Samurai* (1967), Delon worked with the most renowned directors of his era, playing opposite its biggest names, from Jean Gabin to Jane Fonda. He also lent his visage to the ad for Dior's Eau Sauvage.

LES FLEURS DU MAL

F

LES FLEURS DU MAL

The collection of poems titled *Les Fleurs du Mal* (*The Flowers of Evil*), is both Charles Baudelaire's first major work and a masterpiece of modern poetry. When it appeared in 1857, the book incited a scandal, and the poet was forced to suppress six of the poems for causing "offense to public morality." The collection's oxymoronic title is emblematic of a certain aspect of the French spirit, which enjoys the collision of contrarieties, loves nuances and contradictions, and likes to consider both good and evil at the same time and to analyze opposing aspirations. For, as Baudelaire wrote in his collection of aphorisms *Mon Coeur mis á nu* (*My Heart Laid Bare*), "there are in every man, at every hour, two simultaneous impulses, one toward God, and the other toward Satan."

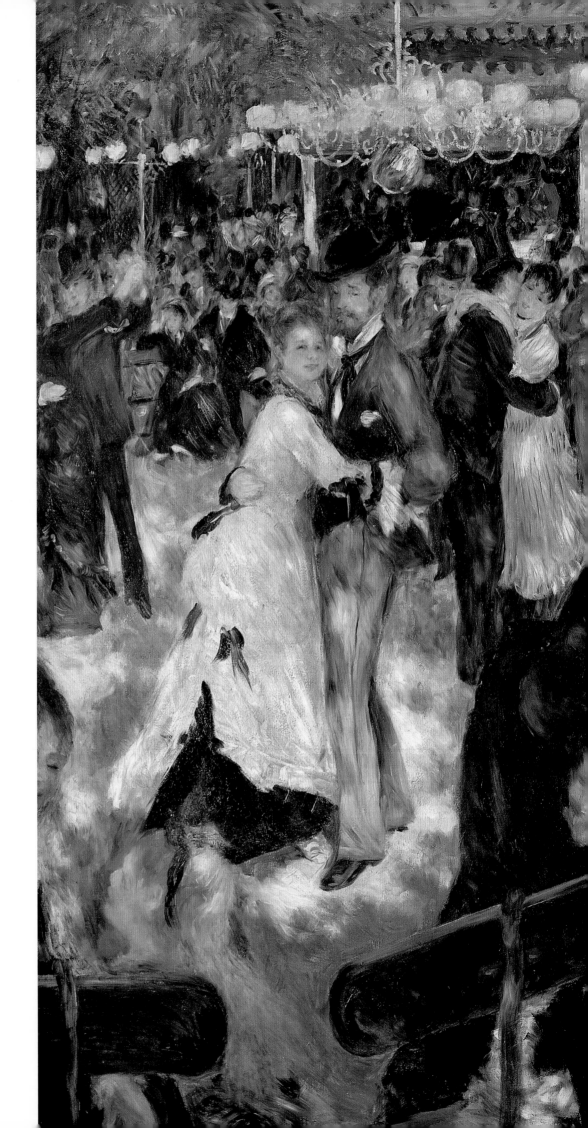

G

GUINGUETTE

The guinguette, a small restaurant, most often outdoors, with live music and dancing, in a relaxed, family-oriented atmosphere, once offered a few hours of relaxation on a Sunday afternoon on the banks of the Marne or the Seine. Very popular in the first half of the 20th century, guinguettes were a subject that often inspired painters, in particular Auguste Renoir, whose *Le déjeuner des canotiers* (*Luncheon of the Boating Party*, 1881, now in The Phillips Collection in Washington, D.C.) is perhaps the most famous such canvas. Recent years have seen a limited revival of the guinguette, especially along the Marne.

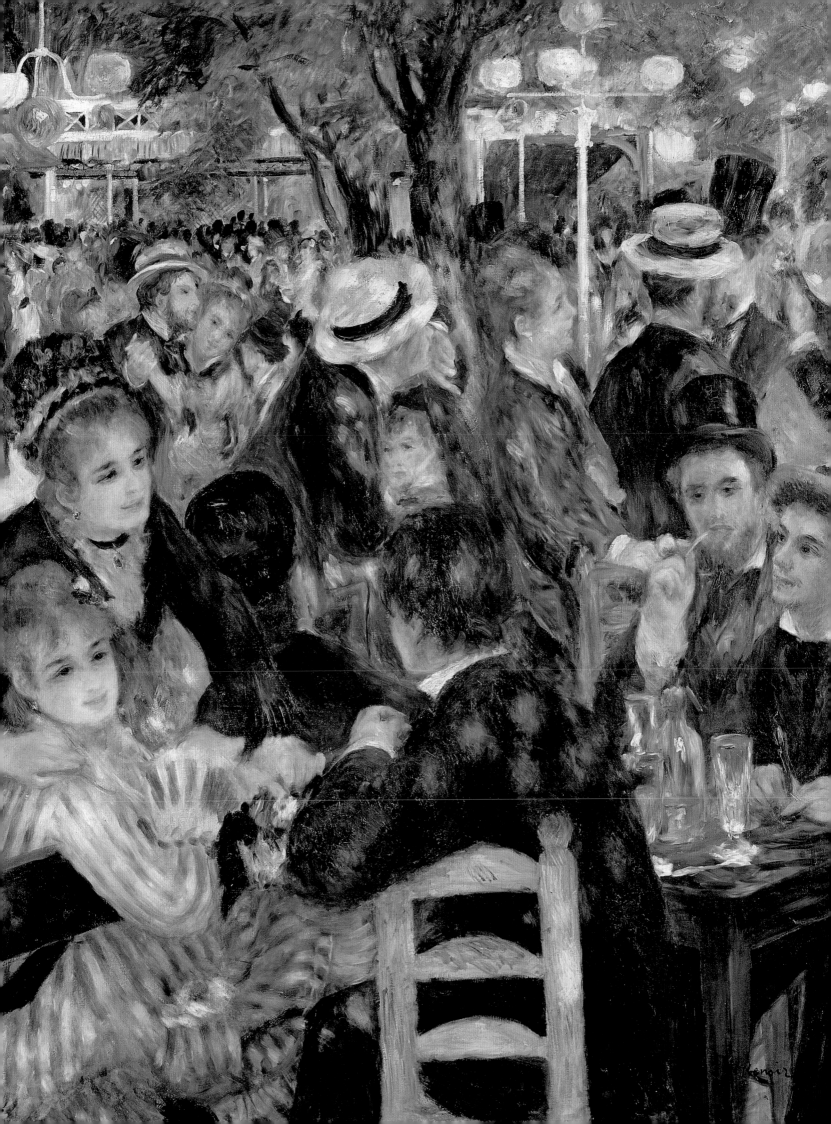

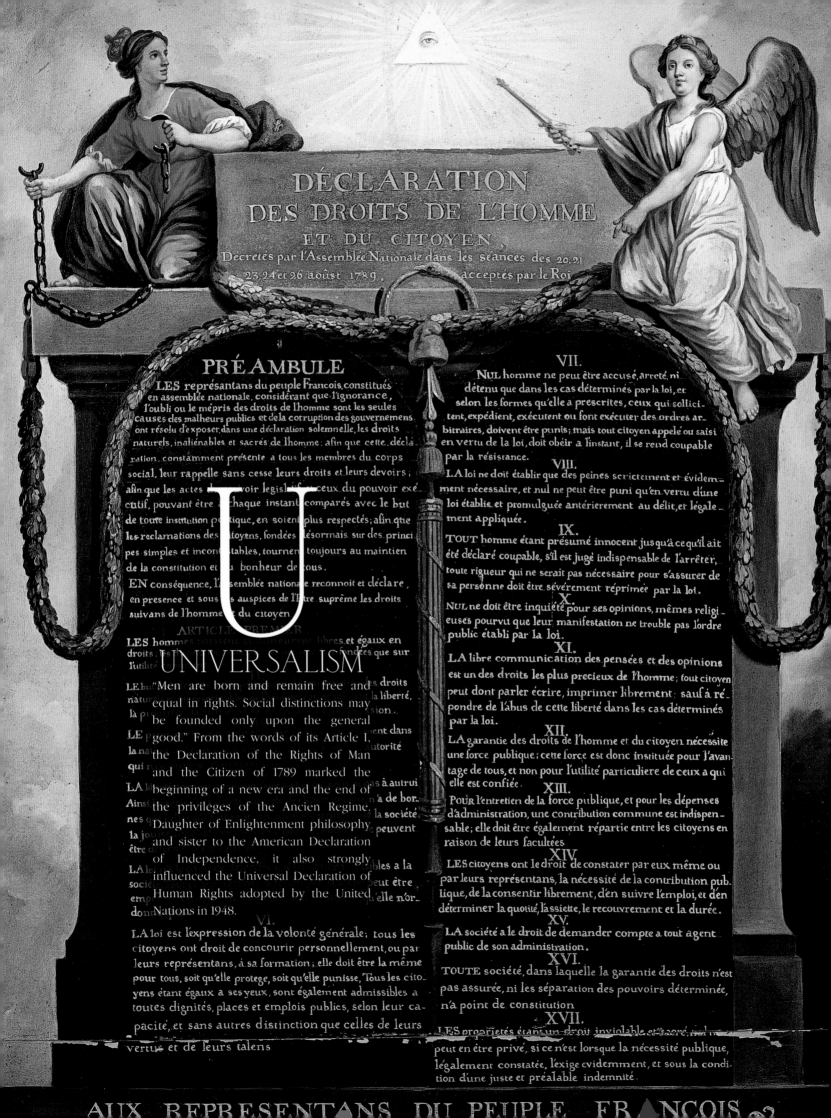

UNIVERSALISM

"Men are born and remain free and equal in rights. Social distinctions may be founded only upon the general good." From the words of its Article I, the Declaration of the Rights of Man and the Citizen of 1789 marked the beginning of a new era and the end of the privileges of the Ancien Regime. Daughter of Enlightenment philosophy and sister to the American Declaration of Independence, it also strongly influenced the Universal Declaration of Human Rights adopted by the United Nations in 1948.

ACCORDION

In France, the history of the accordion goes hand in hand with that of the *bal musette*, a form of dance and music that began in the cafés and bars of Paris and achieved immense popularity in the early 1900s. The accordion was the king of the musette orchestra—for foreign visitors its sound became synonymous with festive Paris—with Yvette Horner as the muse of the musette. Today, no longer considered only a folkloric curiosity, the instrument has even been adopted by French rock groups, and new virtuosos have emerged, such as jazz musician Richard Galliano, who has revitalized a long-neglected tradition with his invention of *le new musette*.

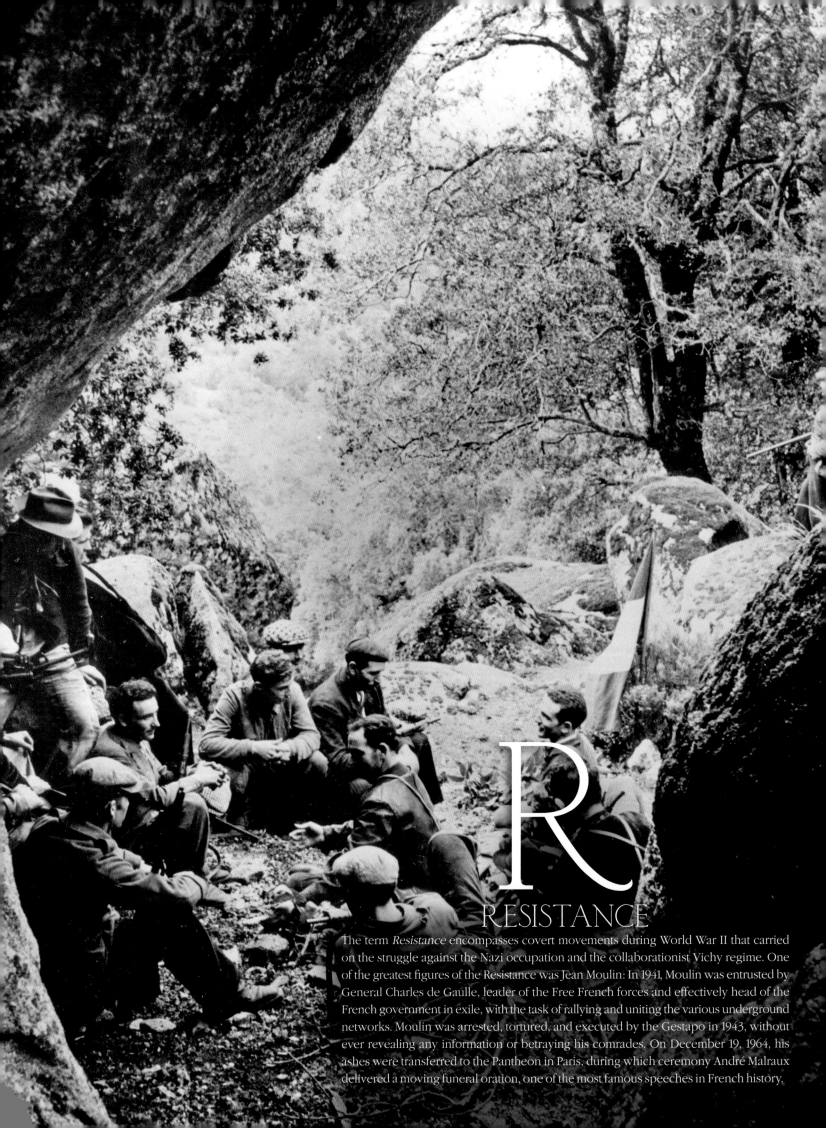

R
RESISTANCE

The term *Resistance* encompasses covert movements during World War II that carried on the struggle against the Nazi occupation and the collaborationist Vichy regime. One of the greatest figures of the Resistance was Jean Moulin: In 1941, Moulin was entrusted by General Charles de Gaulle, leader of the Free French forces and effectively head of the French government in exile, with the task of rallying and uniting the various underground networks. Moulin was arrested, tortured, and executed by the Gestapo in 1943, without ever revealing any information or betraying his comrades. On December 19, 1964, his ashes were transferred to the Pantheon in Paris, during which ceremony André Malraux delivered a moving funeral oration, one of the most famous speeches in French history.

B

BLUE, WHITE, RED

In the 18th century, French sympathizers with the cause of liberty raised a tricolored flag of blue, white, and red. These have become the emblematic colors of that century's two great revolutions: the American War of Independence and the French Revolution. However, while the United States adopted a more demonstrative design of stars and stripes, the French, with Cartesian simplicity, opted for three equal vertical panels.

PARLONS FRANÇAIS

J

JOAN OF ARC

Joan of Arc, the most famous hero in the history of France, was born into a peasant family. At age 13 Joan claimed to hear celestial voices commanding her to liberate France from the English invaders. At 17 she took up arms. Nicknamed "the Maid of Orléans," Joan reversed the course of the Hundred Years War when she led the French troops to victory over the English. In 1431, at age 19, she was captured and burned at the stake. Her reputation extends far beyond the borders of France: Joan of Arc has become a symbol of patriotic struggle for many peoples.

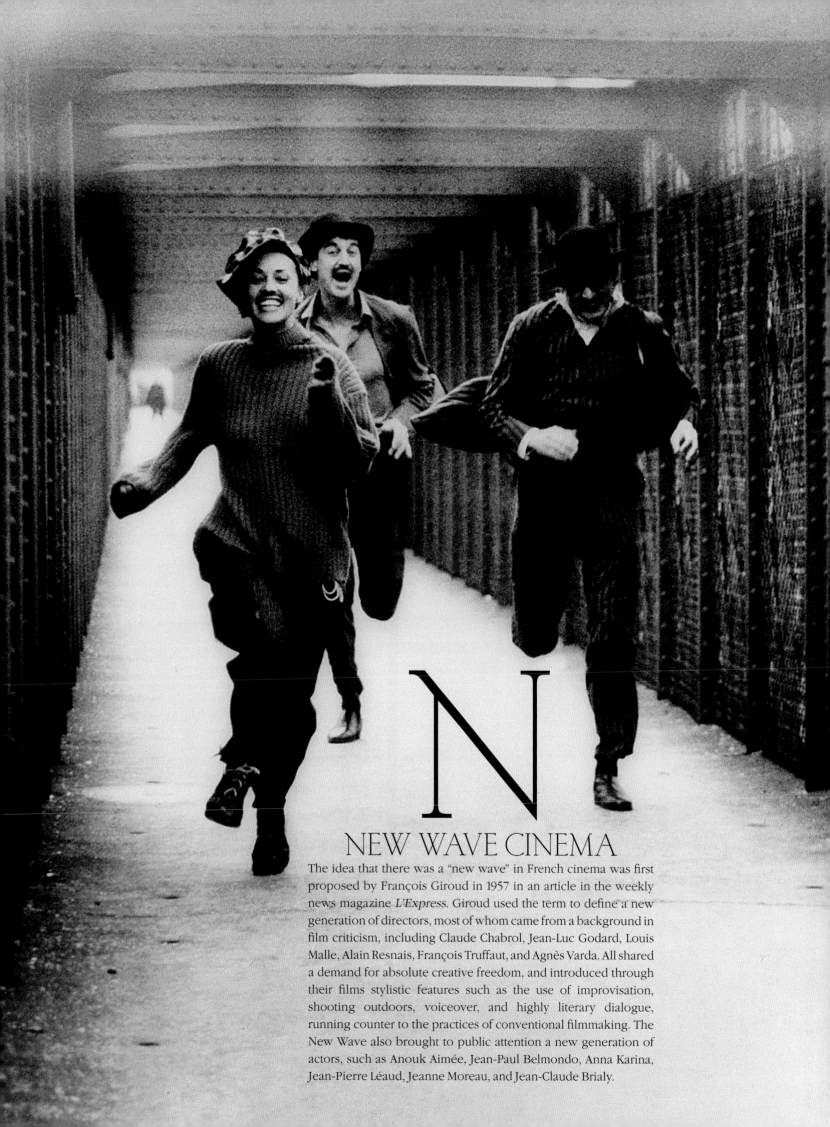

N
NEW WAVE CINEMA

The idea that there was a "new wave" in French cinema was first proposed by François Giroud in 1957 in an article in the weekly news magazine *L'Express*. Giroud used the term to define a new generation of directors, most of whom came from a background in film criticism, including Claude Chabrol, Jean-Luc Godard, Louis Malle, Alain Resnais, François Truffaut, and Agnès Varda. All shared a demand for absolute creative freedom, and introduced through their films stylistic features such as the use of improvisation, shooting outdoors, voiceover, and highly literary dialogue, running counter to the practices of conventional filmmaking. The New Wave also brought to public attention a new generation of actors, such as Anouk Aimée, Jean-Paul Belmondo, Anna Karina, Jean-Pierre Léaud, Jeanne Moreau, and Jean-Claude Brialy.

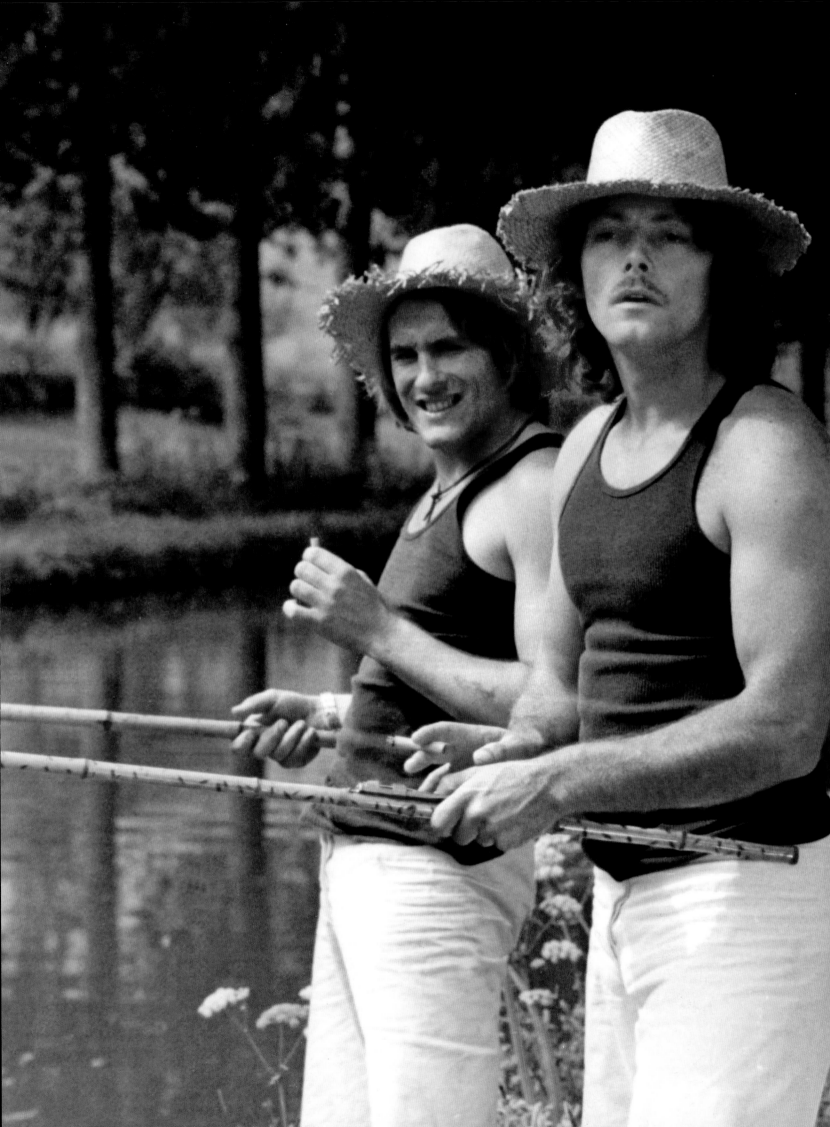

M
MARCEL

The sleeveless T-shirt or tank top was supposedly invented in Paris in the mid-19th century by the warehousemen of Les Halles (formerly a large wholesale market in the first arrondissement, demolished in 1971 and replaced with an underground shopping mall). Known as the *marcel* in France after the name of its first manufacturer, Marcel Eisenberg, the garment was originally worn only as underwear, but has today emerged as standard apparel, as seen here in the 1974 cult film by Bertrand Blier, *Les Valseuses* (*Going Places*), which starred Gérard Depardieu, Patrick Dewaere and Miou-Miou.

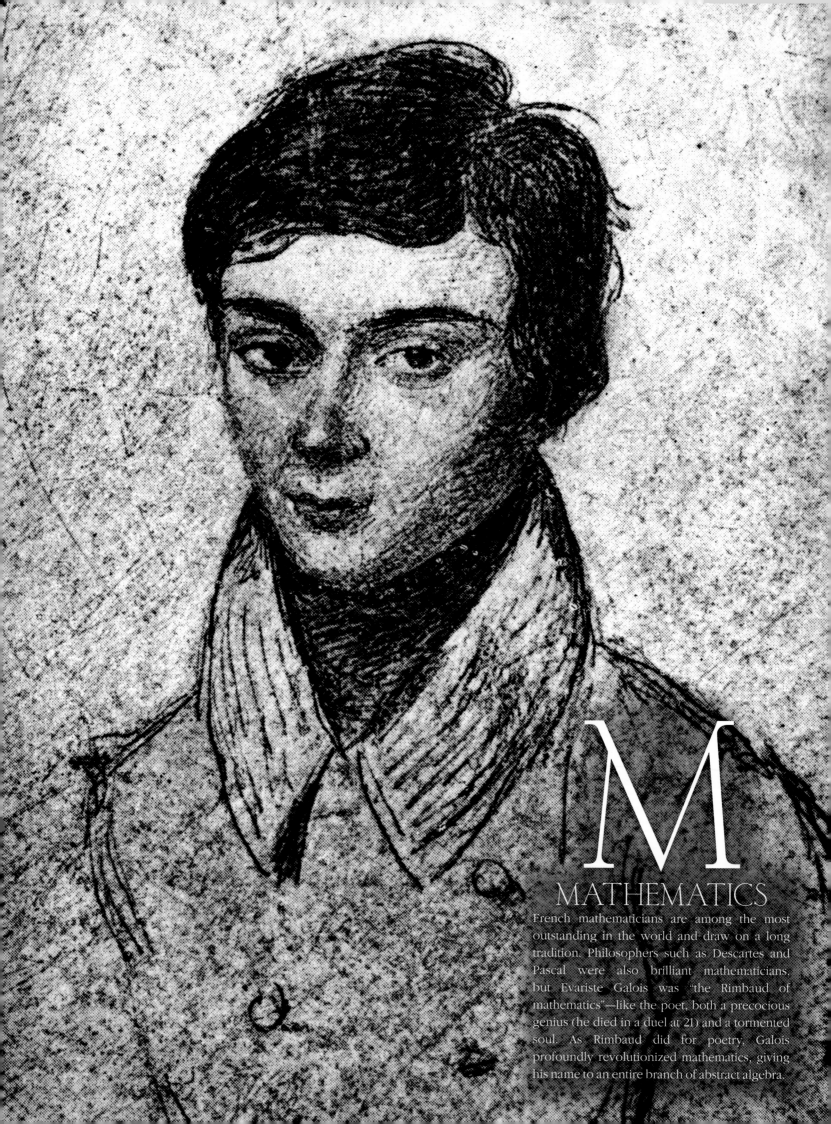

M
MATHEMATICS

French mathematicians are among the most outstanding in the world and draw on a long tradition. Philosophers such as Descartes and Pascal were also brilliant mathematicians, but Evariste Galois was "the Rimbaud of mathematics"—like the poet, both a precocious genius (he died in a duel at 21) and a tormented soul. As Rimbaud did for poetry, Galois profoundly revolutionized mathematics, giving his name to an entire branch of abstract algebra.

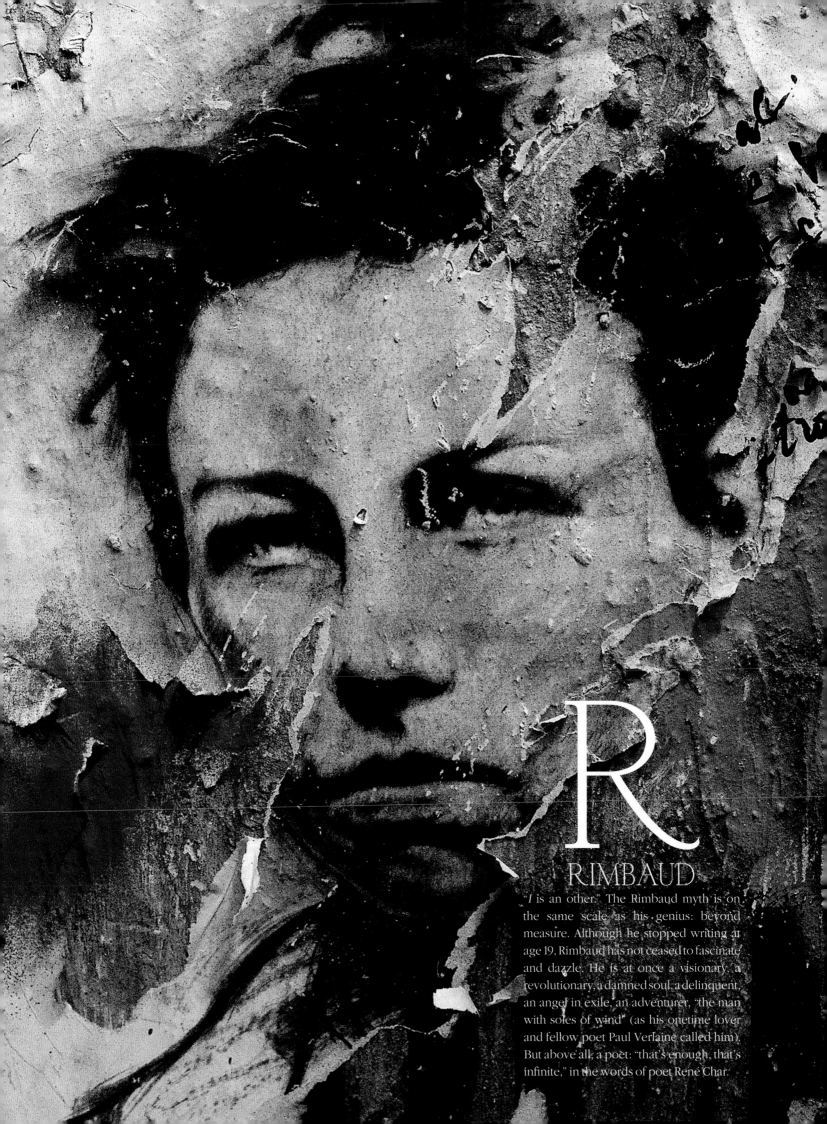

R
RIMBAUD

"I is an other." The Rimbaud myth is on the same scale as his genius: beyond measure. Although he stopped writing at age 19, Rimbaud has not ceased to fascinate and dazzle. He is at once a visionary, a revolutionary, a damned soul, a delinquent, an angel in exile, an adventurer, "the man with soles of wind" (as his onetime lover and fellow poet Paul Verlaine called him). But above all, a poet: "that's enough, that's infinite," in the words of poet René Char.

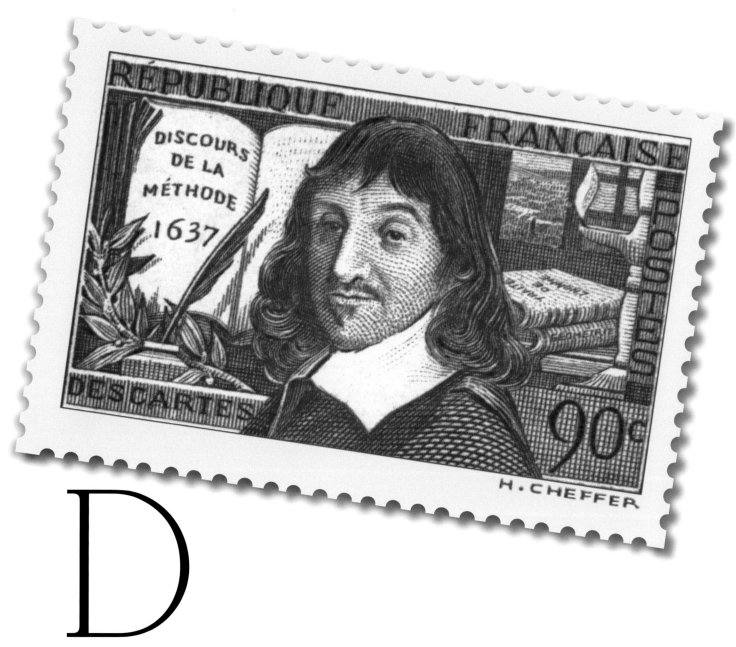

D
DESCARTES

As a child, René Descartes studied mathematics, physics, and philosophy, but he decided to leave all his books behind to go and observe the world. Descartes fought in several wars and traveled all across Europe. In 1629 he retired to seclusion in Holland in order to discover for philosophy a new and certain basis. Demanding of himself that he doubt everything, even his own existence, the philosopher sought evidence that could not be refuted. "I think, therefore I am" was his first certitude, the realization that enabled Descartes to reconstruct the world within his own understanding. Within a few pages, Descartes's *Discourse on Method* (1637), followed by the *Meditations* (1641), obliterated the medieval world, with all its superstitions and dogmas. Considered to be one of the founders of modern philosophy, Descartes paved the way for the development of science, and for the very idea of progress itself.

AEROPOSTAL

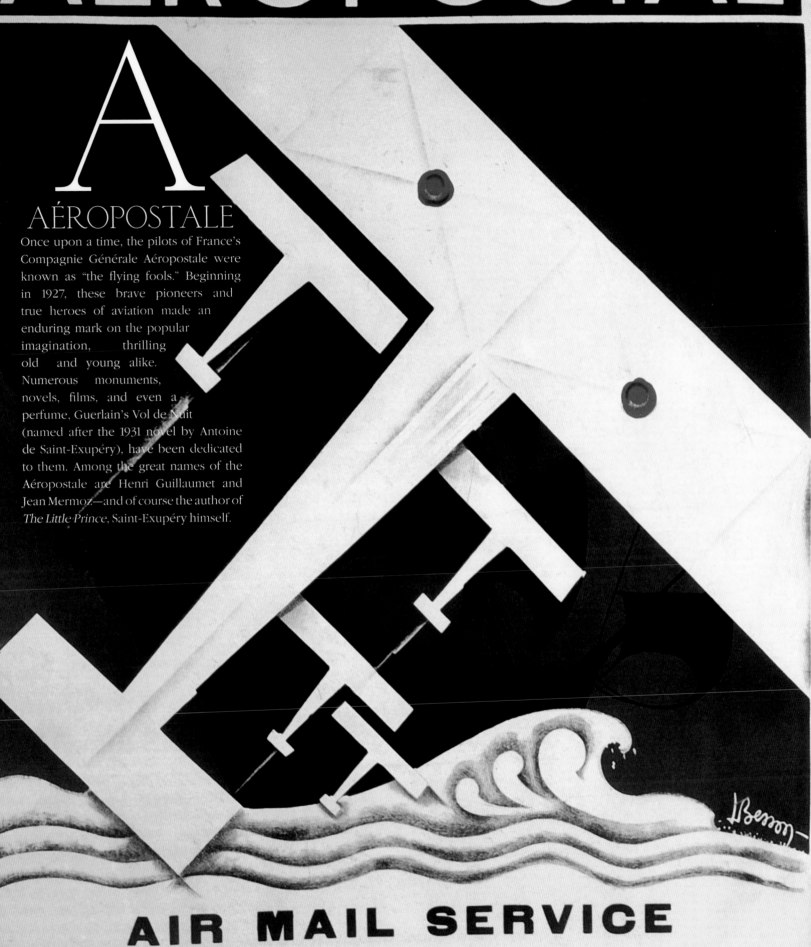

A

AÉROPOSTALE

Once upon a time, the pilots of France's Compagnie Générale Aéropostale were known as "the flying fools." Beginning in 1927, these brave pioneers and true heroes of aviation made an enduring mark on the popular imagination, thrilling old and young alike. Numerous monuments, novels, films, and even a perfume, Guerlain's Vol de Nuit (named after the 1931 novel by Antoine de Saint-Exupéry), have been dedicated to them. Among the great names of the Aéropostale are Henri Guillaumet and Jean Mermoz—and of course the author of *The Little Prince*, Saint-Exupéry himself.

AIR MAIL SERVICE
EUROPE, AFRICA, AMERICA

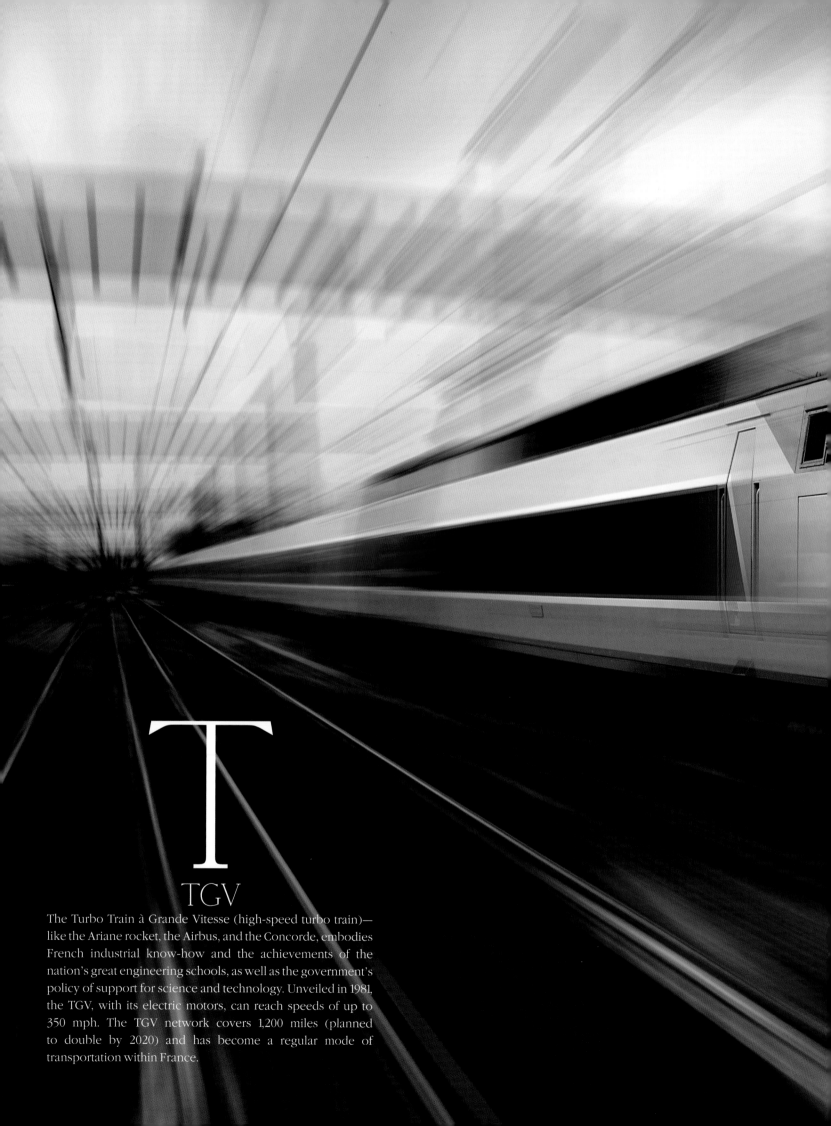

T
TGV

The Turbo Train à Grande Vitesse (high-speed turbo train)—like the Ariane rocket, the Airbus, and the Concorde, embodies French industrial know-how and the achievements of the nation's great engineering schools, as well as the government's policy of support for science and technology. Unveiled in 1981, the TGV, with its electric motors, can reach speeds of up to 350 mph. The TGV network covers 1,200 miles (planned to double by 2020) and has become a regular mode of transportation within France.

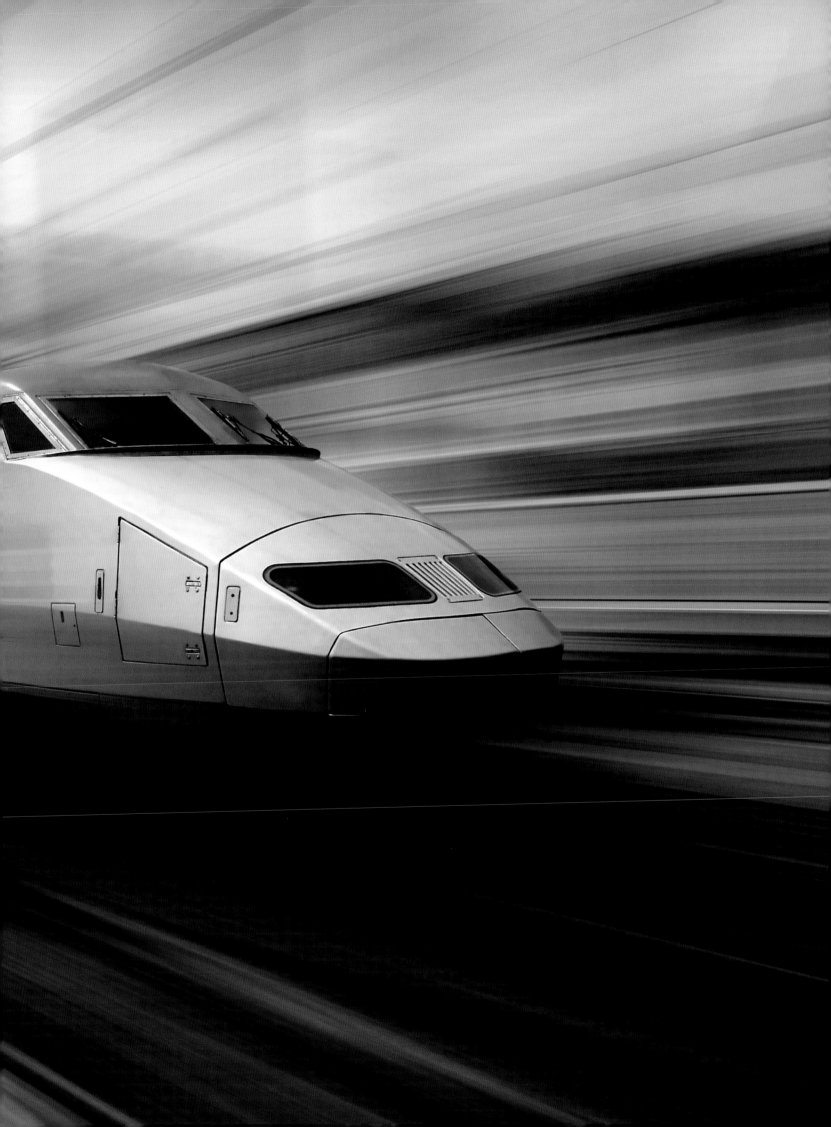

S

SMART CARD

In 1974, self-taught inventor Roland Moreno (1945–2012) filed a patent for a credit card–size piece of plastic embedded with an information-carrying miniaturized electronic circuit. Also called in English the chip card or integrated circuit card (ICC), the device is known in French as the *carte à puce* (literally, "flea card") after the familiar name for a silicon chip. With his invention, Moreno revolutionized daily life for the French, and ultimately for people around the world. Today the smart card is everywhere, with credit, debit, and prepaid cards; ID badges and access cards; owner ID cards inside mobile phones, and more. Together with champagne, photography, cinema, the TGV, and the Concorde, the smart card is one of the inventions of which the French are most proud.

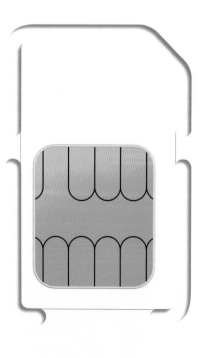

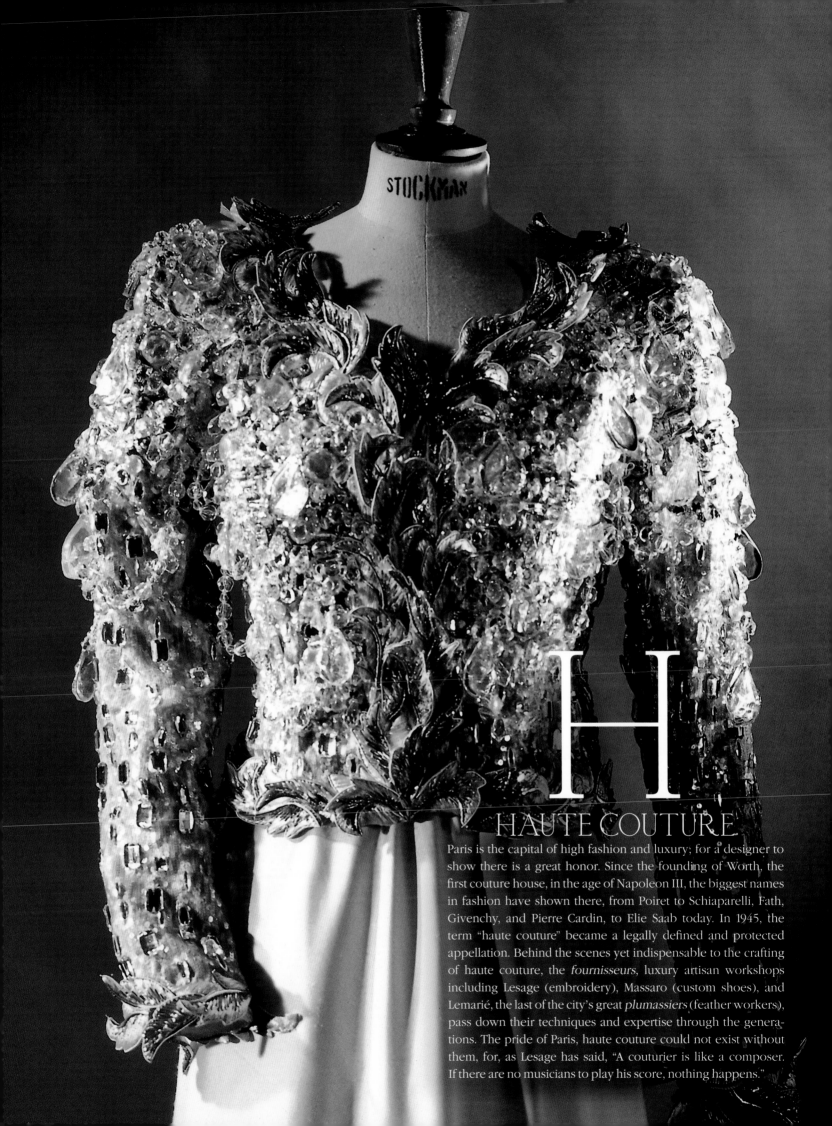

H
HAUTE COUTURE

Paris is the capital of high fashion and luxury; for a designer to show there is a great honor. Since the founding of Worth, the first couture house, in the age of Napoleon III, the biggest names in fashion have shown there, from Poiret to Schiaparelli, Fath, Givenchy, and Pierre Cardin, to Elie Saab today. In 1945, the term "haute couture" became a legally defined and protected appellation. Behind the scenes yet indispensable to the crafting of haute couture, the *fournisseurs*, luxury artisan workshops including Lesage (embroidery), Massaro (custom shoes), and Lemarié, the last of the city's great *plumassiers* (feather workers), pass down their techniques and expertise through the generations. The pride of Paris, haute couture could not exist without them, for, as Lesage has said, "A couturier is like a composer. If there are no musicians to play his score, nothing happens."

D

DIOR

With his first collection, in 1947, which introduced the New Look, Christian Dior changed the face of fashion and established himself as a leading figure of haute couture. All over the world, the name of Dior has remained ever since a synonym for luxury and refinement.

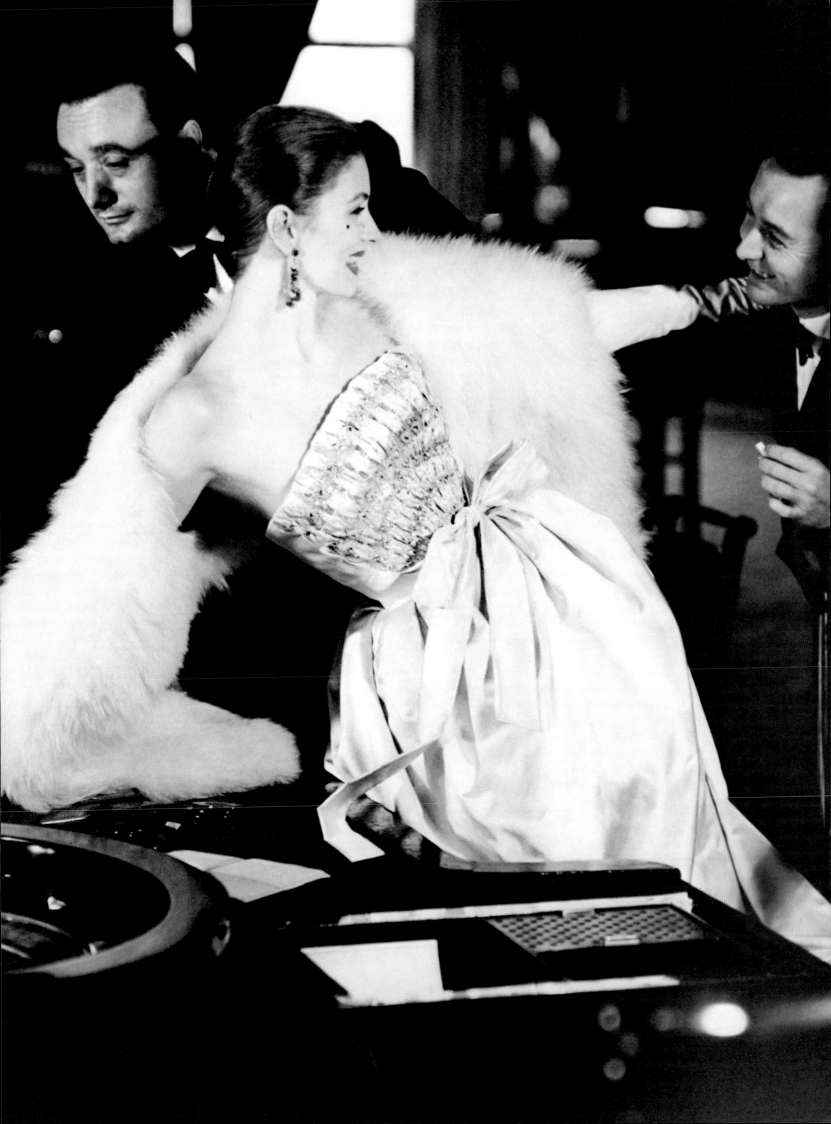

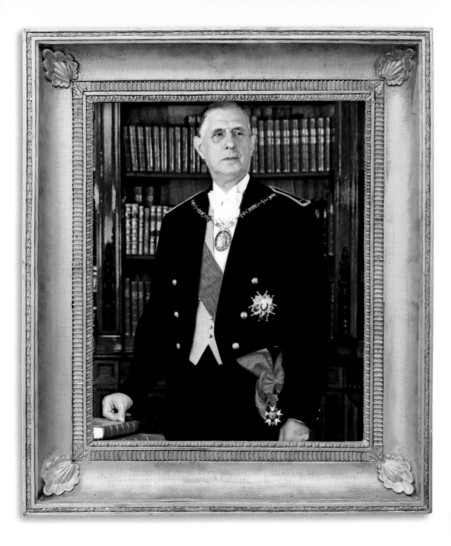

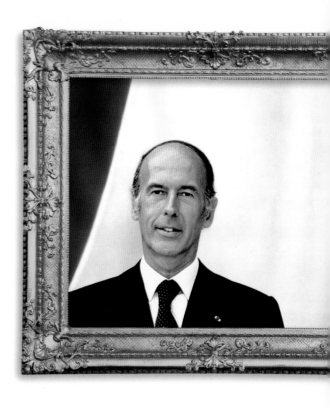

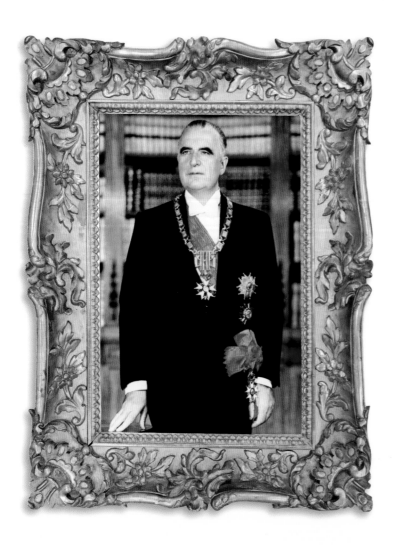

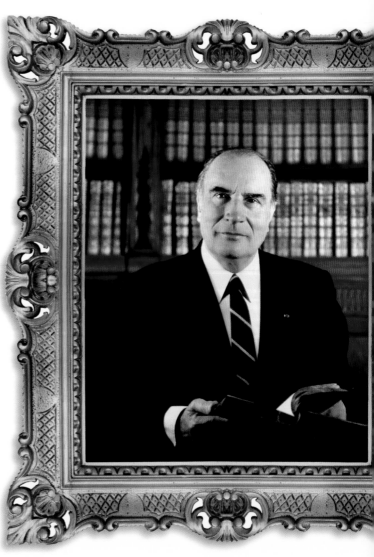

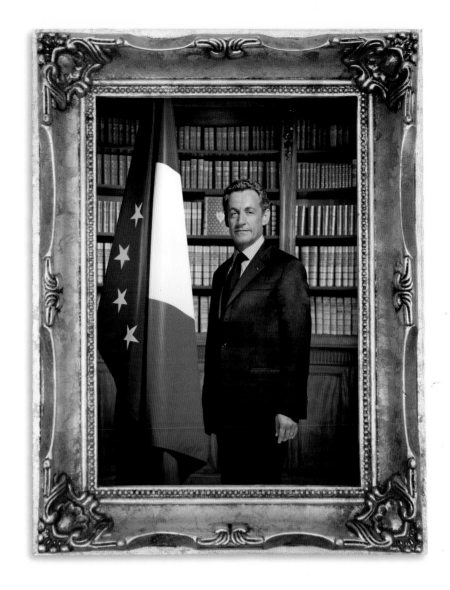

P
PRESIDENT

Since 1962, when the Fifth Republic was founded by Charles de Gaulle, the French president has been elected by direct universal suffrage. The powers of the office are so extensive that they have even been compared to those of a republican monarch. The president appoints the prime minister, with whom he shares executive power; he is also in charge of the armed forces and the country's foreign policy.

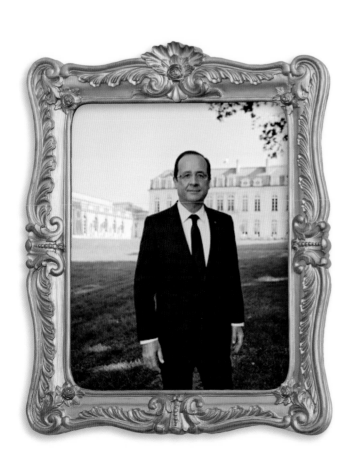

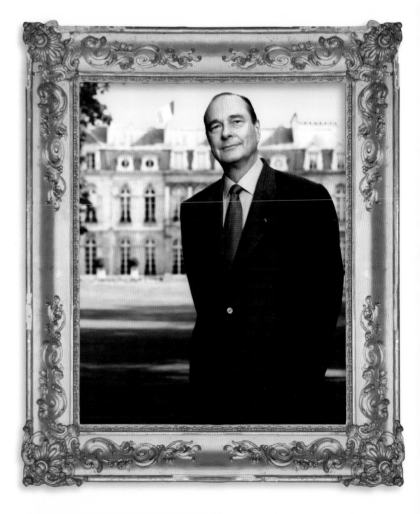

LIBERTÉ
ÉGALITÉ
FRATER‑
NITÉ

For Victor Hugo, this motto, originating in the French Revolution and officially adopted by the French government in 1848, expressed the three pillars of the Republic: "Liberty is a right; equality is a fact; fraternity is a duty. All the man is there."

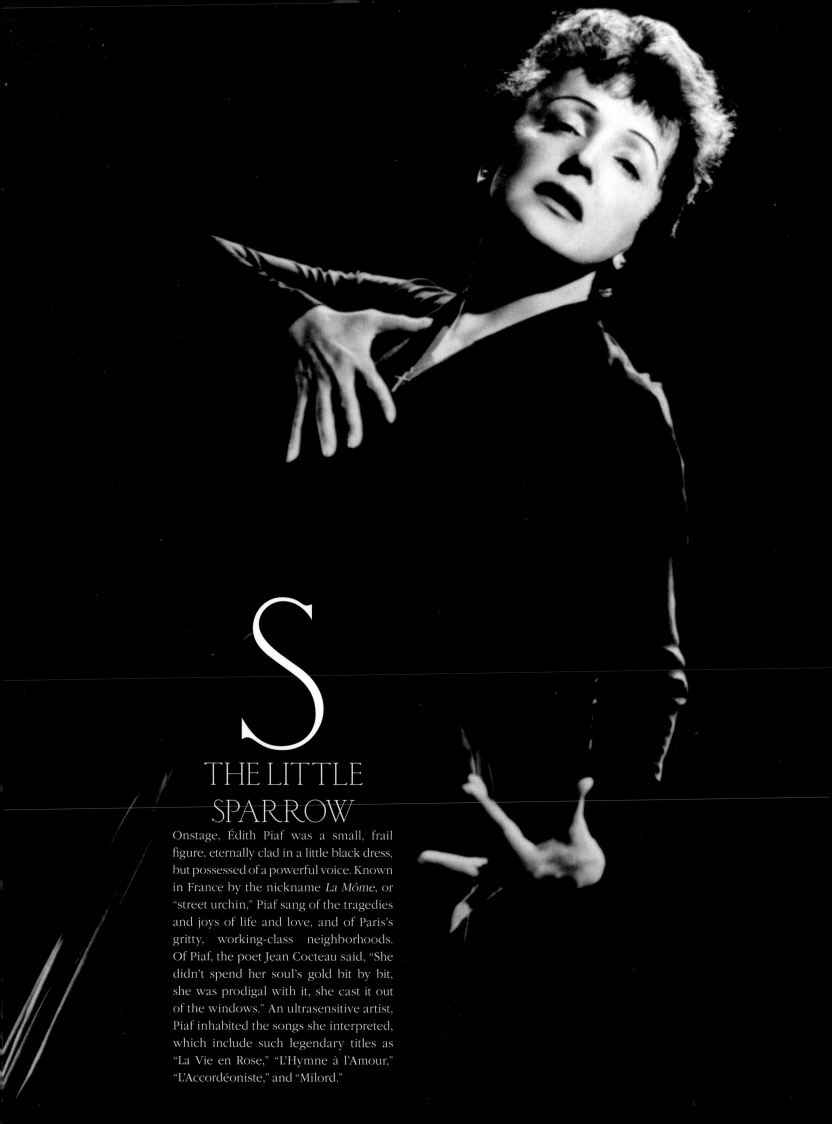

S
THE LITTLE SPARROW

Onstage, Édith Piaf was a small, frail figure, eternally clad in a little black dress, but possessed of a powerful voice. Known in France by the nickname *La Môme*, or "street urchin," Piaf sang of the tragedies and joys of life and love, and of Paris's gritty, working-class neighborhoods. Of Piaf, the poet Jean Cocteau said, "She didn't spend her soul's gold bit by bit, she was prodigal with it, she cast it out of the windows." An ultrasensitive artist, Piaf inhabited the songs she interpreted, which include such legendary titles as "La Vie en Rose," "L'Hymne à l'Amour," "L'Accordéoniste," and "Milord."

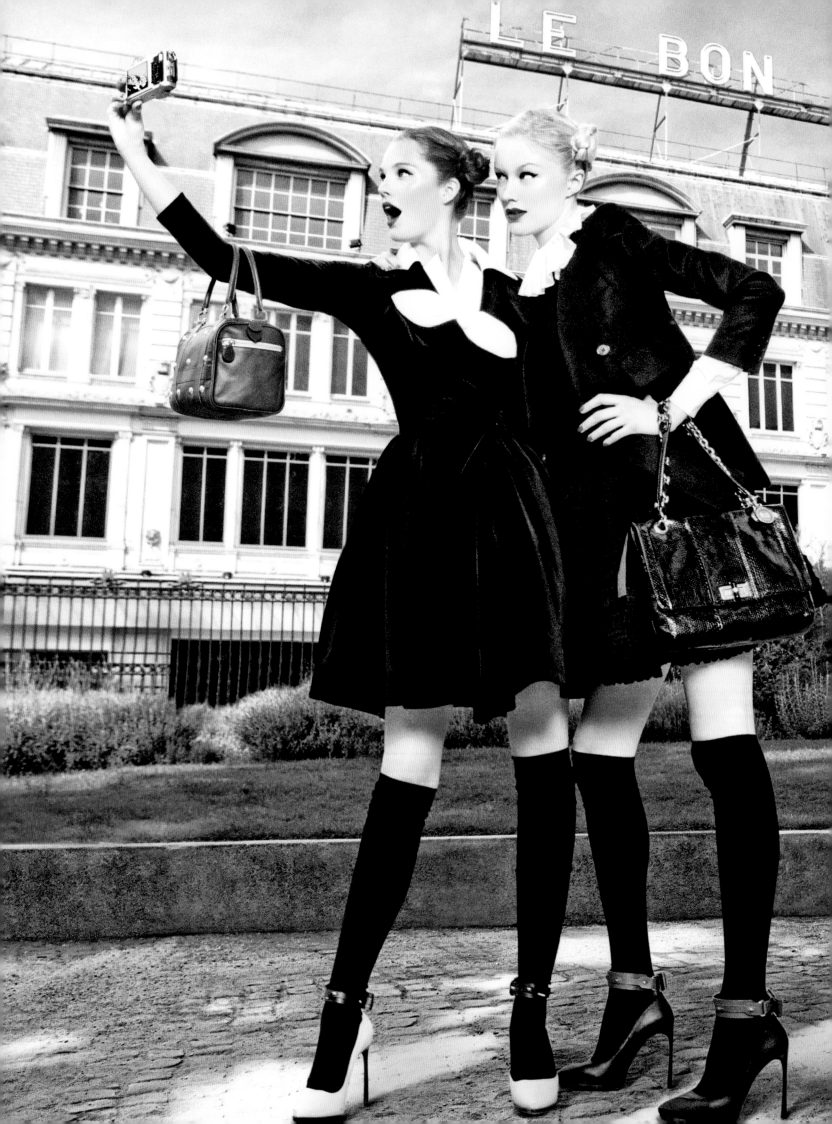

D
DEPARTMENT STORES

The first of France's *grands magasins*, its great department stores, Le Bon Marché (literally, "good market" or, figuratively, "good deal" or "bargain") opened in Paris in 1852. It was soon followed by Galeries Lafayette and Printemps, and the French model was then copied worldwide. Offering a vast array of products divided among various departments on several floors, the department store constituted a genuine commercial revolution.

LES
ESSAIS
DE MICHEL
SEIGNEUR
DE MONTAIGNE.

DONNEZ SUR LES PLUS ANCIENNES ET LES PLUS CORRECTES
Editions : Augmentez de plusieurs Lettres de l'Auteur ; & où les Passages Grecs,
Latins & Italiens, sont traduits plus fidélement, & citez plus exactement
que dans aucune des précedentes.

Avec des Notes, & de nouvelles Tables des Matieres
beaucoup plus utiles que celles qui avoient paru jusqu'ici.

Par PIERRE COSTE.

NOUVELLE EDITION,
plus ample & plus correcte que la derniere de Londres.

TOME PREMIER

A PARIS,
PAR LA SOCIÉTÉ

M. DCC. XXV.
AVEC PRIVILEGE DU ROI.

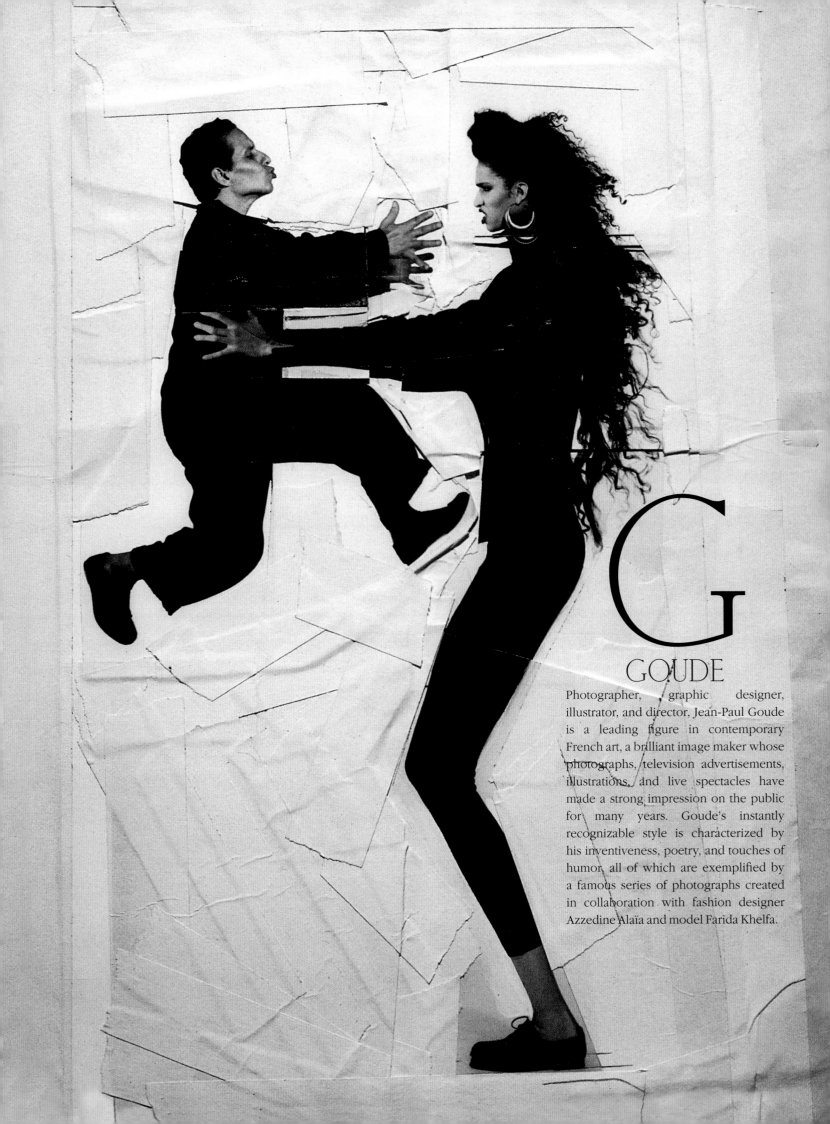

G
GOUDE

Photographer, graphic designer, illustrator, and director, Jean-Paul Goude is a leading figure in contemporary French art, a brilliant image maker whose photographs, television advertisements, illustrations, and live spectacles have made a strong impression on the public for many years. Goude's instantly recognizable style is characterized by his inventiveness, poetry, and touches of humor, all of which are exemplified by a famous series of photographs created in collaboration with fashion designer Azzedine Alaïa and model Farida Khelfa.

B
BÉJART

A major figure in contemporary dance, choreographer and dancer Maurice Béjart made his reputation with such works as *Le Sacre du printemps* (1959), set to Igor Stravinsky's *The Rite of Spring*, and Maurice Ravel's *Boléro* (1961), magnificently interpreted by Argentine dancer Jorge Donn, here shown in a dramatic scene from the 1981 film *Les Uns et les Autres* (released in the U.S as *Bolero*), by Claude Lelouch. Béjart founded and directed the Ballet of the Twentieth Century in Brussels from 1960 to 1987 and the Béjart Ballet Lausanne in Switzerland from 1987 until his death in 2007.

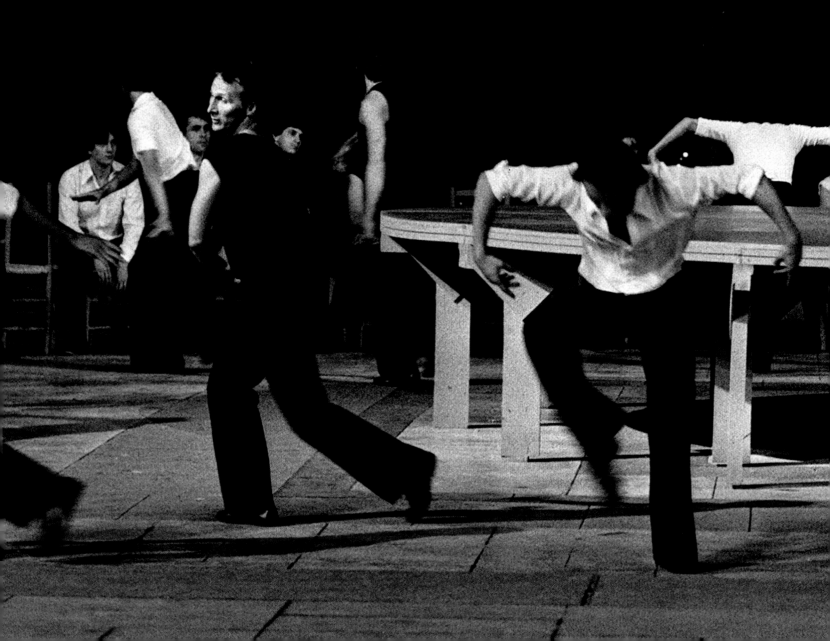

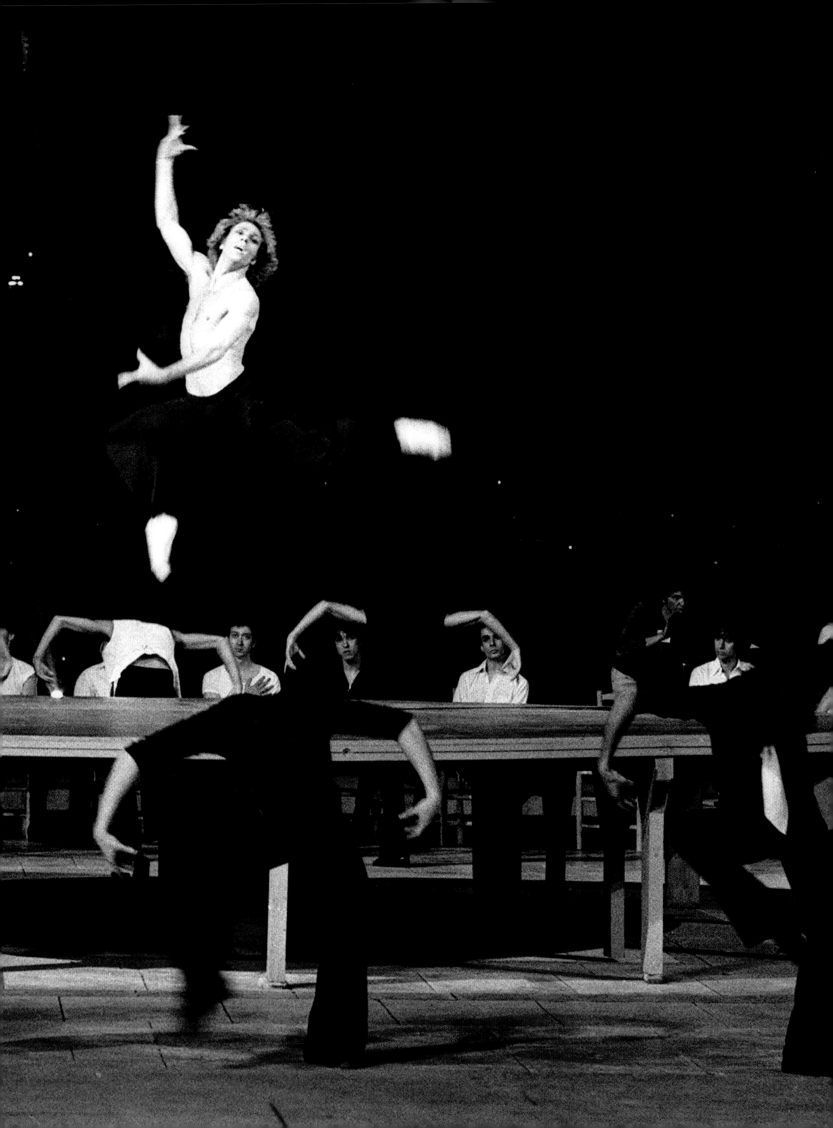

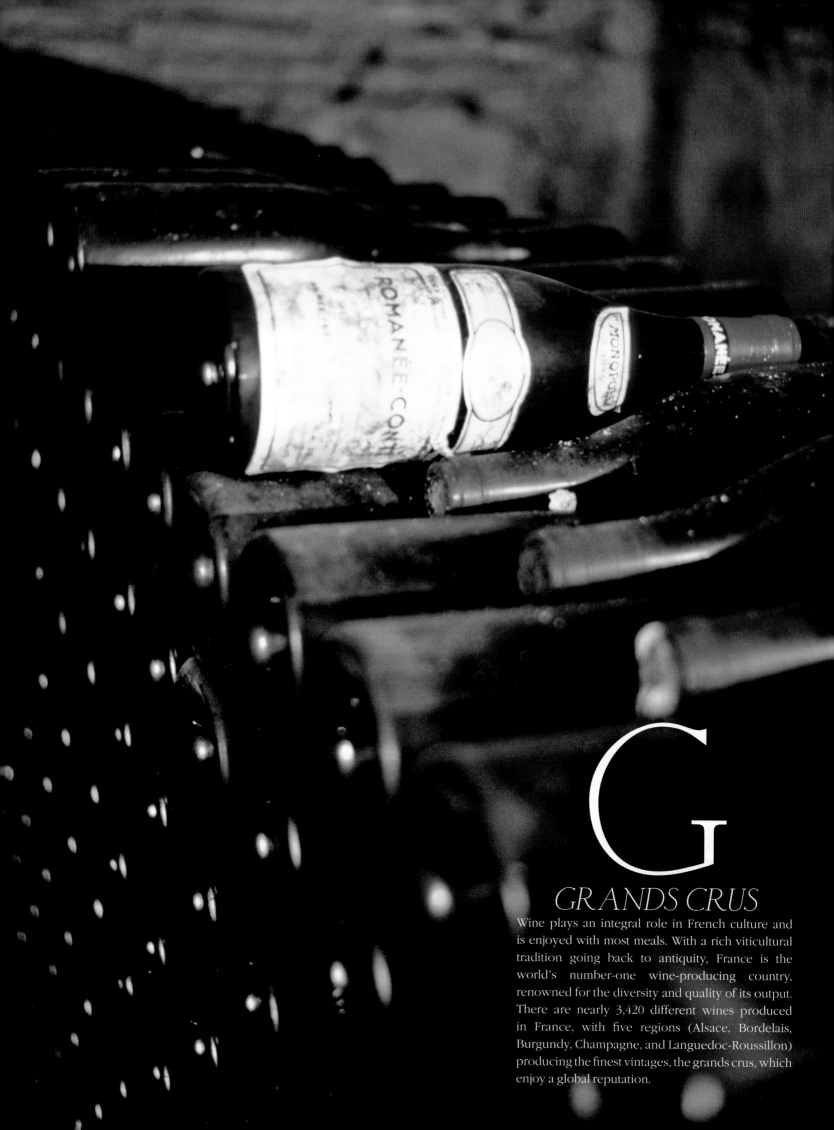

G

GRANDS CRUS

Wine plays an integral role in French culture and is enjoyed with most meals. With a rich viticultural tradition going back to antiquity, France is the world's number-one wine-producing country, renowned for the diversity and quality of its output. There are nearly 3,420 different wines produced in France, with five regions (Alsace, Bordelais, Burgundy, Champagne, and Languedoc-Roussillon) producing the finest vintages, the grands crus, which enjoy a global reputation.

G

GALLIMARD

Éditions Gallimard, one of the leading publishing houses in France, traces its origins to 1911, when Gaston Gallimard collaborated in founding Éditions de la Nouvelle Revue Française, which a few years later evolved into the house that bears his name. The history of Gallimard is marked by stunning successes: Four French authors to win the Nobel prize for literature (Albert Camus, poet Saint-John Perse, Sartre, and J. M. G. Le Clézio) are published by Gallimard. The house has also made its share of faux pas, such as its refusal in 1913 to publish the work of Marcel Proust—yet this too is part of the Gallimard legend.

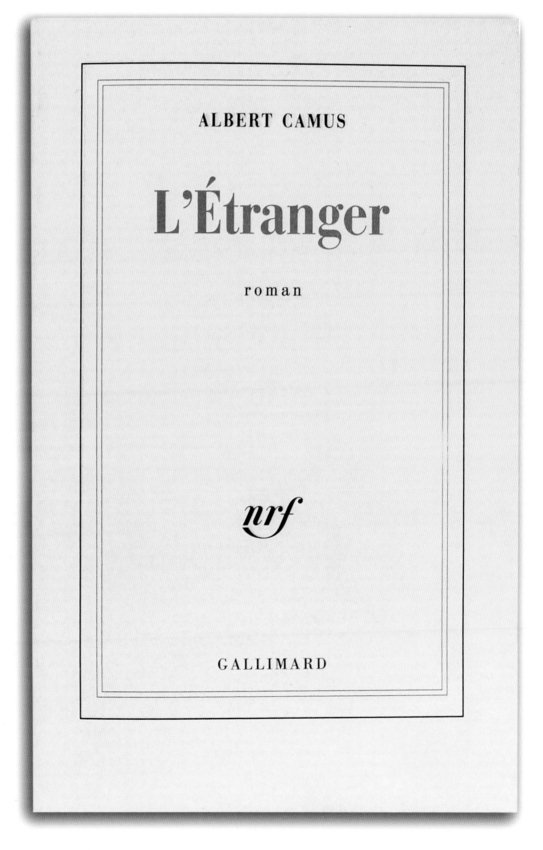

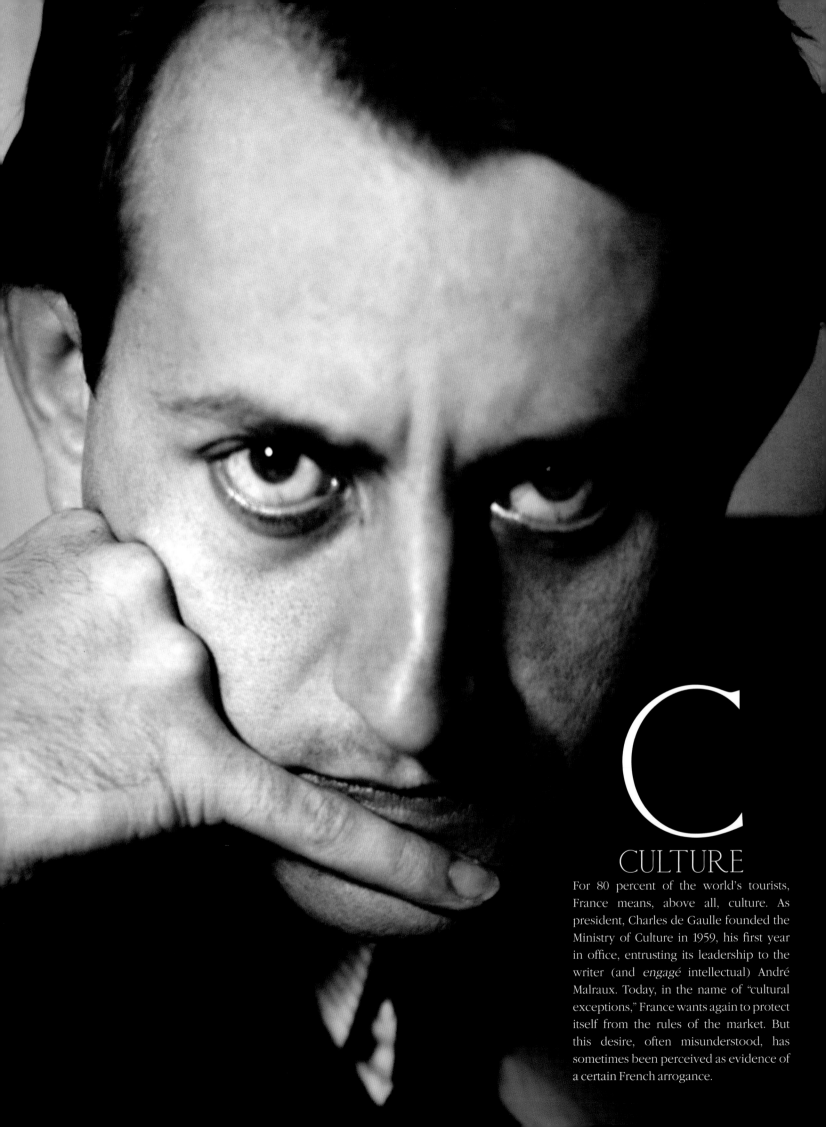

C
CULTURE

For 80 percent of the world's tourists, France means, above all, culture. As president, Charles de Gaulle founded the Ministry of Culture in 1959, his first year in office, entrusting its leadership to the writer (and *engagé* intellectual) André Malraux. Today, in the name of "cultural exceptions," France wants again to protect itself from the rules of the market. But this desire, often misunderstood, has sometimes been perceived as evidence of a certain French arrogance.

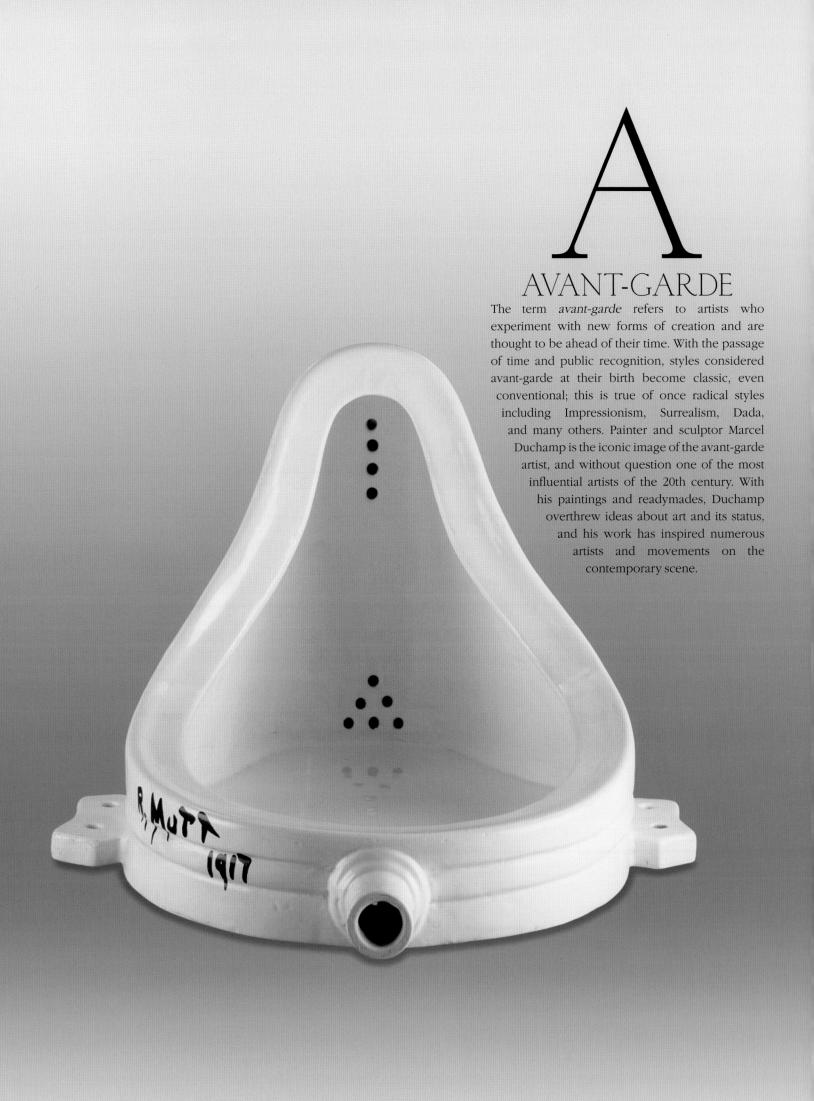

A
AVANT-GARDE

The term *avant-garde* refers to artists who experiment with new forms of creation and are thought to be ahead of their time. With the passage of time and public recognition, styles considered avant-garde at their birth become classic, even conventional; this is true of once radical styles including Impressionism, Surrealism, Dada, and many others. Painter and sculptor Marcel Duchamp is the iconic image of the avant-garde artist, and without question one of the most influential artists of the 20th century. With his paintings and readymades, Duchamp overthrew ideas about art and its status, and his work has inspired numerous artists and movements on the contemporary scene.

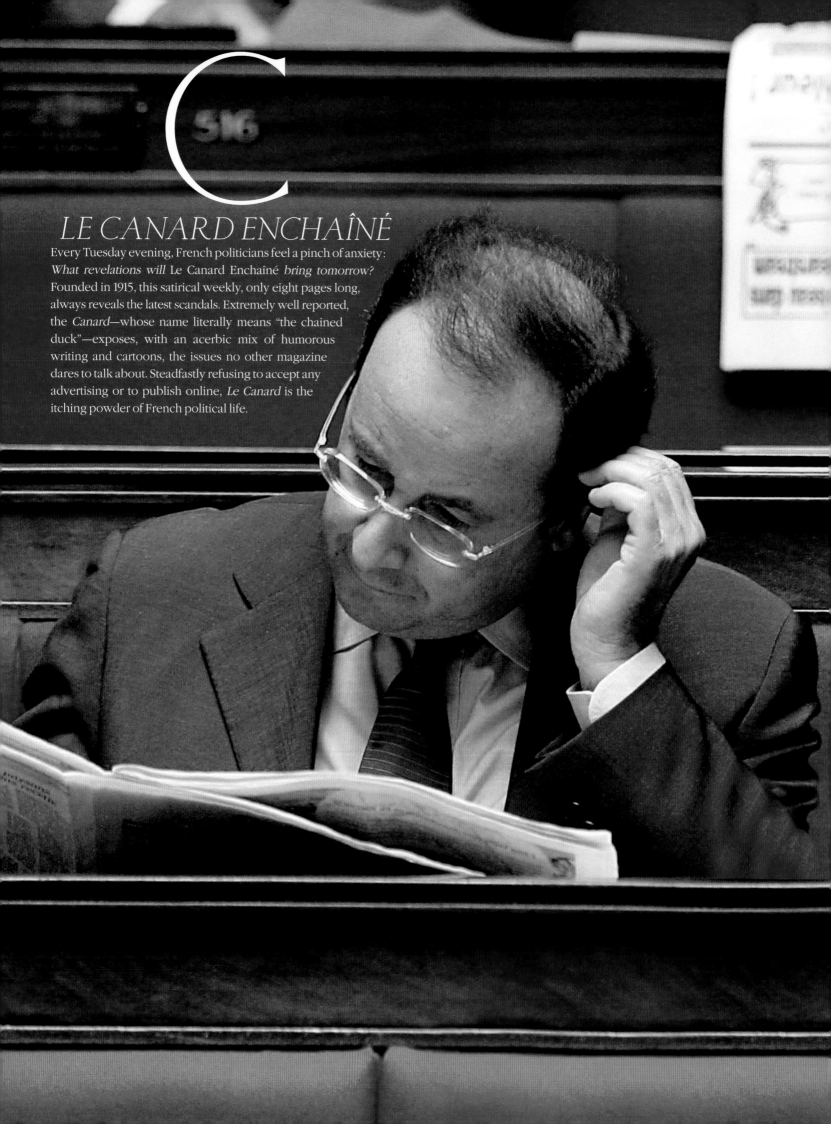

C

LE CANARD ENCHAÎNÉ

Every Tuesday evening, French politicians feel a pinch of anxiety: *What revelations will* Le Canard Enchaîné *bring tomorrow?* Founded in 1915, this satirical weekly, only eight pages long, always reveals the latest scandals. Extremely well reported, the *Canard*—whose name literally means "the chained duck"—exposes, with an acerbic mix of humorous writing and cartoons, the issues no other magazine dares to talk about. Steadfastly refusing to accept any advertising or to publish online, *Le Canard* is the itching powder of French political life.

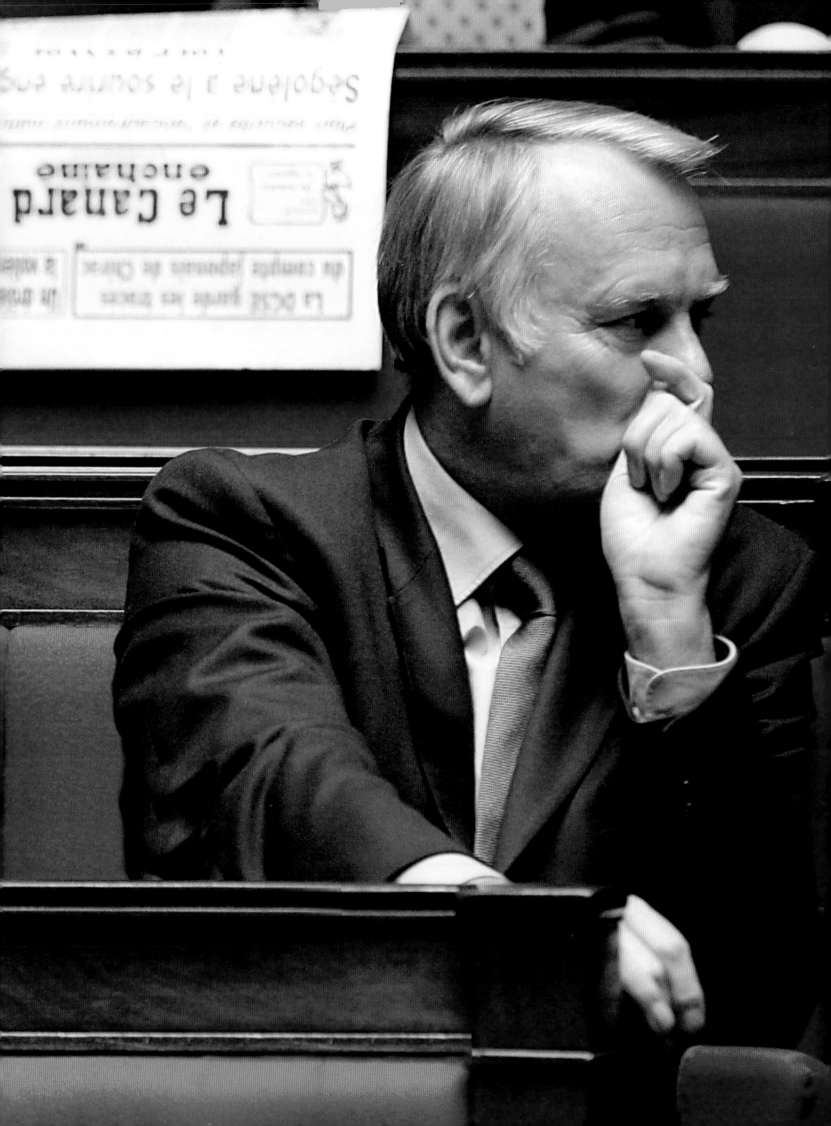

P
PERRIAND

In 1927, architect and designer Charlotte Perriand joined the studio of architects Le Corbusier and his cousin Pierre Jeanneret, with whom she would collaborate for ten years. In all her work in the postwar period, Perriand sought to improve the lives of ordinary French people. Recognized as one of the most influential figures in modern architecture, Perriand is the creator of the Tokyo chaise longue, the Refolo banquette, and the famous Plurima modular bookcase. Her last work before her death in 1999 was her 1993 temporary teahouse, L'Espace Thé (Tea Space), installed on the UNESCO plaza in Paris in 1993.

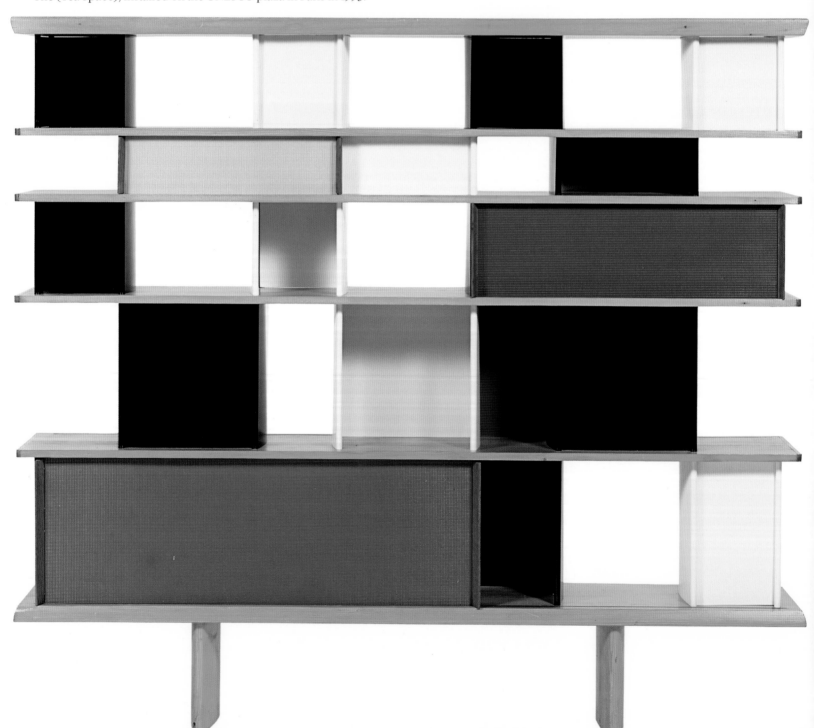

LES VACANCES DE M. HULOT

UN FILM DE

JACQUES TATI

P

PAID VACATIONS

There are a few paradoxes of French life that never fail to intrigue foreign observers: The French are world champions of pessimism, but they have the second-highest birthrate in Europe; they eat and drink a lot, but they have one of the longest life expectancies in the world. And then there is the French love of holidays, their *long* paid vacations—the right to which was won only after fierce struggle, as they just love to remind you. In 2000, in an effort to fight unemployment, the laws governing work were reformed to reduce the legal maximum for salaried full-time workers to 35 hours per week.

SCENARIO DE JACQUES TATI ET HENRI MARQUET
AVEC LA COLLABORATION DE JACQUES LAGRANGE
IMAGES DE JACQUES MERCANTON ET JEAN MOUSSELLE
UNE PRODUCTION FRED ORAIN

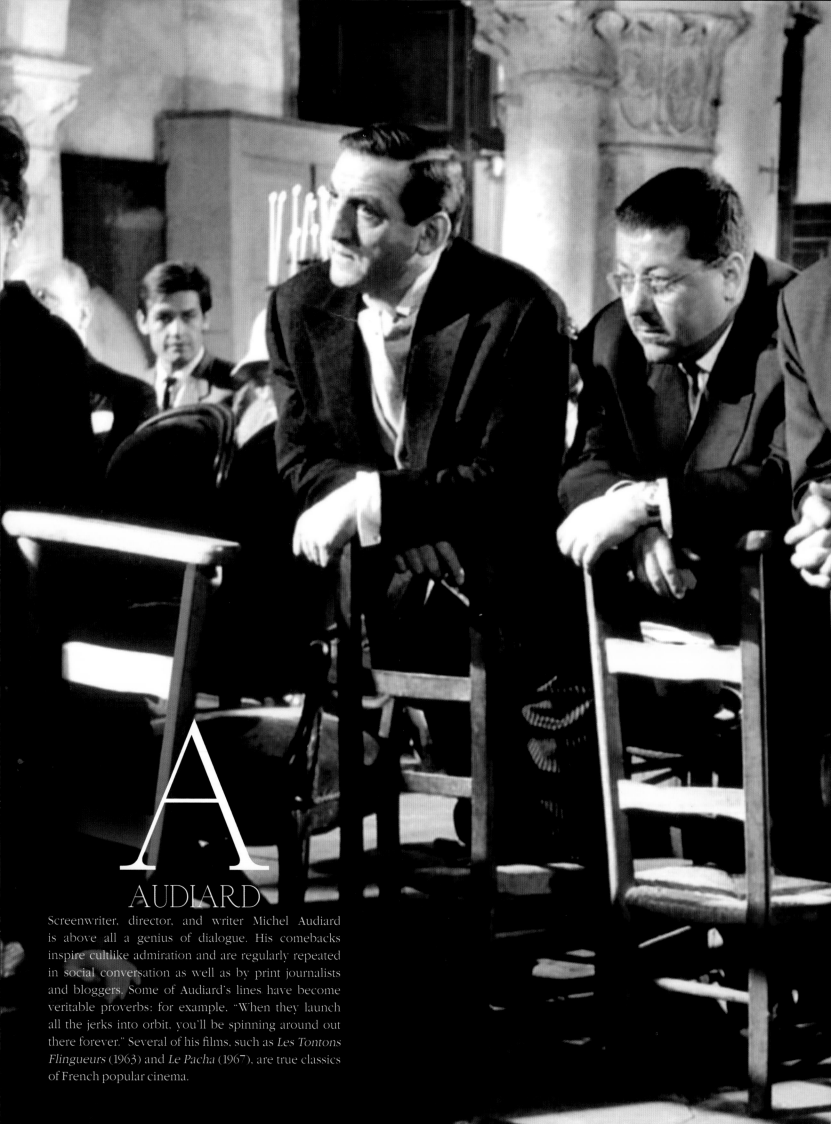

A
AUDIARD

Screenwriter, director, and writer Michel Audiard is above all a genius of dialogue. His comebacks inspire cultlike admiration and are regularly repeated in social conversation as well as by print journalists and bloggers. Some of Audiard's lines have become veritable proverbs: for example. "When they launch all the jerks into orbit, you'll be spinning around out there forever." Several of his films, such as *Les Tontons Flingueurs* (1963) and *Le Pacha* (1967), are true classics of French popular cinema.

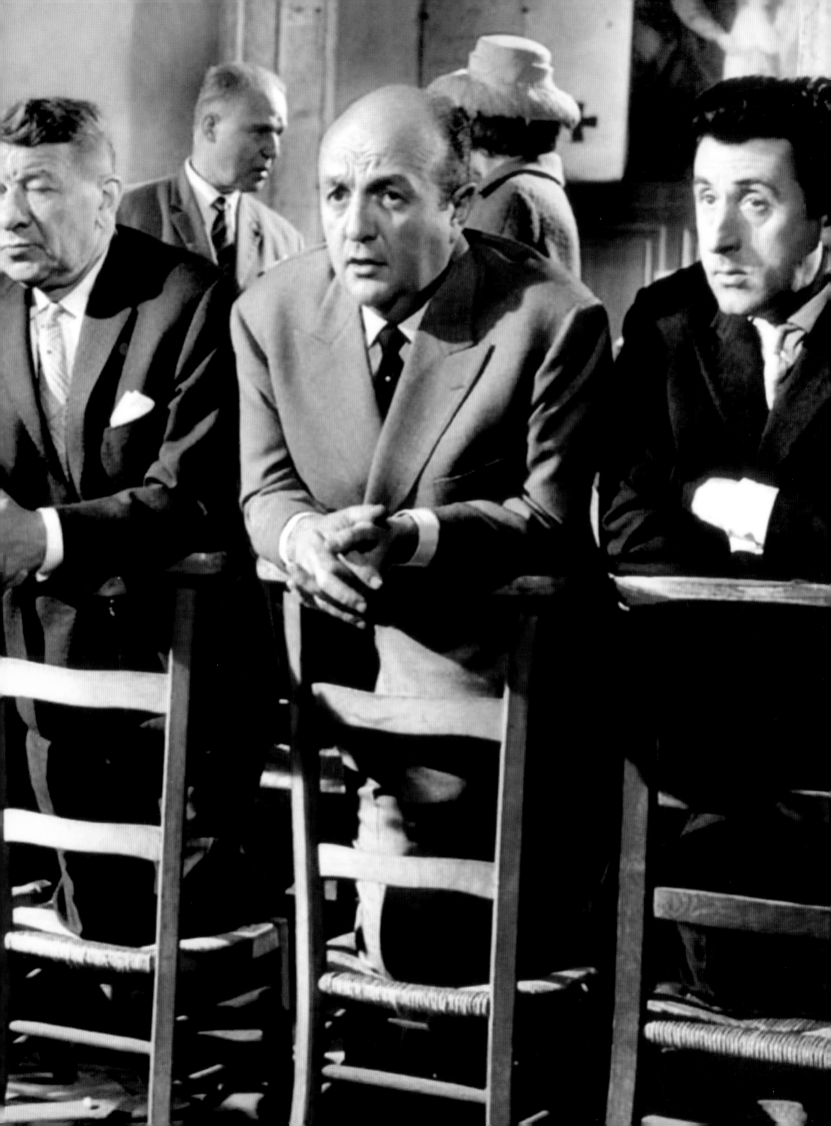

COLUCHE

Popular and provocative, the freethinking humorist known as Coluche (born Michel Gérard Joseph Colucci in Paris in 1944) attacked the foibles of French society, often calling its politics and morality into question. Coluche began humbly in Paris's music halls but went on to triumphant success in large theaters and the movies. In 1981, five years before his premature death (in a motorcycle accident in the French Alps), Coluche ran—briefly—for president, unleashing a resounding scandal. In 1985, he founded the Restaurants du Cœur (Restaurants of the Heart), a charity that distributes food to the poor in wintertime.

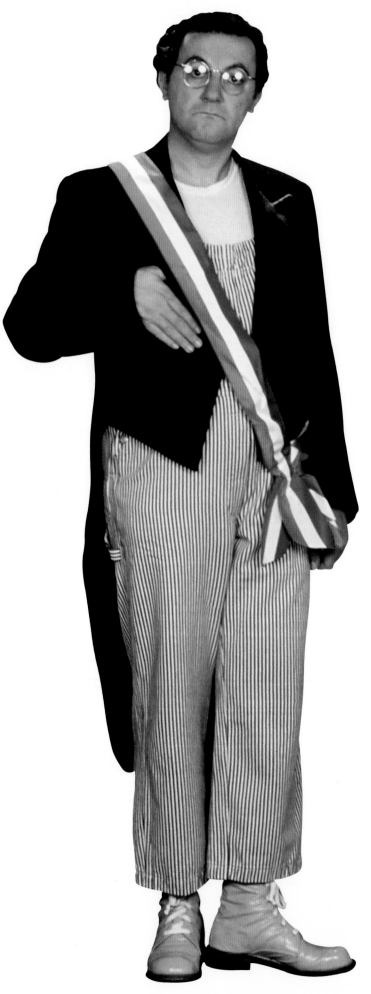

V

PLACE VENDÔME

Anyone looking for a diamond or an unforgettable piece of jewelry ends up in the Place Vendôme: All the great French jewelers have their headquarters in the magnificent buildings surrounding this square, whose distinctive layout was conceived in the 17th century. Marathon shoppers can stay at the Ritz, surrounded by the glittering names (or at least they'll be able to in 2014, when it reopens after its refurbishment). In the center of the square rises the Vendôme Column, erected by Napoleon in 1810 to commemorate his victory at the battle of Austerlitz.

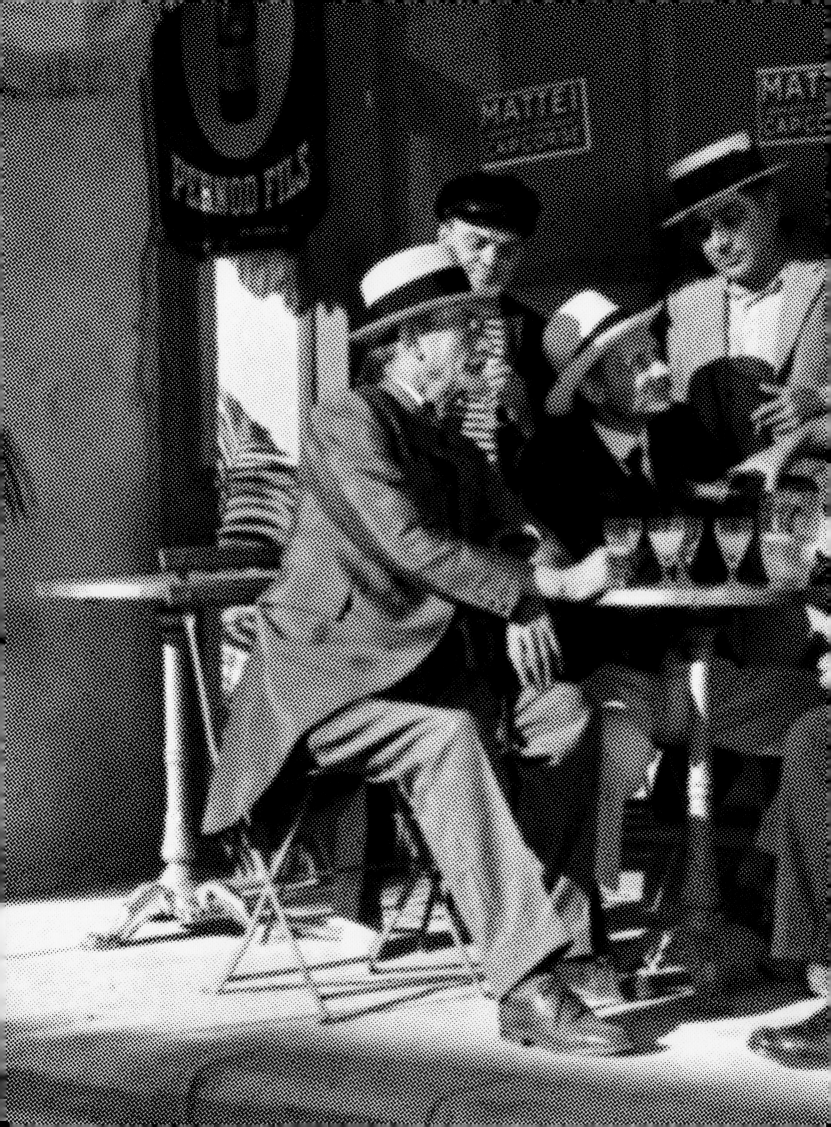

P
PASTIS

Incontestably the quintessential aperitif of the South of France, pastis is associated in the collective French memory with Marcel Pagnol's Marseillaise trilogy of films, *César, Fanny,* and *Marius* (pictured), depicting a romanticized ideal of the rustic Provençal lifestyle, which foreigners may experience in books like *A Year in Provence.* Like other anise-flavored spirits popular around the Mediterranean, such as Greek ouzo, pastis is sipped from a tall glass, with a small amount of the liqueur diluted with cold water, ideally enjoyed on a sunny terrace surrounded by friends and family.

P

PROVENCE

The beauty of this region in the south of France has never ceased to inspire French artists and, especially, one of the country's greatest painters, the Impressionist Paul Cézanne. Summing up his work, Cézanne said that he merely "had sensory experiences and read nature." To contemplate one of his canvases is to rediscover the sensations of Provence: its colors, its fragrances, the dry heat of its *garrigue* (scrubland) and the fresh air of its seaside cliffs.

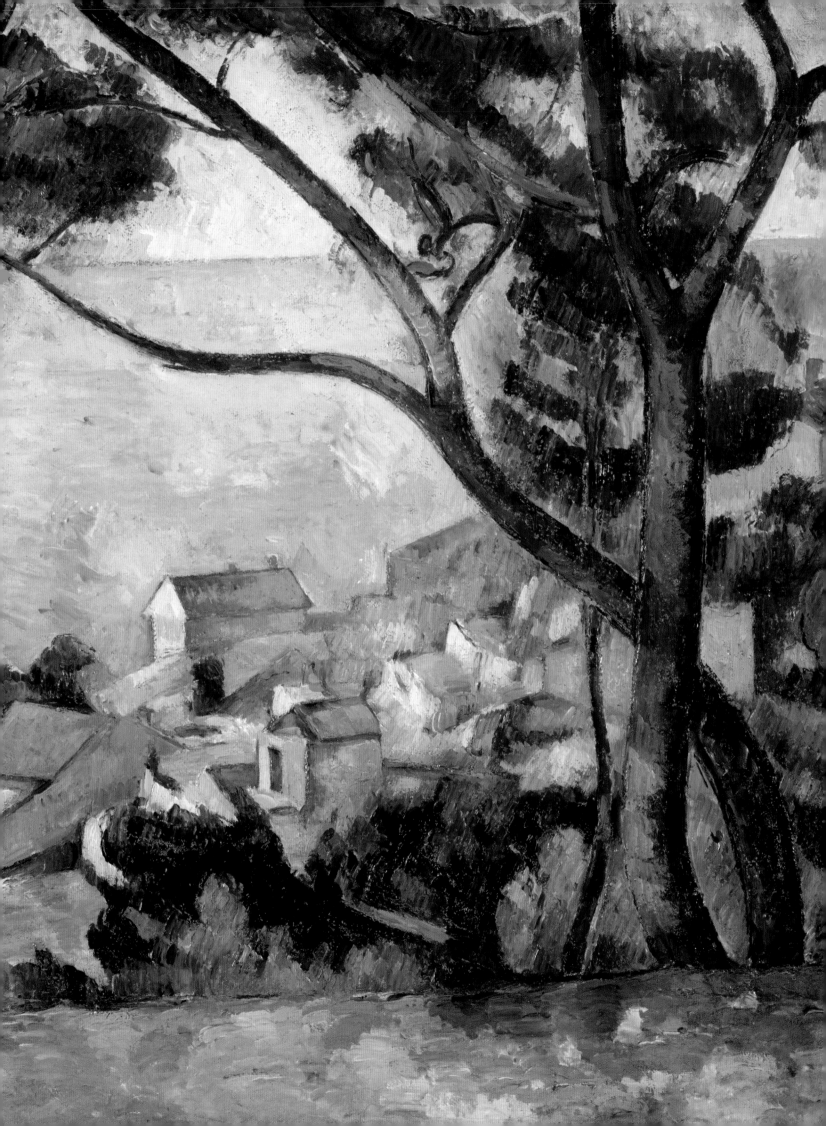

G

GARDENS

The formal French garden is distinguished by a geometrical ground plan that organizes the visitor's visual experience according to the laws of perspective. With its clearly defined rectilinear paths and carefully sculpted boxwood topiary, the French garden embodies the triumph of order over disorder and culture over nature, and is intended to function as an outdoor extension of the building to which it belongs. The gardens at the Palace of Versailles, designed by André Le Nôtre beginning in 1661, inspired admiration and envy in all the royal courts of Europe and were very quickly imitated.

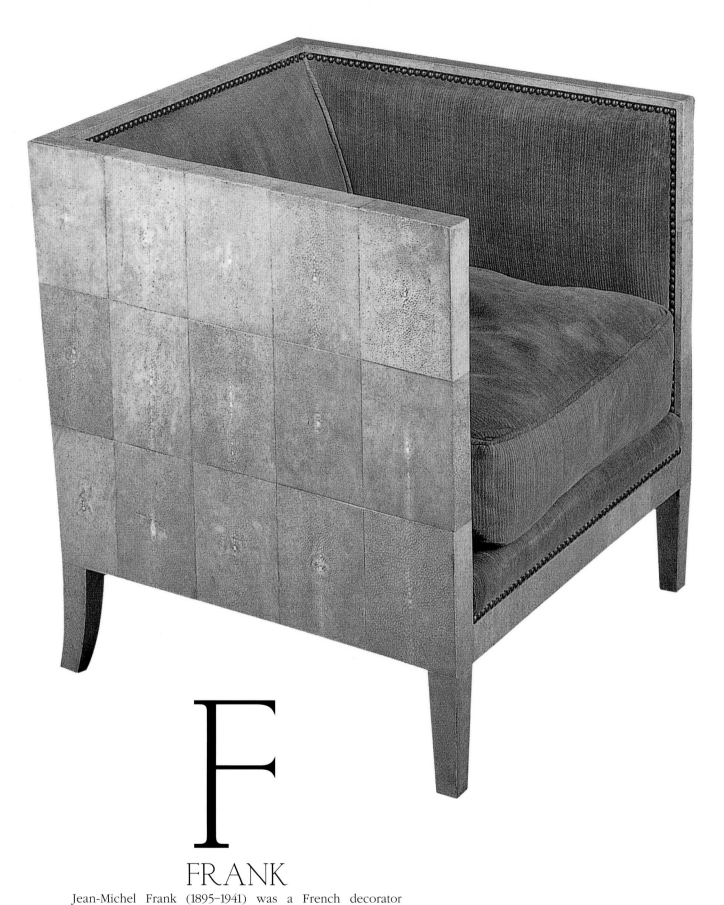

F

FRANK

Jean-Michel Frank (1895–1941) was a French decorator renowned for his minimalist yet luxurious style, featuring simple forms and richly elegant materials. A sofa, aptly named *Confortable* (Comfortable), and a cube-shaped glass vase are only two of his most famous designs. Frank's work is acknowledged as a source of inspiration by numerous contemporary designers, in particular the French interior designer Andrée Putman.

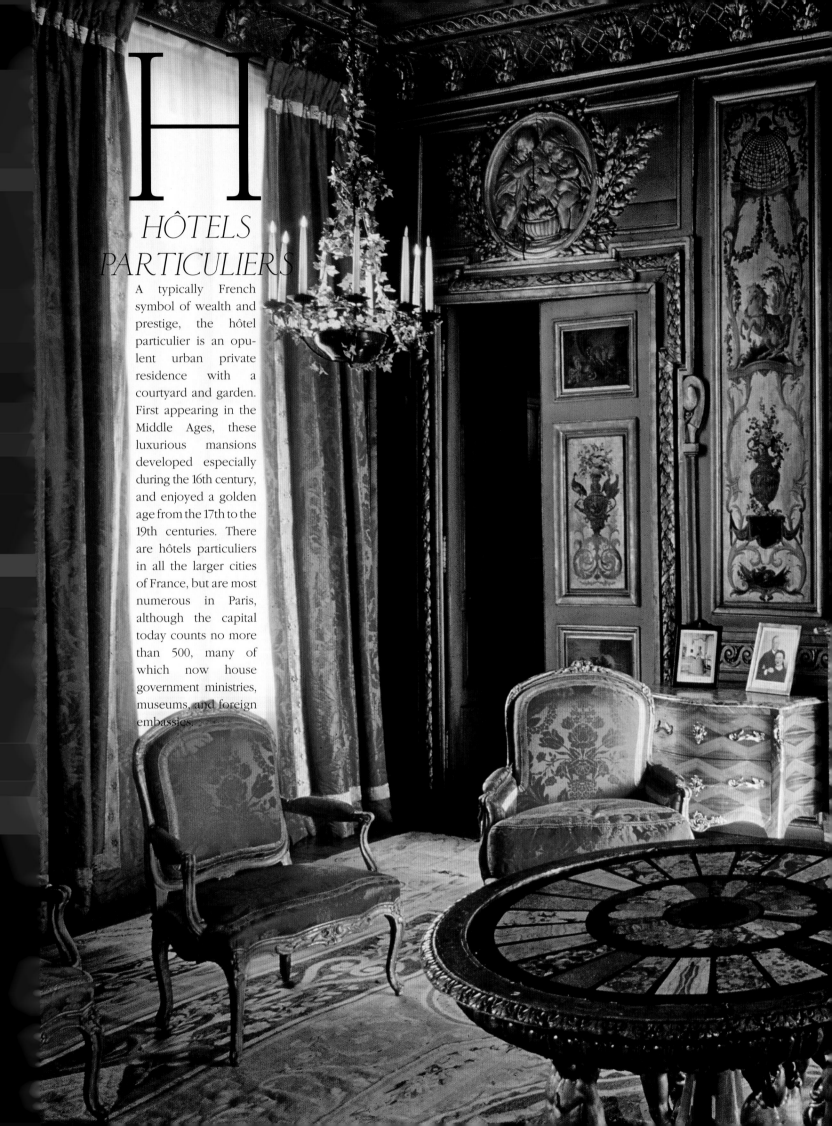

H
HÔTELS PARTICULIERS

A typically French symbol of wealth and prestige, the hôtel particulier is an opulent urban private residence with a courtyard and garden. First appearing in the Middle Ages, these luxurious mansions developed especially during the 16th century, and enjoyed a golden age from the 17th to the 19th centuries. There are hôtels particuliers in all the larger cities of France, but are most numerous in Paris, although the capital today counts no more than 500, many of which now house government ministries, museums, and foreign embassies.

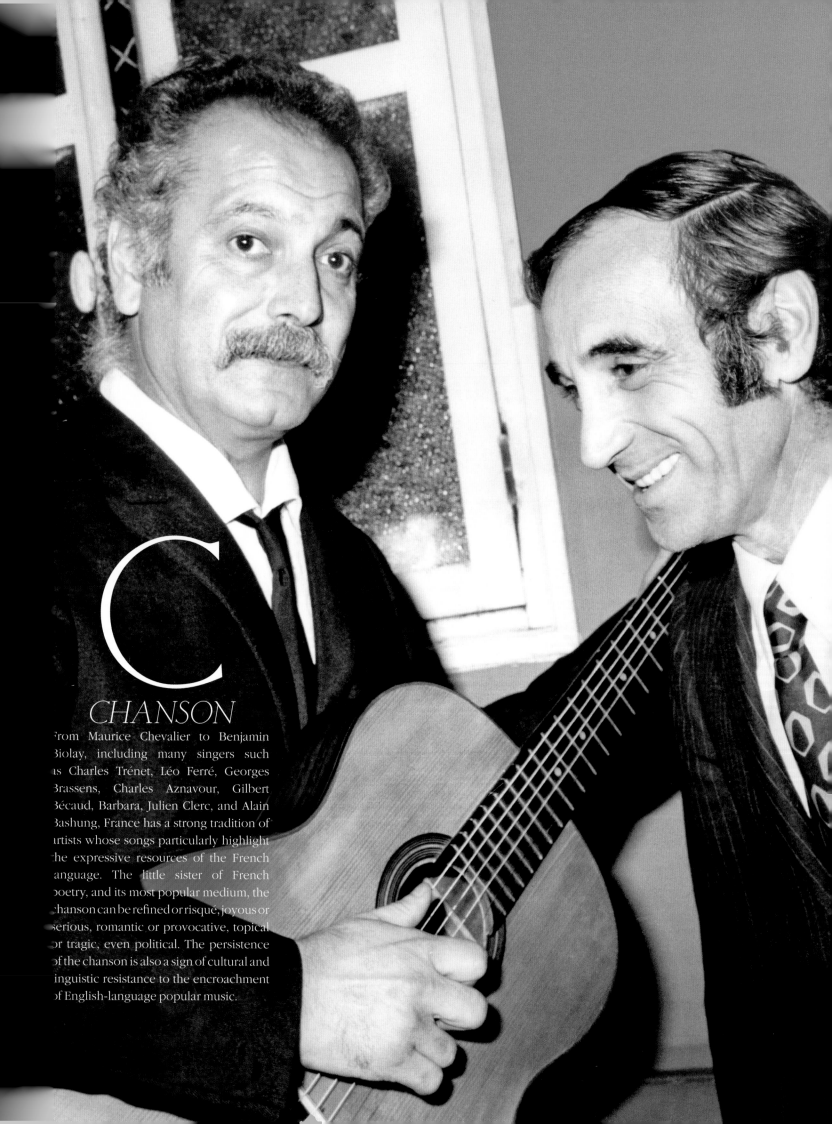

CHANSON

From Maurice Chevalier to Benjamin Biolay, including many singers such as Charles Trénet, Léo Ferré, Georges Brassens, Charles Aznavour, Gilbert Bécaud, Barbara, Julien Clerc, and Alain Bashung, France has a strong tradition of artists whose songs particularly highlight the expressive resources of the French language. The little sister of French poetry, and its most popular medium, the chanson can be refined or risqué, joyous or serious, romantic or provocative, topical or tragic, even political. The persistence of the chanson is also a sign of cultural and linguistic resistance to the encroachment of English-language popular music.

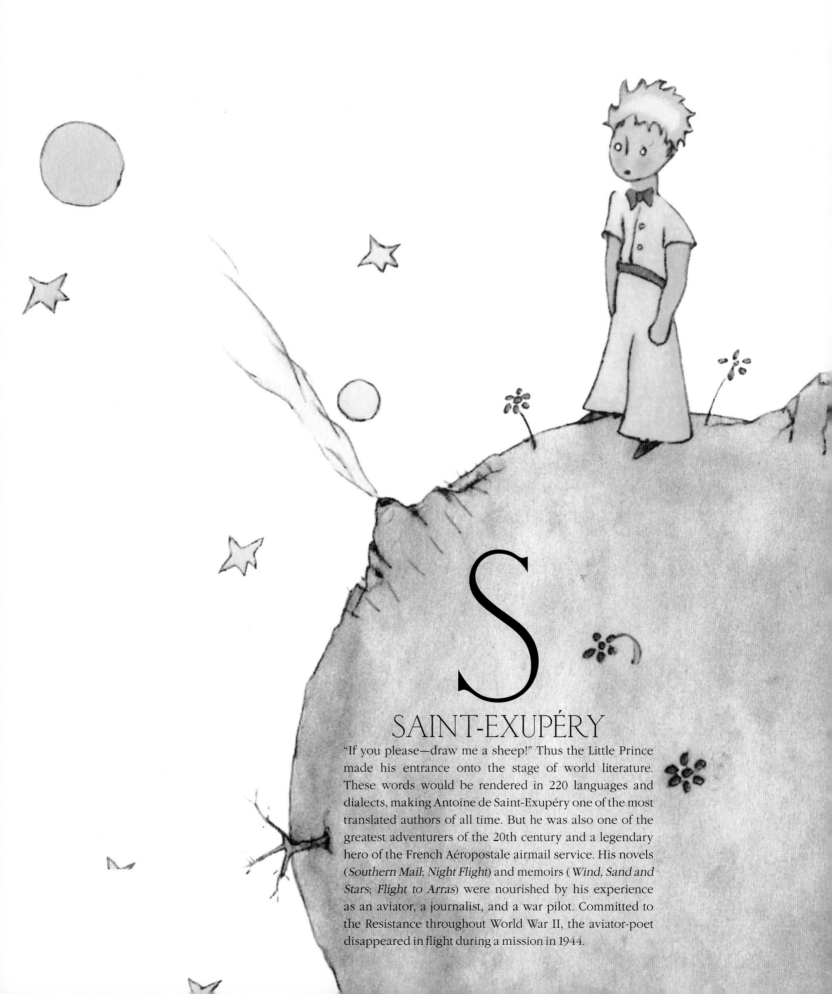

S

SAINT-EXUPÉRY

"If you please—draw me a sheep!" Thus the Little Prince made his entrance onto the stage of world literature. These words would be rendered in 220 languages and dialects, making Antoine de Saint-Exupéry one of the most translated authors of all time. But he was also one of the greatest adventurers of the 20th century and a legendary hero of the French Aéropostale airmail service. His novels (*Southern Mail*; *Night Flight*) and memoirs (*Wind, Sand and Stars*; *Flight to Arras*) were nourished by his experience as an aviator, a journalist, and a war pilot. Committed to the Resistance throughout World War II, the aviator-poet disappeared in flight during a mission in 1944.

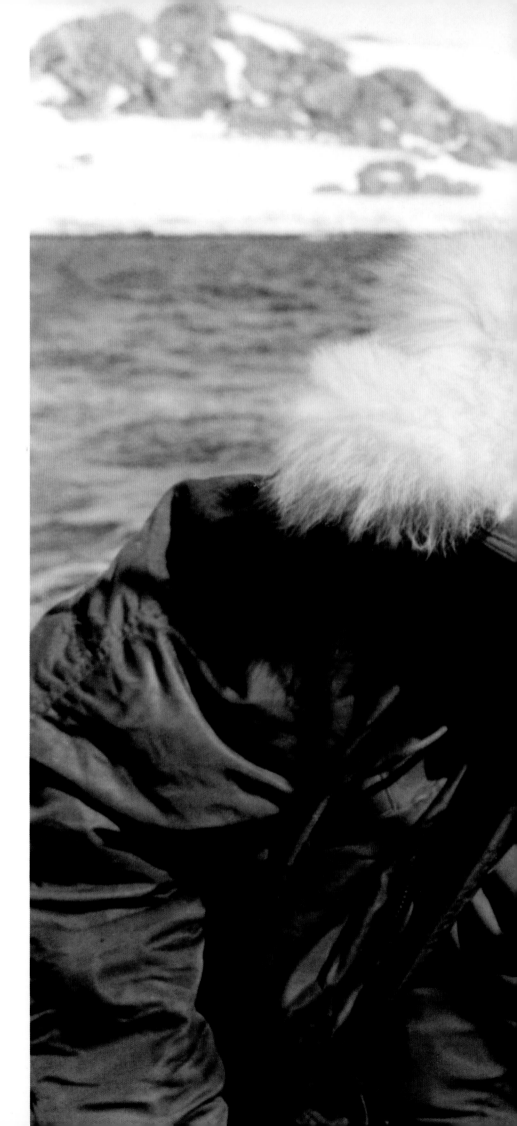

E
EXPLORERS

There is a great tradition of explorers and adventurers in France, from René-Robert Cavelier de La Salle, who explored the Great Lakes region, the Mississippi River, and the Gulf of Mexico in the 17th century; to alpinist Roger Frison-Roche; anthropologist Claude Lévi-Strauss (who did ethnographic fieldwork in Brazil as a young researcher); and marine explorer Captain Jacques Cousteau in the 20th century. The Society of French Explorers was founded in 1937 by a group of young adventurers, including the ethnographer and patron of French polar expeditions Paul-Émile Victor. The founding members were soon joined by other renowned French explorers, including Alexandra David-Néel (who traveled in China and Tibet), Jean de Guébriant (the Amazon Basin), and Théodore Monod (the Sahara Desert). In 1950, Maurice Herzog and Louis Lachenal were the first climbers to reach the summit of Annapurna in the Himalayas.

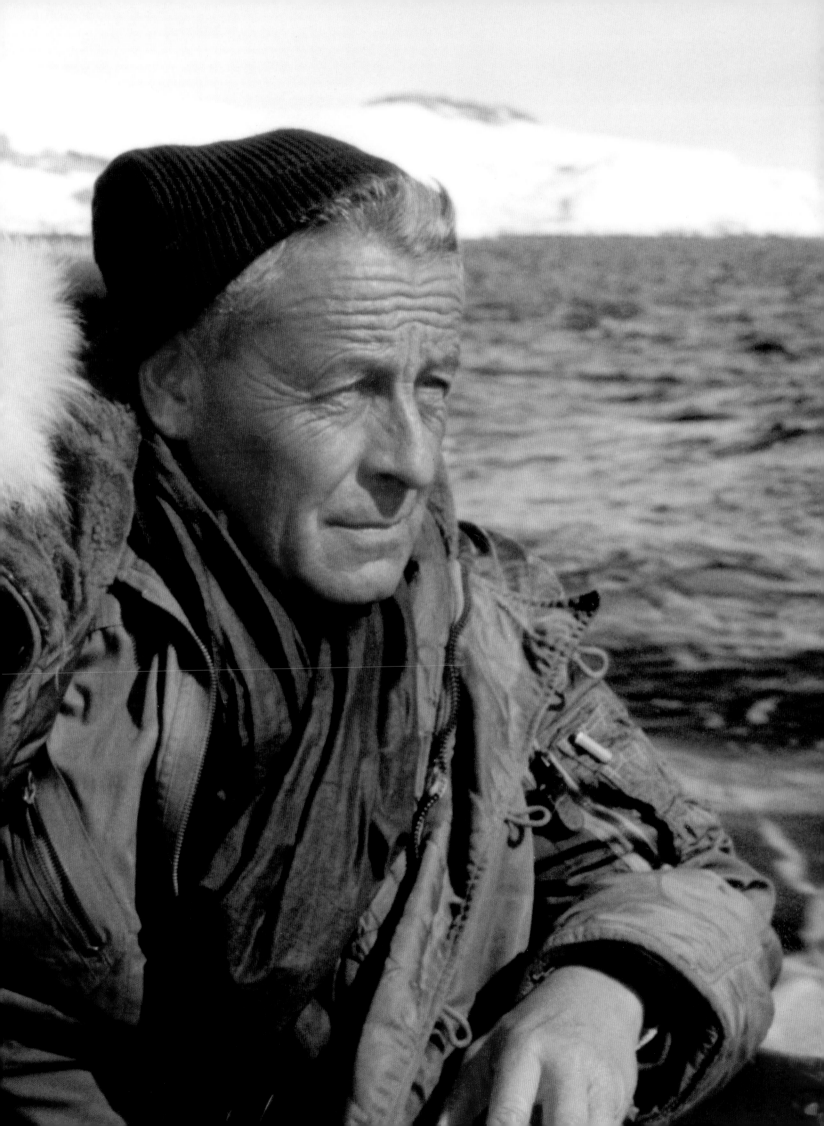

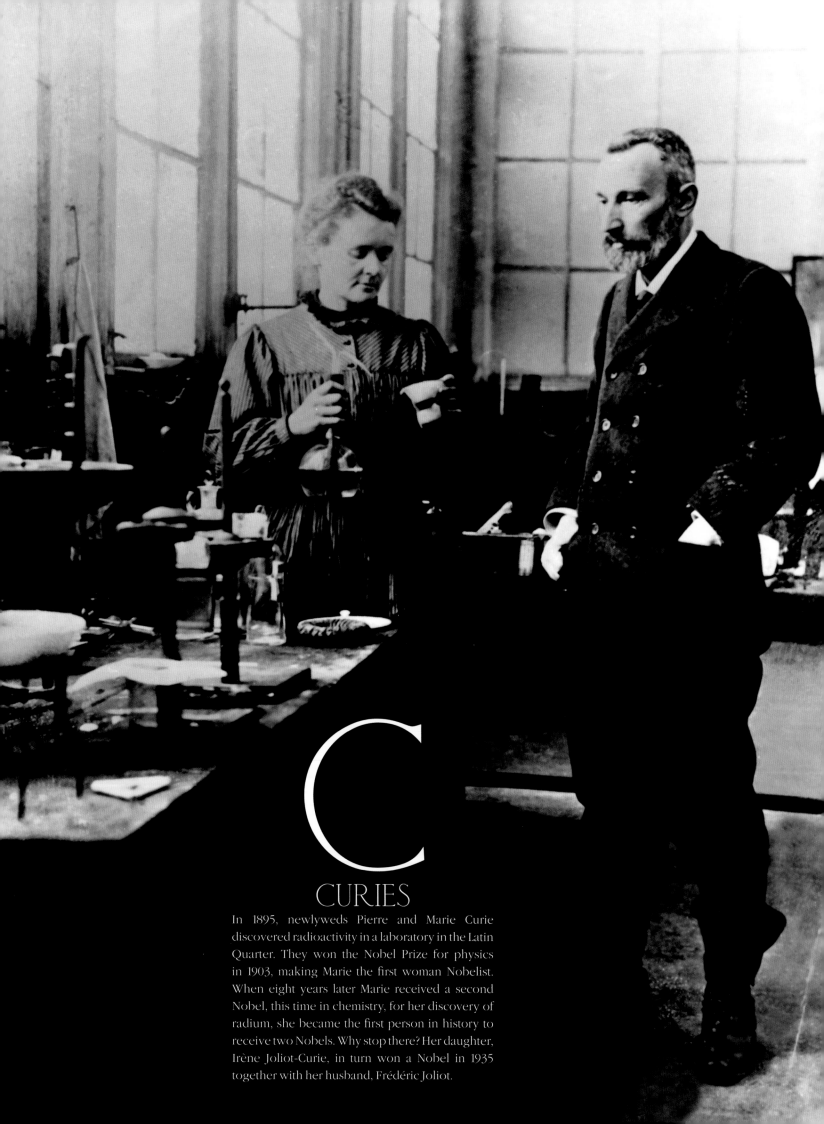

C
CURIES

In 1895, newlyweds Pierre and Marie Curie discovered radioactivity in a laboratory in the Latin Quarter. They won the Nobel Prize for physics in 1903, making Marie the first woman Nobelist. When eight years later Marie received a second Nobel, this time in chemistry, for her discovery of radium, she became the first person in history to receive two Nobels. Why stop there? Her daughter, Irène Joliot-Curie, in turn won a Nobel in 1935 together with her husband, Frédéric Joliot.

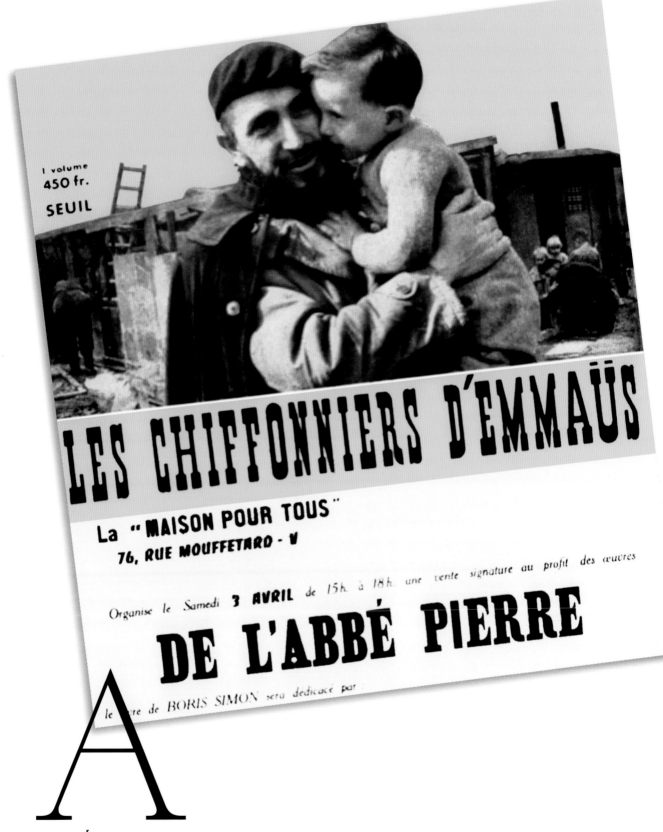

A
ABBÉ PIERRE

Henri Grouès, a Catholic priest, took the name Abbé Pierre when he went underground during World War II. A hero of the Resistance, Abbé Pierre continued to be politically active after the war, founding in 1949 the Emmaus movement, which began as a community of vagabonds dedicated to providing temporary housing to the homeless. The movement today includes more than 300 groups in 36 countries, independent organizations free of religious affiliation, united in fighting poverty, homelessness, and the social exclusion of the very poor. Until his death in 2007, Abbé Pierre was an important public figure and the most respected and admired person in France.

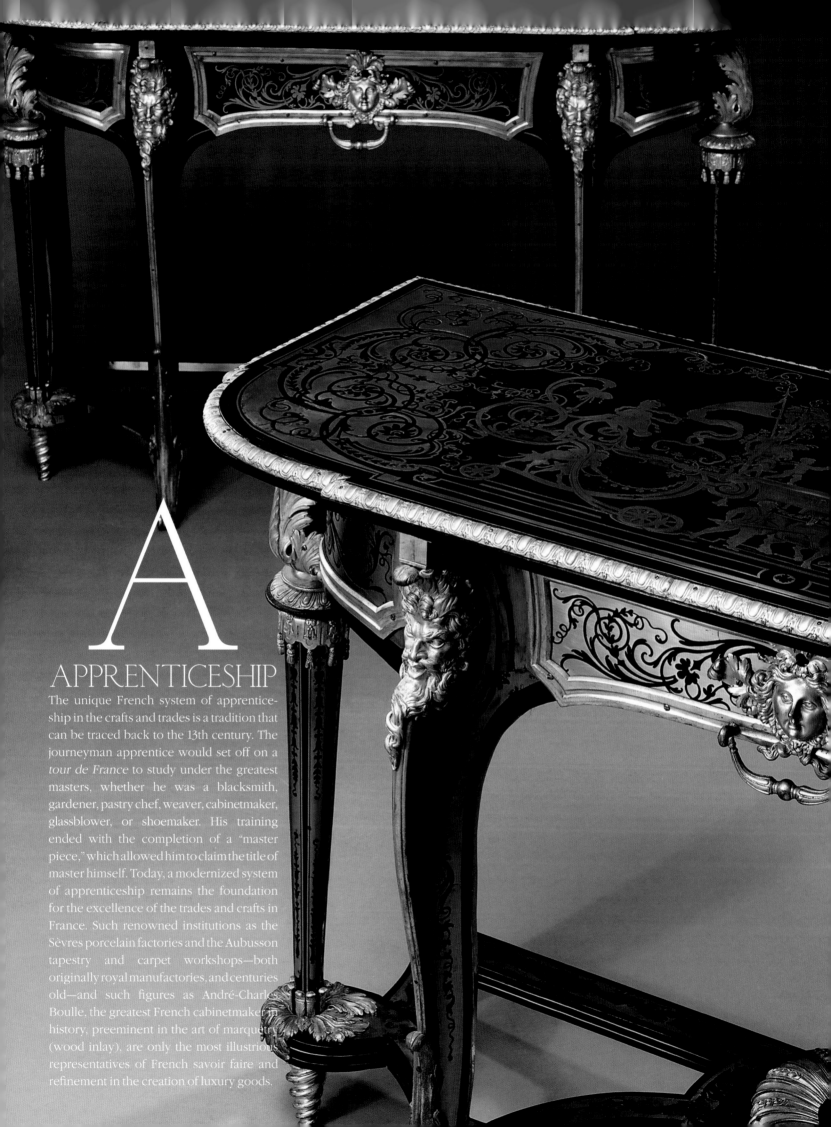

A
APPRENTICESHIP

The unique French system of apprentice-ship in the crafts and trades is a tradition that can be traced back to the 13th century. The journeyman apprentice would set off on a *tour de France* to study under the greatest masters, whether he was a blacksmith, gardener, pastry chef, weaver, cabinetmaker, glassblower, or shoemaker. His training ended with the completion of a "master piece," which allowed him to claim the title of master himself. Today, a modernized system of apprenticeship remains the foundation for the excellence of the trades and crafts in France. Such renowned institutions as the Sèvres porcelain factories and the Aubusson tapestry and carpet workshops—both originally royal manufactories, and centuries old—and such figures as André-Charles Boulle, the greatest French cabinetmaker in history, preeminent in the art of marquetry (wood inlay), are only the most illustrious representatives of French savoir faire and refinement in the creation of luxury goods.

KLEIN

Born in Nice in 1928, Yves Klein was first a devotee of judo, and the first French practitioner to earn a *yodan*, a fourth-degree black belt. Starting in 1954, Klein turned to painting and within a few years had become the most important artist in France's postwar avant-garde. In 1957, he concocted his (later patented) ultramarine blue, which he baptized IKB (International Klein Blue). Klein's paintings evolved into a form of performance art, with his use of naked female models slathered in IKB as "living paintbrushes." Klein died after suffering a heart attack in 1962, at the peak of his fame and influence.

S

STEEPLES

A distinctive feature of the nation's architectural heritage, particularly in the countryside, is the panoply of church steeples that pierce the horizon of French cities and towns. For Marcel Proust, in *Swann's Way*, the first volume of his multivolume novel *In Search of Lost Time*, just glimpsing the church bell towers rising over Martinville (a fictional town in Normandy) gives the narrator the strongest and purest moments of joy in his life. The most frequently photographed of these steeples, and the most visible, remains the spire atop the monastery of Mont Saint-Michel off the Norman coast.

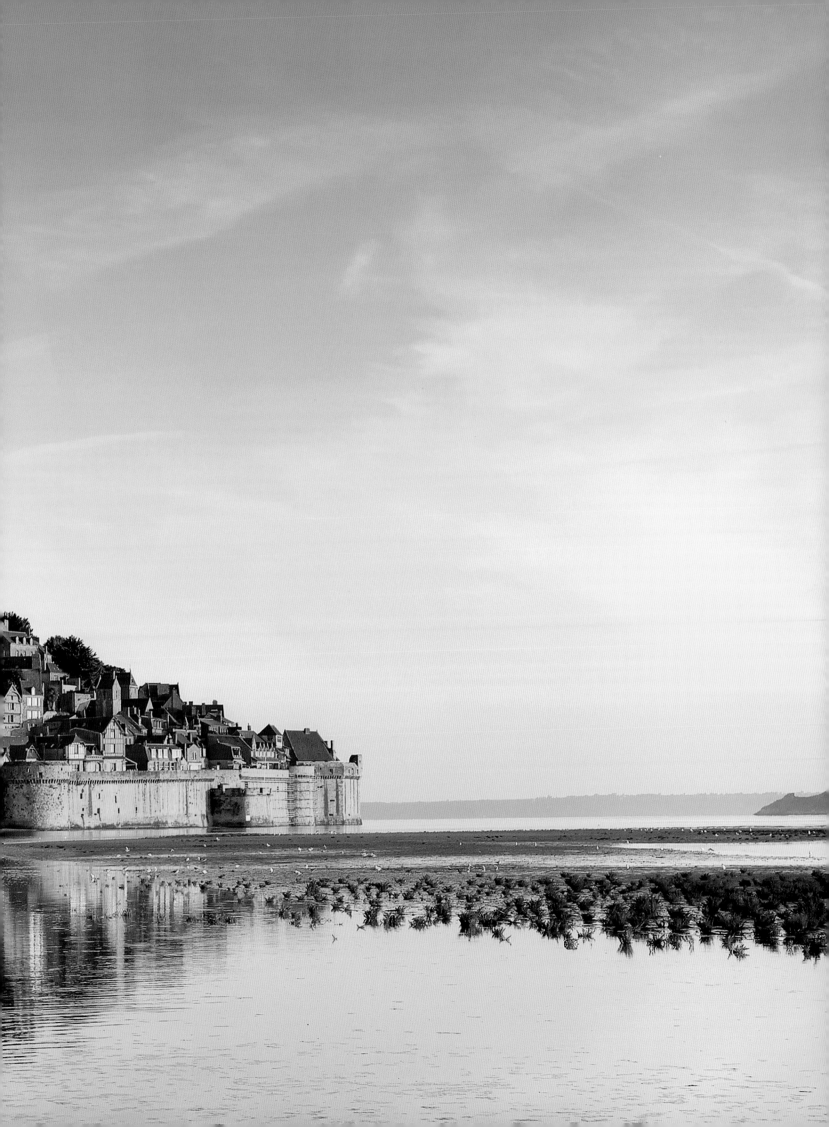

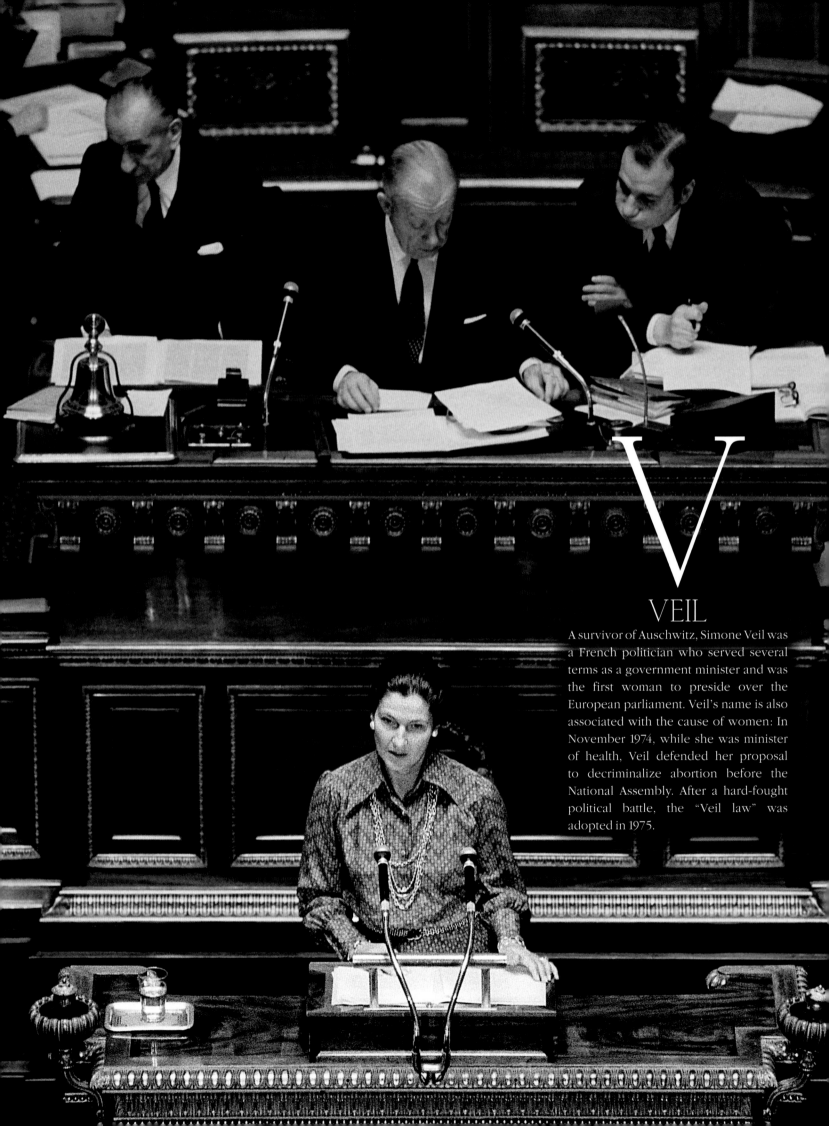

V

VEIL

A survivor of Auschwitz, Simone Veil was a French politician who served several terms as a government minister and was the first woman to preside over the European parliament. Veil's name is also associated with the cause of women: In November 1974, while she was minister of health, Veil defended her proposal to decriminalize abortion before the National Assembly. After a hard-fought political battle, the "Veil law" was adopted in 1975.

R
REVOLUTION

France would not be France without the storming of the Bastille and the Revolution of 1789, the mother of all subsequent revolutions in France—1830, 1848, 1870, 1968. With her first revolution, France showed the world that the people were capable of overturning an entire social order and successfully wresting power from the ruling classes.

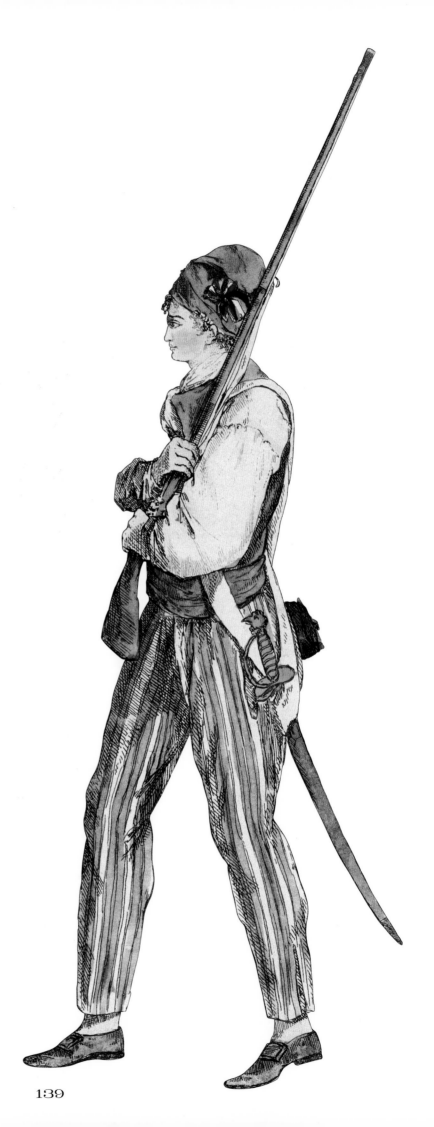

B
BALLET

Originating in the Italian dances brought to the French court by Catherine de' Medici when she married Henri II in 1533, ballet became a truly noble art form in France. King Louis XIV, who loved to dance and performed in many court spectacles, founded the Royal Academy of Dance (later the Paris Opera Ballet) in 1661. Today the POB and its school are the oldest such institutions in the world, though this does not prevent it from cultivating a very modern repertory. Pictured here in a 1993 photo, prima ballerina Sylvie Guillem was appointed an *étoile* ("star," the POB's highest rank) by Rudolf Nureyev in 1984, when she was only 19 years old.

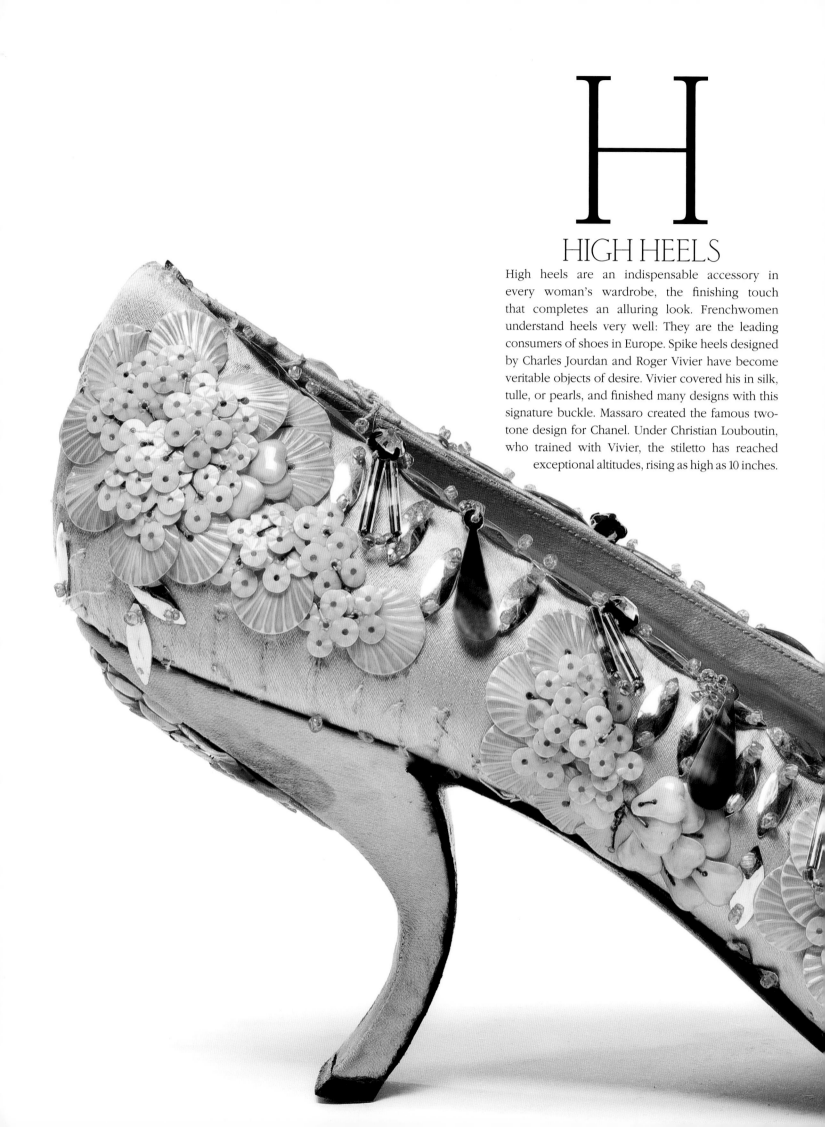

H
HIGH HEELS

High heels are an indispensable accessory in every woman's wardrobe, the finishing touch that completes an alluring look. Frenchwomen understand heels very well: They are the leading consumers of shoes in Europe. Spike heels designed by Charles Jourdan and Roger Vivier have become veritable objects of desire. Vivier covered his in silk, tulle, or pearls, and finished many designs with this signature buckle. Massaro created the famous two-tone design for Chanel. Under Christian Louboutin, who trained with Vivier, the stiletto has reached exceptional altitudes, rising as high as 10 inches.

A

ALEXANDRE
DE PARIS

Inventor of *haute coiffure*, Alexandre de Paris styled the tresses of the biggest stars and the crowned heads of Europe in the 20th century. He was a master of the art of the chignon, an elegant knot at the nape of the neck. His creativity and his collaborations across several decades with leading designers of haute couture, especially Yves Saint Laurent and Chanel, earned him the nickname "the Prince of Hairdressing."

104

Un geste plein d'at
juste pour moi, au

tion: Avedon prend une photo-souvenir,
ours d'une séance en studio pour Vogue-USA

105

Photograph by Richard Avedon, Paris, August 1961

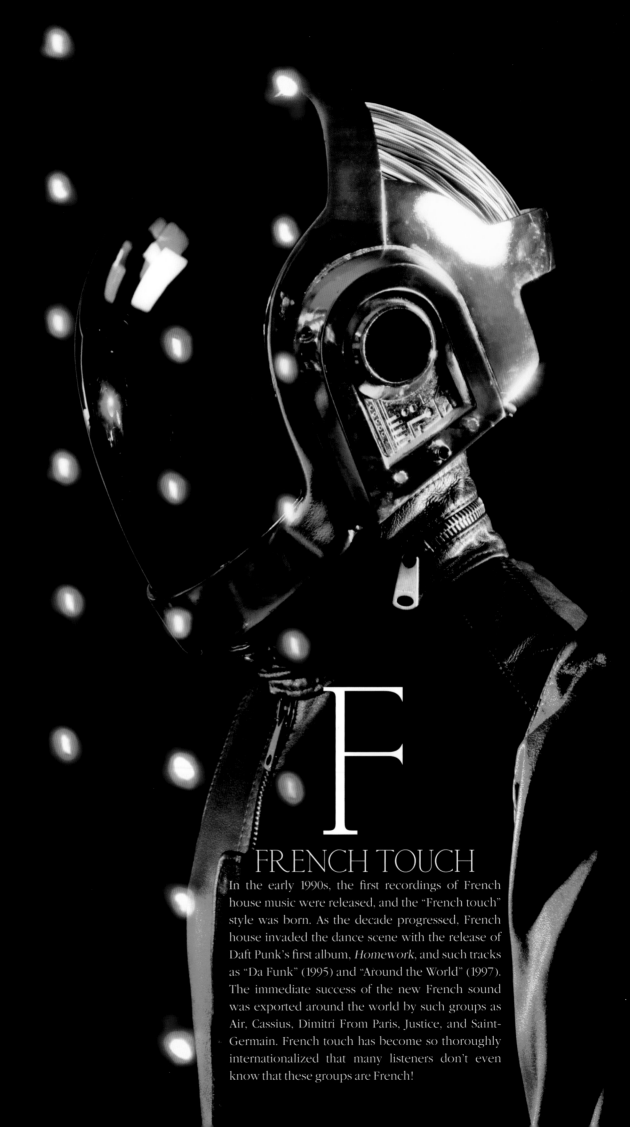

F
FRENCH TOUCH

In the early 1990s, the first recordings of French house music were released, and the "French touch" style was born. As the decade progressed, French house invaded the dance scene with the release of Daft Punk's first album, *Homework*, and such tracks as "Da Funk" (1995) and "Around the World" (1997). The immediate success of the new French sound was exported around the world by such groups as Air, Cassius, Dimitri From Paris, Justice, and Saint-Germain. French touch has become so thoroughly internationalized that many listeners don't even know that these groups are French!

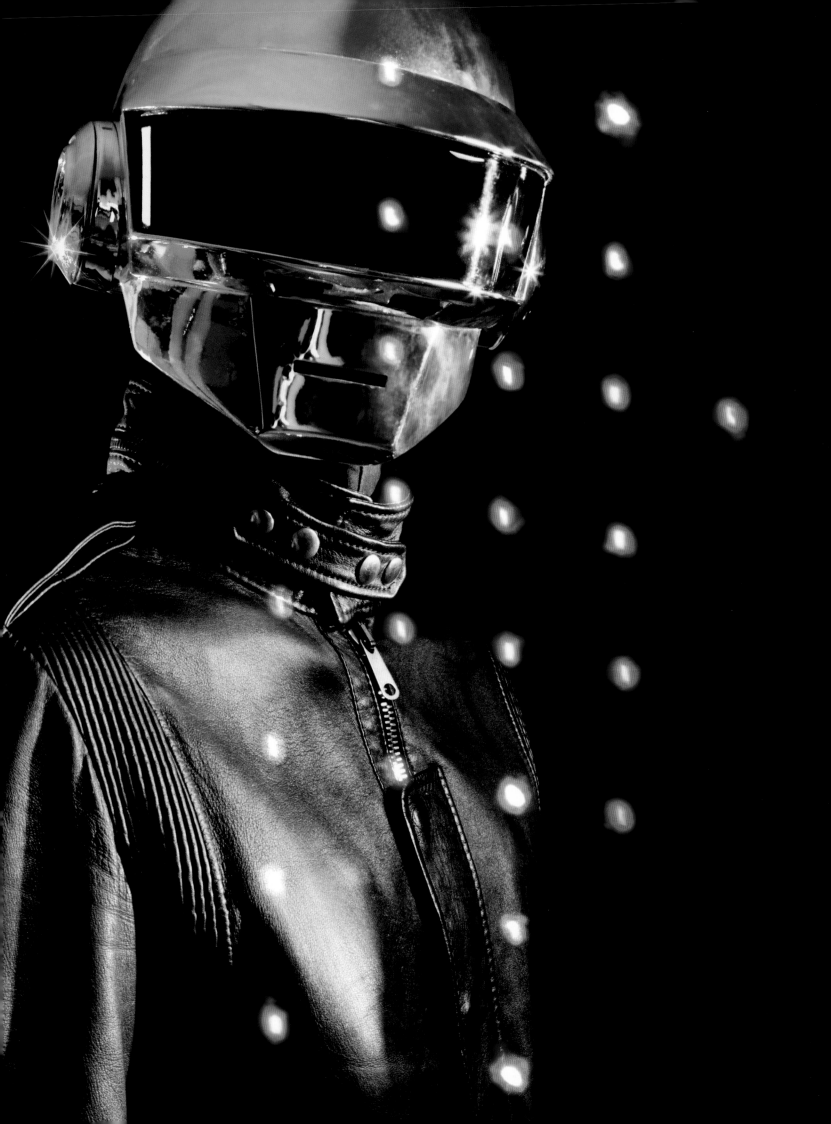

OPERA

French opera was born in the 17th century under the aegis of composer and violinist Jean-Baptiste Lully (born Giovanni Battista Lulli in Florence in 1632), Superintendant of Music in the court of Louis XIV. The French style was distinguished from Italian conventions by such unique genres as the *opéra-ballet*, the *opéra-comique*, and the French grand opera. Later, distinctive forms of comic opera evolved, especially in the work of composer Jacques Offenbach, as well as operetta, whose particular blend of music, singing, and dancing would influence the development of the American musical in the 20th century. Drawing on all the resources of theater—instrumental and vocal music, dance, text, and visual spectacle—opera is considered to be the premier total art form.

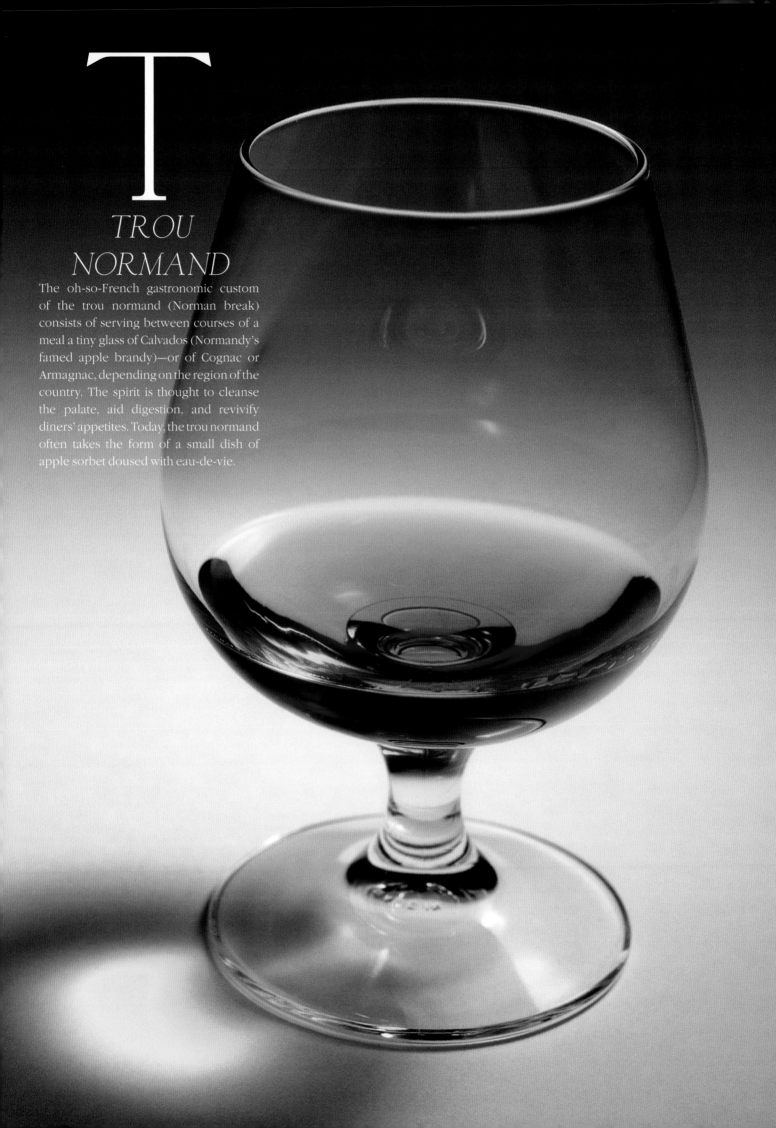

T
TROU NORMAND

The oh-so-French gastronomic custom of the trou normand (Norman break) consists of serving between courses of a meal a tiny glass of Calvados (Normandy's famed apple brandy)—or of Cognac or Armagnac, depending on the region of the country. The spirit is thought to cleanse the palate, aid digestion, and revivify diners' appetites. Today, the trou normand often takes the form of a small dish of apple sorbet doused with eau-de-vie.

P
PASTRY

Traditional artisanal pastry has been one of the major disciplines of the French culinary arts since the 17th century. To walk through the doors of Pierre Hermé, Dalloyau, Ladurée, Jean-Paul Hévin, or Lenôtre is to enter a universe of sweet marvels whose shapes, colors, and flavors are among the most sophisticated in the world. For pastry in France is not only a pleasure for the taste buds but a feast for the eyes as well.

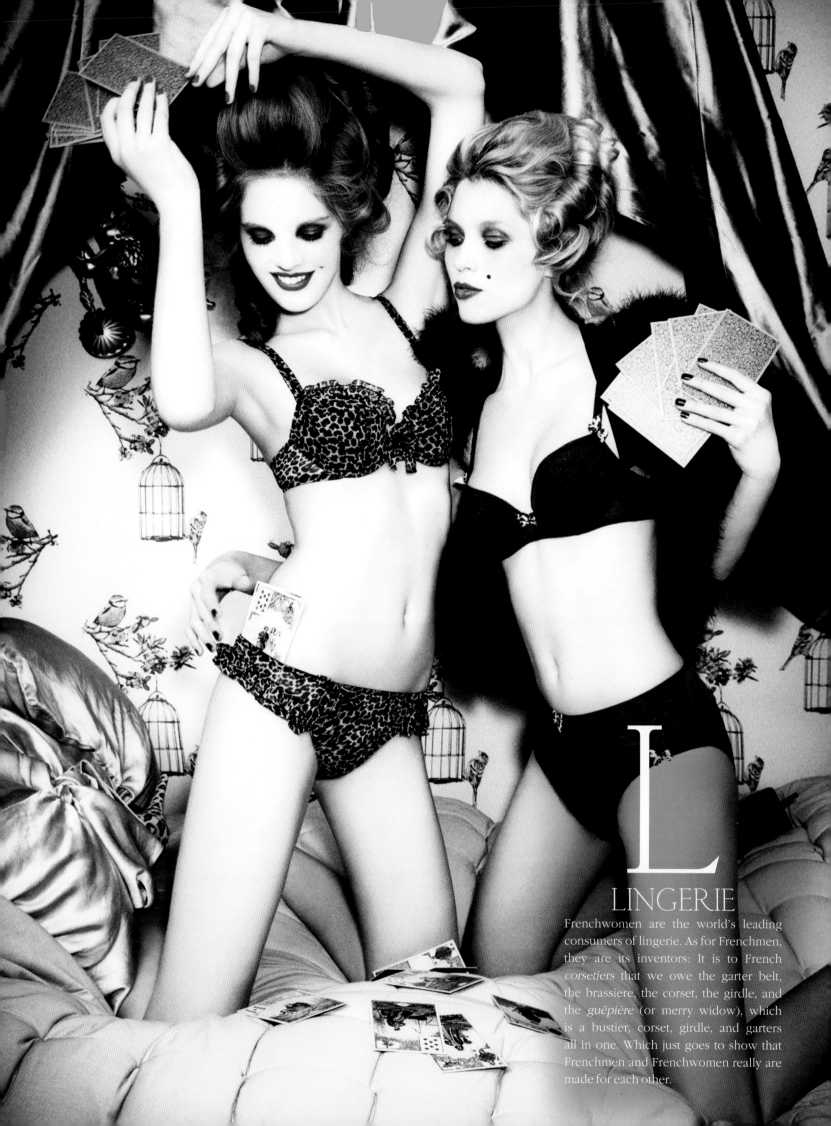

L
LINGERIE

Frenchwomen are the world's leading consumers of lingerie. As for Frenchmen, they are its inventors: It is to French *corsetiers* that we owe the garter belt, the brassiere, the corset, the girdle, and the *guêpière* (or merry widow), which is a bustier, corset, girdle, and garters all in one. Which just goes to show that Frenchmen and Frenchwomen really are made for each other.

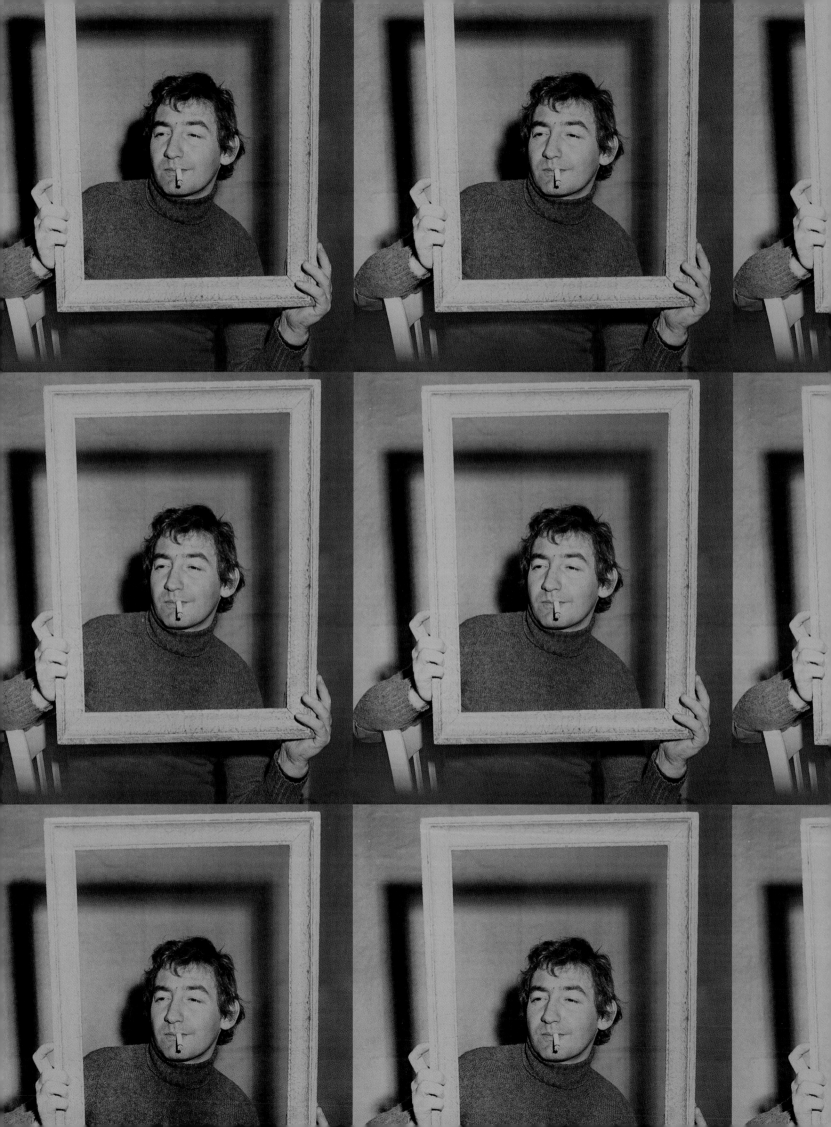

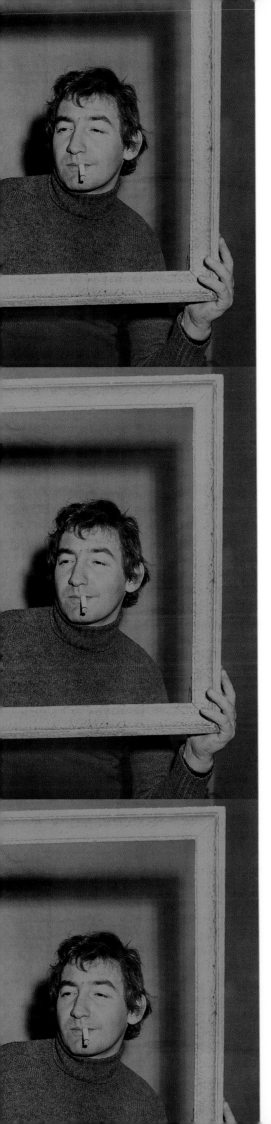

S
SATIRE

Political satire is a great French tradition. Practically all humorists in the long lineage of French singers and writers of satirical songs and sketches on the issues of the day have written political comedy for the stage, radio, or television. It must be said that politics plays a central role in French society. Whether or not they love their politicians, the French talk about them a lot and have always stood up for their right to laugh at them along with their comedians, including the TV satire *Le Petit Rapporteur*, the TV puppet news show *Les Guignols de l'Info*, comedian and Resistance activist Pierre Dac, comic performer Nicolas Canteloup, the multitalented Jean Amadou, radio and television personality Philippe Bouvard, singer-impressionist Michel Guidoni, and the scathing monologist Pierre Desproges (pictured).

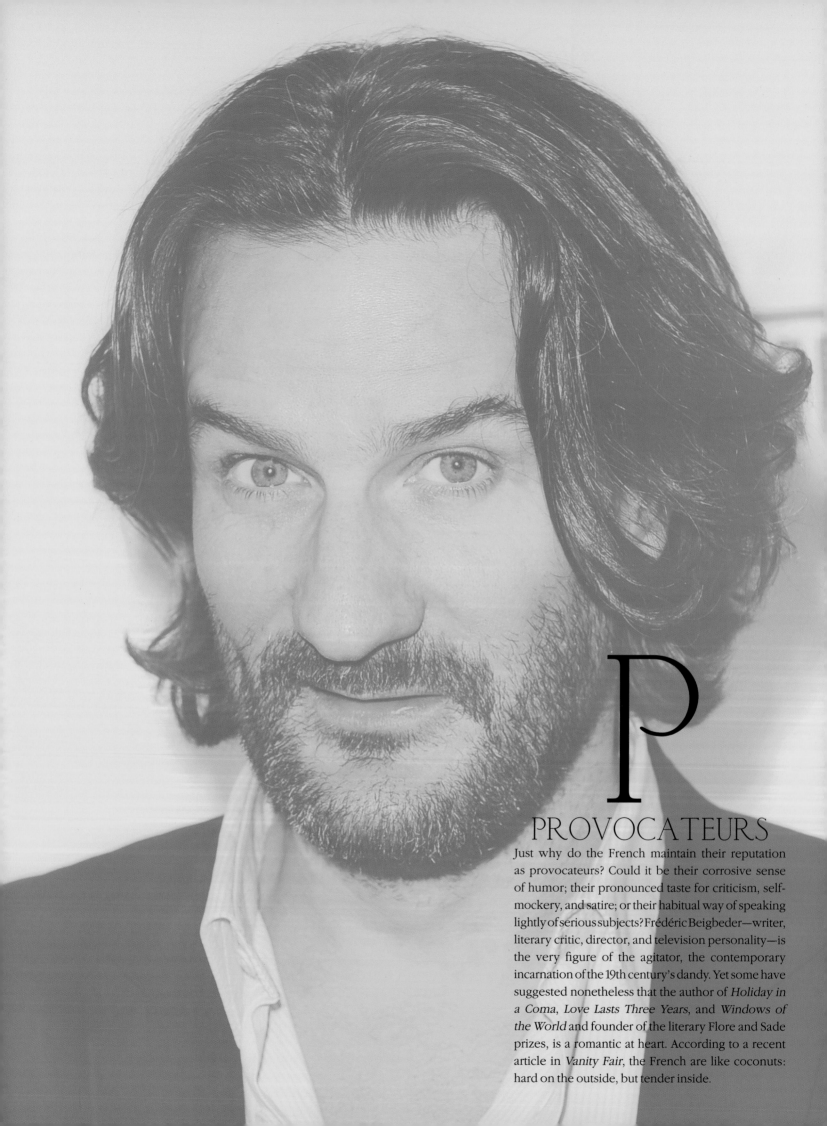

P

PROVOCATEURS

Just why do the French maintain their reputation as provocateurs? Could it be their corrosive sense of humor; their pronounced taste for criticism, self-mockery, and satire; or their habitual way of speaking lightly of serious subjects? Frédéric Beigbeder—writer, literary critic, director, and television personality—is the very figure of the agitator, the contemporary incarnation of the 19th century's dandy. Yet some have suggested nonetheless that the author of *Holiday in a Coma*, *Love Lasts Three Years*, and *Windows of the World* and founder of the literary Flore and Sade prizes, is a romantic at heart. According to a recent article in *Vanity Fair*, the French are like coconuts: hard on the outside, but tender inside.

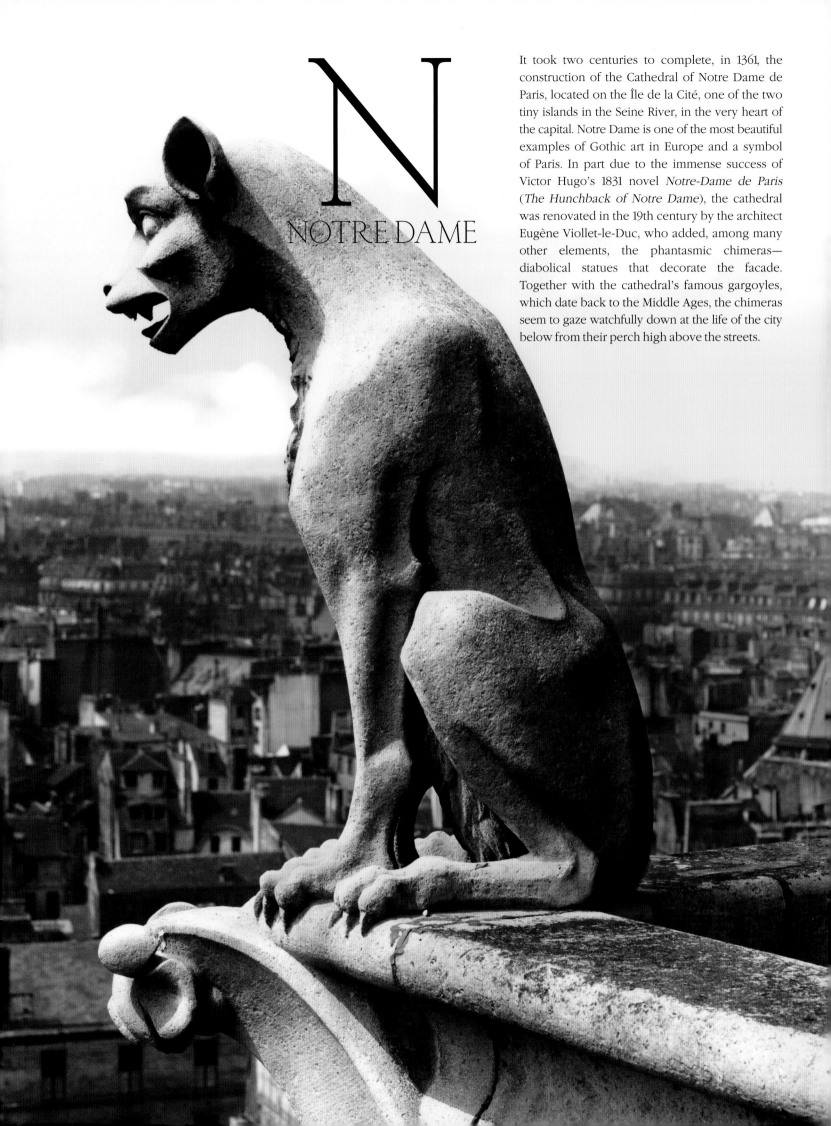

N
NOTRE DAME

It took two centuries to complete, in 1361, the construction of the Cathedral of Notre Dame de Paris, located on the Île de la Cité, one of the two tiny islands in the Seine River, in the very heart of the capital. Notre Dame is one of the most beautiful examples of Gothic art in Europe and a symbol of Paris. In part due to the immense success of Victor Hugo's 1831 novel *Notre-Dame de Paris* (*The Hunchback of Notre Dame*), the cathedral was renovated in the 19th century by the architect Eugène Viollet-le-Duc, who added, among many other elements, the phantasmic chimeras—diabolical statues that decorate the facade. Together with the cathedral's famous gargoyles, which date back to the Middle Ages, the chimeras seem to gaze watchfully down at the life of the city below from their perch high above the streets.

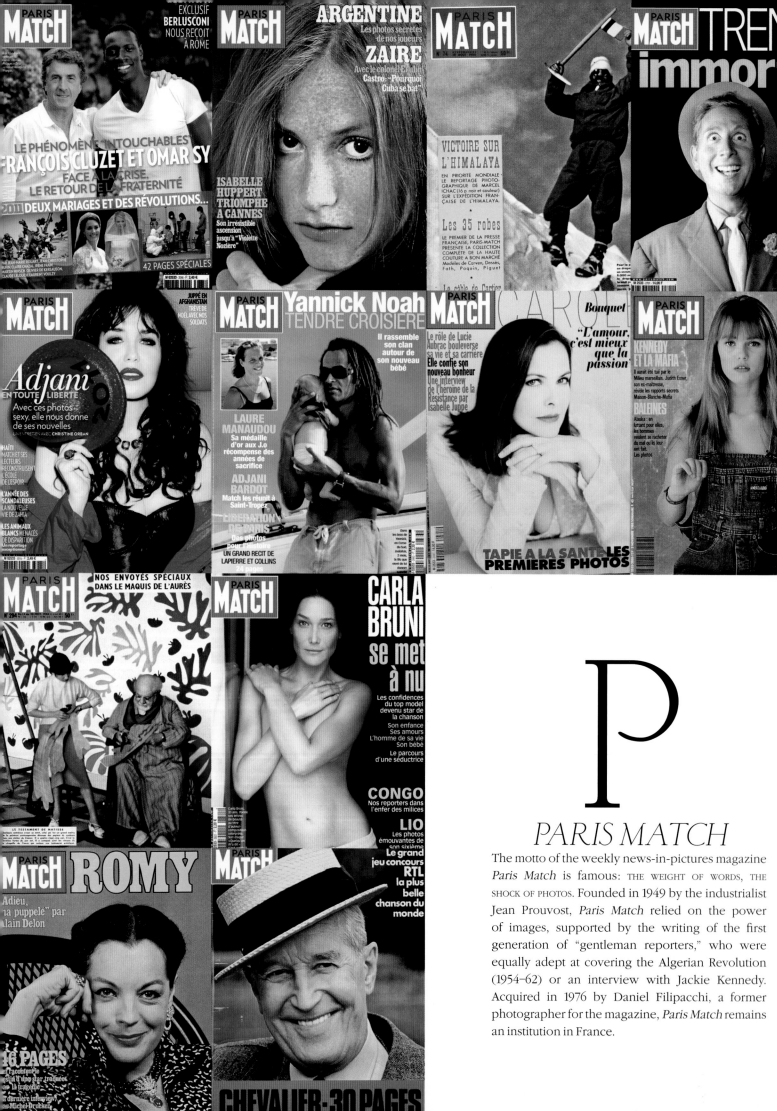

P

PARIS MATCH

The motto of the weekly news-in-pictures magazine *Paris Match* is famous: THE WEIGHT OF WORDS, THE SHOCK OF PHOTOS. Founded in 1949 by the industrialist Jean Prouvost, *Paris Match* relied on the power of images, supported by the writing of the first generation of "gentleman reporters," who were equally adept at covering the Algerian Revolution (1954–62) or an interview with Jackie Kennedy. Acquired in 1976 by Daniel Filipacchi, a former photographer for the magazine, *Paris Match* remains an institution in France.

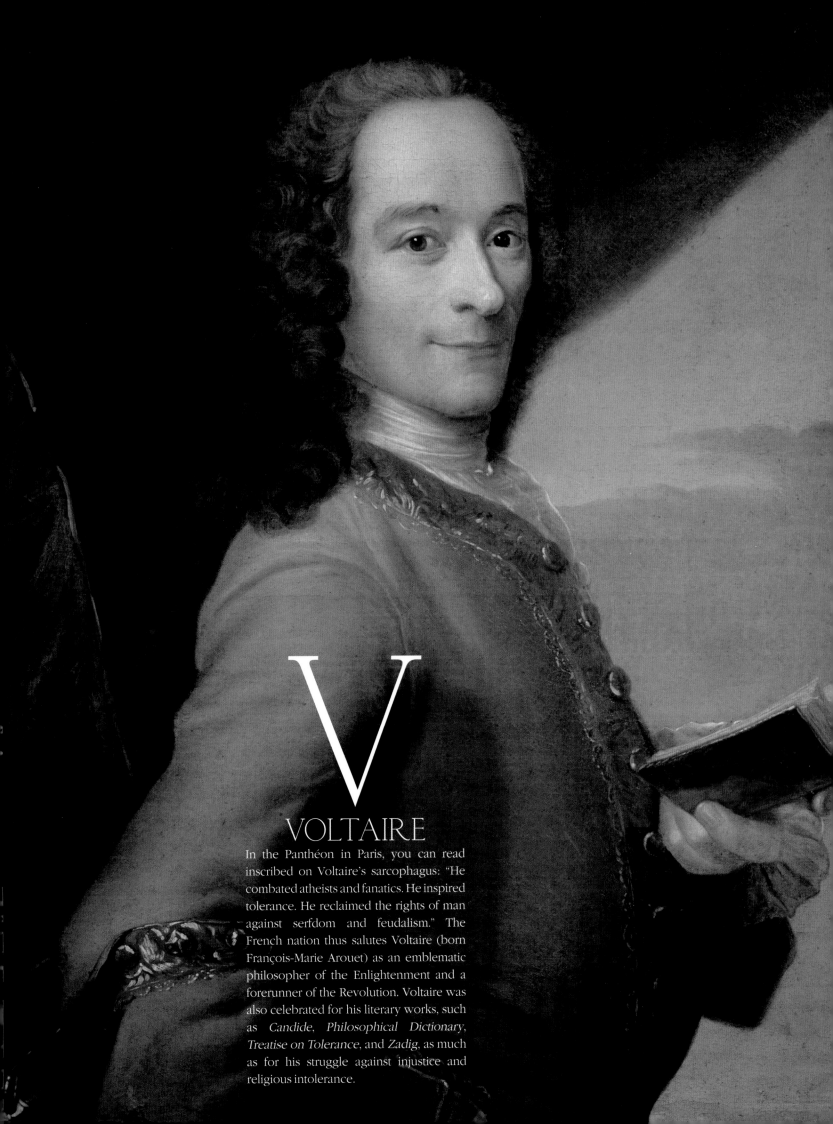

V
VOLTAIRE

In the Panthéon in Paris, you can read inscribed on Voltaire's sarcophagus: "He combated atheists and fanatics. He inspired tolerance. He reclaimed the rights of man against serfdom and feudalism." The French nation thus salutes Voltaire (born François-Marie Arouet) as an emblematic philosopher of the Enlightenment and a forerunner of the Revolution. Voltaire was also celebrated for his literary works, such as *Candide*, *Philosophical Dictionary*, *Treatise on Tolerance*, and *Zadig*, as much as for his struggle against injustice and religious intolerance.

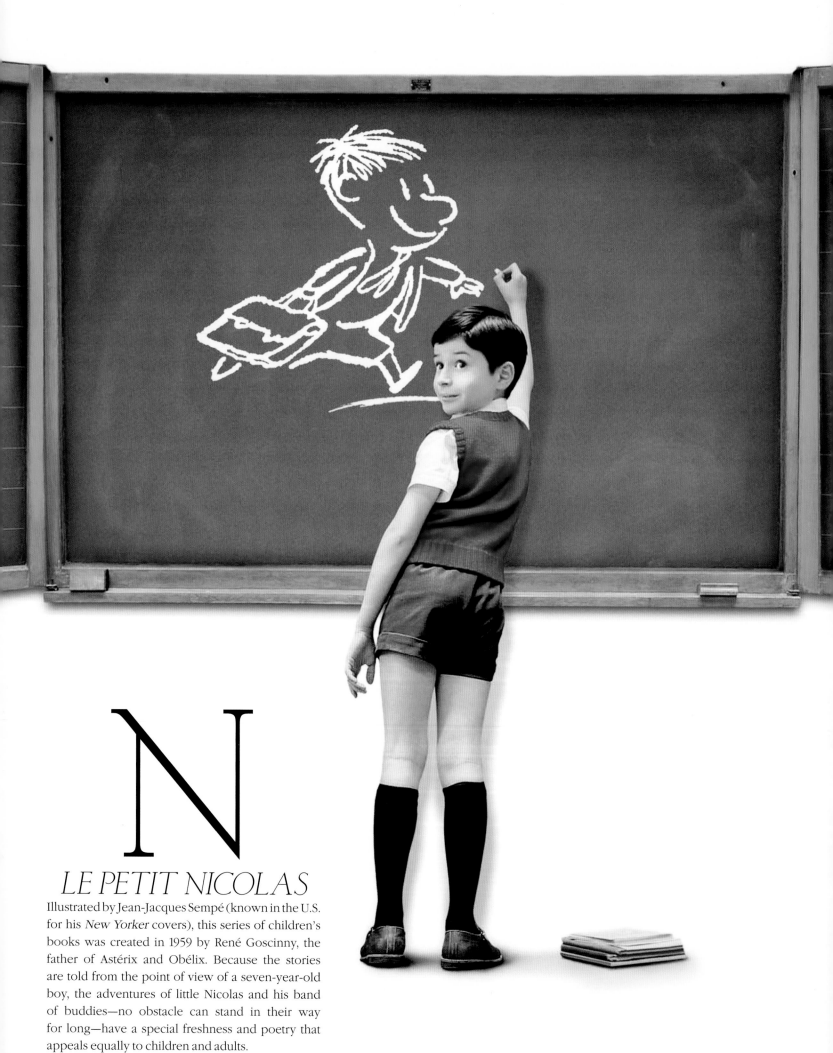

N

LE PETIT NICOLAS

Illustrated by Jean-Jacques Sempé (known in the U.S. for his *New Yorker* covers), this series of children's books was created in 1959 by René Goscinny, the father of Astérix and Obélix. Because the stories are told from the point of view of a seven-year-old boy, the adventures of little Nicolas and his band of buddies—no obstacle can stand in their way for long—have a special freshness and poetry that appeals equally to children and adults.

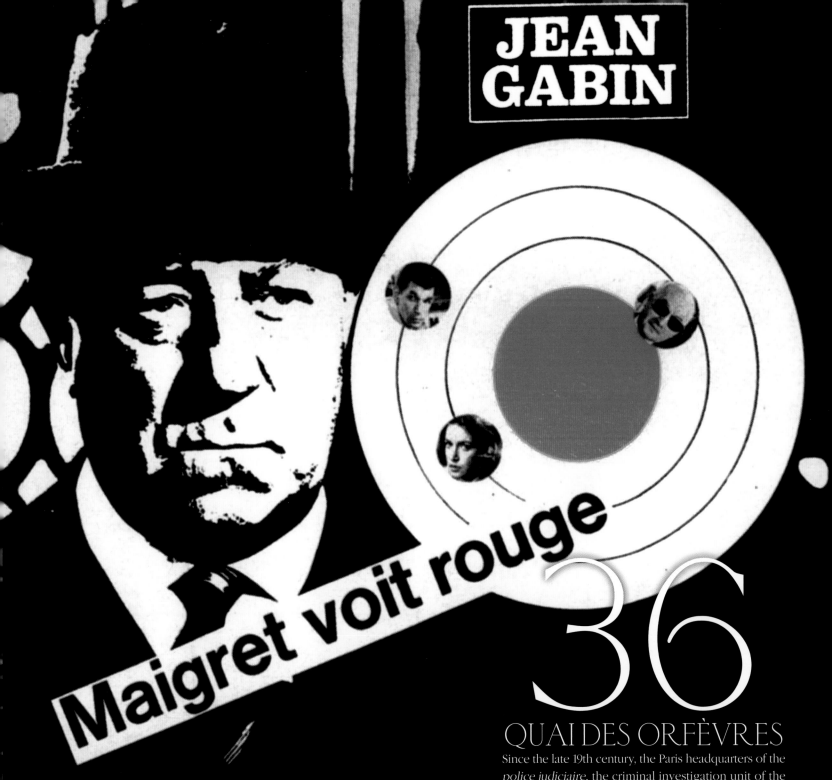

JEAN GABIN

Maigret voit rouge

36
QUAI DES ORFÈVRES

Since the late 19th century, the Paris headquarters of the *police judiciaire*, the criminal investigation unit of the French civilian police, has been at 36 Quai des Orfèvres. This address has achieved mythic status through the dozens of films, television series, and novels that it has inspired. Georges Simenon's detective Maigret is without doubt the most famous fictional character to emerge from the famous "36." And because France is distinguished by its love of literary prizes, the PJ has since 1946 awarded the Prix du Quai des Orfèvres, given annually by a panel of detectives, judges, and journalists, presided over by the director of the Paris prefecture of the PJ, to the best previously unpublished crime or detective novel in the French language.

un film de
GILLES GRANGIER
d'après le roman de
GEORGES SIMENON
"Maigret Lognon et les gangsters"

adaptation de
JACQUES ROBERT
et
GILLES GRANGIER

dialogue de
JACQUES ROBERT

avec
FRANÇOISE FABIAN
MARCEL BOZZUFI · PAUL CARPENTER
MICHEL CONSTANTIN · GUY DECOMBLE
EDWARD MEEKS · RICKY COOPER
et
VITTORIO SANIPOLI

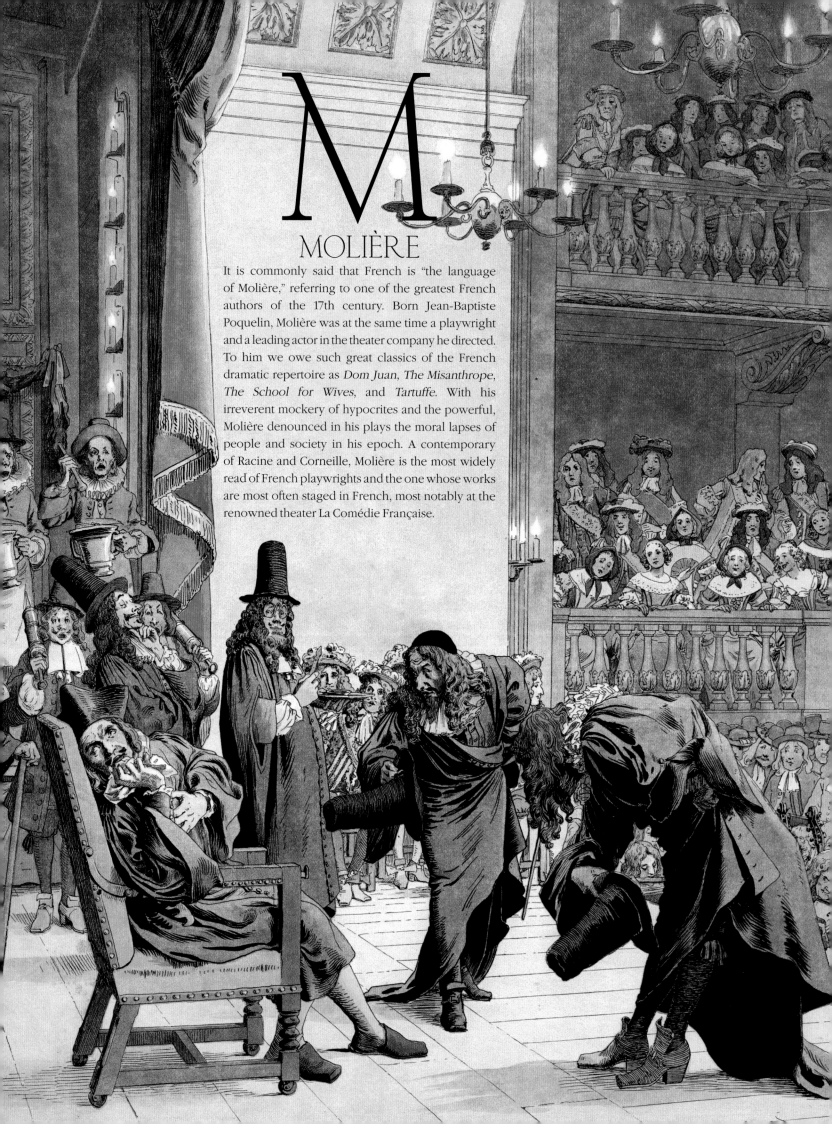

M

MOLIÈRE

It is commonly said that French is "the language of Molière," referring to one of the greatest French authors of the 17th century. Born Jean-Baptiste Poquelin, Molière was at the same time a playwright and a leading actor in the theater company he directed. To him we owe such great classics of the French dramatic repertoire as *Dom Juan*, *The Misanthrope*, *The School for Wives*, and *Tartuffe*. With his irreverent mockery of hypocrites and the powerful, Molière denounced in his plays the moral lapses of people and society in his epoch. A contemporary of Racine and Corneille, Molière is the most widely read of French playwrights and the one whose works are most often staged in French, most notably at the renowned theater La Comédie Française.

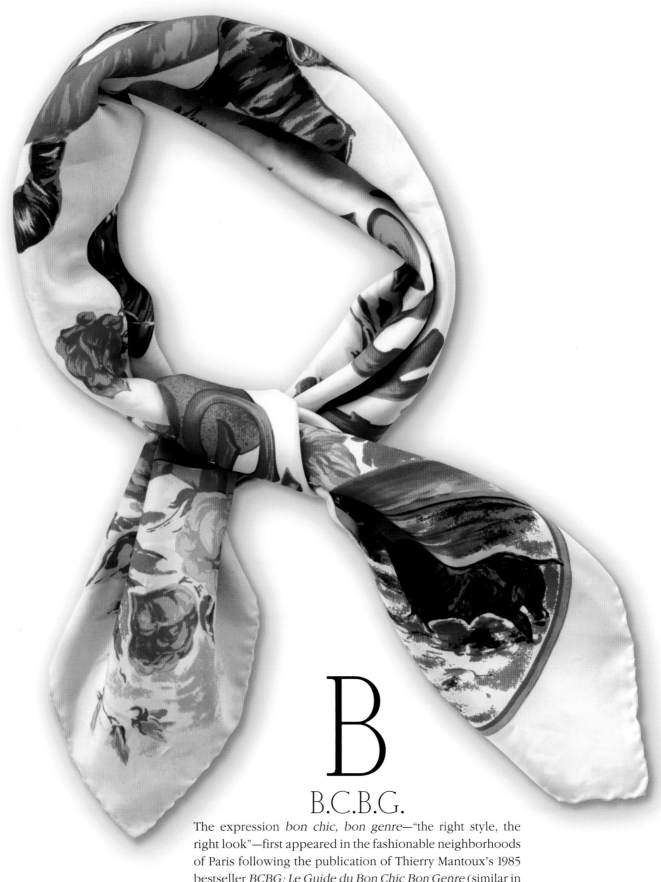

B
B.C.B.G.

The expression *bon chic, bon genre*—"the right style, the right look"—first appeared in the fashionable neighborhoods of Paris following the publication of Thierry Mantoux's 1985 bestseller *BCBG: Le Guide du Bon Chic Bon Genre* (similar in spirit to *The Official Preppy Handbook*, or *The Official Sloane Ranger Handbook*). B.C.B.G. indicates classic, conservative discretion and good taste, represented by such brands as Agnès B., Céline, Chloé, or Lacoste. And Hermès, one of the crown jewels of the French luxury industry, epitomizes B.C.B.G. with its famous square silk scarves and legendary Kelly and Birkin handbags.

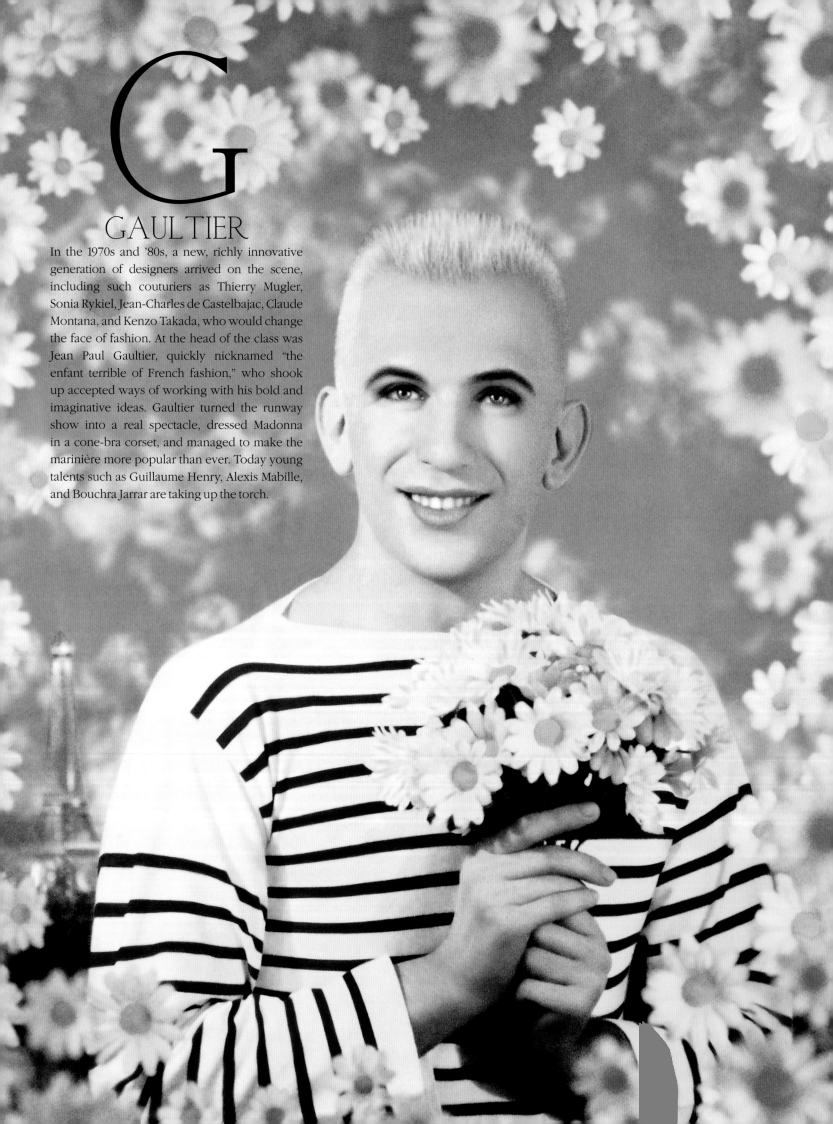

G
GAULTIER

In the 1970s and '80s, a new, richly innovative generation of designers arrived on the scene, including such couturiers as Thierry Mugler, Sonia Rykiel, Jean-Charles de Castelbajac, Claude Montana, and Kenzo Takada, who would change the face of fashion. At the head of the class was Jean Paul Gaultier, quickly nicknamed "the enfant terrible of French fashion," who shook up accepted ways of working with his bold and imaginative ideas. Gaultier turned the runway show into a real spectacle, dressed Madonna in a cone-bra corset, and managed to make the marinière more popular than ever. Today young talents such as Guillaume Henry, Alexis Mabille, and Bouchra Jarrar are taking up the torch.

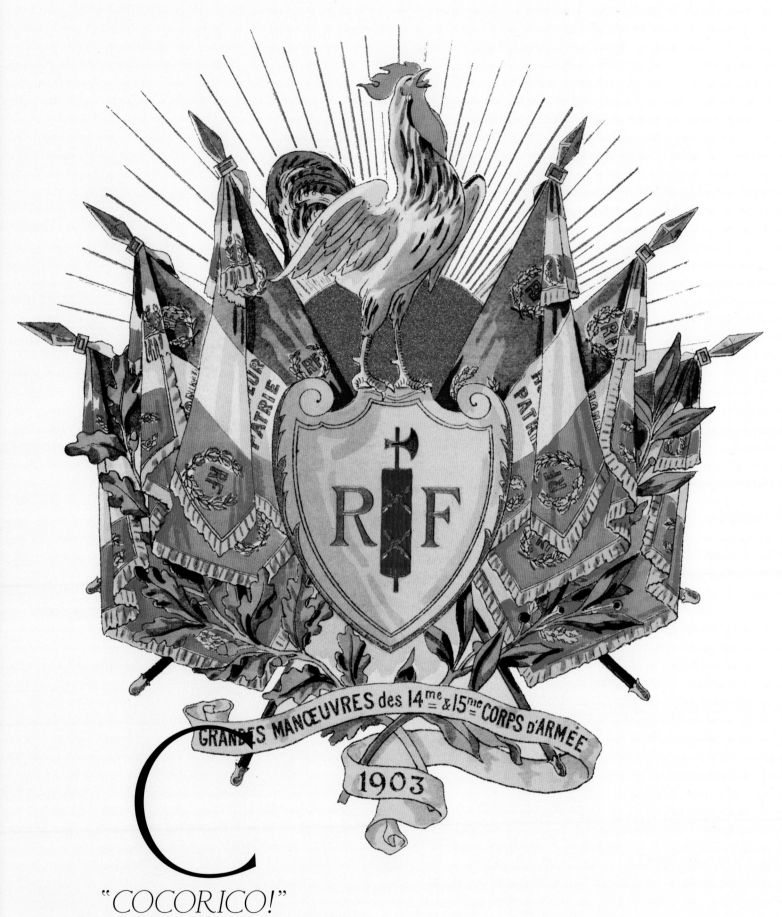

"COCORICO!"

Born from a pun—in Latin, *gallus* means both "Gaul" (the Roman word for Celtic France) and "rooster"—the cock has become one of the emblems of France, even though it has never been recognized as such by the country's kings, emperors, or presidents. All have found the bird either too banal or too shrill to represent France. "Cocorico" is the French onomatopoeic word for a rooster's crowing call.

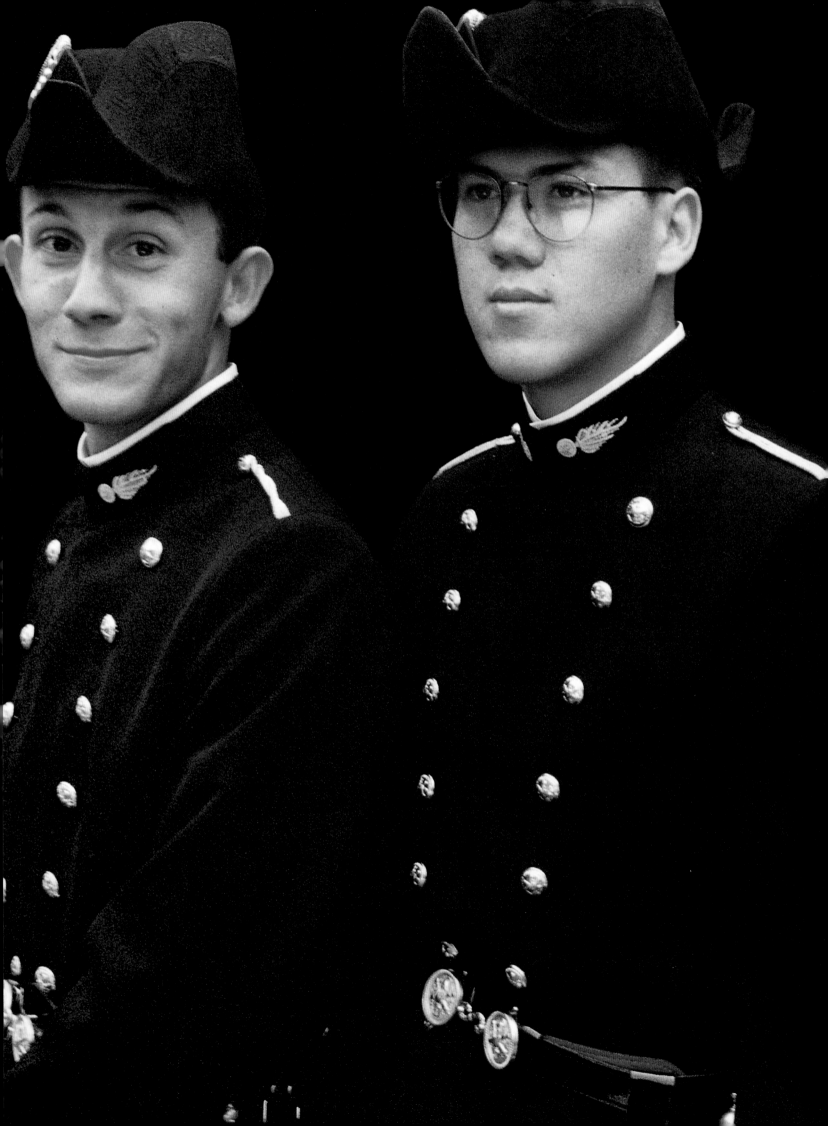

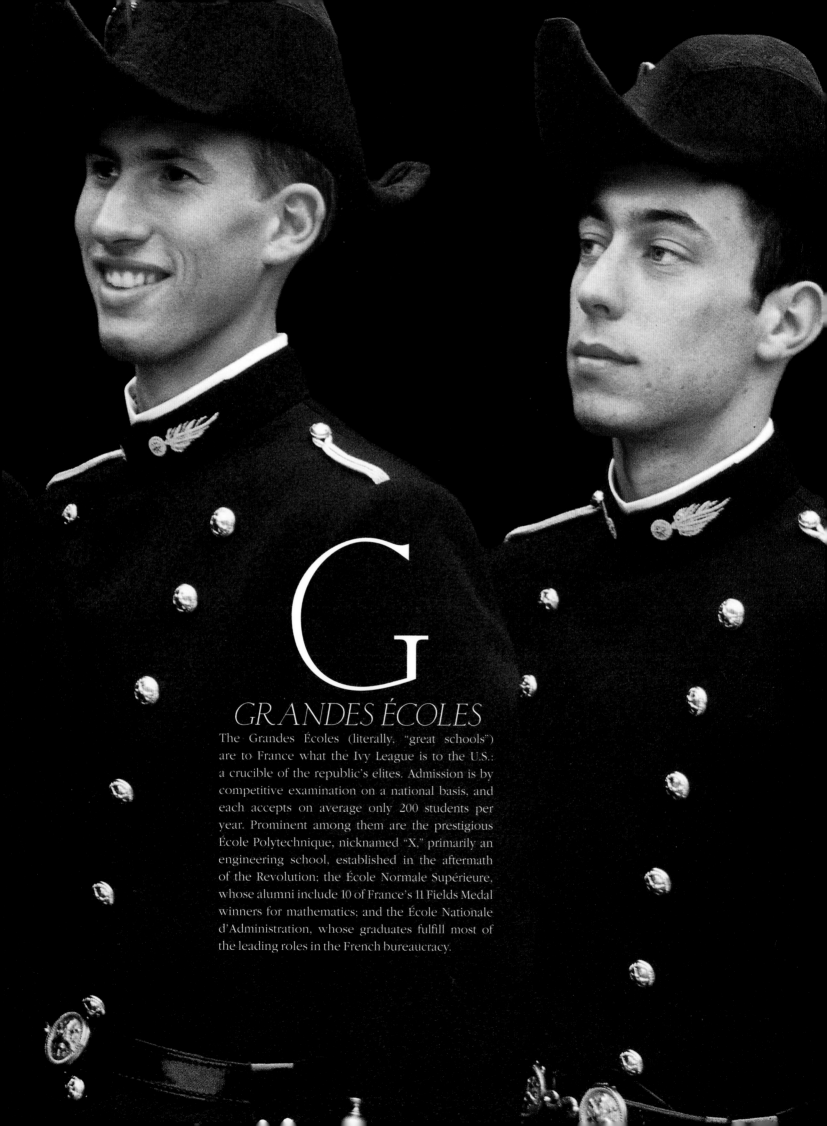

G

GRANDES ÉCOLES

The Grandes Écoles (literally, "great schools") are to France what the Ivy League is to the U.S.: a crucible of the republic's elites. Admission is by competitive examination on a national basis, and each accepts on average only 200 students per year. Prominent among them are the prestigious École Polytechnique, nicknamed "X," primarily an engineering school, established in the aftermath of the Revolution; the École Normale Supérieure, whose alumni include 10 of France's 11 Fields Medal winners for mathematics; and the École Nationale d'Administration, whose graduates fulfill most of the leading roles in the French bureaucracy.

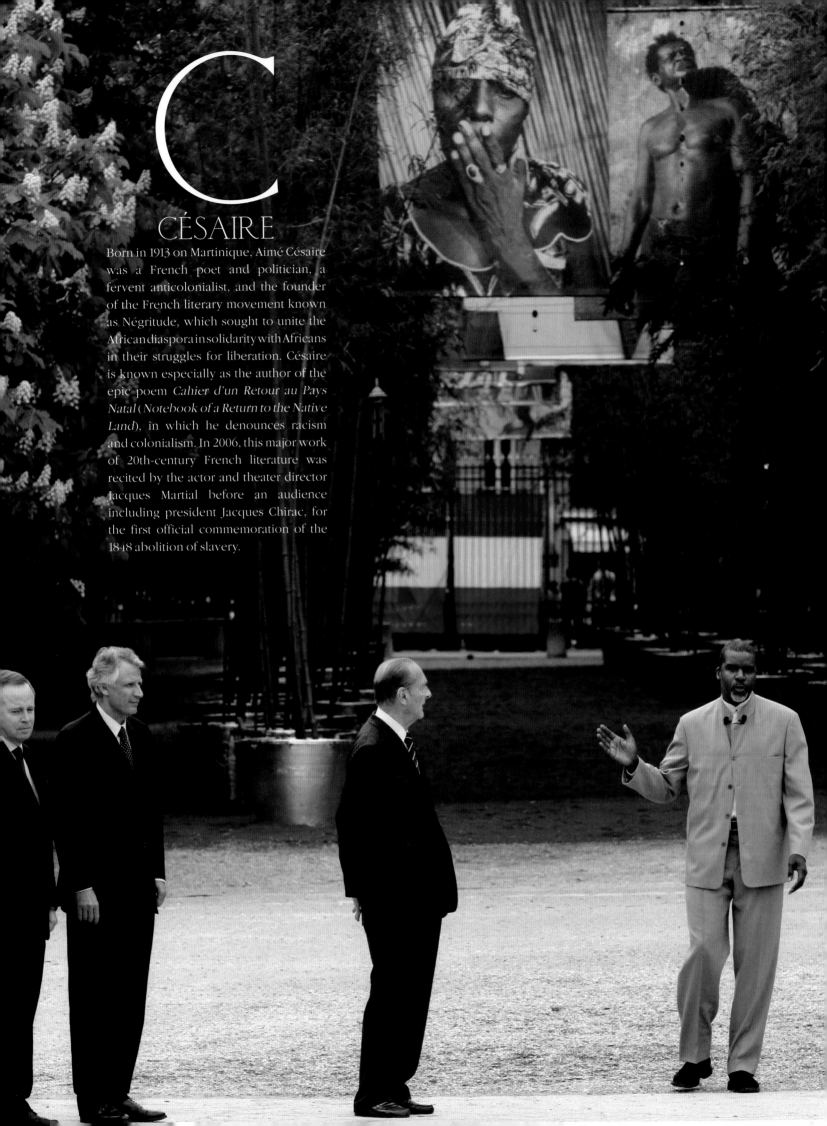

C
CÉSAIRE

Born in 1913 on Martinique, Aimé Césaire was a French poet and politician, a fervent anticolonialist, and the founder of the French literary movement known as Négritude, which sought to unite the African diaspora in solidarity with Africans in their struggles for liberation. Césaire is known especially as the author of the epic poem *Cahier d'un Retour au Pays Natal* (*Notebook of a Return to the Native Land*), in which he denounces racism and colonialism. In 2006, this major work of 20th-century French literature was recited by the actor and theater director Jacques Martial before an audience including president Jacques Chirac, for the first official commemoration of the 1848 abolition of slavery.

Y
S
L

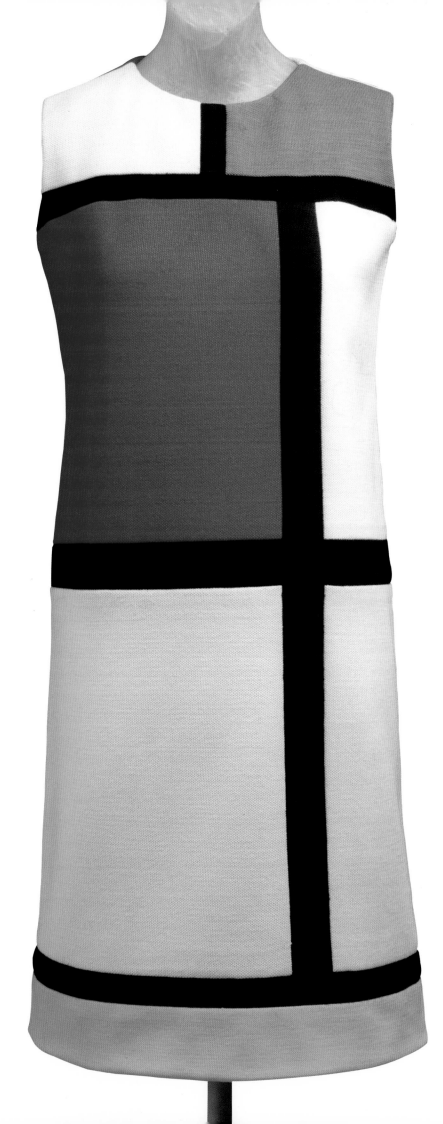

YVES
SAINT LAURENT

After working at Christian Dior, Yves Saint Laurent decided to found his own couture house, with his partner, Pierre Bergé, in 1961. Playing with the conventions of menswear, Saint Laurent reinvented the wardrobe of the modern woman with his takes on the sailor's jacket, the smoking jacket, the safari jacket, and the pantsuit. Seeking to dress all women, not only the wealthy clients of haute couture, Saint Laurent was the first designer to open a ready-to-wear boutique, Saint Laurent Rive Gauche. Throughout his career, his wide-ranging curiosity also led him to explore multiple collaborations with theater and cinema.

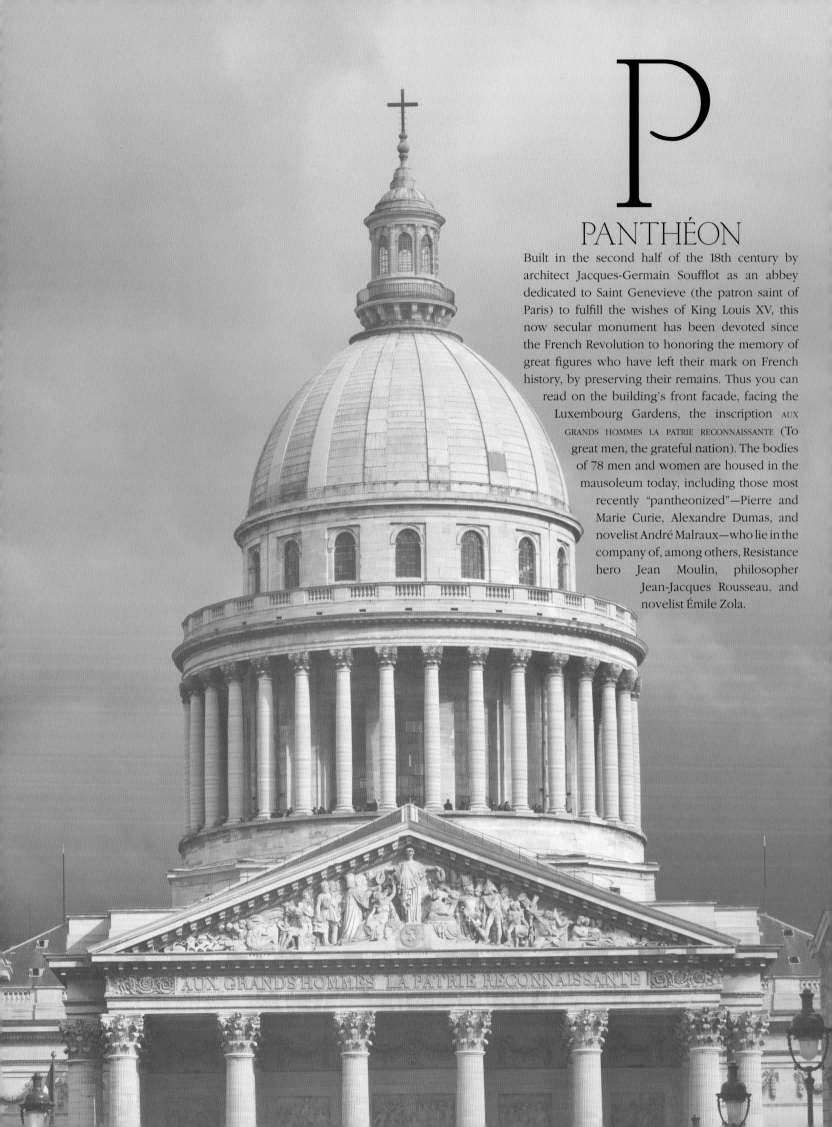

P

PANTHÉON

Built in the second half of the 18th century by architect Jacques-Germain Soufflot as an abbey dedicated to Saint Genevieve (the patron saint of Paris) to fulfill the wishes of King Louis XV, this now secular monument has been devoted since the French Revolution to honoring the memory of great figures who have left their mark on French history, by preserving their remains. Thus you can read on the building's front facade, facing the Luxembourg Gardens, the inscription AUX GRANDS HOMMES LA PATRIE RECONNAISSANTE (To great men, the grateful nation). The bodies of 78 men and women are housed in the mausoleum today, including those most recently "pantheonized"—Pierre and Marie Curie, Alexandre Dumas, and novelist André Malraux—who lie in the company of, among others, Resistance hero Jean Moulin, philosopher Jean-Jacques Rousseau, and novelist Émile Zola.

D
DUMAS

Like Astérix and Obélix and Cyrano de Bergerac, the protagonists of Alexandre Dumas's *The Three Musketeers* (who were in fact *four*), published in 1844, are typically French heroes: flawed, irascible, insubordinate bons vivants and ladies' men—but also brave, appealing, faithful in friendship, and, above all, very, very charming. The musketeers (members of an armed regiment founded by Louis XIII) don't hesitate to defy the king's first minister, Cardinal Richelieu, to defend the honor of a lady, Queen Anne of Austria. Well, they are Frenchmen, after all....

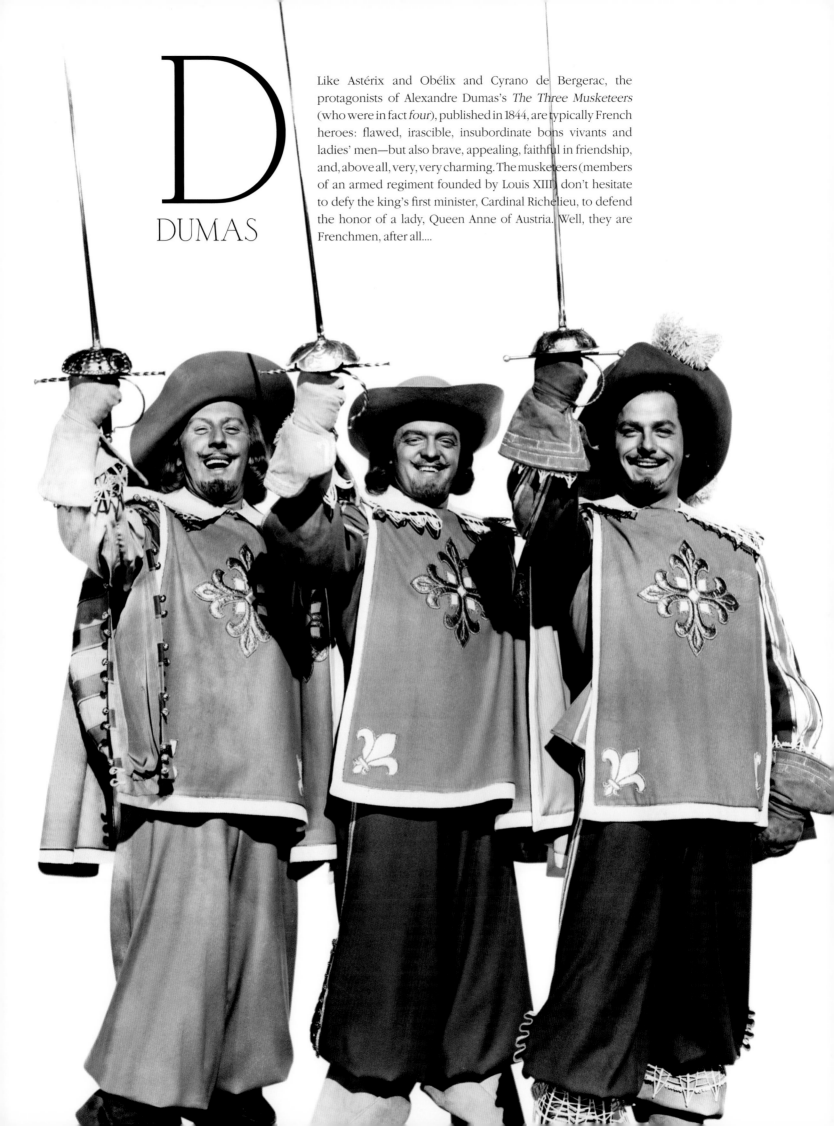

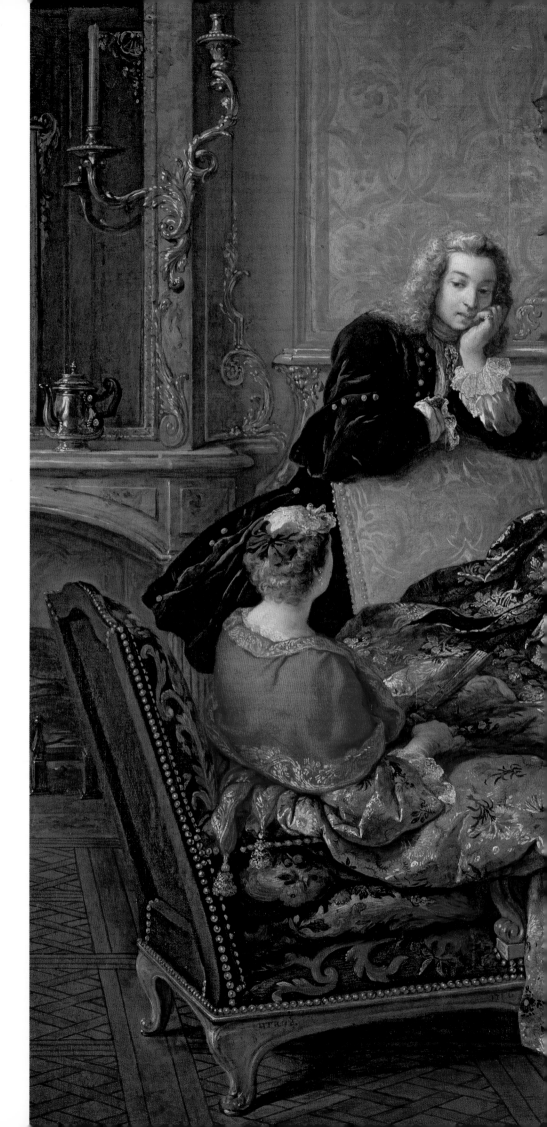

S
SALONS

Literary salons are private gatherings
that bring together men and women of
letters to discuss philosophy, art, and
literature. Social spaces in which new
ideas are spread and sites of great cultural
fertility, salons have played an important
role in the political and intellectual
history of France. Salons were generally
presided over by women who were
often themselves writers and left their
own marks on history. Among the most
dazzling of these women were Madeleine
de Scudéry in the 17th century, Julie de
Lespinasse and Germaine de Staël in the
18th, Juliette Récamier and George Sand
in the 19th, and Colette, Anna de Noailles,
and Louise de Vilmorin in the 20th.

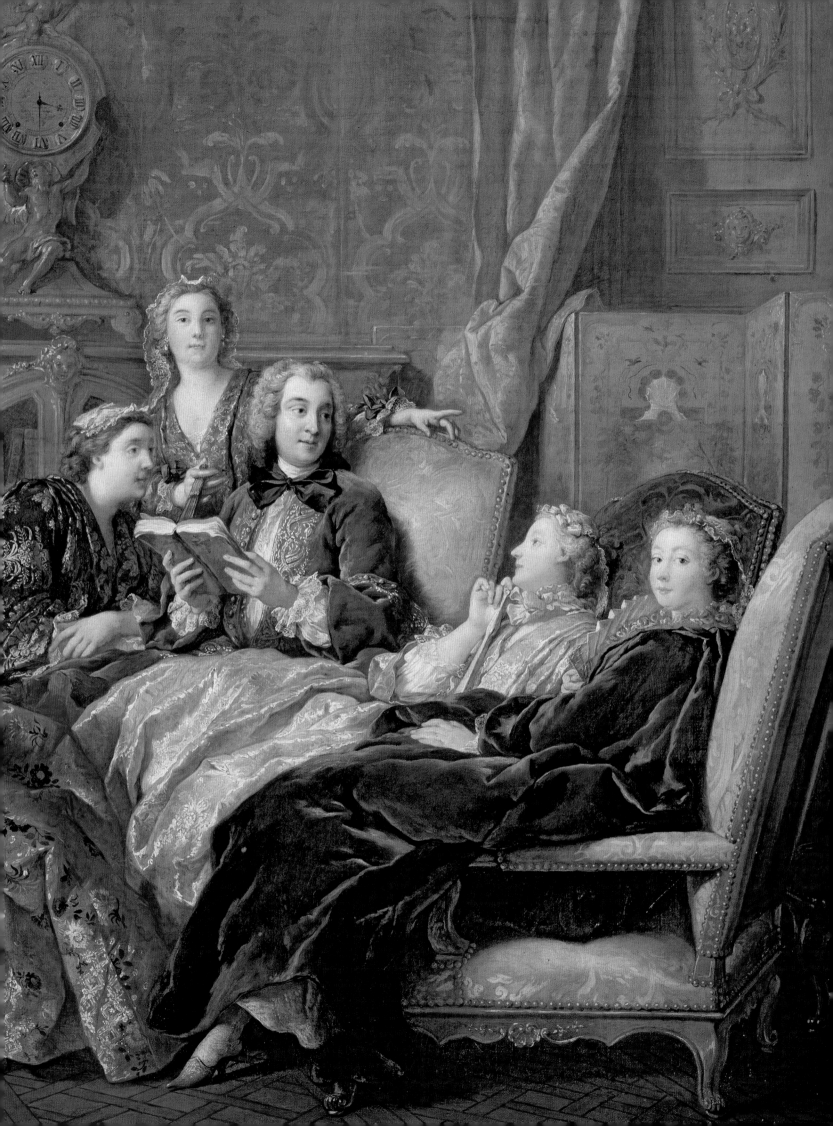

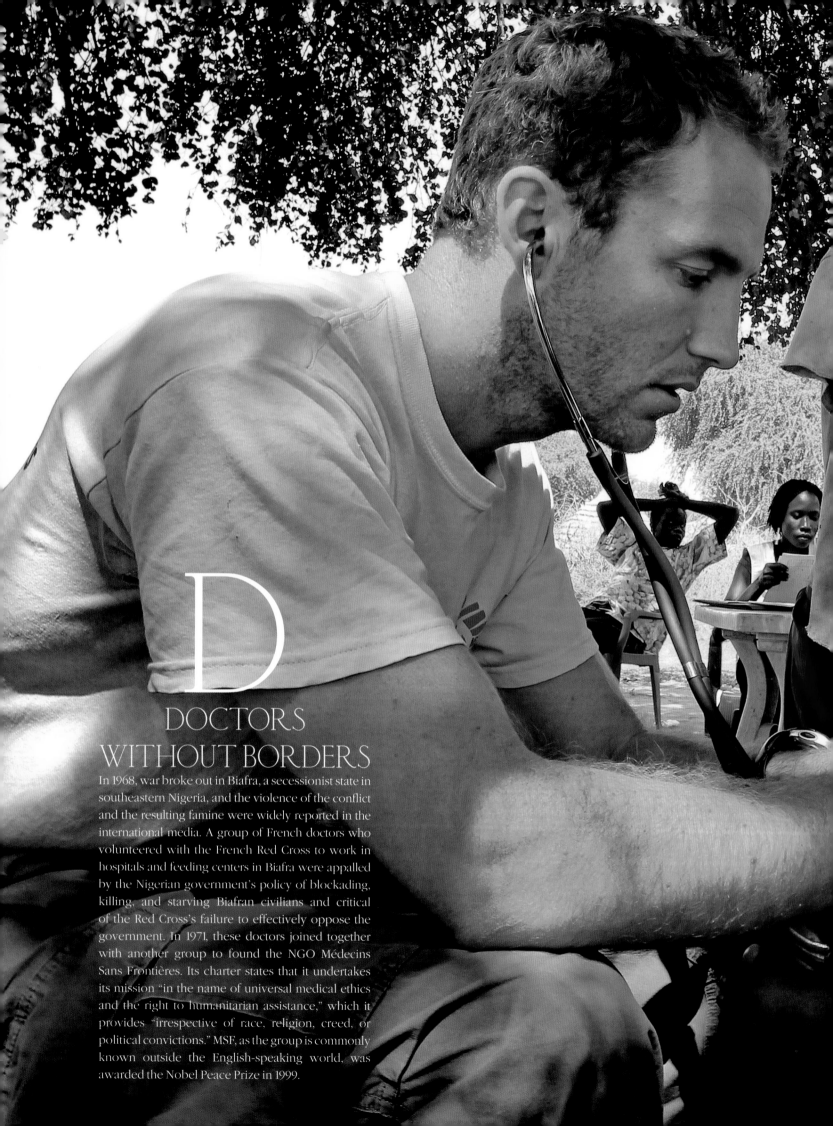

D
DOCTORS WITHOUT BORDERS

In 1968, war broke out in Biafra, a secessionist state in southeastern Nigeria, and the violence of the conflict and the resulting famine were widely reported in the international media. A group of French doctors who volunteered with the French Red Cross to work in hospitals and feeding centers in Biafra were appalled by the Nigerian government's policy of blockading, killing, and starving Biafran civilians and critical of the Red Cross's failure to effectively oppose the government. In 1971, these doctors joined together with another group to found the NGO Médecins Sans Frontières. Its charter states that it undertakes its mission "in the name of universal medical ethics and the right to humanitarian assistance," which it provides "irrespective of race, religion, creed, or political convictions." MSF, as the group is commonly known outside the English-speaking world, was awarded the Nobel Peace Prize in 1999.

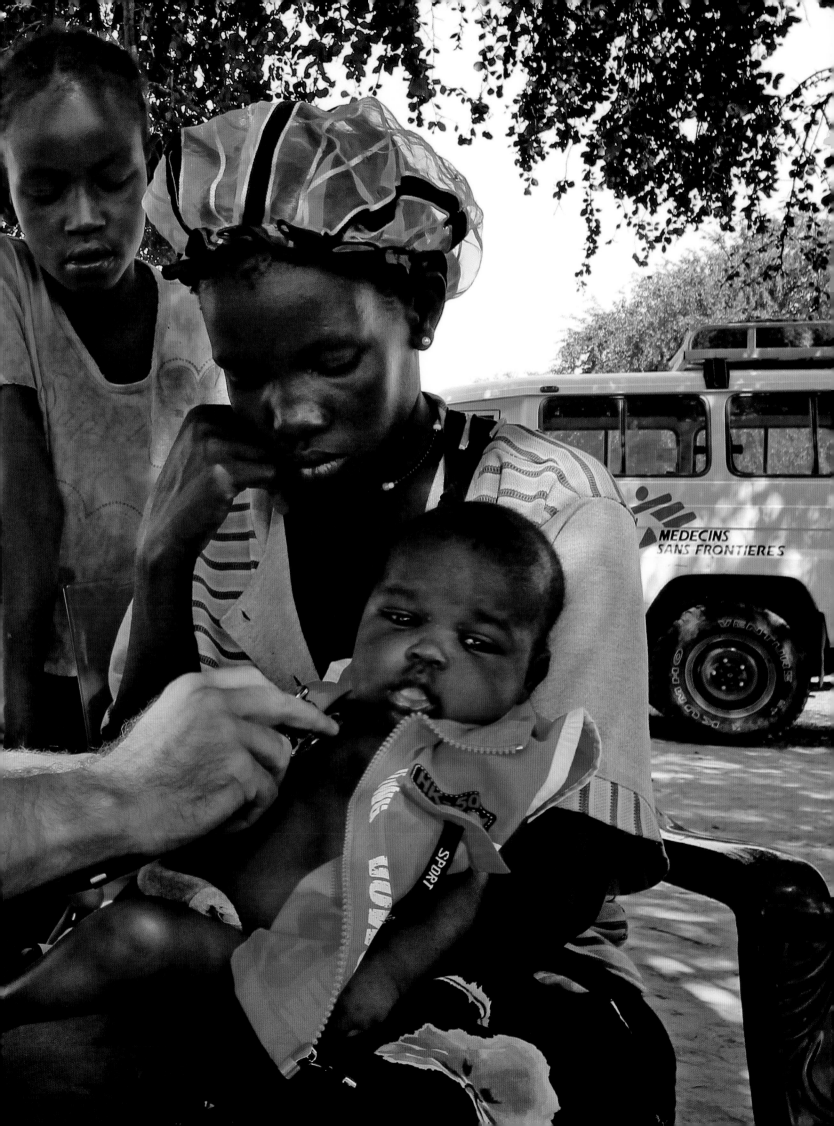

L

LÉGION D'HONNEUR

The French are crazy about honors, which they love both to give and receive. The Légion d'Honneur, instituted in 1802 by Napoleon Bonaparte, is one of the most prestigious. It is awarded in recognition of eminent service, military or civilian, rendered to the French nation by both French citizens and foreign nationals. The Légion d'Honneur is presented in five degrees: Chevalier (Knight), Officier (Officer), Commandeur (Commander), Grand Officier (Grand Officer), and Grand Croix (Grand Cross).

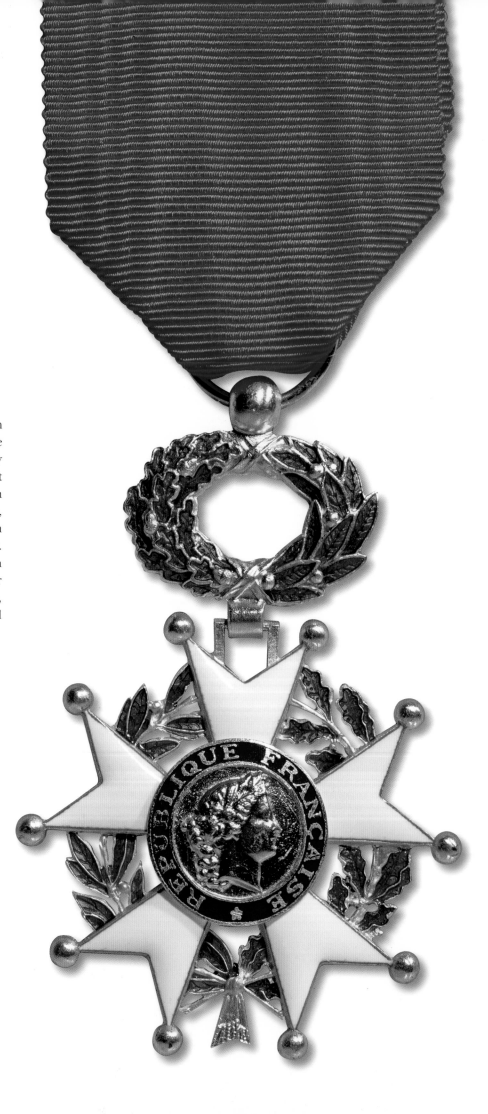

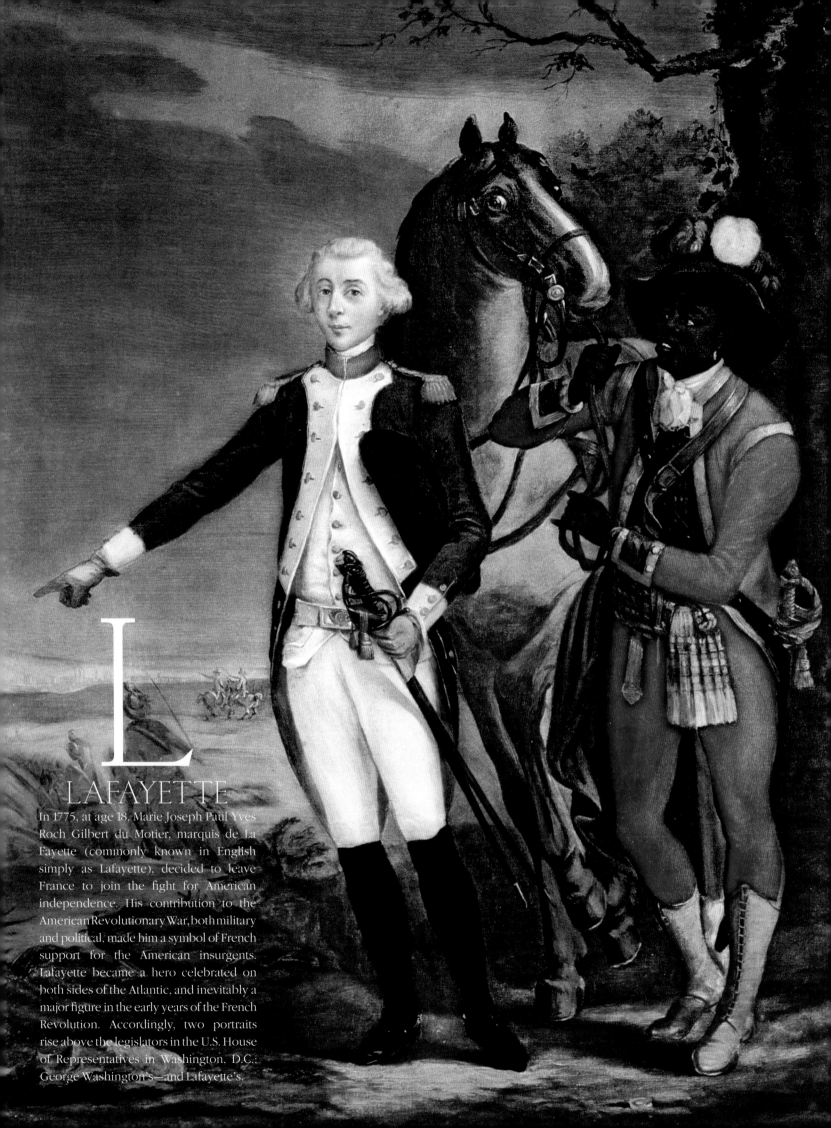

L
LAFAYETTE

In 1775, at age 18, Marie Joseph Paul Yves Roch Gilbert du Motier, marquis de La Fayette (commonly known in English simply as Lafayette), decided to leave France to join the fight for American independence. His contribution to the American Revolutionary War, both military and political, made him a symbol of French support for the American insurgents. Lafayette became a hero celebrated on both sides of the Atlantic, and inevitably a major figure in the early years of the French Revolution. Accordingly, two portraits rise above the legislators in the U.S. House of Representatives in Washington, D.C.: George Washington's—and Lafayette's.

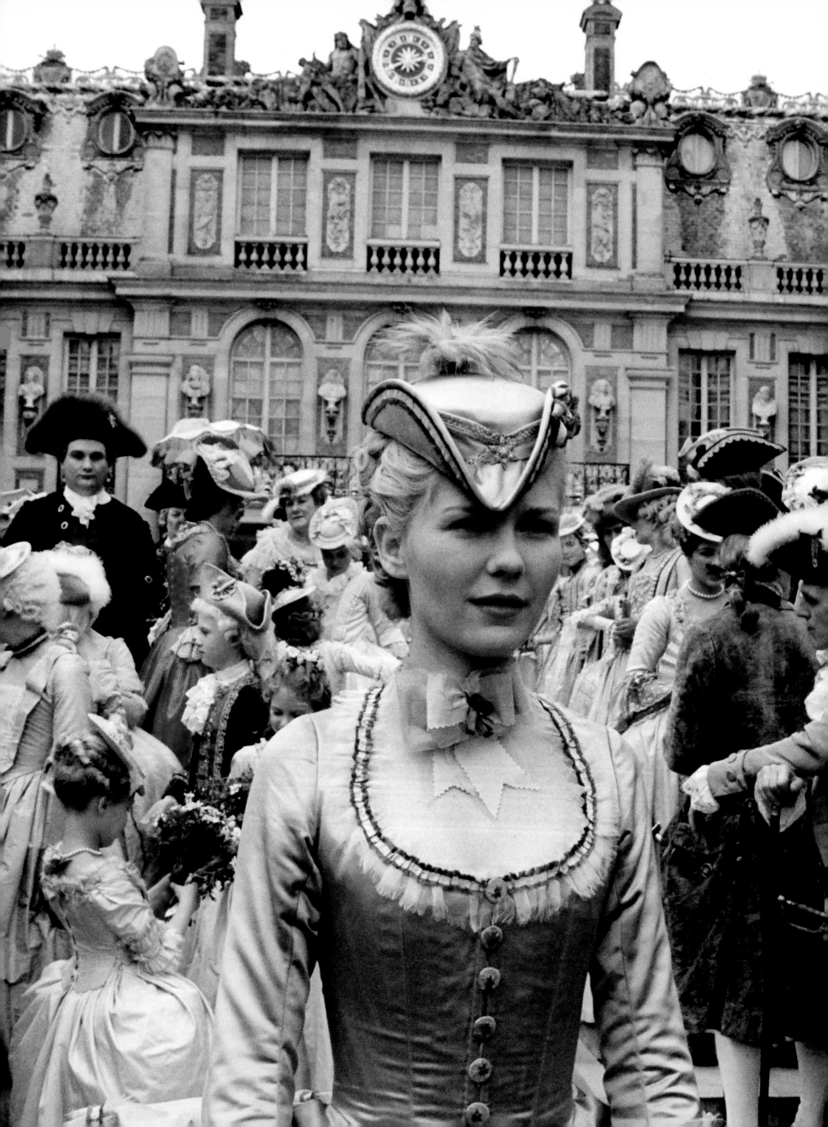

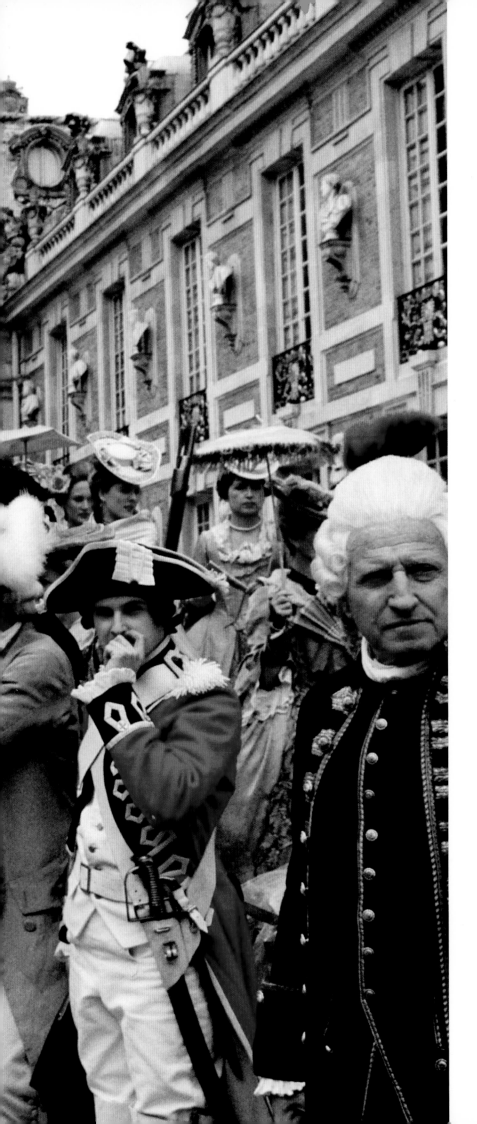

V
VERSAILLES

King Louis XIV installed the French royal court at the Château de Versailles in 1682, enlarging the palace and commanding the construction of the famous Hall of Mirrors, decorated with 357 enormous looking glasses and destined to dazzle visitors for centuries to come. The Sun King also inaugurated a long series of sumptuous royal celebrations that would endure through the reigns of his successors, thus making Versailles a symbol of the splendor (or the ostentatious excess) and the power of the French monarchy—and also of its downfall. In 1789, when the Revolution broke out, the people invaded the palace and forced King Louis XVI and his family to return to Paris, where he was executed in 1793.

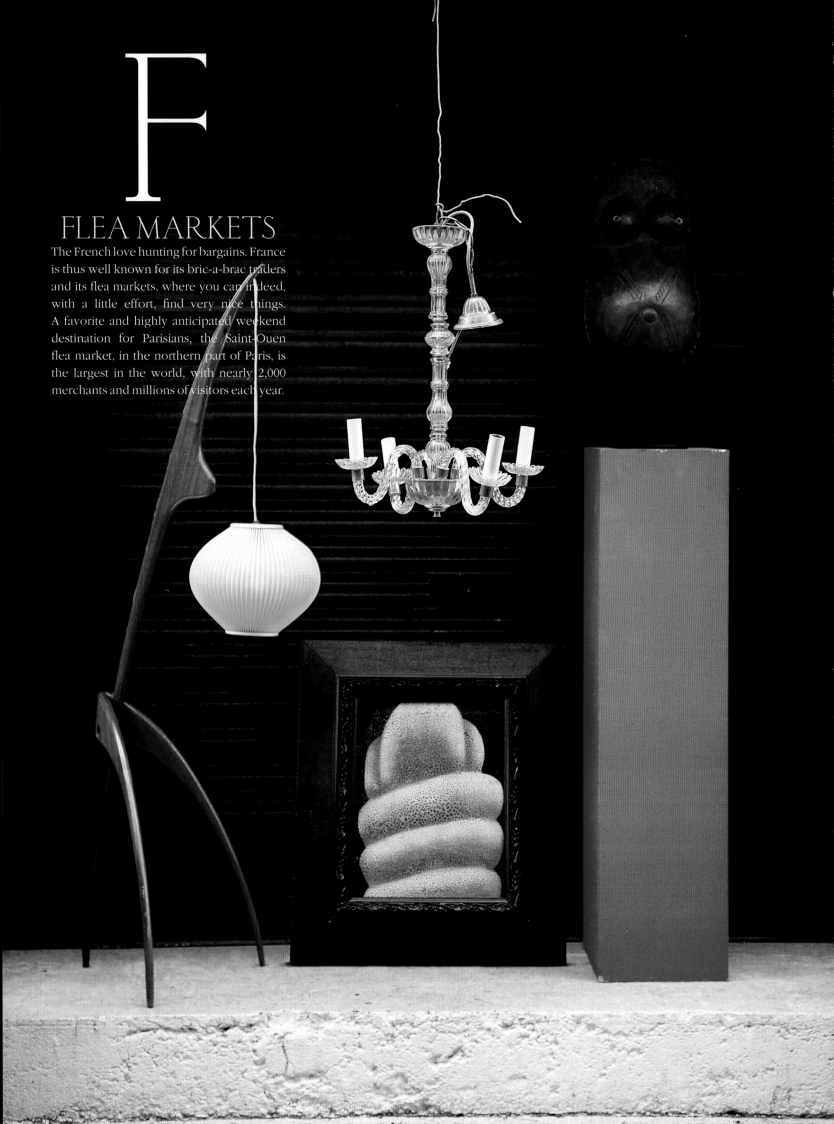

F

FLEA MARKETS

The French love hunting for bargains. France is thus well known for its bric-a-brac traders and its flea markets, where you can indeed, with a little effort, find very nice things. A favorite and highly anticipated weekend destination for Parisians, the Saint-Ouen flea market, in the northern part of Paris, is the largest in the world, with nearly 2,000 merchants and millions of visitors each year.

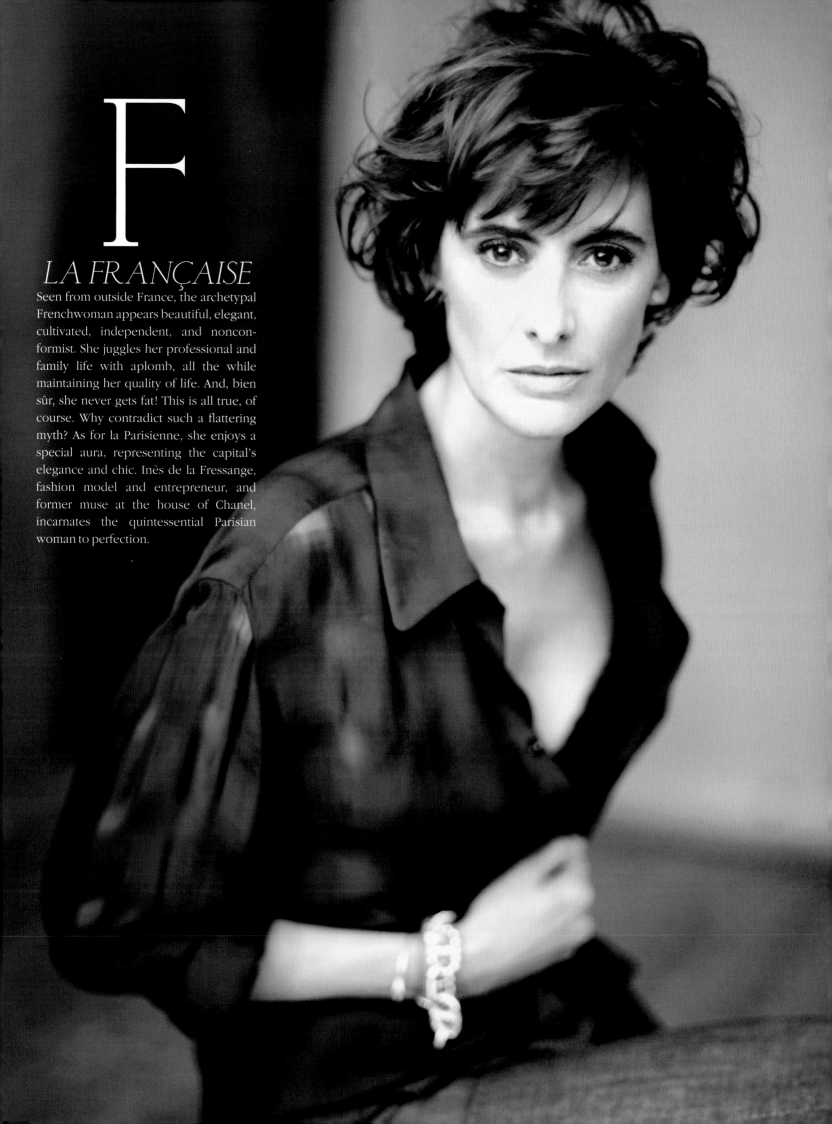

F
LA FRANÇAISE

Seen from outside France, the archetypal Frenchwoman appears beautiful, elegant, cultivated, independent, and nonconformist. She juggles her professional and family life with aplomb, all the while maintaining her quality of life. And, bien sûr, she never gets fat! This is all true, of course. Why contradict such a flattering myth? As for la Parisienne, she enjoys a special aura, representing the capital's elegance and chic. Inès de la Fressange, fashion model and entrepreneur, and former muse at the house of Chanel, incarnates the quintessential Parisian woman to perfection.

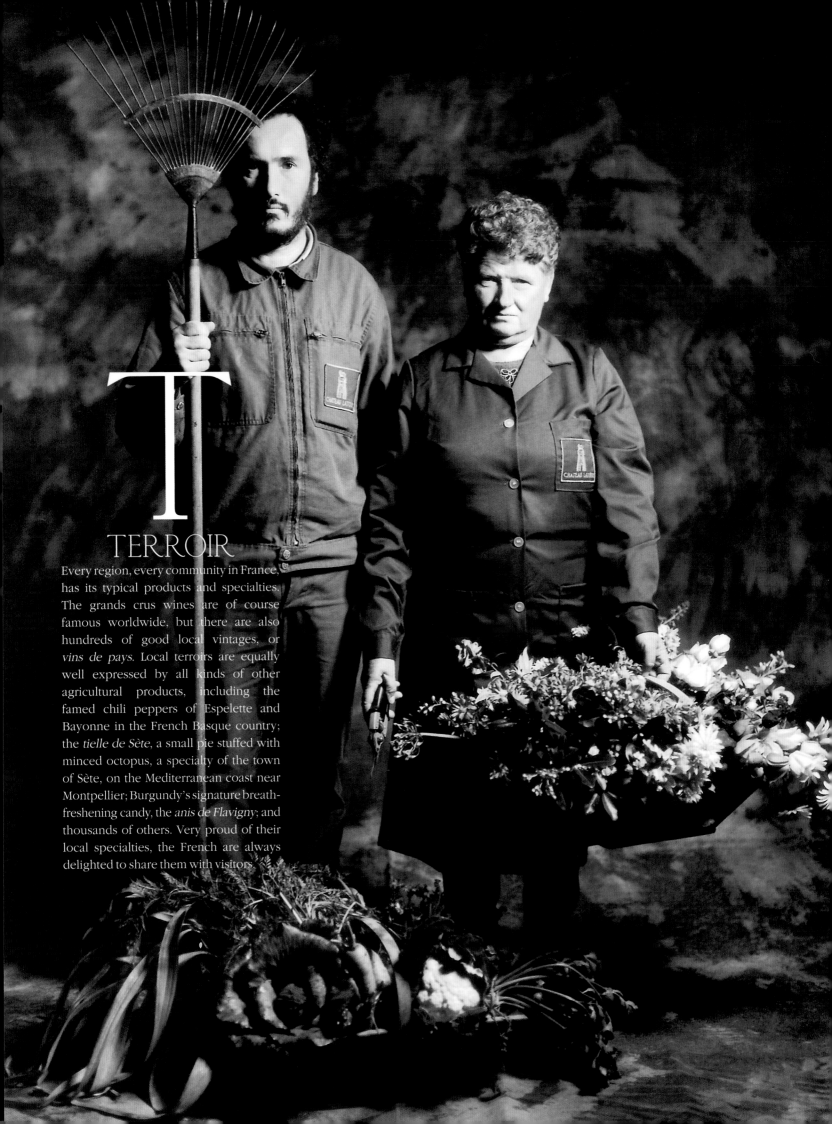

T

TERROIR

Every region, every community in France, has its typical products and specialties. The grands crus wines are of course famous worldwide, but there are also hundreds of good local vintages, or *vins de pays*. Local terroirs are equally well expressed by all kinds of other agricultural products, including the famed chili peppers of Espelette and Bayonne in the French Basque country; the *tielle de Sète*, a small pie stuffed with minced octopus, a specialty of the town of Sète, on the Mediterranean coast near Montpellier; Burgundy's signature breath-freshening candy, the *anis de Flavigny*; and thousands of others. Very proud of their local specialties, the French are always delighted to share them with visitors.

L

LVMH

Founded in 1987 with the merger of the high-end leather goods company Louis Vuitton and Moët Hennessy (champagne and cognac), the LVMH group is the world's leading manufacturer of luxury goods. Directed today by Bernard Arnault, LVMH includes nearly 60 prestigious brands, such as Dior, Guerlain, Berluti (custom footwear), and Dom Pérignon, with more than 3,000 retail outlets around the world.

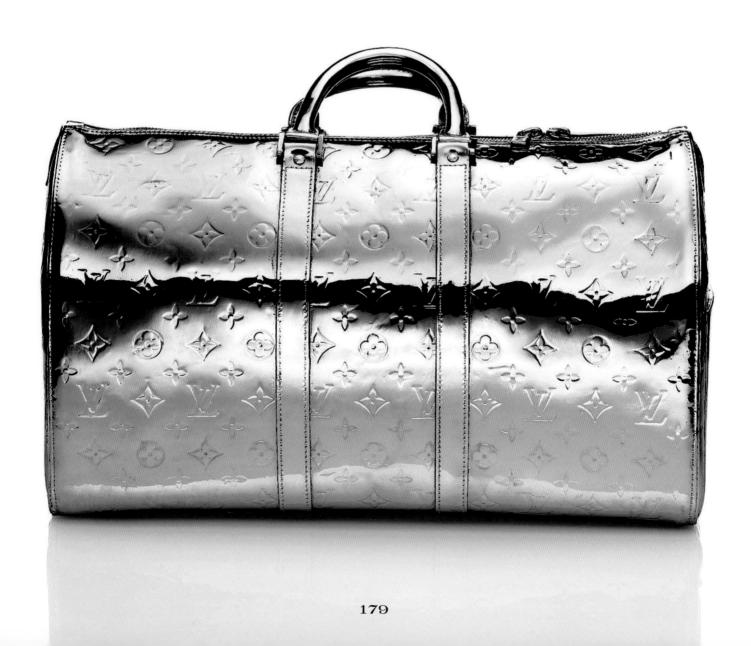

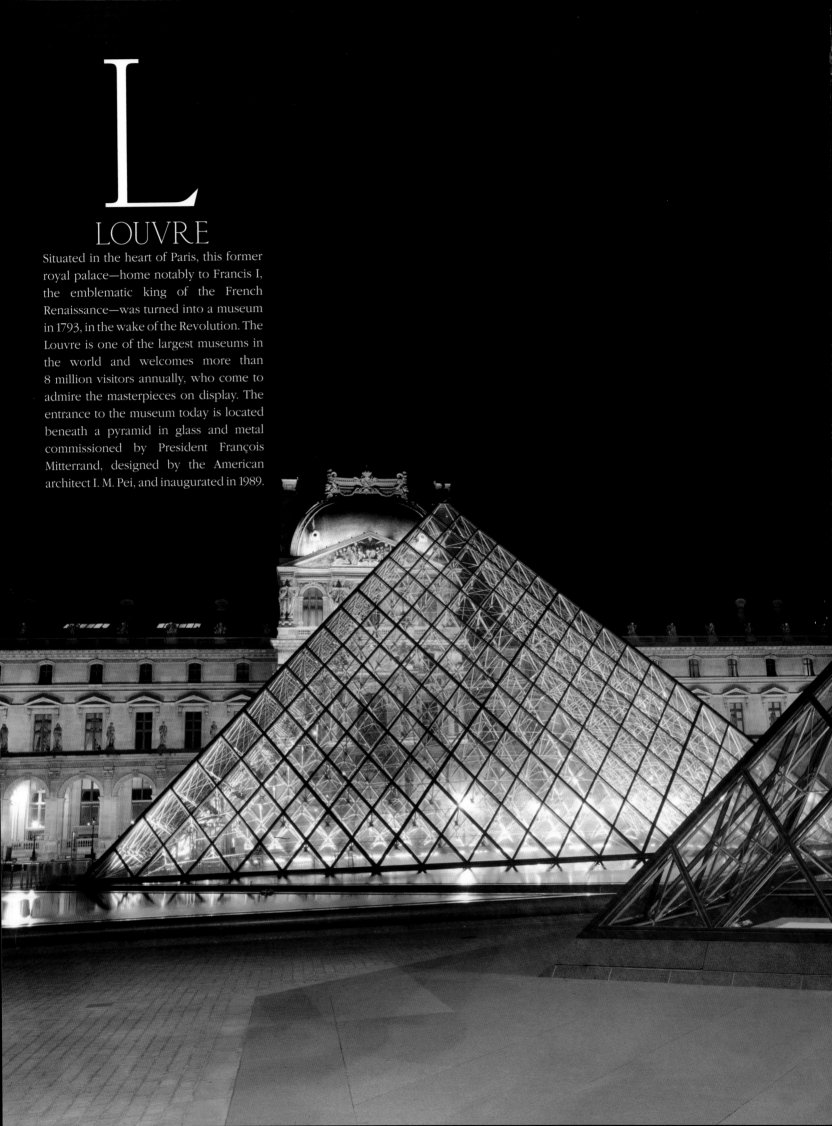

L
LOUVRE

Situated in the heart of Paris, this former royal palace—home notably to Francis I, the emblematic king of the French Renaissance—was turned into a museum in 1793, in the wake of the Revolution. The Louvre is one of the largest museums in the world and welcomes more than 8 million visitors annually, who come to admire the masterpieces on display. The entrance to the museum today is located beneath a pyramid in glass and metal commissioned by President François Mitterrand, designed by the American architect I. M. Pei, and inaugurated in 1989.

ART OF THE TABLE

According to the rules of the *art de la table*, beyond setting an attractive table, offering guests a gracious welcome, presenting each course properly, and mastering the hierarchy of cutlery, a host or hostess must also be adept at arranging the guests themselves. Since the introduction of the fork to the French court in the 16th century by Catherine de' Medici, who brought with her the manners of the Italian Renaissance when she married Henri II of France, the French have invented an arsenal of highly specialized implements to enhance the art of food. The most famous French producers of luxury tableware, such as Baccarat, Christofle, Lalique, Saint-Louis, and Sèvres, have become synonyms for refinement in the art of hospitality.

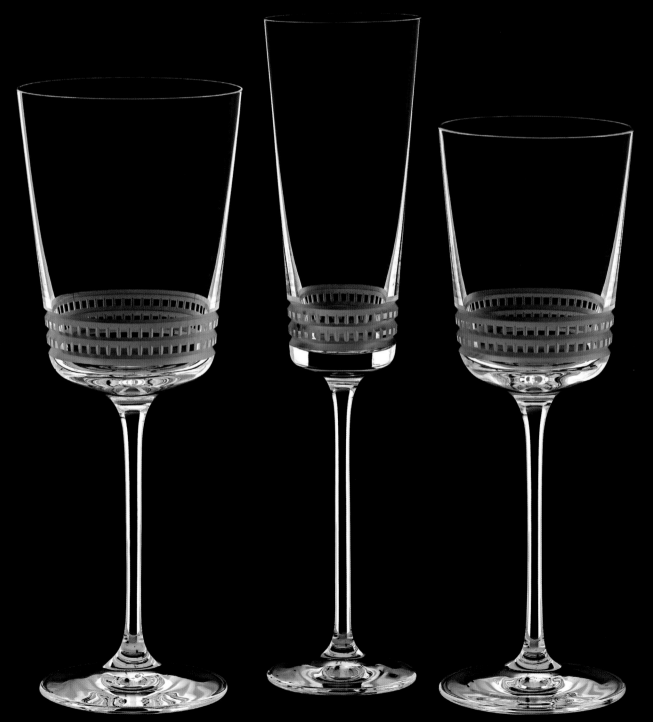

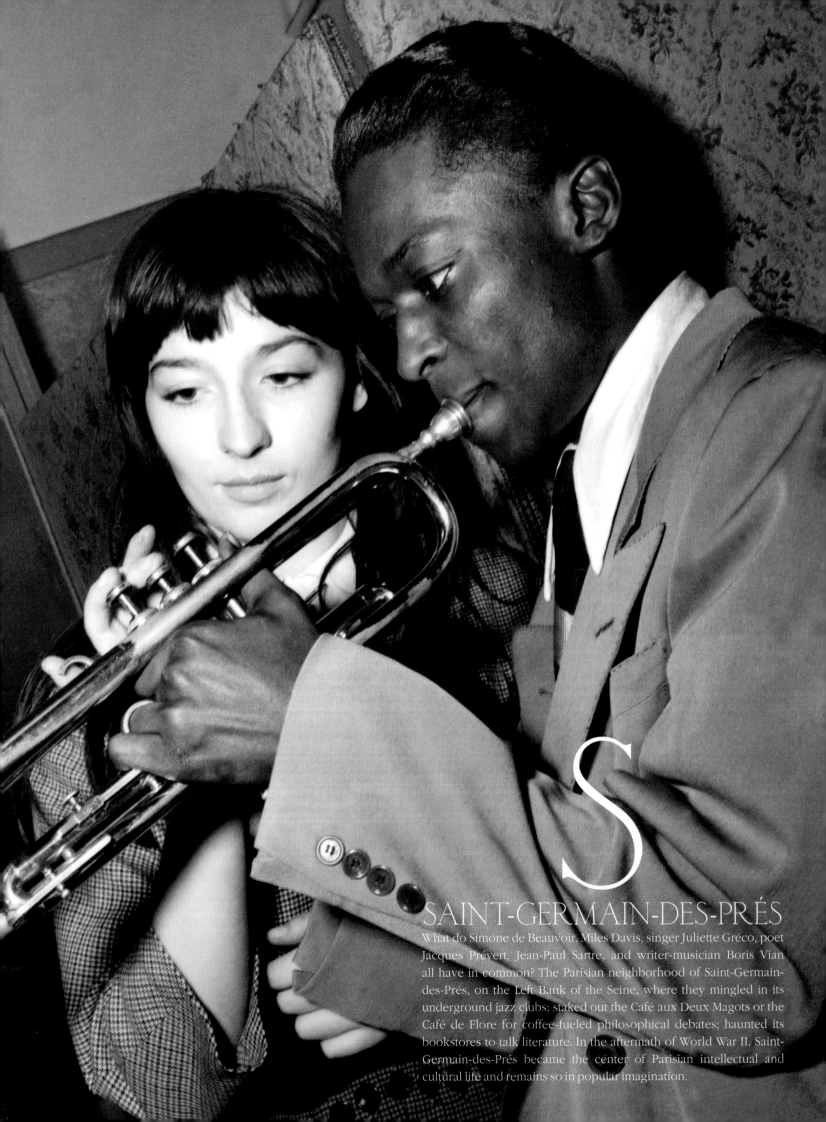

S
SAINT-GERMAIN-DES-PRÉS

What do Simone de Beauvoir, Miles Davis, singer Juliette Gréco, poet Jacques Prévert, Jean-Paul Sartre, and writer-musician Boris Vian all have in common? The Parisian neighborhood of Saint-Germain-des-Prés, on the Left Bank of the Seine, where they mingled in its underground jazz clubs; staked out the Café aux Deux Magots or the Café de Flore for coffee-fueled philosophical debates; haunted its bookstores to talk literature. In the aftermath of World War II, Saint-Germain-des-Prés became the center of Parisian intellectual and cultural life and remains so in popular imagination.

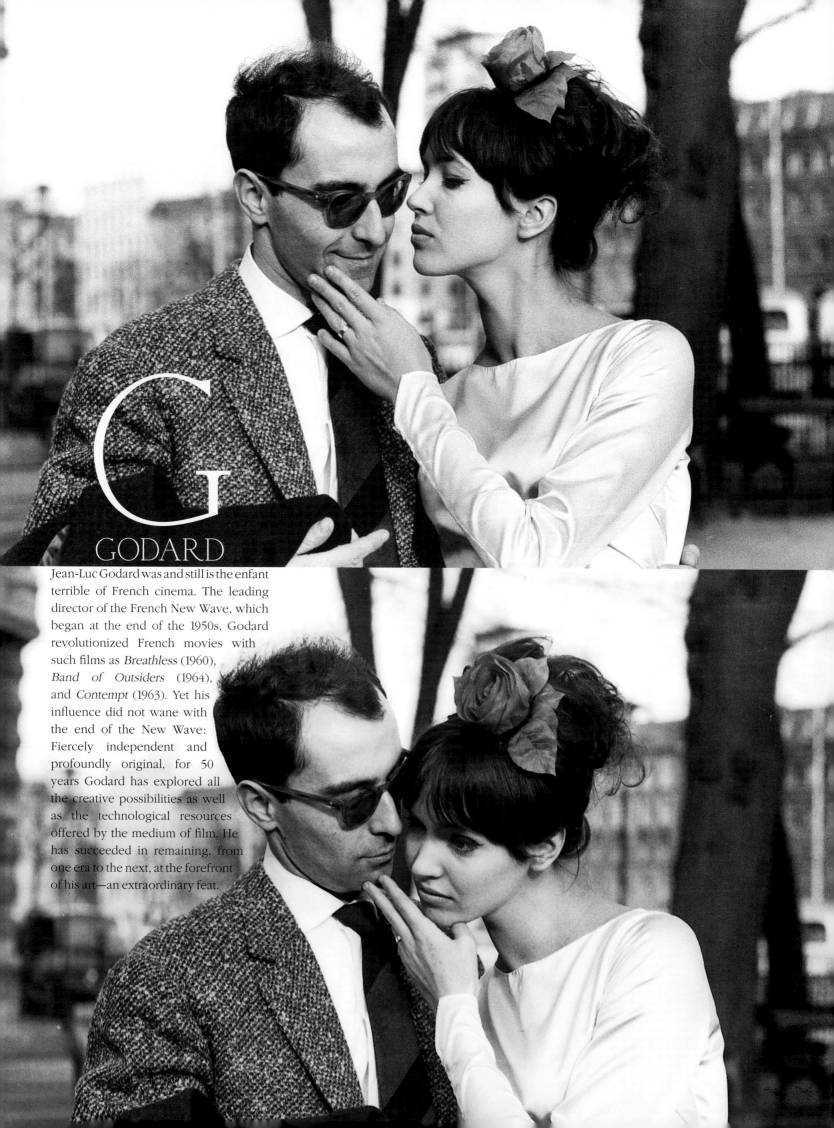

G
GODARD

Jean-Luc Godard was and still is the enfant terrible of French cinema. The leading director of the French New Wave, which began at the end of the 1950s, Godard revolutionized French movies with such films as *Breathless* (1960), *Band of Outsiders* (1964), and *Contempt* (1963). Yet his influence did not wane with the end of the New Wave: Fiercely independent and profoundly original, for 50 years Godard has explored all the creative possibilities as well as the technological resources offered by the medium of film. He has succeeded in remaining, from one era to the next, at the forefront of his art—an extraordinary feat.

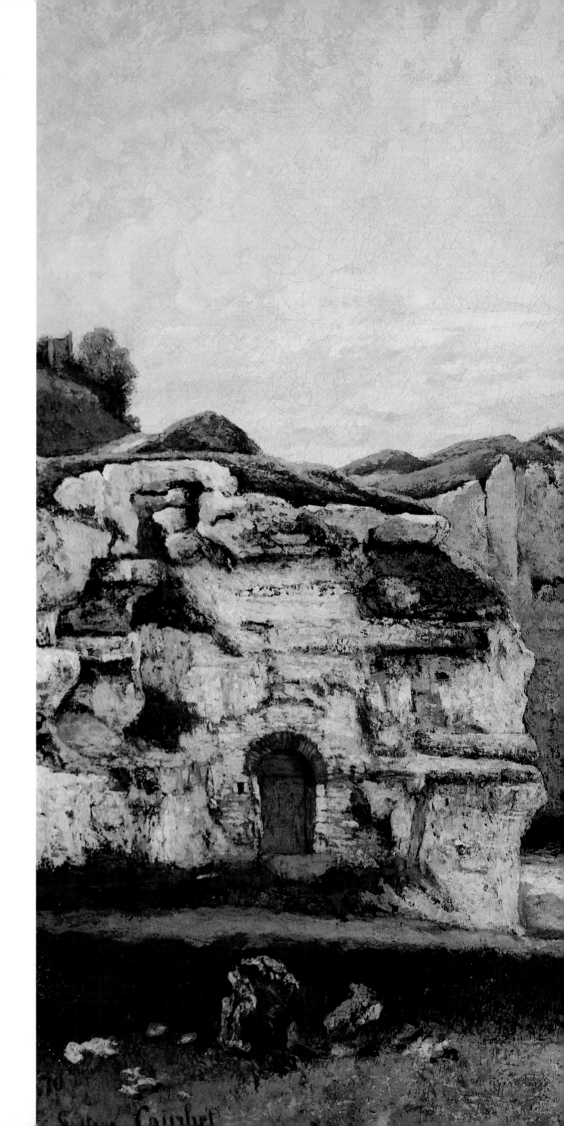

E
ÉTRETAT

With coastlines extending more than 7,000 kilometers (4,350 miles), France is a country lapped on three sides by water: In the north, by the North Sea and the English Channel; to the west, by the Atlantic; and in the south, by the Mediterranean. Each coast offers very lovely destinations, and one of the finest is the monumental cliffs of Étretat, in Normandy, whose three famous arches and pointed "needle," sculpted by the erosive force of the ocean tides, have been immortalized on canvas by such painters as Gustave Courbet and Claude Monet.

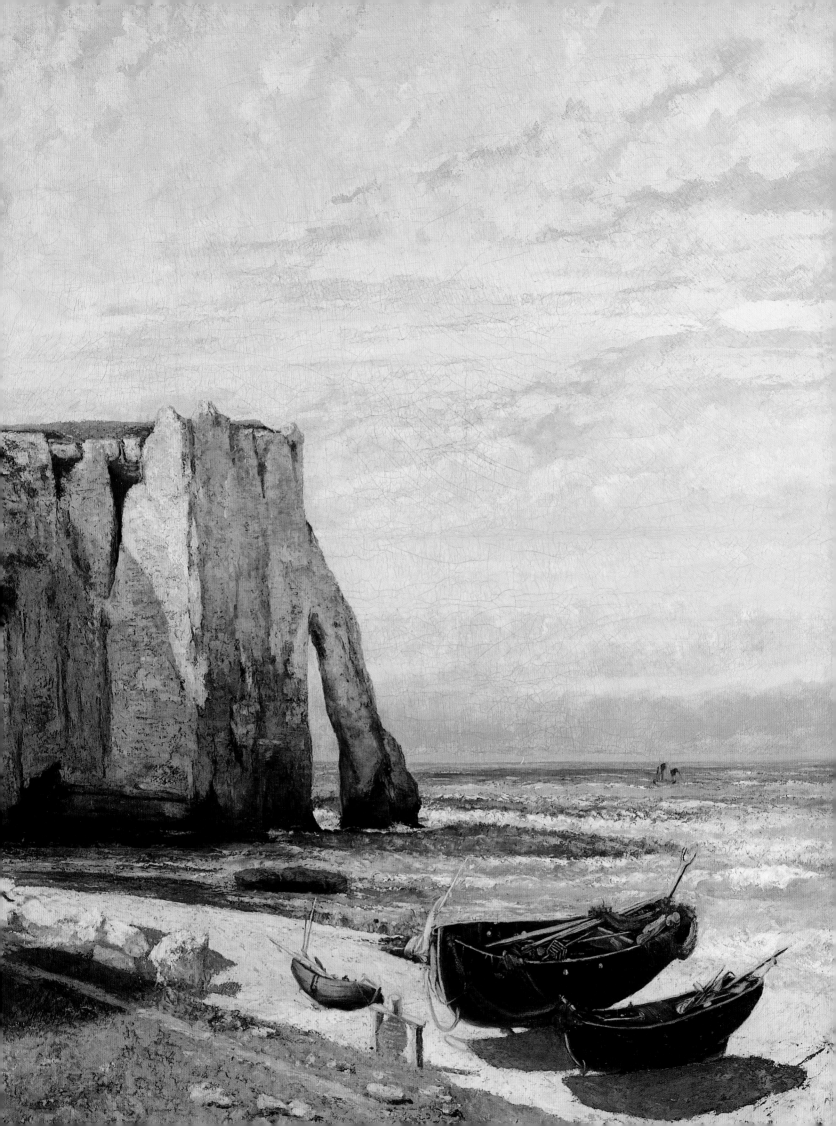

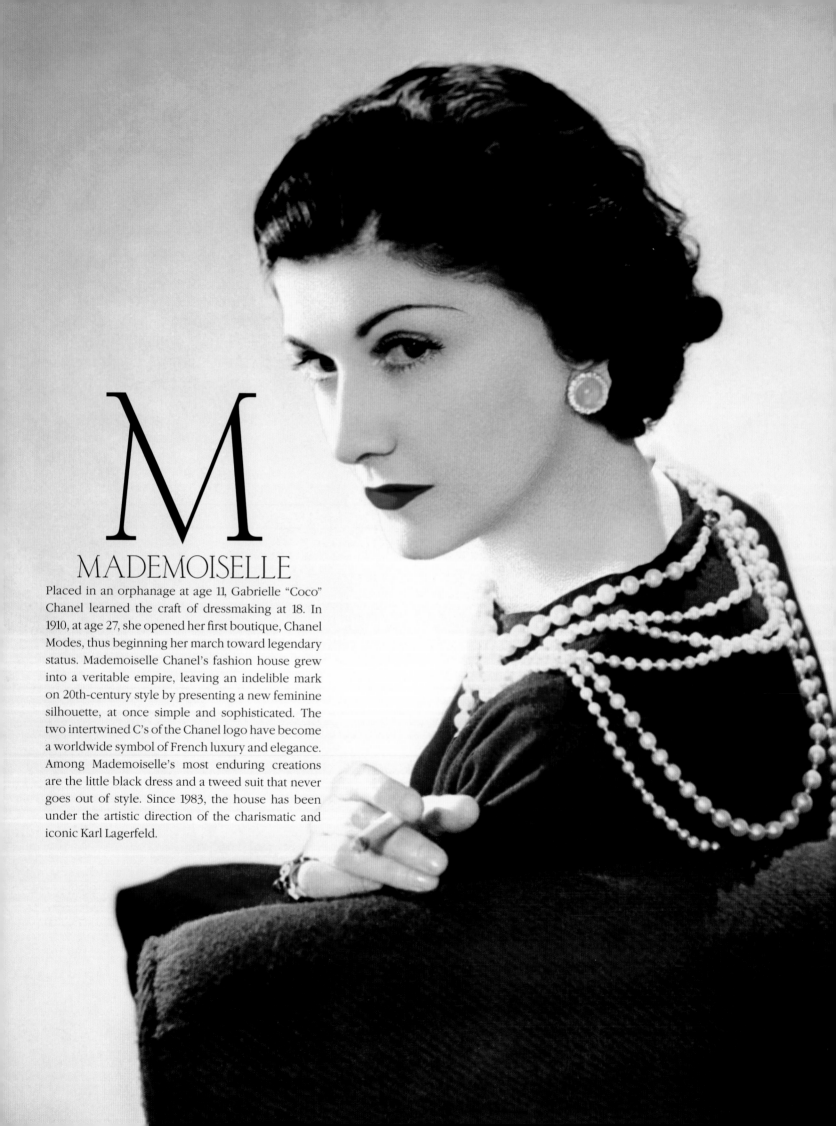

M

MADEMOISELLE

Placed in an orphanage at age 11, Gabrielle "Coco" Chanel learned the craft of dressmaking at 18. In 1910, at age 27, she opened her first boutique, Chanel Modes, thus beginning her march toward legendary status. Mademoiselle Chanel's fashion house grew into a veritable empire, leaving an indelible mark on 20th-century style by presenting a new feminine silhouette, at once simple and sophisticated. The two intertwined C's of the Chanel logo have become a worldwide symbol of French luxury and elegance. Among Mademoiselle's most enduring creations are the little black dress and a tweed suit that never goes out of style. Since 1983, the house has been under the artistic direction of the charismatic and iconic Karl Lagerfeld.

ELLE

www.elle.fr

**VESTES
BLOUSES
MARINIÈRES
SHORTS...**

PORTEZ-LES CHIC OU BRANCHÉ

DÉTOX
ANTI-KILOS
UNE SEMAINE POUR S'ALLÉGER FACILE

BONS PLANS SKI
LA MONTAGNE À PETIT PRIX

FAUSSE PANTHÈRE
VRAI GLAMOUR DEVENEZ
UNE BÊTE DE MODE !

LE TOUR DU MONDE DES SPAS
LES PETITS PARADIS DU BIEN-ÊTRE

ADIEU JAMES BOND
LE NOUVEAU DANIEL CRAIG

IRAN LA VOIX DES FEMMES QU'ON VEUT FAIRE TAIRE

SOPHIE MARCEAU
"UN RIEN ME REND HEUREUSE"

E

ELLE

Created in 1945 at the instigation of Hélène Lazareff, by women, for women, *Elle* magazine conquered France and indeed the whole world, with its 42 international editions and millions of readers. Fusing guilt-free glamour and committed feminism, Elle succeeds in creating a synthesis that is typically French. This cover features actress Sophie Marceau, a favorite French female personality from the age of 14.

M 01648 - 3288 - F: 2,30 €

HEBDOMADAIRE. 3 JANVIER 2009

FRANCE MÉTROPOLITAINE 2,30 €. DOM avion 5 €. BEL 2,50 €. CH 4,90 FS. A 4,20 €. ALG 370 DA. AND 2,30 €. CDN $ 5.50. D 4,20 €. ESP 3,50 €. FIN 5,50 €. GB £ 2.85. GR 4,40 €. IRL 4,40 €. ITA 3,50 €. LUX 2,50 €. MAR 32 DH. NC 1 200 F. CFP. NL 4,20 €. POLY. FR 1 400 F. CFP. PORT cont 3,50 €. TUN 4,20 DT. USA 5.50.

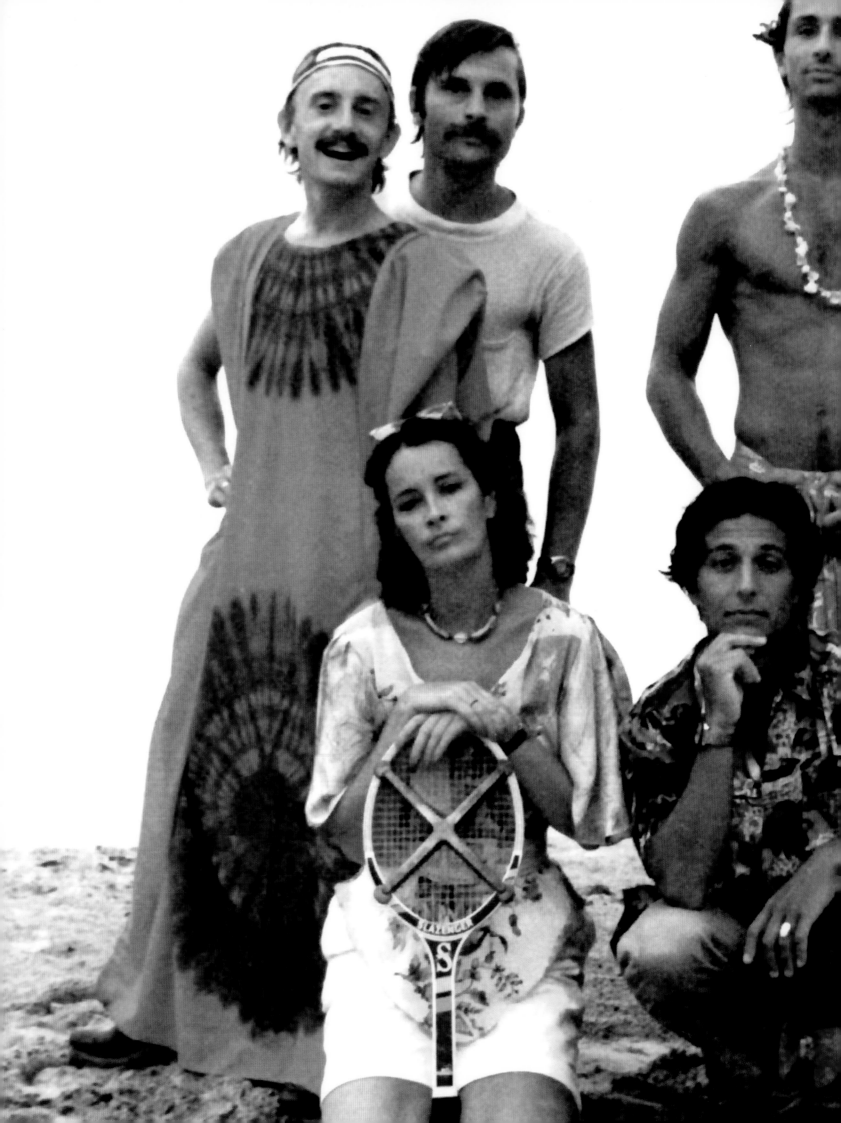

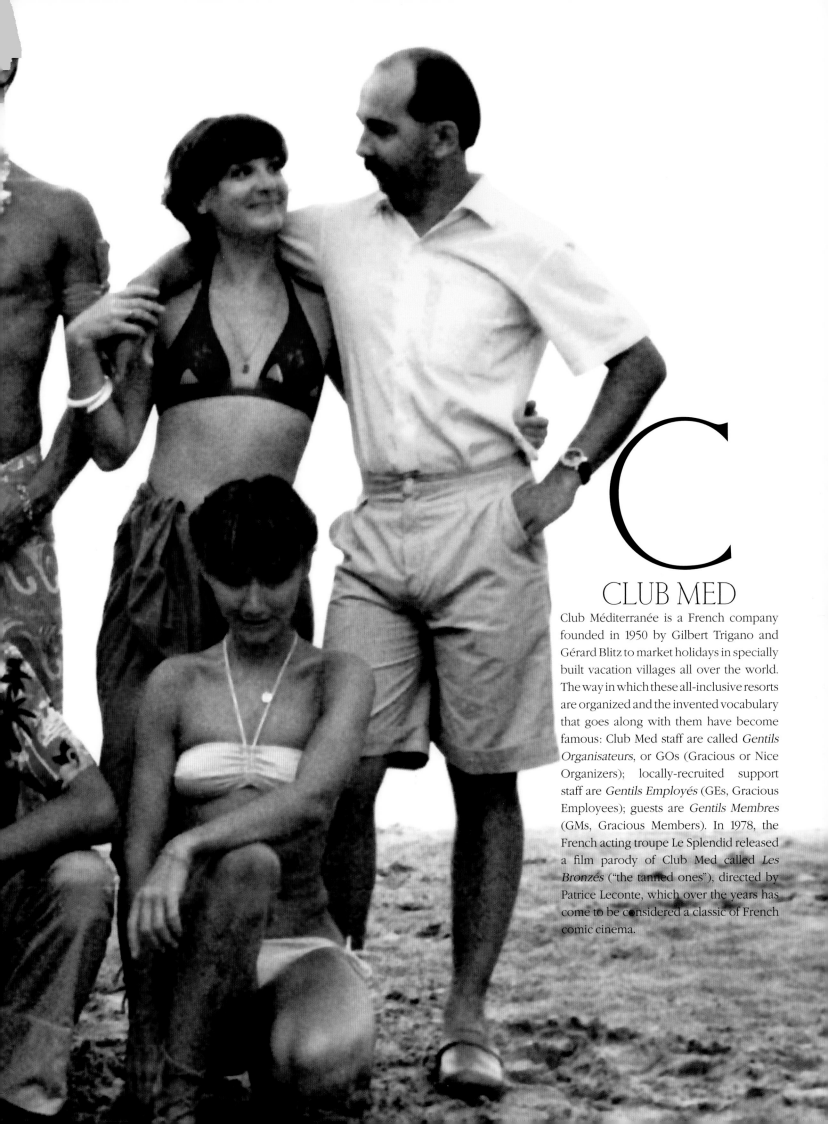

C
CLUB MED

Club Méditerranée is a French company founded in 1950 by Gilbert Trigano and Gérard Blitz to market holidays in specially built vacation villages all over the world. The way in which these all-inclusive resorts are organized and the invented vocabulary that goes along with them have become famous: Club Med staff are called *Gentils Organisateurs*, or GOs (Gracious or Nice Organizers); locally-recruited support staff are *Gentils Employés* (GEs, Gracious Employees); guests are *Gentils Membres* (GMs, Gracious Members). In 1978, the French acting troupe Le Splendid released a film parody of Club Med called *Les Bronzés* ("the tanned ones"), directed by Patrice Leconte, which over the years has come to be considered a classic of French comic cinema.

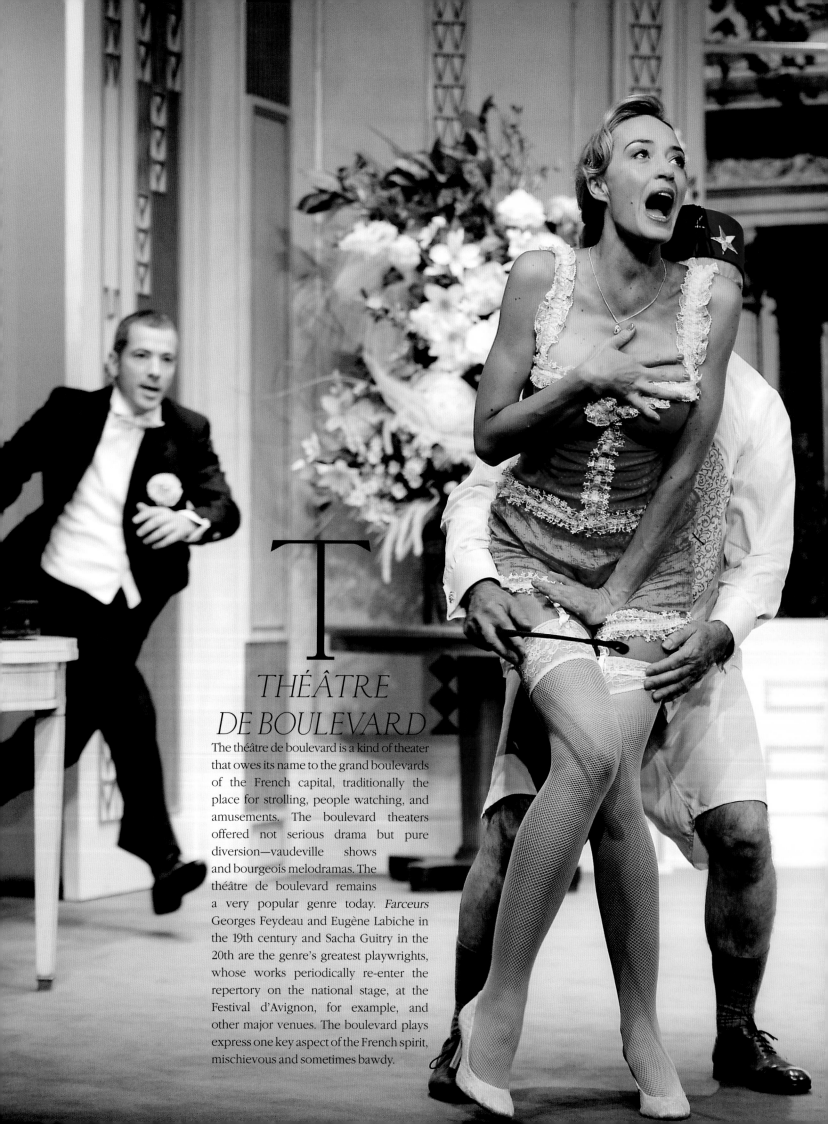

T

THÉÂTRE DE BOULEVARD

The théâtre de boulevard is a kind of theater that owes its name to the grand boulevards of the French capital, traditionally the place for strolling, people watching, and amusements. The boulevard theaters offered not serious drama but pure diversion—vaudeville shows and bourgeois melodramas. The théâtre de boulevard remains a very popular genre today. *Farceurs* Georges Feydeau and Eugène Labiche in the 19th century and Sacha Guitry in the 20th are the genre's greatest playwrights, whose works periodically re-enter the repertory on the national stage, at the Festival d'Avignon, for example, and other major venues. The boulevard plays express one key aspect of the French spirit, mischievous and sometimes bawdy.

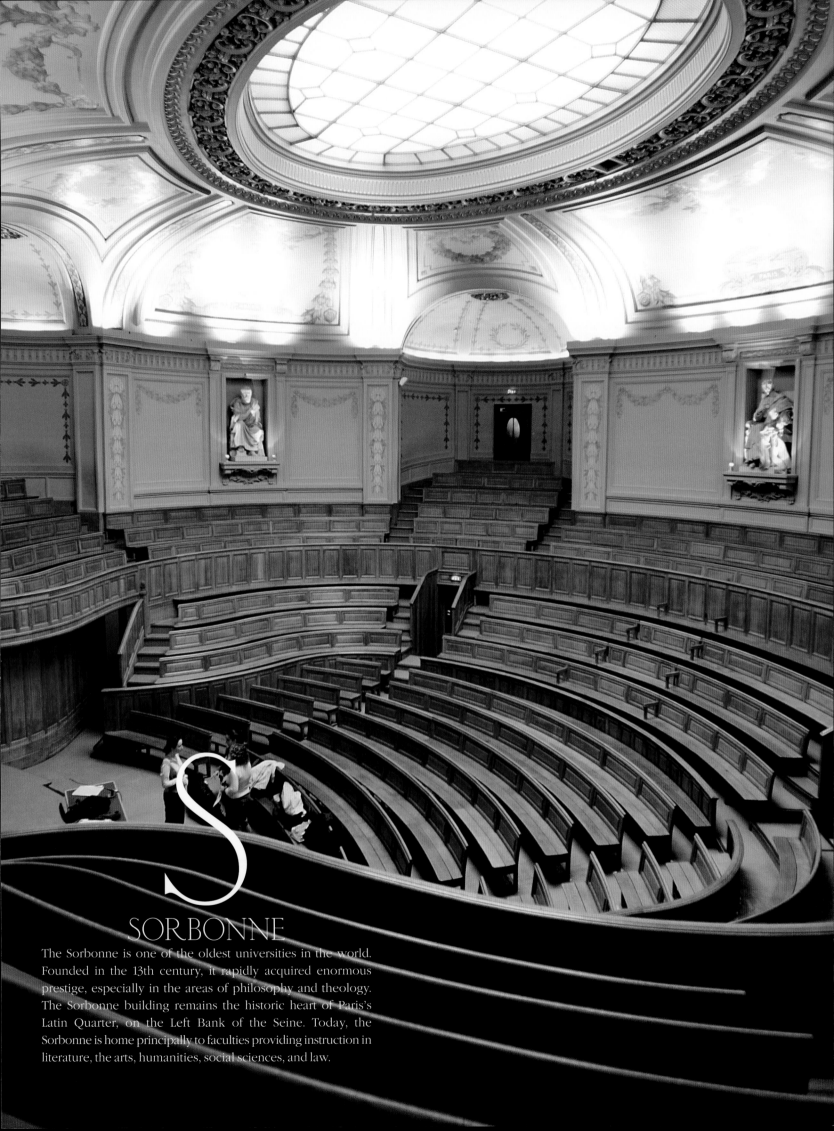

SORBONNE

The Sorbonne is one of the oldest universities in the world. Founded in the 13th century, it rapidly acquired enormous prestige, especially in the areas of philosophy and theology. The Sorbonne building remains the historic heart of Paris's Latin Quarter, on the Left Bank of the Seine. Today, the Sorbonne is home principally to faculties providing instruction in literature, the arts, humanities, social sciences, and law.

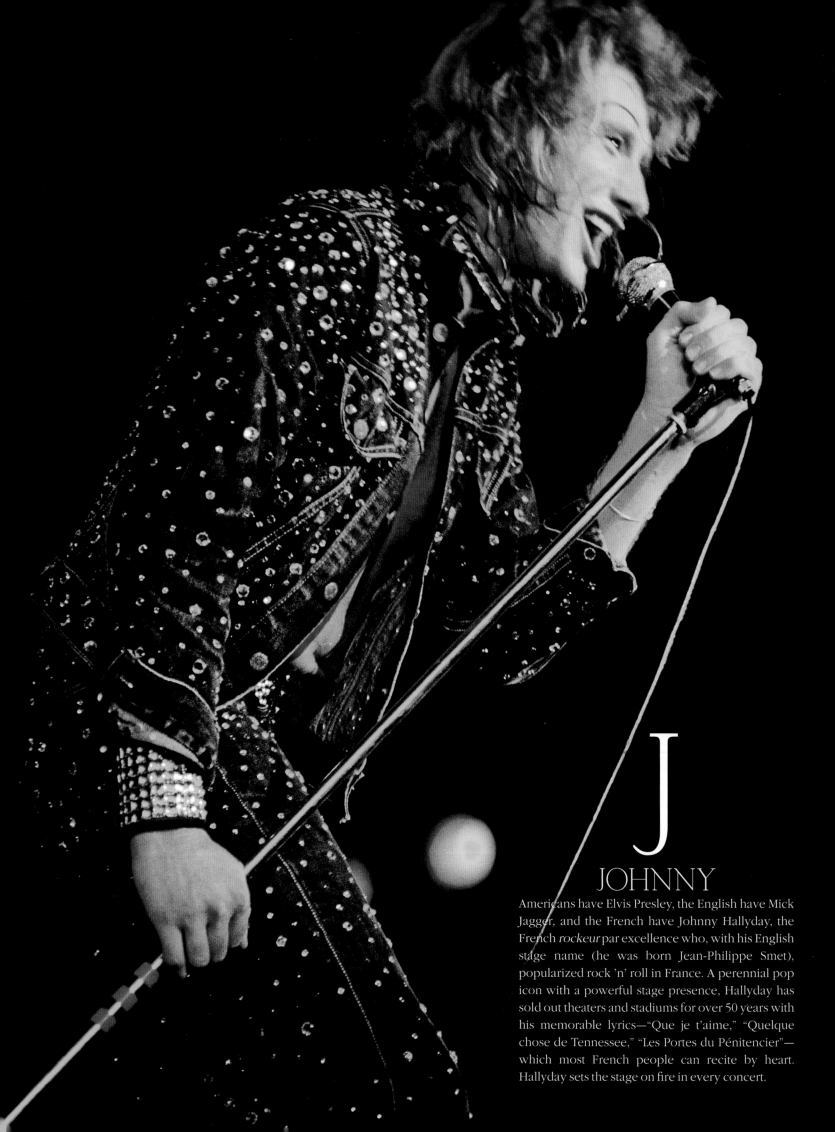

J

JOHNNY

Americans have Elvis Presley, the English have Mick Jagger, and the French have Johnny Hallyday, the French *rockeur* par excellence who, with his English stage name (he was born Jean-Philippe Smet), popularized rock 'n' roll in France. A perennial pop icon with a powerful stage presence, Hallyday has sold out theaters and stadiums for over 50 years with his memorable lyrics—"Que je t'aime," "Quelque chose de Tennessee," "Les Portes du Pénitencier"—which most French people can recite by heart. Hallyday sets the stage on fire in every concert.

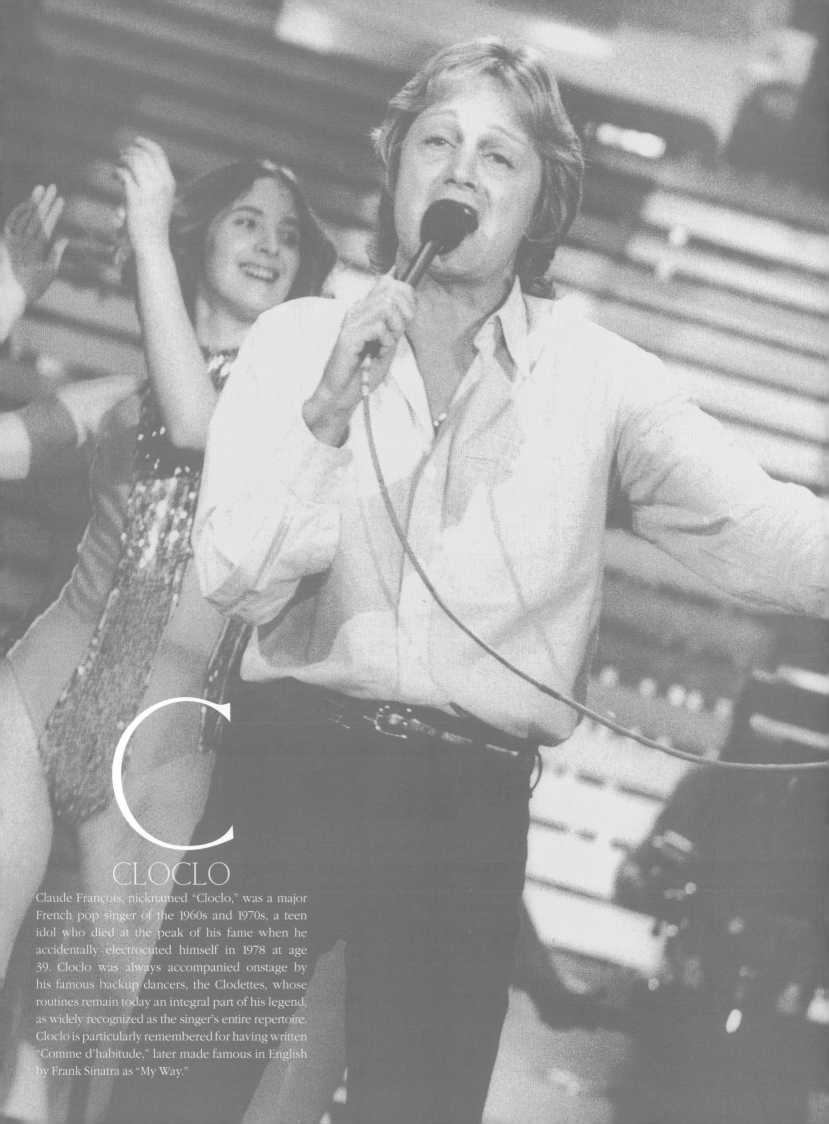

C
CLOCLO

Claude François, nicknamed "Cloclo," was a major French pop singer of the 1960s and 1970s, a teen idol who died at the peak of his fame when he accidentally electrocuted himself in 1978 at age 39. Cloclo was always accompanied onstage by his famous backup dancers, the Clodettes, whose routines remain today an integral part of his legend, as widely recognized as the singer's entire repertoire. Cloclo is particularly remembered for having written "Comme d'habitude," later made famous in English by Frank Sinatra as "My Way."

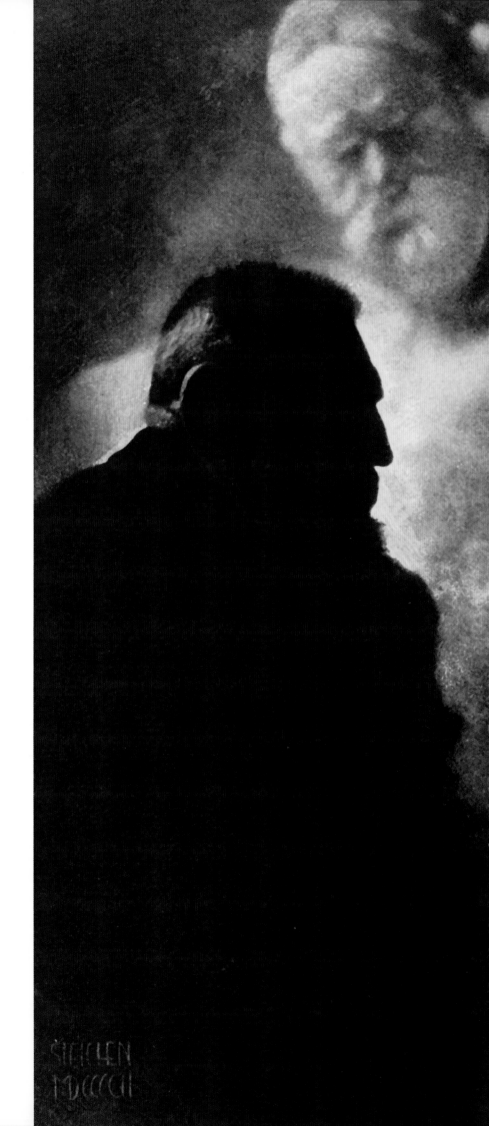

T
THINKERS

The Thinker (1903), perhaps the best-known work of sculptor Auguste Rodin, shown here posing with his creation, is an iconic image of the philosopher, the poet, and the artist all at once. Bought in 1906 by the city of Paris through a campaign soliciting public donations, this bronze statue, which is housed today in the capital's Rodin Museum, was originally installed in front of the Pantheon, that monument to the great figures of the French republic. This initial choice for the statue's placement is revealing: France loves to celebrate above all the works of its thinkers, from Montaigne and Pascal to Claude Lévi-Strauss, Roland Barthes, and Julia Kristeva, who are not only symbols of French cultural identity, but also repositories of universal messages.

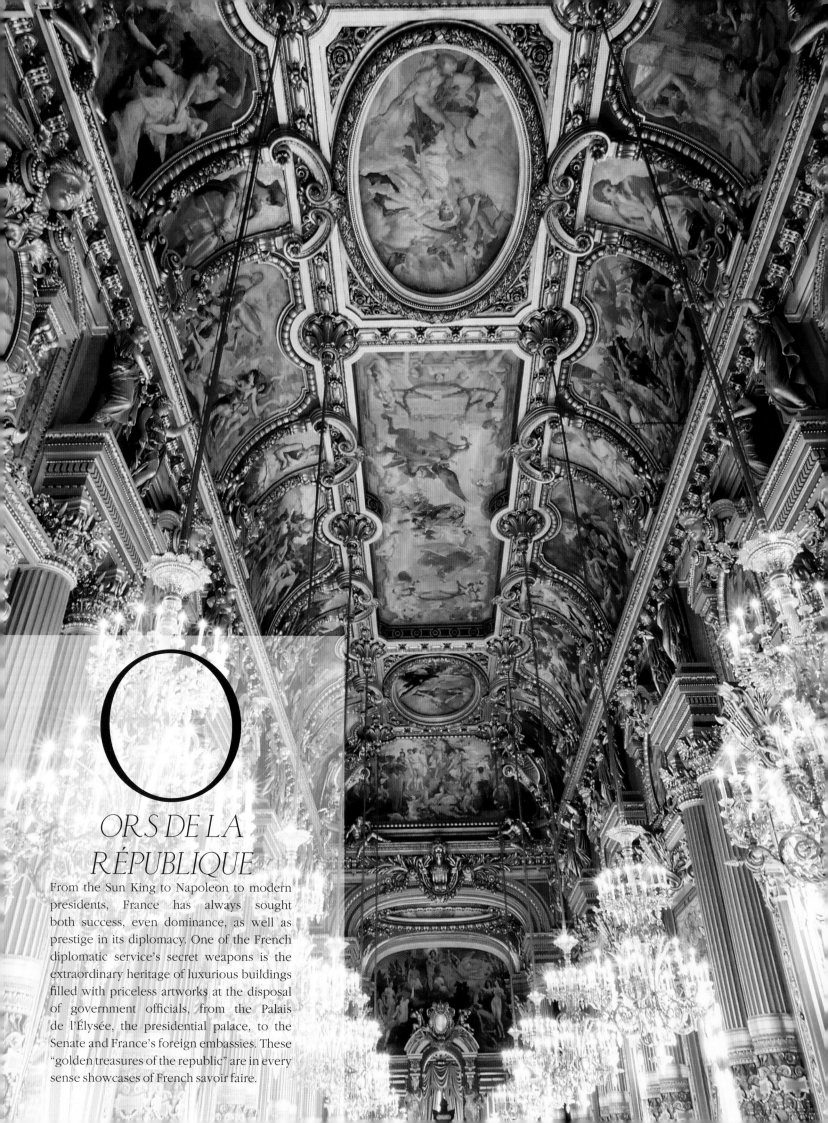

O ORS DE LA RÉPUBLIQUE

From the Sun King to Napoleon to modern presidents, France has always sought both success, even dominance, as well as prestige in its diplomacy. One of the French diplomatic service's secret weapons is the extraordinary heritage of luxurious buildings filled with priceless artworks at the disposal of government officials, from the Palais de l'Élysée, the presidential palace, to the Senate and France's foreign embassies. These "golden treasures of the republic" are in every sense showcases of French savoir faire.

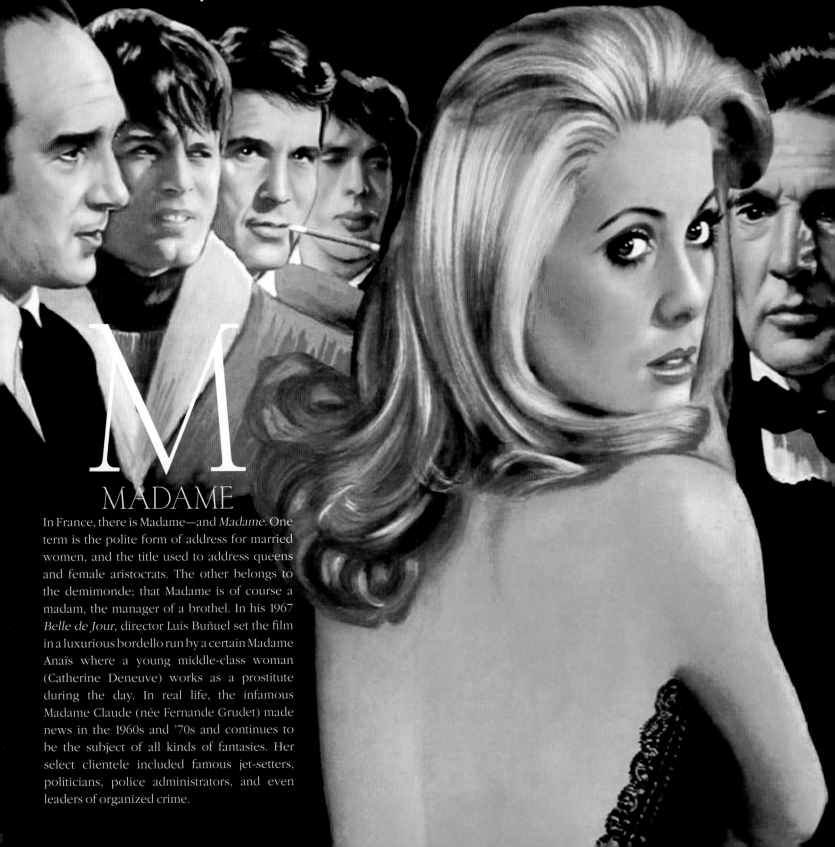

BELLE DE JOUR

d'après le roman de **JOSEPH KESSEL** de l'Académie Française

M

MADAME

In France, there is Madame—and *Madame*. One term is the polite form of address for married women, and the title used to address queens and female aristocrats. The other belongs to the demimonde; that Madame is of course a madam, the manager of a brothel. In his 1967 *Belle de Jour*, director Luis Buñuel set the film in a luxurious bordello run by a certain Madame Anaïs where a young middle-class woman (Catherine Deneuve) works as a prostitute during the day. In real life, the infamous Madame Claude (née Fernande Grudet) made news in the 1960s and '70s and continues to be the subject of all kinds of fantasies. Her select clientele included famous jet-setters, politicians, police administrators, and even leaders of organized crime.

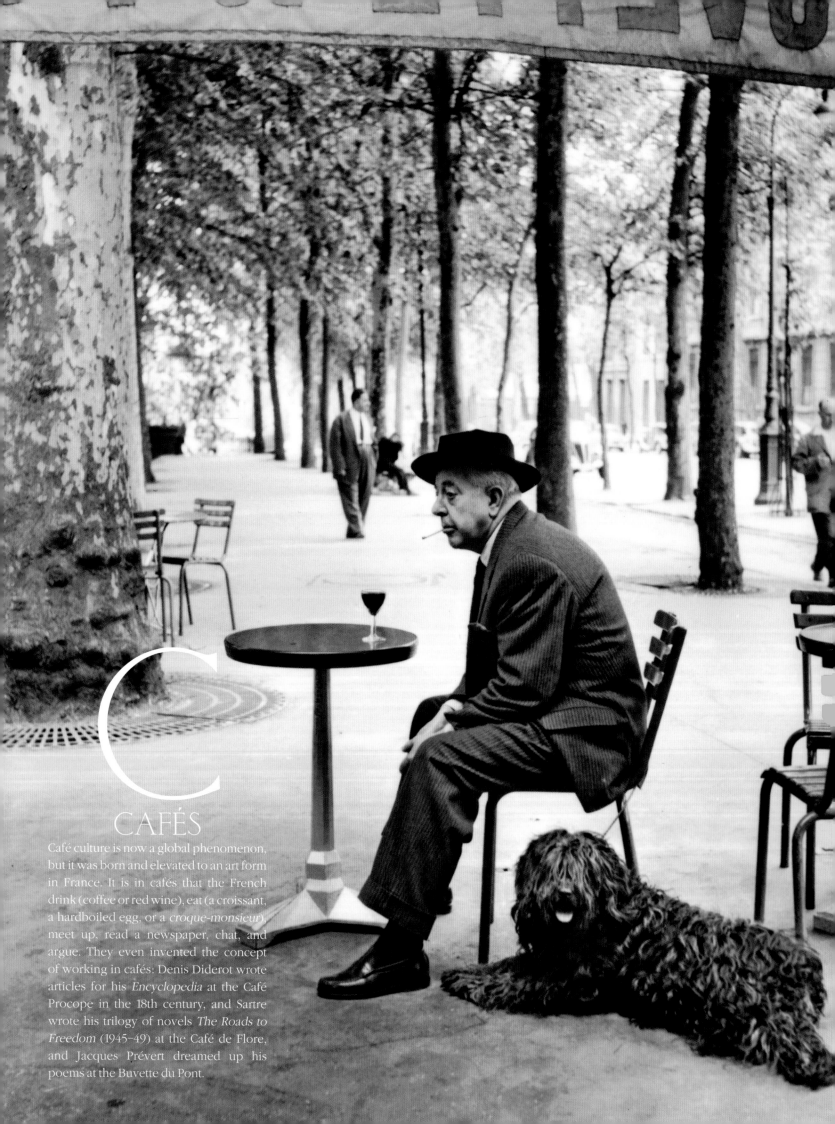

C
CAFÉS

Café culture is now a global phenomenon, but it was born and elevated to an art form in France. It is in cafés that the French drink (coffee or red wine), eat (a croissant, a hardboiled egg, or a *croque-monsieur*), meet up, read a newspaper, chat, and argue. They even invented the concept of working in cafés: Denis Diderot wrote articles for his *Encyclopedia* at the Café Procope in the 18th century, and Sartre wrote his trilogy of novels *The Roads to Freedom* (1945–49) at the Café de Flore, and Jacques Prévert dreamed up his poems at the Buvette du Pont.

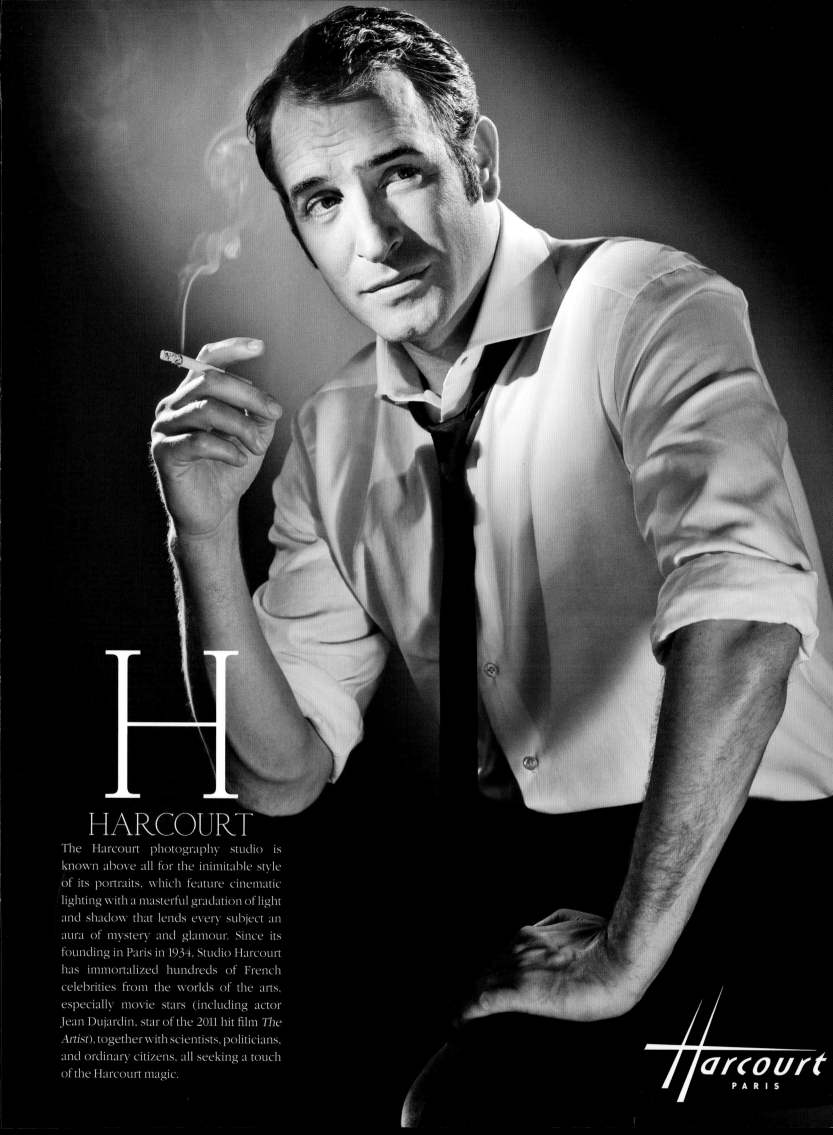

H
HARCOURT

The Harcourt photography studio is known above all for the inimitable style of its portraits, which feature cinematic lighting with a masterful gradation of light and shadow that lends every subject an aura of mystery and glamour. Since its founding in Paris in 1934, Studio Harcourt has immortalized hundreds of French celebrities from the worlds of the arts, especially movie stars (including actor Jean Dujardin, star of the 2011 hit film *The Artist*), together with scientists, politicians, and ordinary citizens, all seeking a touch of the Harcourt magic.

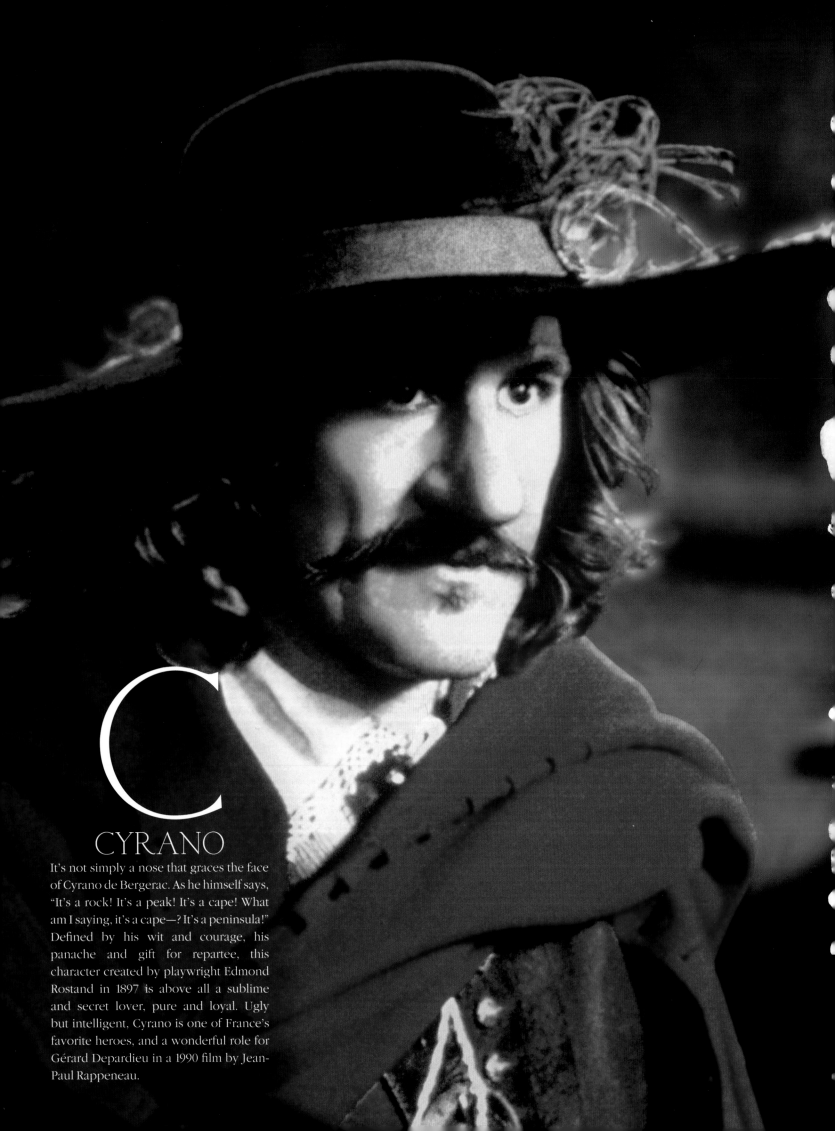

C
CYRANO

It's not simply a nose that graces the face of Cyrano de Bergerac. As he himself says, "It's a rock! It's a peak! It's a cape! What am I saying, it's a cape—? It's a peninsula!" Defined by his wit and courage, his panache and gift for repartee, this character created by playwright Edmond Rostand in 1897 is above all a sublime and secret lover, pure and loyal. Ugly but intelligent, Cyrano is one of France's favorite heroes, and a wonderful role for Gérard Depardieu in a 1990 film by Jean-Paul Rappeneau.

ASTÉRIX

Created in 1959 by René Goscinny and Albert Uderzo, this Franco-Belgian series of comic books follows the adventures of Astérix and Obélix, two heroes of ancient Gaul entrusted by their village with the task of foiling the Roman invasion, aided by a magical potion. Parodying contemporary French customs as well as other countries' idiosyncrasies, the comic presents the very French conviction that even a little shrimp like Astérix and a dim-witted oaf like his pal Obélix can defeat the strongest opponents. With almost 350 million books sold, *Astérix* continues to bring laughter to one generation after another.

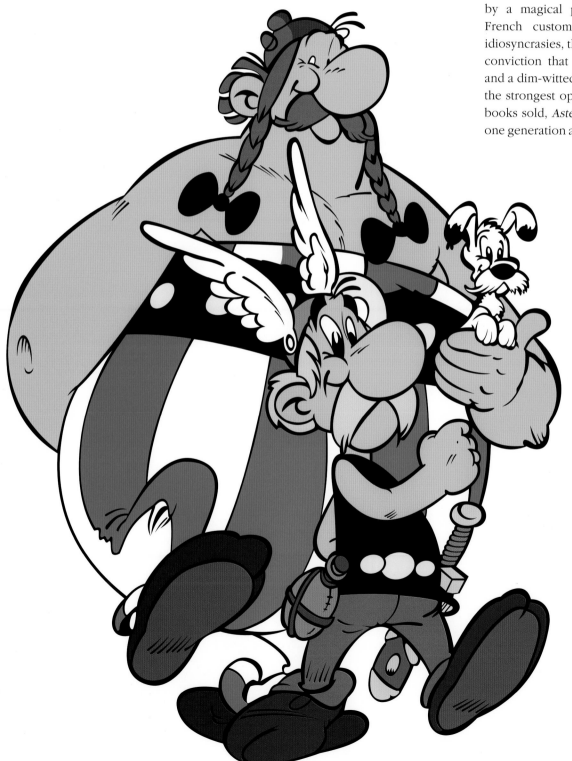

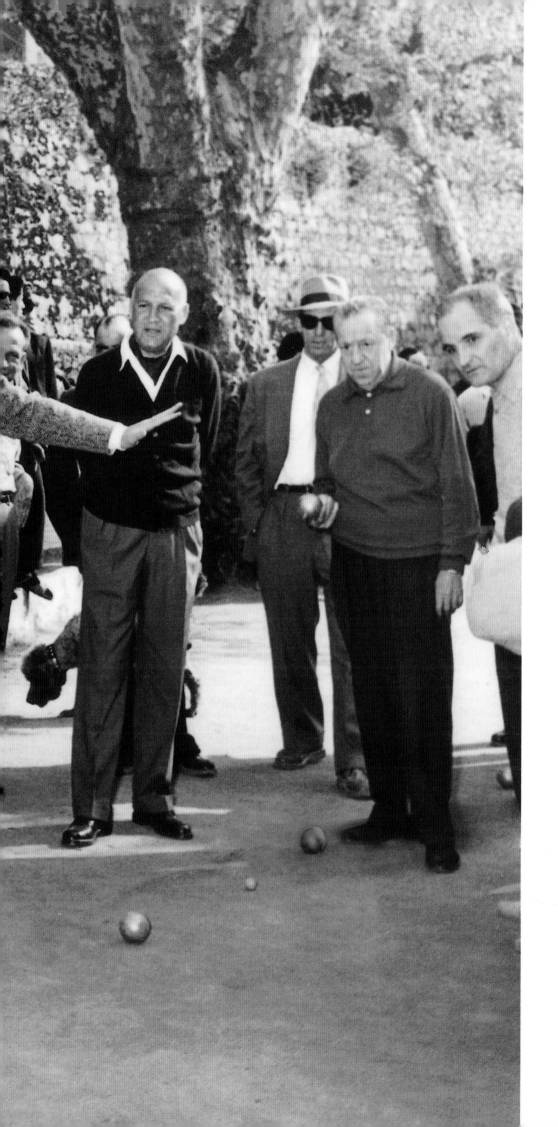

P

PÉTANQUE

Pétanque is one of the most widely practiced leisure sports in France, with nearly 17 million enthusiasts, ranging from real devotees to occasional players, who often gather in public squares and gardens in French cities and towns for a game. The goal is to toss the hollow metal *boules* as close as possible to a tiny wooden ball, called the *cochonnet*, or jack (literally, "piglet"). Play is one on one or in teams of two or three; in singles and doubles each player has three boules, while in triples they have two. Players try to throw a ball as close to the jack as possible, or use their balls to dislodge their opponents'. The winning team receives one point for each ball it lands closer to the jack than the best-placed ball of the opposition. Yves Montand, pictured here with Francis Roux, never missed a friendly game at the Colombe d'Or.

C
CHAMPAGNE

The sparkling white wine produced in the Champagne region, in northeastern France, is often associated with celebratory occasions such as weddings, birthdays, and anniversaries, but champagne is good on any occasion. As Napoleon liked to say, "I cannot live without champagne: In victory, I deserve it; in defeat, I need it."

C
CROISSANT

Breakfast in France is famous for the croissant, the crescent of airy puff pastry that the French simply adore. They eat nearly 50 million of them every week. The croissant, like the baguette, is a culinary symbol of France outside the country.

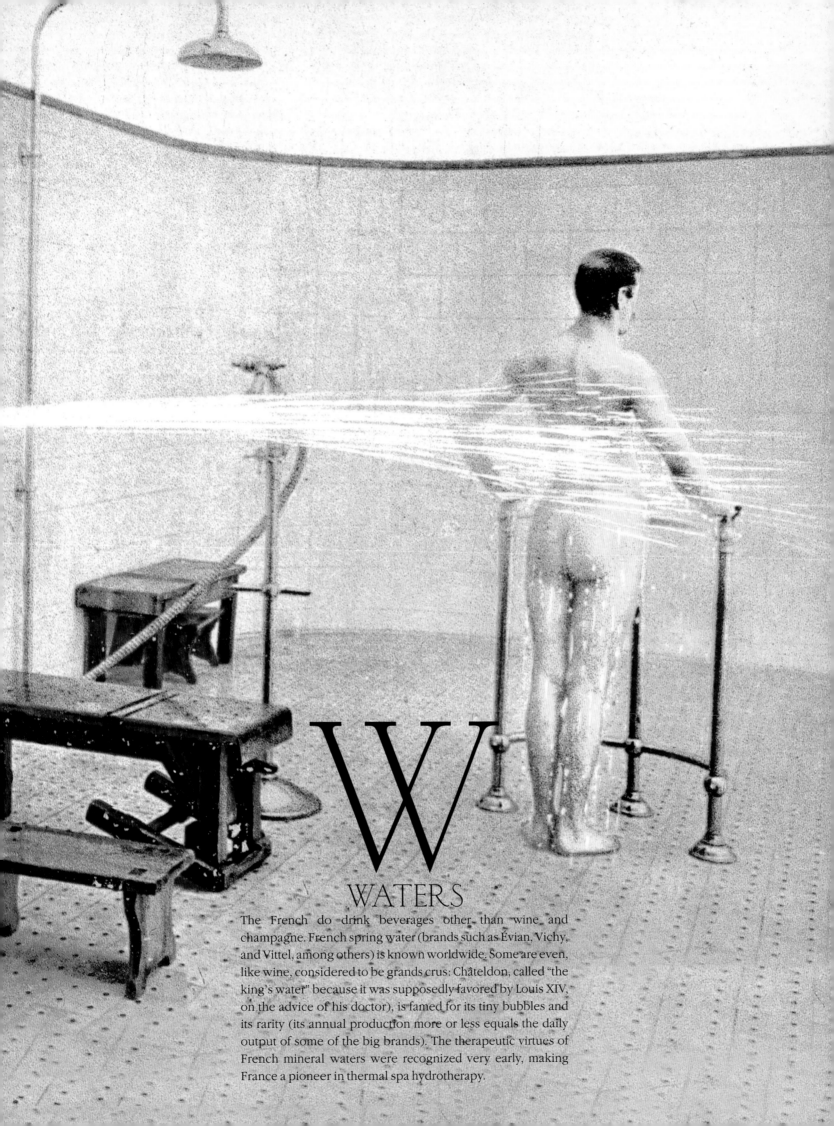

W
WATERS

The French do drink beverages other than wine and champagne. French spring water (brands such as Évian, Vichy, and Vittel, among others) is known worldwide. Some are even, like wine, considered to be grands crus: Châteldon, called "the king's water" because it was supposedly favored by Louis XIV, on the advice of his doctor), is famed for its tiny bubbles and its rarity (its annual production more or less equals the daily output of some of the big brands). The therapeutic virtues of French mineral waters were recognized very early, making France a pioneer in thermal spa hydrotherapy.

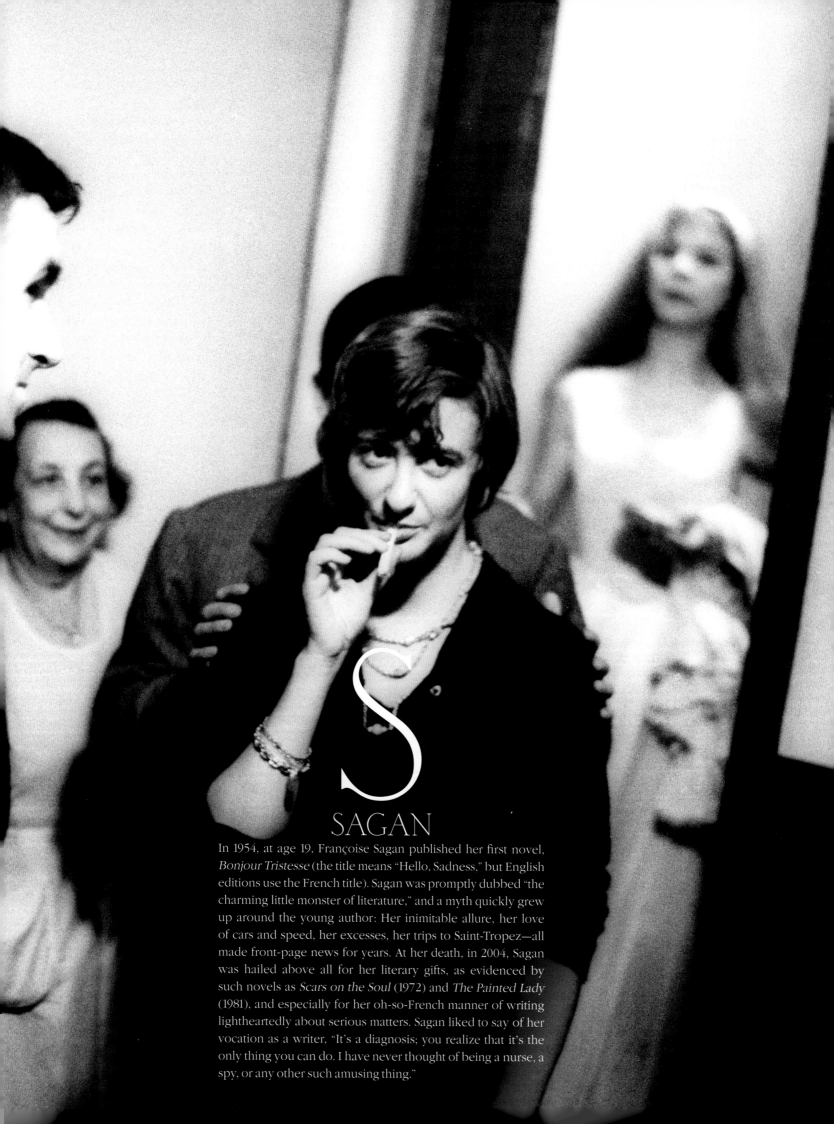

S

SAGAN

In 1954, at age 19, Françoise Sagan published her first novel, *Bonjour Tristesse* (the title means "Hello, Sadness," but English editions use the French title). Sagan was promptly dubbed "the charming little monster of literature," and a myth quickly grew up around the young author: Her inimitable allure, her love of cars and speed, her excesses, her trips to Saint-Tropez—all made front-page news for years. At her death, in 2004, Sagan was hailed above all for her literary gifts, as evidenced by such novels as *Scars on the Soul* (1972) and *The Painted Lady* (1981), and especially for her oh-so-French manner of writing lightheartedly about serious matters. Sagan liked to say of her vocation as a writer, "It's a diagnosis; you realize that it's the only thing you can do. I have never thought of being a nurse, a spy, or any other such amusing thing."

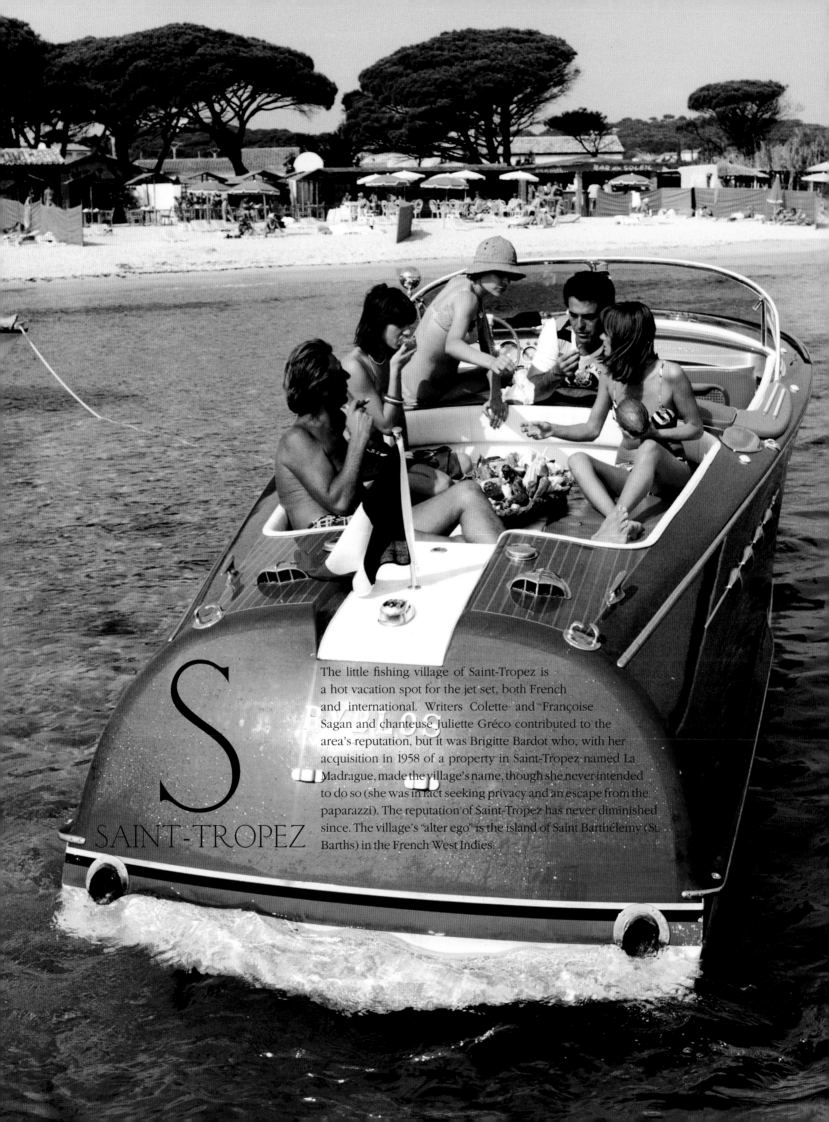

SAINT-TROPEZ

Saint-Tropez

The little fishing village of Saint-Tropez is a hot vacation spot for the jet set, both French and international. Writers Colette and Françoise Sagan and chanteuse Juliette Gréco contributed to the area's reputation, but it was Brigitte Bardot who, with her acquisition in 1958 of a property in Saint-Tropez named La Madrague, made the village's name, though she never intended to do so (she was in fact seeking privacy and an escape from the paparazzi). The reputation of Saint-Tropez has never diminished since. The village's "alter ego" is the island of Saint Barthélemy (St. Barths) in the French West Indies.

P
PUBLICIS

In 1926, Marcel Bleustein-Blanchet, barely 20 years old, founded the public relations agency Publicis. A publicity genius, Bleustein-Blanchet was the first to use radio, then television, as PR media. He started the first radio news program (for Radio Cité) and devised the first jingles. After World War II, Publicis expanded to the U.S., then around the world. Today, Publicis is the third-largest PR company in the world.

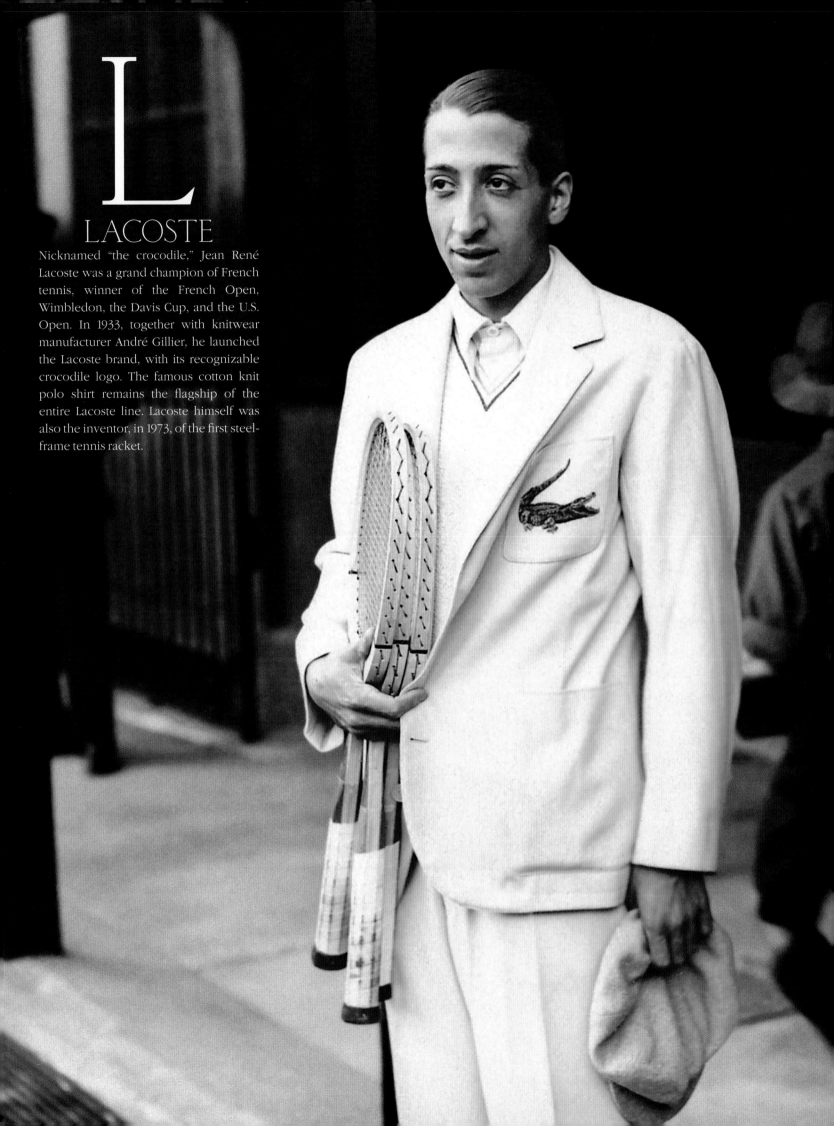

L
LACOSTE

Nicknamed "the crocodile," Jean René Lacoste was a grand champion of French tennis, winner of the French Open, Wimbledon, the Davis Cup, and the U.S. Open. In 1933, together with knitwear manufacturer André Gillier, he launched the Lacoste brand, with its recognizable crocodile logo. The famous cotton knit polo shirt remains the flagship of the entire Lacoste line. Lacoste himself was also the inventor, in 1973, of the first steel-frame tennis racket.

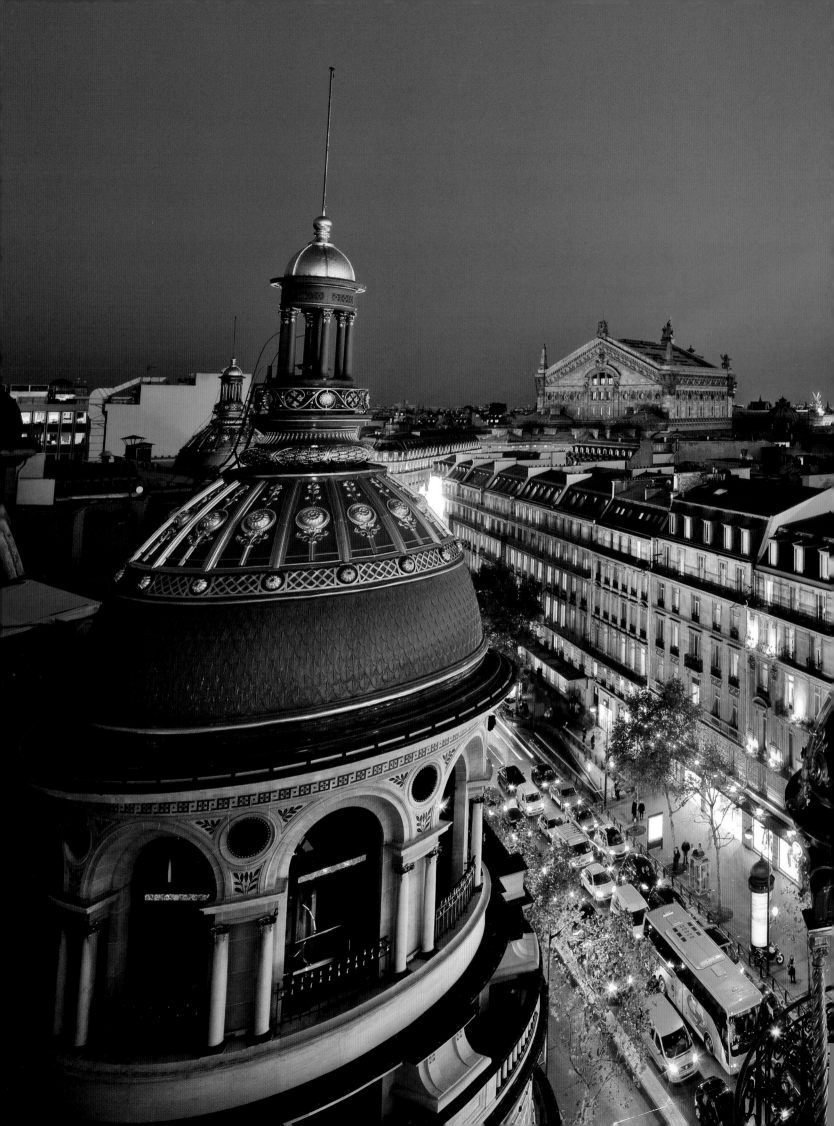

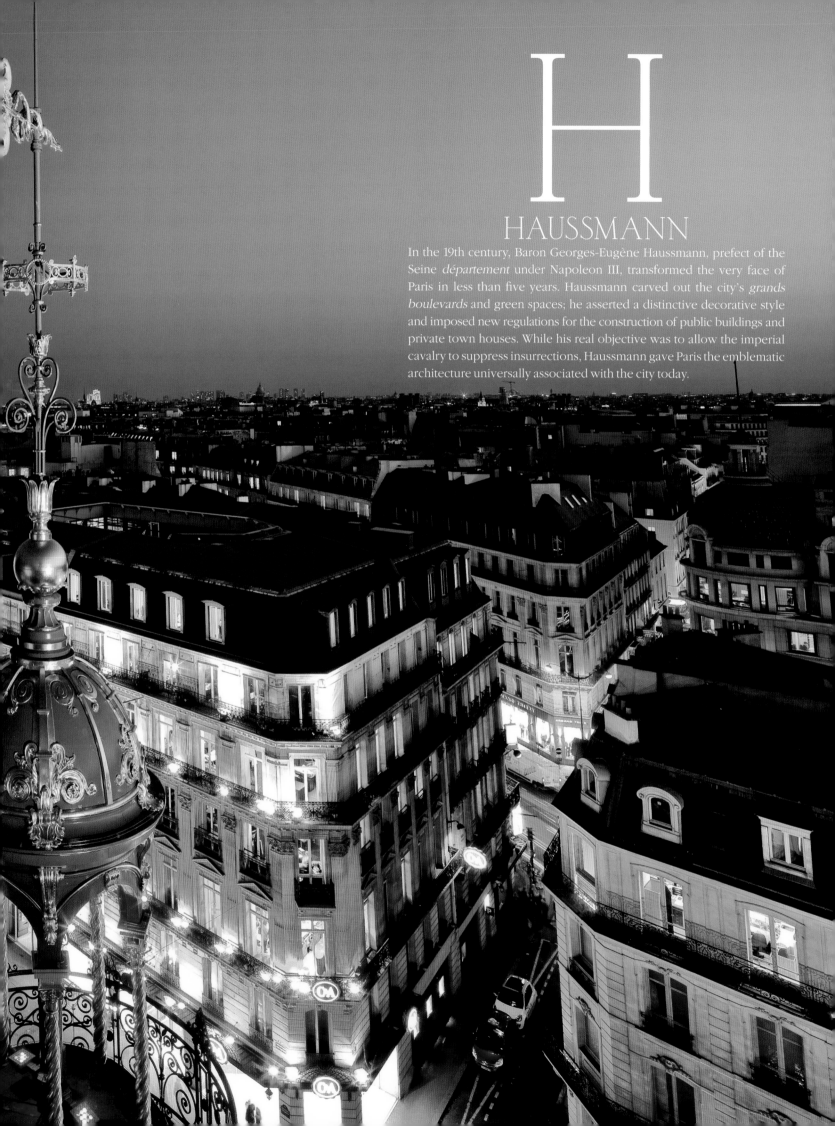

H
HAUSSMANN

In the 19th century, Baron Georges-Eugène Haussmann, prefect of the Seine *département* under Napoleon III, transformed the very face of Paris in less than five years. Haussmann carved out the city's *grands boulevards* and green spaces; he asserted a distinctive decorative style and imposed new regulations for the construction of public buildings and private town houses. While his real objective was to allow the imperial cavalry to suppress insurrections, Haussmann gave Paris the emblematic architecture universally associated with the city today.

Captions & Photo Credits

p. 8: Charles de Gaulle, Corsica, 1958. Photo © Gamma-Keystone via Getty Images.
p. 9: Brigitte Bardot, The Chair Session, 1967. Photo by Sam Levin © Ministère de la Culture/Médiathèque du Patrimoine, Dist. RMN-Grand Palais/Art Resource, NY.
pp. 10-11: Students of the Polytechnique military school, Bastille Day parade, Paris, July 14, 2011. Photo © AFP/Getty Images.
p. 12: *Louis XIV in Royal Costume*, by Hyacinthe Rigaud, 1701, oil on canvas. Photo © Louvre, Paris, France/Giraudon/The Bridgeman Art Library.
p. 13: Guerlain's Shalimar perfume. Photo © Laziz Hamani/Assouline.
p. 14: Provence, 1955. Photo © Elliott Erwitt/Magnum Photos.
p. 15: Laurence Treil models a look from Jean-Paul Gaultier's La Concierge Est Dans l'Escalier collection, spring-summer 1988. Laurence Treil/Agence Silver–Paris. Photo © Jean Paul Gaultier.
pp. 16-17: Chromolithograph poster by Henri de Toulouse-Lautrec, 1896. Photo: Private Collection/© Christie's Images/The Bridgeman Art Library.
p. 18: Photo for the *Amélie* poster, 2001. Photo © Miramax/courtesy Everett Collection.
p. 19: Porte Dauphine Métro station entrance. Photo © Bianchetti/Leemage.
p. 20: Poster for *Le Testament d'Orphée*, directed by Jean Cocteau, 1959. Photo © Private Collection/Archives Charmet/The Bridgeman Art Library. © 2012 ADAGP, Paris/courtesy of M. Pierre Bergé, president of the Comité Jean Cocteau.
p. 21: *Napoleon on the Bridge of Arcole*, by Jean-Antoine Gros, circa 1797. Photo © Hermitage, St. Petersburg, Russia/The Bridgeman Art Library.
pp. 22-23: Film still from *A Trip to the Moon*, by Georges Méliès, 1902. Photo © Roger-Viollet/The Image Works.
p. 24: *Portrait of Marcel Proust*, by Jacques-Émile Blanche, 1892, oil on canvas. Photo: Musée d'Orsay, Paris, France/The Bridgeman Art Library. © 2012 Artists Rights Society (ARS), New York/ADAGP, Paris.
p. 25: Daniel Buren's *Les Deux Plateaux*, in the Palais-Royal courtyard, Paris. Photo © Barbara Dalmazzo-Tempel.
p. 26: Escargots. Photo © Paul Taylor/Corbis.
p. 27: From left: Psychoanalysts Georges Parcheminey, Sacha Nacht, and Jacques Lacan, early 1950s. Photo © Rue des Archives/The Granger Collection, New York.
p. 28: Ad for *Le Figaro*, 1952, illustration by Raymond Savignac. Photo © Collection Kharbine-Tapabor. © 2012 Artists Rights Society (ARS), New York/ADAGP, Paris.
p. 29: Catherine Deneuve in a Chanel dress, January 1963. Photo © Walter Carone/*Paris Match*.
pp. 30-31: Château de Chambord. Photo © Dallas and John Heaton/Corbis.
p. 32: Film still from the TV series *The Undersea World of Jacques Cousteau*, circa 1970. Photo © ABC via Getty Images.
p. 33: Jean-Paul Sartre and Simone de Beauvoir, circa 1946. Photo © David E. Scherman/Time Life Pictures/Getty Images.
p. 34: The Eiffel Tower and the reproduction of the Statue of Liberty, in Paris. Photo © Richard Kalvar/Magnum Photos.
p. 35: Bust of Marianne modeled after Brigitte Bardot, sculpted by Alain Aslan, 1969. Photo © Private Collection/Archives Charmet/The Bridgeman Art Library.
p. 36-37: Chefs and UNESCO officials at the Élysée Palace, Paris, April 6, 2011, to commemorate the addition of French cuisine to the World Heritage list. Photo © AFP/Getty Images.
p. 38: *Portrait of Pascal*, by Jean Donnat, 17th century, charcoal on paper. Photo © Private Collection/The Bridgeman Art Library.
p. 39: *Portrait of Victor Hugo*, circa 1870. Photo © Goupil & Co./Alinari Archives, Florence/Alinari via Getty Images.
pp. 40-41: *The Kiss by the Hôtel de Ville*, 1950. Photo © Robert Doisneau/Gamma-Rapho/Getty Images.
pp. 42-43: Plaza Athénée courtyard. Photo © Frédéric Ducout.
p. 44: *Portrait of the Marquis de Sade Surrounded by Devils*, by H. Biberstein, 1866, from *The Work of the Marquis de Sade*, by Guillaume Apollinaire, 1909. Photo © Private Collection/The Bridgeman Art Library.
p. 45: Serge Gainsbourg and Jane Birkin, photographed on the set of *Madame Claude*, directed by Just Jaeckin, 1977. Photo © Just Jaeckin/Sygma/Corbis.
p. 46: Writer Joseph Kessel at his induction into the Académie Française, Paris, February 6, 1964. Photo © Rue des Archives/The Granger Collection, New York.
p. 47: *L'Aurore* newspaper, January 13, 1898. Photo © Private Collection/Archives Charmet/The Bridgeman Art Library.
pp. 48-49: Ad for Galeries Lafayette, 2003. Photo © Jean-Paul Goude.
p. 50: Guignol puppets. Photo © Jean-Luc Petit/Gamma-Rapho via Getty Images.
p. 51: Zinedine Zidane holding the FIFA trophy, 1998. Photo: Daniel Garcia/AFP/Getty Images.
p. 52: Air France hostess wearing a uniform designed by Christian Dior for winter 1963. Photo © Air France Collection/Air France Museum Collection. All rights reserved.
p. 53: Bic ballpoint pen. Photo © BIC.
p. 54: Philippe Starck with his L'Oreille Qui Voit ("The Ear That Sees") mirror, 2008. Photo © Jean Baptiste Mondino.
p. 55: Babar, 1989. Photo © Nelvana/Ellipse/Collection Christophel.
pp. 56-57: Film still from *Le Corniaud* (*The Sucker*), by Gérard Oury, 1965. Photo © Les Films Corona/Collection Christophel.
p. 58: Ad for the Citroën 2 CV, circa 1960s. Photo © Rue des Archives/The Granger Collection, New York.
p. 59: French cyclist Laurent Fignon on the Champs-Élysées in Paris, July 23, 1989, at the end of the Tour de France. Photo © AFP/Getty Images.
p. 60: French cheeses. Photo © James Carrier/Getty Images.

p. 61: A man reading *Le Monde* at the café Saint Séverin, Paris. Photo © Mark Avery/ZUMA Press/Corbis.
p. 62-63: From left: Johnny Hallyday, Sheila, Sylvie Vartan, and Françoise Hardy, in Saint Raphael, August 22, 1969. Photo © Rue des Archives/The Granger Collection, NY.
p. 64: Brochure for French railway company PLM, circa 1930. Photo © Mary Evans/Retrograph Collection/Everett Collection.
p. 65: Marcel Marceau, 1966. Photo © Starstock/Photoshot.
p. 66: A young woman at a protest against the controversial CPE law, Paris, March 7, 2006. Photo © AP Photo/François Mori.
p. 67: Daniel Cohn-Bendit, one of the student leaders of the May 1968 protests. Photo © Gilles Caron/Contact Press Images.
p. 68: The first Michelin Guide, 1900. Photo © Apic/Getty Images.
p. 69: *The Artist's Garden at Vétheuil*, by Claude Monet, 1880. Photo © National Gallery of Art, Washington DC, USA/Giraudon/The Bridgeman Art Library.
pp. 70-71: Film still from *The Discreet Charm of the Bourgeoisie*, 1972. Photo courtesy Everett Collection.
pp. 72-73: Joey Starr and Kool Shen performing at the Olympia Theater, Paris, June 23, 2008. Photo © Foc Kan/WireImage.
p. 74: Marion Cotillard arriving at the screening of *De Rouille et d'Os* (*Rust and Bone*), at the Cannes Film Festival, May 17, 2012. Photo © Brock Miller/Splash News/Corbis.
p. 75: Film still from *Breathless*, 1960. Photo courtesy Everett Collection.
p. 76: Alain Delon, photographed in Saint-Tropez, August 1966, later used for the ad for Dior's Eau Sauvage, an iconic men's fragrance launched in 1966. The image has been modified with the photographer's consent. Photo: Jean-Marie Perrier © Christian Dior Parfums.
p. 77: Title page of a first edition of *Les Fleurs du Mal*, with a dedication to Paul de Saint-Victor. Photo © Bibliothèque Littéraire Jacques Doucet, Paris, France/Archives Charmet/The Bridgeman Art Library.
pp. 78-79: *Le Moulin de la Galette*, by Pierre-Auguste Renoir, 1876. Photo © Musée d'Orsay, Paris, France/Giraudon/The Bridgeman Art Library.
p. 80: *Declaration of the Rights of Man and of the Citizen*, decreed by the National Assembly and accepted by the King on August 26, 1789. Photo © De Agostini Picture Library/G. Dagli Orti/The Bridgeman Art Library.
p. 81: Accordion. Photo © C Squared Studios/Getty Images.
p. 82: A Resistance group in the Corsican campaign during World War II. Photo © Rue des Archives/The Granger Collection, NY.
p. 83: *The Witness*, an illustration of Marianne by Paul Iribe, on the cover of *Parlons Français*, July 1, 1934. Photo © Private Collection/Archives Charmet/The Bridgeman Art Library.
p. 84: Poster by Haskell Coffin, circa 1917.
p. 85: Film still from *Jules et Jim* starring Jeanne Moreau, Henri Serre, and Oskar Werner, 1962. Photo © DPA/courtesy Everett Collection.
pp. 86-87: Film still from *Les Valseuses* (*Going Places*), 1974. Photo © C.A.P.A.C./Prodis/Collection Christophel.
p. 88: *Portrait of Evariste Galois*, heliogravure, French school, 19th century. Photo © Private Collection/Giraudon/The Bridgeman Art Library.
p. 89: Detail of *Rimbaud Dans Paris*, by Ernest Pignon-Ernest, 1978, silkscreen print. Photo © Ernest Pignon-Ernest. © 2012 Artists Rights Society (ARS), New York/ADAGP, Paris.
p. 90: René Descartes and *The Discourse on Method* French postage stamp designed by H. Cheffer, 1937. Photo © CCI/The Art Archive at Art Resource, NY.
p. 91: Aéropostal poster by Besson, circa 1920s. Photo © Collection Kharbine-Tapabor.
pp. 92-93: The TGV. Photo © Michael Dunning/Getty Images.
p. 94: Smart card. Photo © Shutterstock.
p. 95: Evening jacket Hommage à Ma Maison, Yves Saint Laurent collection spring-summer 1990, embroidery by Lesage. Photo © Keiichi Tahara/Assouline.
pp. 96-97: Model Suzy Parker wearing Dior, at the Casino de Monte Carlo, 1954. Photo: Henry Clarke © 2012 Artists Rights Society (ARS), New York/ADAGP, Paris.
pp. 98-99: Official portraits of French presidents, clockwise from top left: Charles de Gaulle, photo by Jean-Marie Marcel; Valéry Giscard d'Estaing, photo by Jacques-Henri Lartigue; Nicolas Sarkozy, photo by Philippe Warrin; Jacques Chirac, photo by Bettina Rheims; François Hollande, photo by Raymond Depardon; François Mitterrand, photo by Gisèle Freund; Georges Pompidou, photo by François Pagès/*Paris-Match*. All photographs © Dila/La Documentation Française.
p. 101: Edith Piaf, circa 1950s. Photo © Michael Ochs Archives/Getty Images.
pp. 102-103: Ad for Le Bon Marché, 2011. Photo © Les Fraises Sauvages/Ellen von Unwerth/Art + Commerce.
p. 104: Title page from the first volume of *Les Essais* (*Essays*), by Montaigne, 1725, from the National Library of Catalonia, Barcelona, Spain. Photo © J. Bedmar/Iberfoto/The Image Works.
p. 105: Azzedine Alaïa and the model Farida Khelfa, collage of cut-up photograph and adhesive tape, circa 1980s. © Jean-Paul Goude.
pp. 106-107: Film still from *Les Uns et Les Autres*, 1981. Photo © Laurent Maous/Gamma-Rapho via Getty Images.
p. 108: Bottles of Romanée-Conti. Photo © Guillard Jacques/Scope-Image.
p. 109: Cover of *L'Etranger* by Albert Camus. Photo courtesy of Gallimard.
p. 110: André Malraux, 1934. Photo © Philippe Halsman/Magnum Photos.
p. 111: *Fountain*, by Marcel Duchamp, 1917. Photo © The Israel Museum, Jerusalem, Israel/Vera & Arturo Schwarz Collection of Dada and Surrealist Art/The Bridgeman Art Library. © 2012 Artists Rights Society (ARS), New York/ADAGP, Paris/Succession Marcel Duchamp.

INDEX & ACKNOWLEDGMENTS

A big thank-you to Antonin, Rémy, and Juliette for their support and thoughtful suggestions. Thank you from the bottom of my heart to Martine Assouline for her wonderful energy and for the trust and confidence she showed me in proposing this project. Thanks also to Prosper and the whole Assouline team, particularly Cécilia Maurin, Amy L. Slingerland, Rebecca Stepler, and Valérie Tougard for their professionalism, responsiveness, and kindness.

Bérénice Vila Baudry

Assouline would like to thank: Jessica Daniel, Air France; Sylvie Fabregon, Agence Silver; Kimberly D. Waldman, AP Images; Kimberly La Porte, Art + Commerce; Lauren Graves and Janet Hicks, Artists Rights Society; Jennifer Belt, Art Resource; Richard Aujard; Eugenia Bell, Avedon Foundation; Carole Baudin, BIC Group; Wendy Zieger, Bridgeman Art Library; Elizabeth Kerr, Camera Press; Jérôme Gautier and Frédéric Bourdelier, Christian Dior Couture; Jeffrey D. Smith, Contact Press Images; Oscar Espaillat, Corbis; Barbara Dalmazzo-Tempel; Isabelle Guégan, DILA; Frédéric Ducout; Marci Brennan, Everett Collection; Emmanuelle de Noirmont, Galerie Jérôme de Noirmont; Charles Gil, Gallimard; Jelka Music and Thoaï Niradeth, Jean Paul Gaultier; Mary Scholz, Getty Images; Virginie Laguens and Grâce Salemme, Jean-Paul Goude; Silka Quintero, Granger Collection; Laziz Hamani; Maya Ahluwalia, Lalique; Joo Lee, Leemage; Michael Shulman, Magnum Photos; Nathalie Egli, Marilyn Agency; Catherine Moyen de Baecque; Rachel Brishoual, Musées des Arts Décoratifs; Yvette Ollier-Pignon; Aline Lauvergeon, Photo12; Marvin Woodyatt, Photoshot; Pierre & Gilles; Marine Attrazic, Pierre Hermé; Isabelle Maurin and Alexandra Seigle, Plaza Athénée Paris; Caroline Charrier, RMO; Diego Sanchez and Sylvie Fleury; Djilali Boubekeur, Scoop; Mia Champetier de Ribes, Starck Network; Ivann Franchi, Studio Harcourt; Keiichi Tahara; Kharbine Tapabor; Gilles Targat; Jessica Almonte and Lorraine Goonan, The Image Works.